# Sailing through Time

## THE SHIP IN GREEK ART

ATHENS 1995

Translated by
Dr DAVID HARDY

© KAPON EDITIONS
 23-27 Makriyanni Str, Athens 117 42, Greece
Tel. 92 35 098, Fax 92 14 089

ISBN 960-7254-15-5

# Sailing through Time

## THE SHIP IN GREEK ART

*Text*
ELSI SPATHARI

*Prologue: Vassos Karageorghis*

KAPON EDITIONS

## PUBLISHER'S NOTE

It is only rarely that we are able to give free rein to our emotions while realizing a dream closely connected with our professional interests. Even more rarely are we granted the opportunity to select subject, material and colleagues in the same carefree way that a child arranges a game, yet without betraying the high standards we demand of ourselves.

The primeval image of the boat is an allusion to the desire to travel, and every childhood shore is a shipyard full of dreams of distant voyages to the ends of our mind and our map. The idea of such a voyage through time, with pictures of boats ploughing the endless sea lanes, left us with "a taste of the storm on our lips".

We quickly became aware that there is an enormous, absorbing bibliography on the subject, which might easily have quelled our initial enthusiasm. Our original intention, however, led us to chart a course different from the one usually followed: we were concerned not so much with the quantity of the historical and visual material as in the quality of the approach and presentation. We believe that on a voyage of this kind what counts is the style, the intent, the *bon voyage*.

The text written by Mrs Elsi Spathari is articulated in historical terms, beginning at the dawn of the Neolithic period and the early maritime cross-roads of the Cycladic miracle. It travels via Minoan Crete and the Sea Empire of the Mycenaeans to the time of Homer, the Archaic period and the wooden walls of Themistokles, and then to the pioneering navigational feats of Nearchos and Pytheas, the Roman galleys and the *dromons* of the byzantine fleet, ending at the present day, when the forms and characters change, though still retaining the spirit and attitude blessed over the centuries by the "Gorgona Panayia".

The illustrations are set against a cultural spectrum covering many millennia, and their aesthetic presentation is designed to bring out the links binding yesterday with today, the apocalyptic nature of travel, and the freedom of spirit brought to us from all directions by the murmur of the boundless sea.

MOSES and RACHEL KAPON

# ACKNOWLEDGEMENTS

The publication of this book owes much to the interest and financial support of the Mortgage Bank of Greece, to whom we extend warm thanks. We would also like particularly to thank Professor Vassos Karageorghis, for generously offering to write an introduction to the volume.

Thanks are due, finally, to the museums, foundations, collectors, friends and colleagues, both in Greece and abroad, a list of whose names follows, for permission to publish exhibits from their collections, and for their assistance in our long efforts to assemble the illustrative material:

M. ACHEIMASTOU-POTAMIANOU, ARCHIMANDRITE PHILOTHEOS DEDES, M. BORBOUDAKIS, Mr CENIVAL, T. CHRYSOCHOÏDOU, E. DAKORONIA, A. DELIVORRIAS, K. DEMAKOPOULOU, M. HATZIKOSTI, L. KARAPIDAKI, E. KARASTAMATI, A.KARETSOY, A. KOKKOU, E. KOURKOUTIDOU, G. LIONTOS, X. MICHAIL, CH. MICHAILIDIS, J. PAPAÏOANNOU, I. PAPANTONIOU, A. PASQUIER, V.PENNA, G. RAGIAS, F. RIZOPOULOU, J. SAKELLARAKIS, R. SYMES, A.P.TZAMALIS, N. ZIAS.

## MUSEUMS - COLLECTIONS

**ALEXANDRIA (EGYPT):** Greco-Roman Museum **AMORGOS:** Archaeological Museum **ARGOS:** Archaeological Museum **ATHENS:** Commercial Bank, Credit Bank, Ionian Bank, A. Amandry Collection, A. G. Levendis Collection, A. Mintzas-A. Skouryialos Collection, K. Mitsotakis Collection, M. Païdousis Collection, I. Vorres Collection, National Gallery, Acropolis Museum, Benaki Museum, Byzantine Museum, Kanellopoulos Museum, Kerameikos Museum, Museum of Greek Folk Art, National Archaeological Museum, National Historical Museum, Numismatic Museum, Publishing House "Melissa", Society of the Greek Literary and Historical Archive **BASEL:** Antikenmuseum und Sammlung

Ludwig **BERLIN:** Staatliche Museen - Antikensammlungen **CHAERONIA:** Archaeological Museum **COLOGNE:** M. Krasakis Collection **CORINTH:** Archaeological Museum **CYPRUS:** Asinou, Panayia Forviotissa, Museum of Kykkos' Monastery, Nicosia, Church of Ayios Antonios, Nicosia, Archaeological Museum, Nicosia, Byzantine Museum of the Makarios III Foundation, Paphos, Monastery of Panayia Chrysorrhoiatissa **DELOS:** Archaeological Museum **ELEUSIS:** Archaeological Museum **FLORENCE:** Archaeological Museum **GALAXIDI:** Galaxidi Museum **HERAKLEION:** Archaeological Museum, Historical Museum of Crete **ISCHIA (ITALY):** Archaeological Museum **ISTHMIA:** Archaeological Museum **KERKYRA:** Church of the Panayia ton Xenon, Monastery of the Platytera, Museum of the Antivouniotissa **KOS:** Archaeological Museum **LAMIA:** Archaeological Museum **LONDON:** British Museum, Victoria and Albert Museum **MADRID:** National Library **MOUNT ATHOS:** Monastery of Panteleimon **MUNICH:** Antikensammlungen **MYKONOS:** Aegean Nautical Museum **MYTILINI:** Vareia, Theophilos Museum, Petra, T. Eleftheriadis Collection **NAFPLION:** Archaeological Museum, Peloponnesian Folklore Foundation **NAPLES:** National Archaeological Museum **NEW YORK:** Metropolitan Museum **OINOUSSAI:** Naval Museum **PARIS:** Musée du Louvre **PIRAEUS:** Greek Naval Museum **RAVENNA (ITALY):** Archaeological Museum **ROME:** Musei Capitolini (Palazzo dei Conservatori), Museo della Civiltà Romana, Museum of the Villa Giulia **RUVO (ITALY):** Jatta Collection **SITEIA:** Toplou Monastery **SKYROS:** Archaeological Museum **SPARTA:** Archaeological Museum **SPERLONGA (ITALY):** Archaeological Museum **STOCKHOLM:** Museum of Mediterranean and Middle Eastern Antiquities **THEBES:** Archaeological Museum **TOLEDO:** Museo di Santa Cruz **TORONTO:** Royal Ontario Museum **TUNISIA:** Bardo Museum **VATICAN:** Pio Clementino Museum **VOLOS:** Archaeological Museum, Kitsos Makris Collection **VENICE:** Museum of the Greek Institute of Byzantine and Post-Byzantine Studies.

**PROLOGUE**  The historical fortunes of no other Mediterranean country are so closely linked to the sea as those of Greece. Almost anywhere you stand in Greece, you gaze upon the sea, are aware of its presence, feel the need to tame it. From very early Neolithic times, small rafts traversed the Greek seas, transporting obsidian from Melos to meet the needs of the prehistoric Aegean settlements, and later carrying food-stuffs, animals and metals. There was no life without the sea, no communication without the ship. The most important phases of Greek civilization are connected with overseas exploration and expeditions: the commercial dealings of the Mycenaeans with the eastern and the central Mediterranean, the colonization of Cyprus and, in historical times, the founding of Greek colonies in southern Italy and the eastern Mediterranean.

Commercial transactions, the movement of artists and intellectuals, of goods and ideas, the defeating of enemies – all these were bound up with ships. The Homeric poems sing of the Greek naval expedition to Troy, and the wanderings of Odysseus may be thought of as a component of the life of all Greeks at all periods.

The ship, whether merchantman or warship, is depicted in ancient vase-painting, figurine-modelling, metal-work and seal engraving. Nor is it absent from Byzantine wall-paintings and popular art, or from contemporary Greek art.

Technological progress has made it possible today to investigate the depths of the sea, and to excavate shipwrecks of all periods. The recent underwater excavations at Dokos, Iria, Alonnesos, and the astonishing discoveries at Kaş and the Gelidonya Cape on the southwest coast of Asia Minor fire the imagination and enrich our knowledge of the scale and importance of trade amongst Greeks, and between the Mycenaeans and the Cypriots, and other Mediterranean peoples. The ship of Cyreneia, both the ancient vessel and "Cyreneia II", has revived images of the Greek naval tra-

dition. Exhibitions and conferences with titles such as "Greece and the Sea", "Cyprus and the Sea", and "Res Maritimae" reveal how topical the subject of the ship is at present. The volume you hold in your hands appears at precisely the right time, and is an enrichment of the Greek archaeological bibliography.

Recently published academic works dealing with the iconography of the ancient ship, such as Dorothea Gray's *Seewesen, Archaeologia Homerica* (1974), or Lucien Basch's *Le musée imaginaire de la marine antique* (1987) and others, have undoubtedly made important contributions to the science of archaeology. The volume *Sailing through Time - The Ship in Greek Art*, written by the archaeologist Mrs Elsi Spathari, though aimed at a broader public, is no less scholarly in its documentation. The text is harmoniously interwoven with the illustrations, and the two together give an excellent picture of the ship, both as a means of communication, as it evolved over time, and as an inspiration for artistic creation. The assembling of such a vast quantity of material from a large number of Greek and foreign museums has been a major endeavour, which has been realized thanks to the persistence and love of Rachel and Moses Kapon. Their love frequently becomes a passion for Greek art and Greece in general, and their aesthetic sensibilities have significantly raised the standard of Greek books, as may be seen from the long list of publications produced by them. I am sure that their latest offering will greatly assist both Greeks and foreigners alike to a greater awareness of the importance of the Greek naval tradition.

VASSOS KARAGEORGHIS

Professor of Archaeology, University of Cyprus
Foreign Member of the Academy of Athens

# CONTENTS

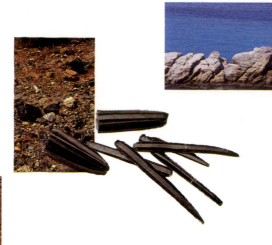

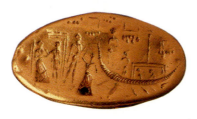

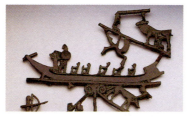

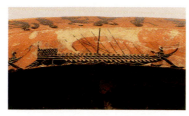

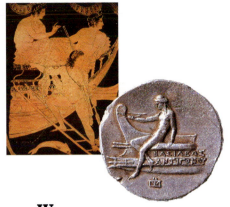
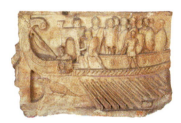
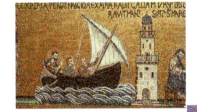
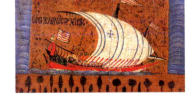
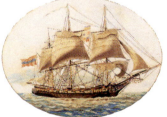
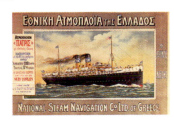

**INTRODUCTION** The sea and ships, the only means of travelling across the sea, have always exercised a strong fascination for the human imagination. The sea of the men of olden days, boundless and enigmatic, was tamed in ancient times by the sail and the oar, by ships that were always at the mercy of the winds. "Your helmsman shall be the wind," says the enchantress Circe to Odysseus, as he sets out to find the gates of Hades on the Ocean. In those days the sea, whichever ocean it was, whatever its name, was an enormous surface, a boundless universe that divided land masses, and at the same time united them.

The sea of the Greeks, the Aegean, the Cretan and the Ionian Sea, the Black Sea and, ultimately, the entire Mediterranean, played a role of fundamental importance in the life of Greece from the dawn of prehistory. Ever since the Greeks first appeared on the coasts and islands surrounded by the sea, they transmitted their messages to the inhabitants of this region, who inherited their restless mobility, their vitality, their constant search for something new. And this region, this Greek land, has always lived with the sea, off the sea, and thanks to the sea. The Aegean was without doubt the centre of the Greek lands.

To the Greeks, the sea that divides land masses was, and still is, an element that unites, that implies communication. Before it became a connecting link, however, and before the Greeks found a way of making roads on it, the sea was a barrier, empty and desolate.

This sea, however, with the small islands scattered upon it visible on the horizon, one after the other, naturally aroused man's curiosity and impelled him to travel, in order to seek out and learn what was unknown to him – especially when he was obliged by the barren land to seek abroad the sufficiency he needed to improve his life. To understand what it was that bound the Greeks to the sea in an eternal relationship, it is necessary to examine the environment in which they lived and evolved, the land in which the Greek character was formed.

The land of Greece is characterized by its variety and the combination of opposites, the interplay between mountains and sea. Tall mountains with

sheer, inaccessible sides soar above the sea only a short distance inland, and endless coasts stretch for thousands of kilometres. The Greek terrain has a restless, sharp relief quality, and is fragmented into a complex pattern with a great diversity of coastal formations. There are bays, both large and small, and countless islands, small or large land masses scattered across the sea. The sea is perpetually in motion, penetrating narrow straits and girdling the intricate land formations, its boundless waters offering an ideal surface on which to open up roads. And whereas the land is impenetrable, and has no routes to offer, the sea affords unlimited opportunities for communication.

Communication was always assisted by the limpid atmosphere and the blowing of the winds. The brilliant, coloured outline of the shores reflected in the far distance, bathed in warm, golden light, beckoned to man and prepared him to begin his journey, his unending journey through time.

The sea was thus, from very ancient times, the womb in which Greek civilization was conceived and born, and the Aegean Sea at the heart of Greece – the "White Sea" as it was popularly known – gave the Greeks what the land was unable to offer.

The hardships of the land and the hazards of the sea, the struggle to win a drop of water, the battle with the winds and waves, all endowed the men of this land with a determination to succeed and a resourceful character; they became daring and acquired an appetite for enquiry and a thirst for knowledge. There is a mysterious bond between the Greeks and the sea. The ocean that gives new life with its motion and its vitality makes the Greeks ever ready to hoist their sails and weigh anchor in bold pursuit of the new. Each time, they set sail without thought for the storms and the monsters, in search of the Golden Fleece, or heading for Ithake, towards a new achievement. And this bond is unbroken, eternal, unending.

Many peoples have distinguished themselves upon the oceans for longer or shorter periods of time. But only the Greeks can boast a continual presence on the sea for a sequence of thousands of years, from primeval times to the present day.

# THE OBSIDIAN ROUTES

Ten thousand years ago, and perhaps even more, at an epoch when men survived by hunting and gathering food, long before the emergence of farmers and stock-breeders, the inhabitants of the Aegean region had begun to investigate the sea. Sailing south to the island of Melos, they discovered obsidian (fig. 1), a hard volcanic glass, from which they were able to fashion their knives and scrapers (fig. 2).

The sources of obsidian in the Mediterranean are to be found on a few Aegean islands: Melos, Antiparos and Yali. This valuable stone, a material suitable for making tools and weapons, has been found in many Neolithic settlements in Greece, as far afield as Thessaly and Macedonia, demonstrating that there were regular sea-borne communications.

The Franchthi cave on the east coast of the Peloponnese has also yielded blades of this material, found together with fish bones and dating from the 9th century B.C. – evidence that at this date there were seafarers who knew the Aegean routes and entered into communications with each other, crossing the sea in some kind of floating vessel.

The obsidian discovered at Franchthi in the Peloponnese may be regarded as the earliest evidence for human communications and the transporting of goods along the sea routes of the Aegean, not only to this specific destination but perhaps also further afield to the whole of the then known world.

The distance from Melos to the east Peloponnese is about 80 nautical miles (150 kilometres). We thus have a secure sailing distance, from the source of obsidian to its transfer to the neighbouring coast.

What, then, was the form of these earliest floating vessels, the first ships used by men to communicate by sea and at the same time to transport their goods? At least five millennia later, the surviving depictions of ships give us an idea of their form, and later still the written sources preserve

1. *Melos. Pieces of obsidian on the surface.*

2. *Obsidian cores and blades. Athens, National Archaeological Museum.*

15

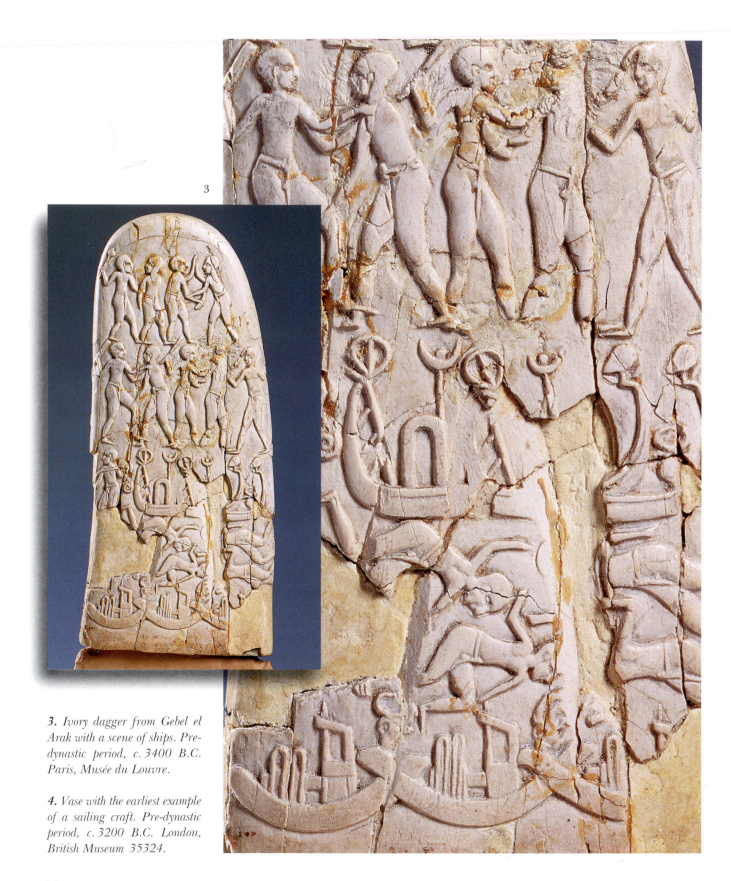

3

**3.** *Ivory dagger from Gebel el Arak with a scene of ships. Pre-dynastic period, c. 3400 B.C. Paris, Musée du Louvre.*

**4.** *Vase with the earliest example of a sailing craft. Pre-dynastic period, c. 3200 B.C. London, British Museum 35324.*

16

accounts of the way in which they were built. In those primeval times, however, in that distant past, what means were used to cross the sea from the source of obsidian, the distant island of Melos, to the mainland, albeit at the nearest point?

The earliest known depictions of ships come from the Near East and Egypt, that is from the eastern Mediterranean area (fig. 3-4). They are no earlier than 3500 B.C. and they are completely stylized, so that it is difficult to make out any of the features of their construction. We can only conjecture about the material used in them. Modern scholars of the history of early seafaring vessels suggest that they were made of papyrus. Their argument is based on these earliest depictions, the different conditions that prevailed at that period in this part of the world, the way of life of the primitive inhabitants, the tools at their disposal, and the climate, and their conclusions accord with what we know today of early navigation.

A tradition on Corfu speaks of journeys on the open sea made in olden days from Corfu to Italy in papyrus-boats with two prows. The Corfu papyrus-boat did not, and still does not have sails. The earliest ships in Egypt also lacked sails, and the boats of the Aegean originally only had oars. The use of sails is first attested in the Aegean in the first half of the 2nd millennium, since which time it has never been abandoned.

Experts have studied all the evidence that has survived to the present day in the naval tradition and have experimented in constructing a small boat of this kind, in which they undertook a voyage. The papyrus-boat they used was like that of Corfu. The results of the voyage, and the conclusions drawn were very encouraging. It is now thought likely that the papyrus-boat was the first form of ship, the precursor of the boats incised many centuries later on functional objects owned by the inhabitants of this area in the Mediterranean.

It is beyond dispute that goods were carried by sea and exchanged in those very ancient times, and that there must therefore have been some form of seafaring vessel. Research based on a combination of historical evidence and modern knowledge (fig. 5) suggests as a preliminary conclusion that this will have been some kind of papyrus-boat, floating raft, or dug-out canoe, though other theories may yet be advanced. One thing is certain:

4

17

*5. Papyrus-boats on Lake Tana in Ethiopia, still used today by the native population (from G. Moorhouse, The Nile, 1989).*

*6. Impression of a cylinder seal from Mesopotamia depicting a ship curved at both ends, c. 2300 B.C. London, British Museum 89588.*

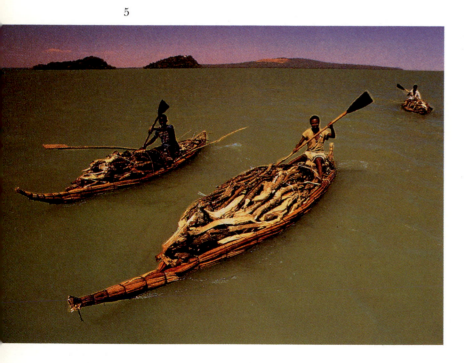

men travelled by sea, and there must therefore have been some means of sailing upon it.

Their voyages were not confined to the Aegean. In the 6th millennium B.C., obsidian was exported to Cyprus, the Greek island close to the east coast of the Mediterranean, where it was used to make tools. On the island of Malta, at the other end of the Mediterranean, where life first appeared from 5000 B.C. onwards, the inhabitants began to procure supplies of stone from neighbouring Sicily at a very early date, amongst which was obsidian.

There was thus trade in this precious material from very ancient times, though it was initially confined to the areas closest to the obsidian sources. There is no evidence to suggest that the first sea routes, which were opened up out of the need to search for new products, were either busy or very long, or that there was regular communication and frequent contact between the inhabitants of different areas. For many years during that distant epoch, the sea contributed very little to the creation and development of large-scale commercial exchanges.

## The Earliest Depictions of Ships in the Mediterranean

Navigation, at least in the modern sense of the word, was unknown in the Mediterranean before the 3rd millennium. The history of seafaring may be considered to begin with the Egyptian voyages to Byblos, the port of ancient Phoenicia or, more properly, to start in the Aegean, with the building of the first ships in the Cyclades. The Cycladic boats sometimes had sails and sometimes only oars and a ram, and above all were fitted with a keel that kept them afloat; they were in any case different from the flat-bottomed river boats or the vessels that sailed along the coasts between Byblos and Egypt.

6

For a long time, sea voyages covered only short distances, from one known site to another close by. Navigation clung to the coasts, which it used as a guideline. Men sailed from one shore to another, in voyages that never lasted more than a day; wherever they arrived in the evening, they broke off their journey until dawn of the following day, spending the night on land.

The small Greek caiques, which still carry people and goods between the Aegean islands, speak in their own way of the old days, and voyages over short distances. The cautious sailors seldom go beyond their own sea, where they know the local waters, the currents, the coasts, the customs, and the changes in the wind. "The boat is passing Cape Malea, it's leaving its own country," says a Greek proverb. It was this headland on the south coast of the Peloponnese,

that was the last sight of Greece for the early seafarers, who passed it before taking to the open sea for the distant harbours of the East and the West.

The Minoans appear to have been the first to venture as far as the Nile Delta, sailing on the open sea to the south. On unknown routes the sea was a source of fear, holding in store surprises and dangers. This was why the early sailors, not feeling confident enough in their boats to brave the unknown, contented themselves with coastal navigation, so that there was only limited commercial intercourse with distant lands.

Religious ceremonies aimed at securing a successful voyage are known from prehistoric times and still survive in the harbours of Greece and, indeed, the entire Mediterranean, demonstrating just how insurmountable is man's fear of the ocean and the dangers it holds in store. Even in comparatively recent times, a voyage on the open sea was regarded as a feat of courage.

This fear explains why trade, involving short voyages along the coasts, first developed in the closed seas of the Mediterranean, around the shores of which there were many harbours. The bold voyager bought here and sold there, travelling from one harbour to the next.

When man began his sea travels, the ocean became a channel for commercial and cultural interchange. Goods, merchandise and skills, all began to be carried along the sea routes and dispersed to distant places.

Before men took to the sea, of course, they had sailed on rivers, and in very ancient times important civilizations had evolved around the great rivers. Good examples of this are Mesopotamia and Egypt. Their rivers, the Euphrates, the Tigris and the Nile, became communication routes. They initially sailed in small boats (fig. 6) and later in rafts made of inflated animal skins tied together (fig. 7-8). These rafts floated down-stream bearing their loads, and the skins were then deflated and carried back on animals.

The need to cross the river was undoubtedly a factor of fundamental importance in the evolution of the Mesopotamian civilization. Even today, as we see how the boats on the Euphrates move over the wide sweeps of water, we can see before our eyes the reliefs of the palace at Nineveh, with reed boats gliding amongst the hippopotamuses and fish, in the marshy shallows near banks on which the water breaks in gentle waves.

Navigation on the Nile was just as important as it was on the Euphrates. The history of sailing in Egypt is ultimately the history of an internal sea (fig. 9-18). The reliefs of ships carved on the earliest pyramids frequently depict them as made of bundles of papyrus tied together. They are almost identical with the rafts of Mesopotamia, with raised prow and stern and a flat bottom, so that they could avoid collisions with one another and traverse the marshes safely to the low banks. As the techniques of shipbuilding developed, the early reeds were soon replaced with planks of sycamore or acacia from Upper Egypt, or cedar from Lebanon.

These early wooden craft were assembled from solid planks with their ends raised and a cross-beam, and resembled small rowing boats. They are depicted on the walls of Egyptian tombs in hunting and fishing scenes, and are frequently found in funeral processions, transporting the dead to their last resting place. These boats could clearly easily navigate the river. The prevailing wind system assisted them as they travelled up river, while down river they relied on the current, needing only rarely to use rows of oars to propel them.

The same boats were also used to transport goods, which was quite feasible on the Nile. Valuable metals, gold and precious stones were all brought into the country on the river.

The Nile was the foundation of the wealth and unity of Egypt.

Almost from the dawn of Egyptian history, voyages began to be made from Egypt to the coast of Phoenicia. In the middle of the 3rd millennium Byblos was linked with the harbours of the Delta by a veritable fleet. Ships, however, which were known as Egyptian vessels, had probably been constructed by the Canaanites, the forerunners of the Phoenicians. Unlike the Egyptians, who had always had a tendency to

**7.** *Drawing of a relief from the palace of Sennacherib at Nineveh showing raft with inflated animal skins (V.Place, Ninive et l'Assyrie, III, 1870, pl. XLIII, 1).*

**8.** *Relief with a ship from the palace of Ashurnasirpal II (883-859 B.C.) at Nimrud. London, British Museum.*

7

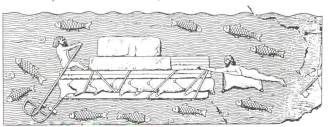

8

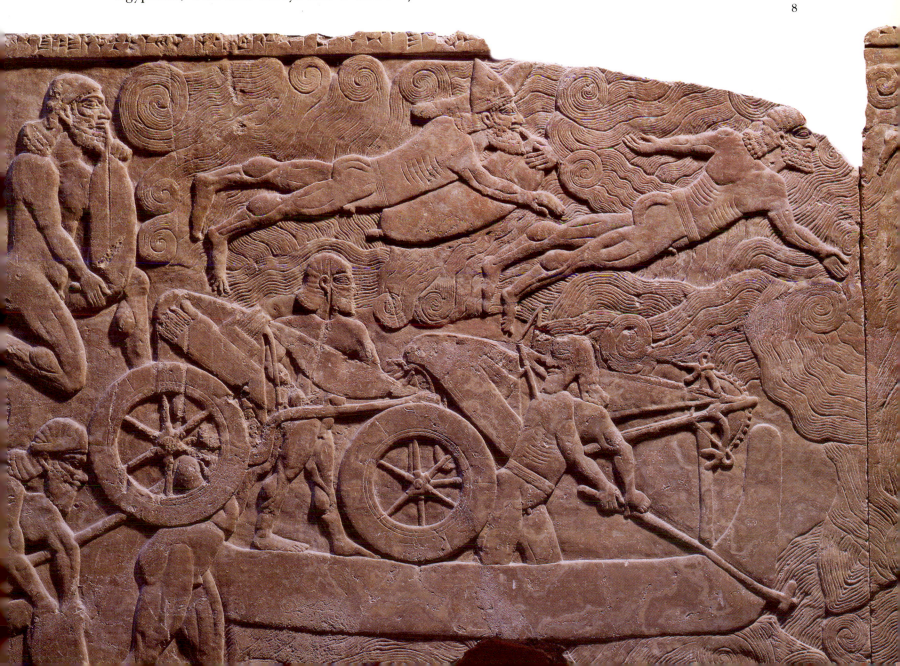

9. *Wall-painting with a scene of a ship from the tomb of Ounsou. New Kingdom, c.1450 B.C. Paris, Musée du Louvre 1430.*

10. *Painted clay model of a ship. Thinite period, 3000-2705 B.C. Paris, Musée du Louvre E.27136.*

11. *Painted limestone relief with a sailing ship. Mastaba of Akethetep from Sakkara. Old Kingdom, 5th Dynasty, 2560-2420 B.C. Paris, Musée du Louvre E.10958*

stay in their own country, the Canaanites were a seafaring people. A tablet from Egyptian Thebes dating from a thousand years later depicts them wearing their characteristic dress, unloading produce from Canaan in Egypt, from ships built by themselves. These were sailing ships of the so-called Egyptian type, with the ends turned up almost at right angles and no keel; they were normally used for river work, and were ill-equipped for the hazards of the sea.

During the Bronze Age, in the 3rd millennium B.C., the Greeks ventured across the seas and made contact with the other peoples of the Mediterranean basin. A new type of boat emerged at this time, born of the adventures of the Aegean peoples. This Aegean craft, with oars and a keel that strengthened the hull as it made contact with the waves, giving it stability and strength as it plunged into the water, is the direct forerunner of the Phoenician, Greek and Roman ships. It was, in essence, the first transport ship, and was truly adapted to the sea: the ship that expedited the dissemination of Greek civilization.

There were, then, two regions in which boats were made and sailors lived in very ancient times: the coast of Lebanon and the islands of the Aegean. These vessels became the bearers of cultural goods as they plied back and forth, uniting

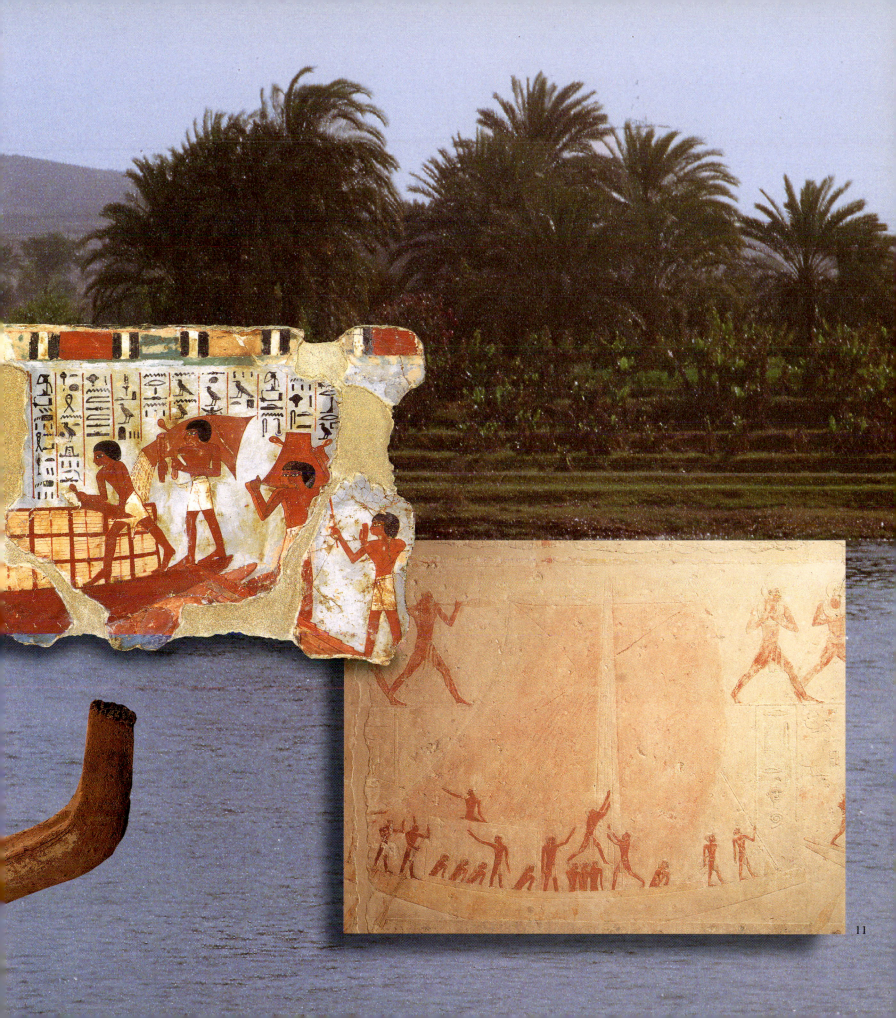

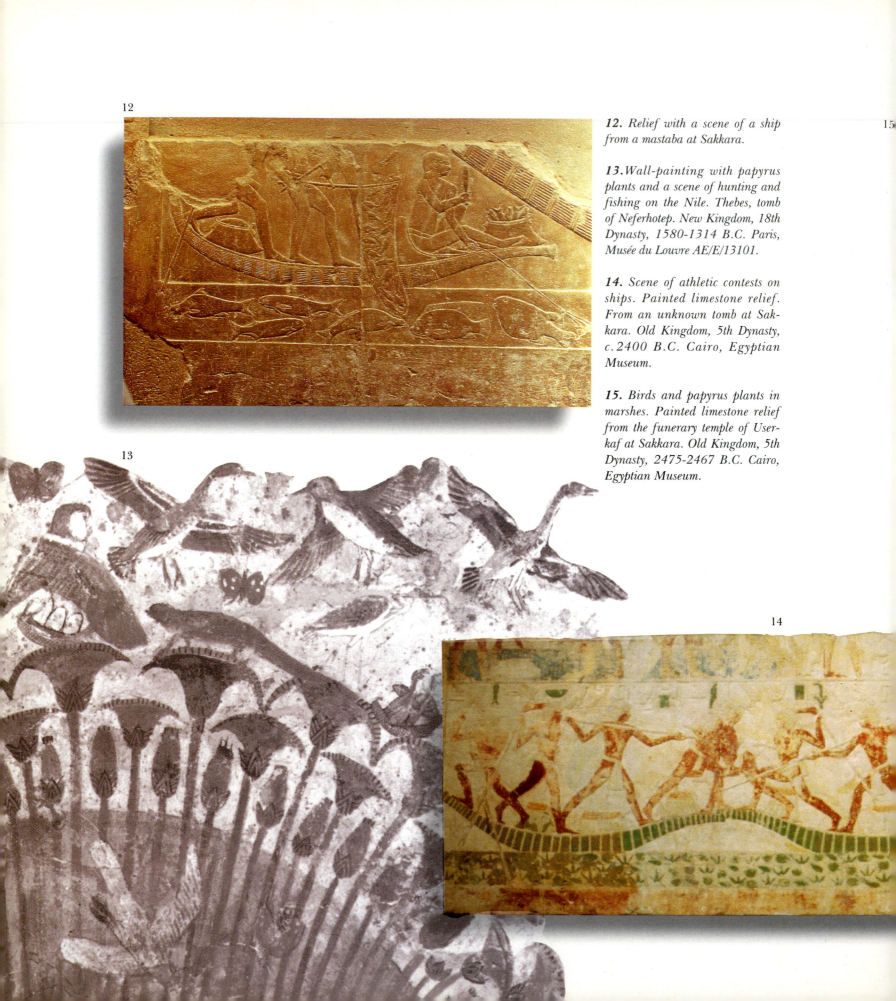

**12.** *Relief with a scene of a ship from a mastaba at Sakkara.*

**13.** *Wall-painting with papyrus plants and a scene of hunting and fishing on the Nile. Thebes, tomb of Neferhotep. New Kingdom, 18th Dynasty, 1580-1314 B.C. Paris, Musée du Louvre AE/E/13101.*

**14.** *Scene of athletic contests on ships. Painted limestone relief. From an unknown tomb at Sakkara. Old Kingdom, 5th Dynasty, c.2400 B.C. Cairo, Egyptian Museum.*

**15.** *Birds and papyrus plants in marshes. Painted limestone relief from the funerary temple of Userkaf at Sakkara. Old Kingdom, 5th Dynasty, 2475-2467 B.C. Cairo, Egyptian Museum.*

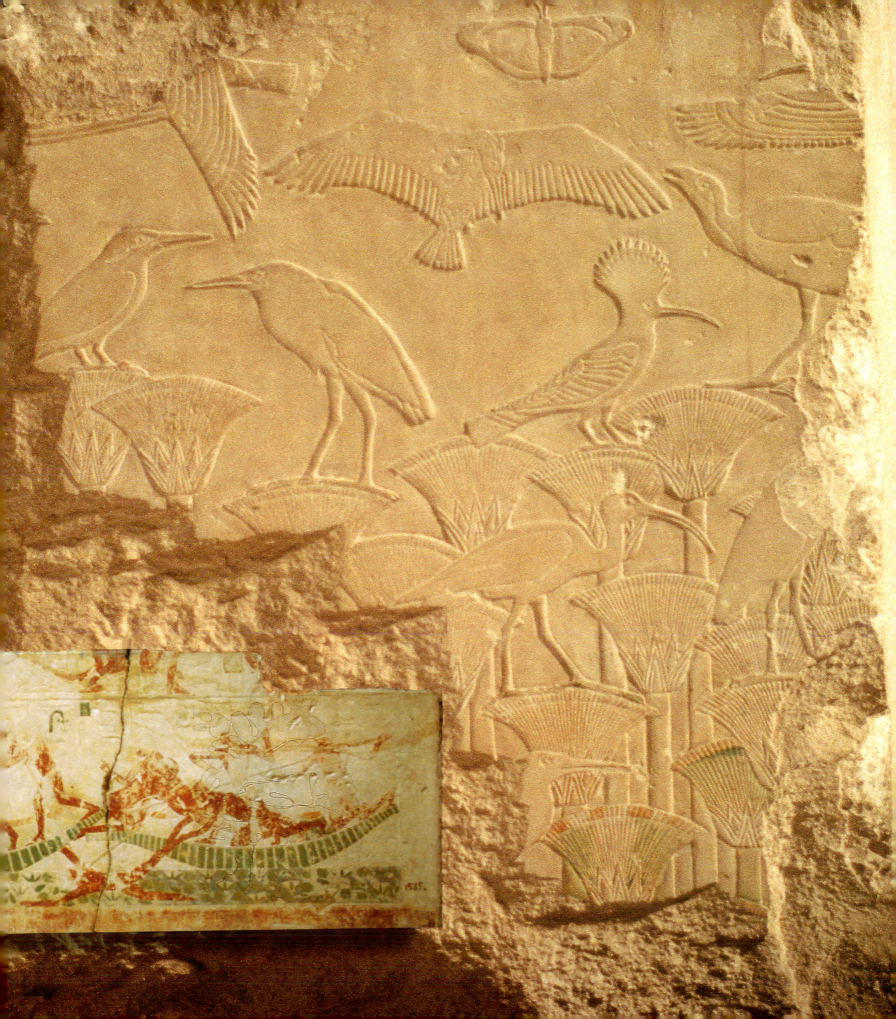

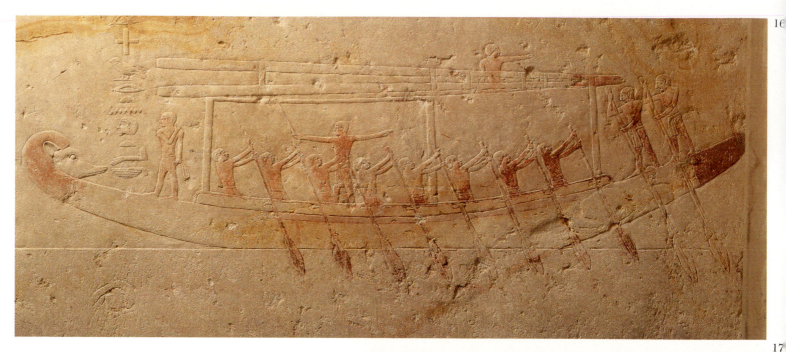

**16.** *Painted limestone relief with a sailing scene. Mastaba of Akhethetep from Sakkara. Old Kingdom, 5th Dynasty, 2560-2420 B.C. Paris, Musée du Louvre E.10958*

**17.** *Sacred ship with a prow in the form of an animal, limestone relief. Paris, Musée du Louvre.*

**18.** *Finials of a gold necklace in the shape of a ship. Late Kingdom, 700 B.C. Paris, Musée du Louvre E.10687.*

different peoples and civilizations. They became a means of exchanging ideas as well as merchandise. And while Egypt gradually became hermetically sealed within itself, the other peoples turned to the sea and transformed it from an element that divides into one that unites.

This was the period of travel, trade and, above all, of adventure. At this time (the Early Bronze Age) some areas of the Aegean prospered greatly as they engaged in sea-borne trade and exchanged their minerals and ores. Sailors from the Cyclades travelled to the coasts of Asia Minor, Crete and the Greek mainland, eastward to Troy and westwards to the northern

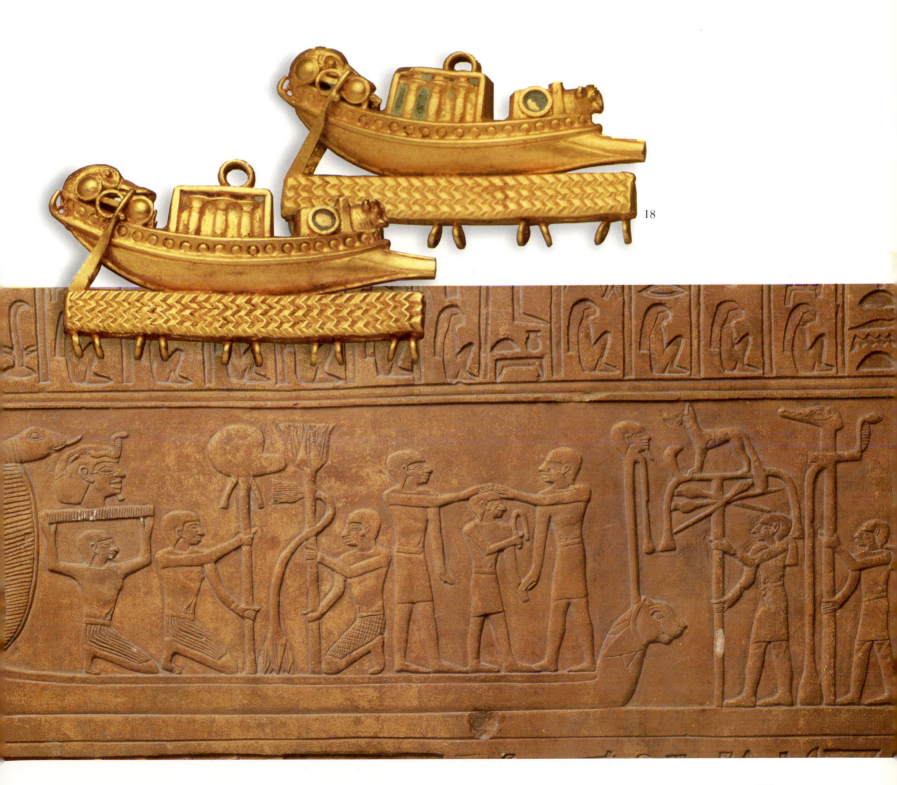

Sporades. Their products reached even further afield, as far as the Dalmatian coast and Sicily.

These Aegean islanders must have been experienced sailors and the boats they built will certainly have been able to cope with the difficult weather conditions on the ocean. The strong, frequently sudden winds demand great navigational skill, and above all require ships especially built on advanced hydrodynamic and aerodynamic principles, so that they are able not only to withstand the fierce winds that pose such a threat to their progress, but also to exploit wind-power in order to improve their performance.

The traders from the Aegean islands used long, narrow, oared boats like those incised on the pots known conventionally as "frying pan" vessels. In these scenes, the boats are long and low, with a high stern ending in a fish, and the low prow terminating in a ram (fig. 19-21). Over twenty oars are depicted on each side of some of these boats, while others have a single paddle. There is no indication of the existence of a mast. It is likely that, before they began to make voyages under sail, these early inhabitants of the Cyclades navigated for a long period only with the aid of oars, taming the wind by means of this elevated stern, which may have performed the function of the sail in modern boats. The fish at the pinnacle of the stern, which acted as a wind-vane and aid to navigation in the Aegean, is exactly like the wind-vanes found today on the roofs of the houses on the island of Mykonos.

The boats incised by the craftsmen of the period on the "frying-pan" vessels found on Syros are rendered in minute detail. Every line has its purpose, and every element has a specific function. The ships are portrayed sailing with the wind – the most favourable and desirable weather conditions, particularly for these light craft.

Whatever the function of these "frying-pan" vessels – ritual objects, votives, or vessels of every day use – the fact that they are found mainly in tombs indicates that the boats were engraved upon them as symbols, directly related to religion and life after death.

The sagely built Cycladic vessel was disseminated abroad in a variety of different versions, as is clear from ships from other regions (fig. 23).

20

19

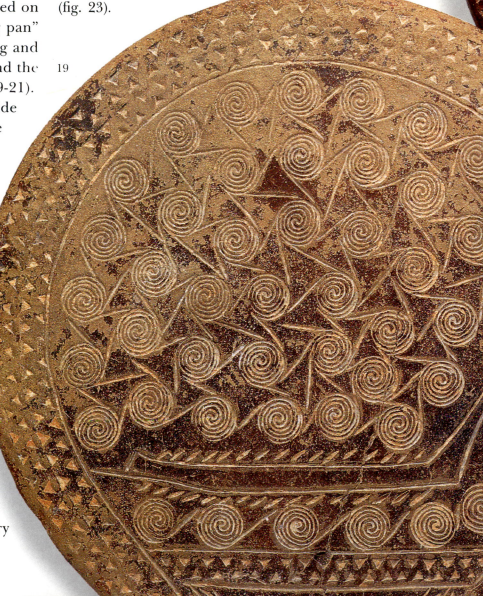

28

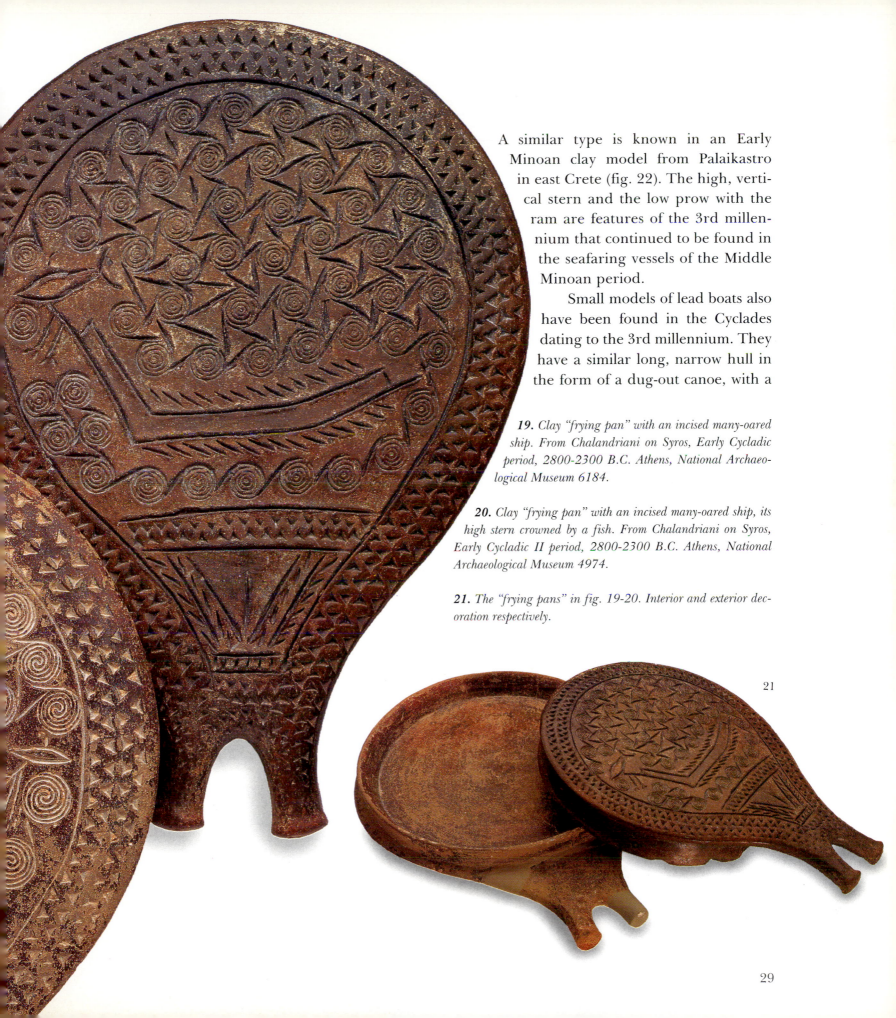

A similar type is known in an Early Minoan clay model from Palaikastro in east Crete (fig. 22). The high, vertical stern and the low prow with the ram are features of the 3rd millennium that continued to be found in the seafaring vessels of the Middle Minoan period.

Small models of lead boats also have been found in the Cyclades dating to the 3rd millennium. They have a similar long, narrow hull in the form of a dug-out canoe, with a

**19.** Clay "frying pan" with an incised many-oared ship. From Chalandriani on Syros, Early Cycladic period, 2800-2300 B.C. Athens, National Archaeological Museum 6184.

**20.** Clay "frying pan" with an incised many-oared ship, its high stern crowned by a fish. From Chalandriani on Syros, Early Cycladic II period, 2800-2300 B.C. Athens, National Archaeological Museum 4974.

**21.** The "frying pans" in fig. 19-20. Interior and exterior decoration respectively.

21

high stern and a low prow. There is a much closer resemblance, however, between the type of ship incised on the "frying-pan" vessels and boats carved on a rock in the Early Cycladic sanctuary of Korphi t' Aroniou on Naxos. These are completely stylized, with an elevated stern so tall that its height is equal to the length of the hull, and they have a low prow ending in a ram.

**22.** *Clay models of boats. The first comes from the island of Mochlos, Crete, and the second, which has a high prow and ram, from Palaikastro near Siteia. Early Minoan II period, 2400-2200 B.C. Herakleion, Archaeological Museum 5570 and 3911.*

**23.** *Part of the handle of a clay askos with an incised scene of a ship. From Orchomenos in Boeotia, Early Helladic II period, about the middle of the 3rd millennium B.C. Chaeronia, Archaeological Museum 1793.*

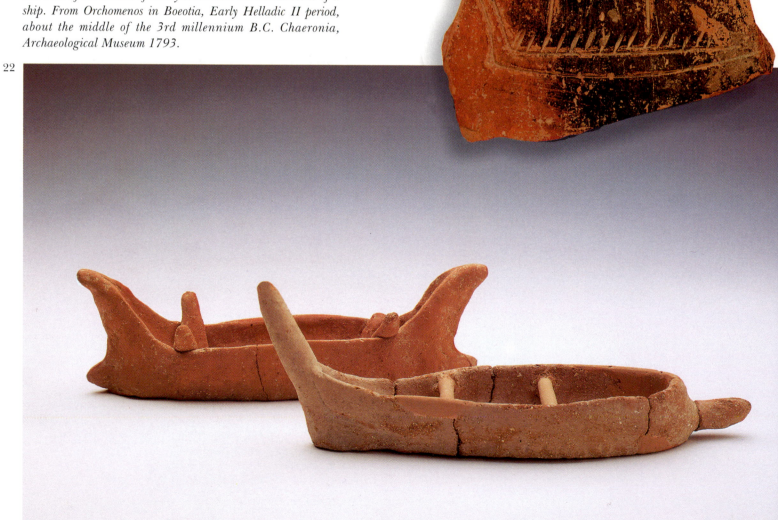

23

22

# The Expansion and Influence of Minoan Civilization

*For Minos was the earliest . . . to acquire
a navy, and made himself master of most of
what is now called the Greek sea...*

Thucydides I, 4

The Greeks and the Phoenicians were the first to travel on the seas of the Mediterranean and engage in trade in the eastern Mediterranean, mainly the Aegean. They handed on the baton of navigation to Crete, whose merchants and sailors have left traces of their activities everywhere. Protected by its position as an island, Crete developed the most authentic and the most outstanding of the early ancient civilizations. Minoan civilization, which has properly been regarded as the first European civilization, was created in the midst of and thanks to the sea.

Crete was a large island floating on the ocean, detached from the rest of the Greek world, in which for many years the cultural currents of the Aegean met with little response. The legend of Europa, who was abducted by Zeus on the coast of Phoenicia and brought to Crete, hints at the relations developed between the island and the peoples of the eastern Mediterranean.

Once bronze became the raw material used for making weapons, tools and implements, and vessels, it became necessary to seek out the major sources which, in this case, were found in another large island, Cyprus. The Cretans travelled to Cyprus in ships loaded with their own produce, which they exchanged for the precious metal. When, later, it was discovered that in order to harden the bronze it had to be alloyed with tin, they voyaged as far as the coast of Asia Minor and Syria. Cretan ships, therefore, had to make increasingly long voyages, and be made larger and stronger, and the sailors were obliged to seek out new sea routes.

During the period when the Cycladic ships – the ones preserved incised in clay, or in the form of models – were already criss-crossing the Aegean, and when Troy was at the height of its power in the Hellespont, Crete was still at the dawn of its civilization. It soon took the lead in the 2nd

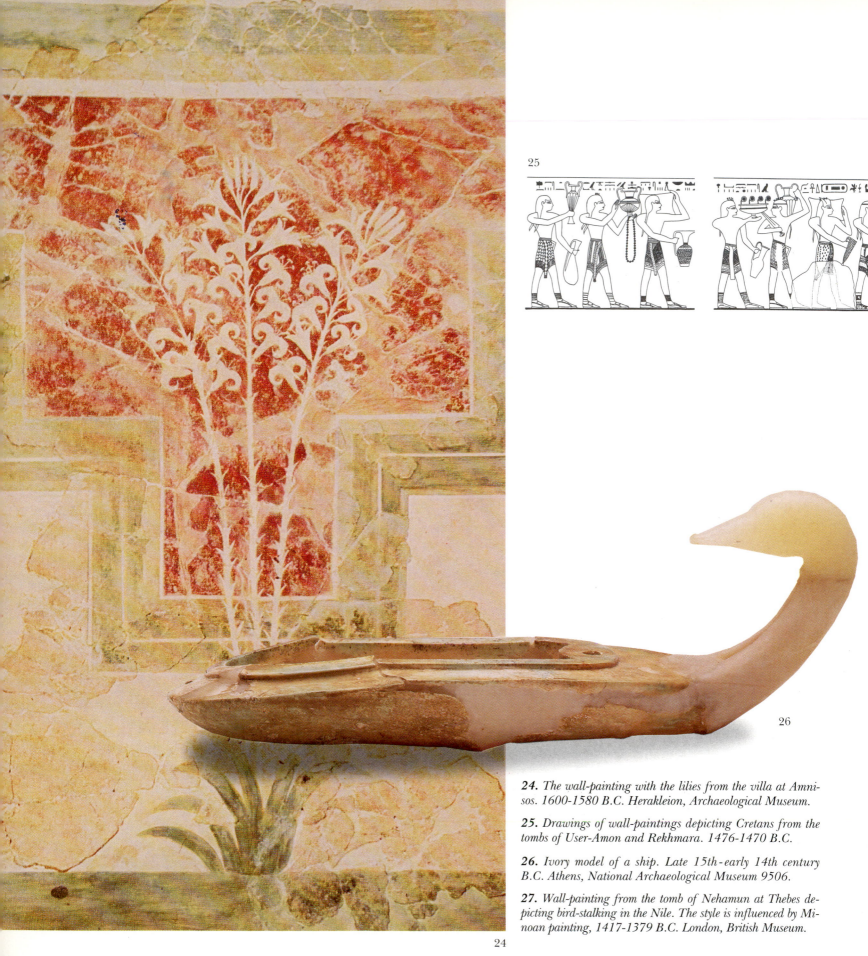

25

26

24

32

**24.** *The wall-painting with the lilies from the villa at Amnisos. 1600-1580 B.C. Herakleion, Archaeological Museum.*

**25.** *Drawings of wall-paintings depicting Cretans from the tombs of User-Amon and Rekhmara. 1476-1470 B.C.*

**26.** *Ivory model of a ship. Late 15th-early 14th century B.C. Athens, National Archaeological Museum 9506.*

**27.** *Wall-painting from the tomb of Nehamun at Thebes depicting bird-stalking in the Nile. The style is influenced by Minoan painting, 1417-1379 B.C. London, British Museum.*

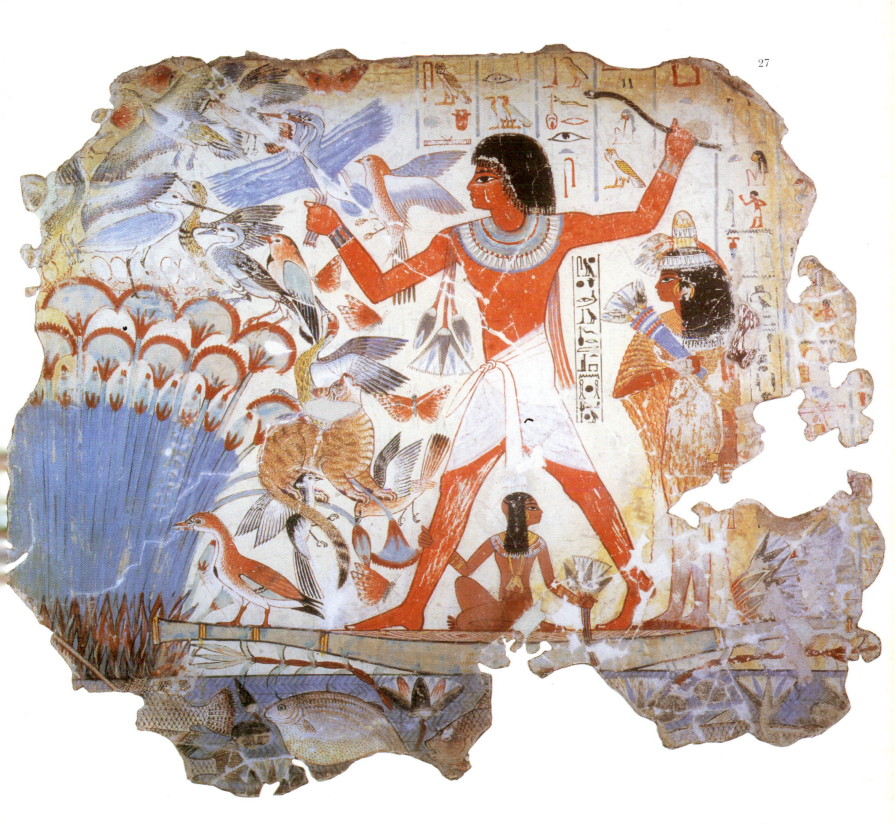

29

millennium, however, and came to dominate the Mediterranean world.

Two "palatial" periods have been identified in Crete, the first dating from 2000 to 1700 B.C. and the second from 1700 to 1450. At the time when seafaring was at its height in the East, the island owed its progress to the activities of its sailors and traders, who left their traces everywhere. It was a period when Minoan ships furrowed not only the seas near to home, but also the Aegean and the eastern Mediterranean. Cretan colonies and naval outposts were installed on mainland Greece and the islands, in Asia Minor, Cyprus and Phoenicia, and grew at a rapid rate.

It was at this period that Cretans are depicted in minute detail in Egyptian wall-paintings (fig. 25), along with all the other peoples of the Near East. This was also the period at which Minoan pottery inundated the entire Middle East. On the walls of tombs at Egyptian Thebes, the naturalistic models of Minoan painting (fig. 24) overthrew the austere Egyptian tradition (fig. 27). At the same time, Minoan potters drew

**28.** *The Ayia Triada sarcophagus with a scene of a religious ceremony painted on the plaster covering the poros stone. Late Minoan III period, c.1400 B.C. Herakleion, Archaeological Museum.*

**29.** *Detail of fig. 28. In her hands the priestess holds a semicircular model of a ship like a crescent moon, an offering to the deity.*

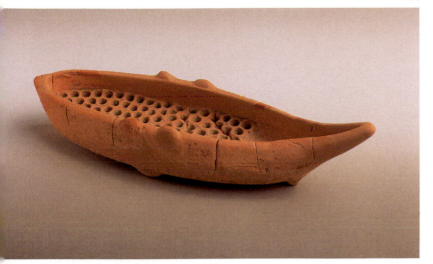

inspiration from the lotus flowers and aquatic birds of the distant Nile and rendered them with astonishing beauty and power.

Crete developed into a commercial centre that was visited by businessmen and merchants, who received and gave commissions and orders. This commercial flowering, which was perhaps at its height between 1700 and 1450 B.C., transported the lights of Minoan civilization to the whole of the then known world, thanks to the Cretan ships that crossed the sea and travelled to distant lands. Crete became the foremost naval power in the eastern Mediterra-

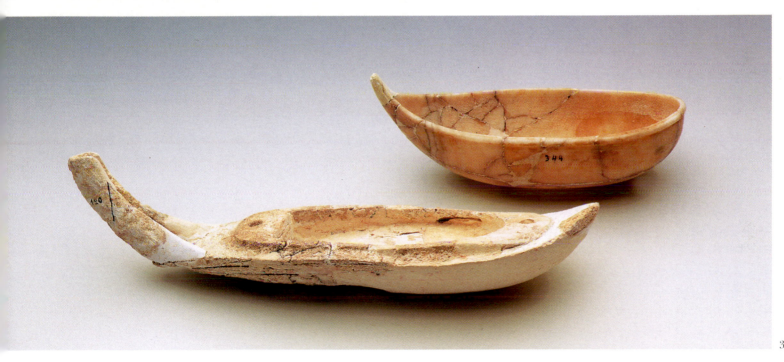

*30. Clay model of a ship with a honeycomb pattern on the hull. Grave offering from a tholos tomb of the Old Palace period in the area of the Hodegetria Monastery at Asteria, 2160/1979-1700/1650 B.C. Athens, K. Mitsotakis Collection.*

*31. Models of ships. The alabaster model is from Ayia Triada and dates from the New Palace period (c.1500 B.C.). The ivory model, from the hill Zapher-Papoura near Knossos, has an elevated stern in the form of a bird and belongs to the Late Minoan III period, c.1400 B.C. Herakleion, Archaeological Museum Λ.344 and Ελ.120.*

nean, exercised a monopoly on sea-borne trade and enjoyed enviable might and prosperity.

This dynamic opening up of Crete is more perceptible in the period of the New Palaces when, according to tradition, the legendary king Minos of Knossos set seafaring on an organized basis, drove the pirates from the sea lanes, and made himself master of the Aegean. At this period the economy expanded rapidly, depending directly on the sea.

Despite the boldness of the seafaring Minoans, however, long voyages continued to be dangerous. Man always felt fear and awe in the face of the power of the sea, and piously sought the help of the gods. Cults and customs associated with the sea have very ancient roots. They survive in Homer and live on in the present day. The ship, a means of communication that transports the experience of life from one region to another, became a religious symbol and played its role in the sphere of life after death. In Egyptian tombs, the deceased are carried in ships across the ocean to the next world. Similarly, in Greek legend, Hermes, the escorter of souls, ferries the dead in his boat to the opposite bank of Lake Acherousia, guiding them to the entrance to Hades.

The ship, then, which unites lands and seas and forms a way of life, is also used to transport the souls of the dead to the underworld. We may not be aware of the metaphysical beliefs held by the Minoans, but it is clear that the depictions of ships on Minoan objects connected with the cult of the dead reflected a similar belief. The Ayia Triada sarcophagus is adorned with a narrative scene of a religious ritual, in which the priestess is holding in her hands a semi-circular craft, shaped like a crescent moon, with no mast, oar or rudder, as an offering to the divine power (fig. 28-29). The models of small boats found in Minoan tombs are a reference to the voyage made by the dead to Hades (fig. 26, 30-31).

In other scenes, the ship is connected with the cult of the sea. It is certainly the case that it was used as a symbol by the Minoans, in the same way as the tree, the column, the double axe, bull's horns, ritually tied ribbons, certain sacred animals – the snake, the dove, the bull – and the Earth Mother-Goddesses.

Similar scenes adorn gold Minoan finger-rings: strange craft with their sterns ending in an animal's head and a tree growing out of their hull (fig. 32), just as later, in the Archaic period, ivy branches grow from the ship of Dionysos. Impelled by some power, these ships sail on tranquil waters, near hills, their masts decorated with garlands, carrying their distinguished pas-

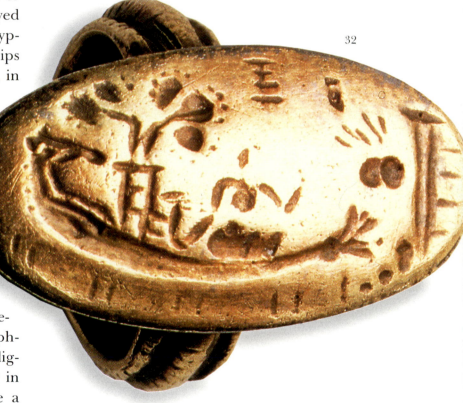

32

sengers – priestesses or rulers, seated beneath luxurious awnings – to some religious ceremony.

The Minoans drew pictures of ships on the objects produced by their civilization, filling the surrounding space with scenes of the entire world of the sea, and revealing their close relationship with the ocean and seafaring.

In addition to the boats-symbols depicted on finger-rings or sarcophagi, we have faithful reproductions of ships on the sealstones used by the Cretans throughout the entire Minoan period, from Early Minoan onwards. At the

**32.** *Minoan gold seal-ring from the island of Mochlos, Crete. On the elliptical bezel a female marine deity seated in a ship with the form of an animal. Herakleion, Archaeological Museum.*

**33.** *Chalcedony sealstone with a scene of a masted ship, from the island of Mochlos, Crete. Middle Minoan III period, 1700-1580 B.C. Herakleion, Archaeological Museum 748.*

**34.** *Agate sealstone with a ship and a male figure rowing. Found in the sanctuary at Anemospilia, Archanes. Old Palace period. Herakleion, Archaeological Museum.*

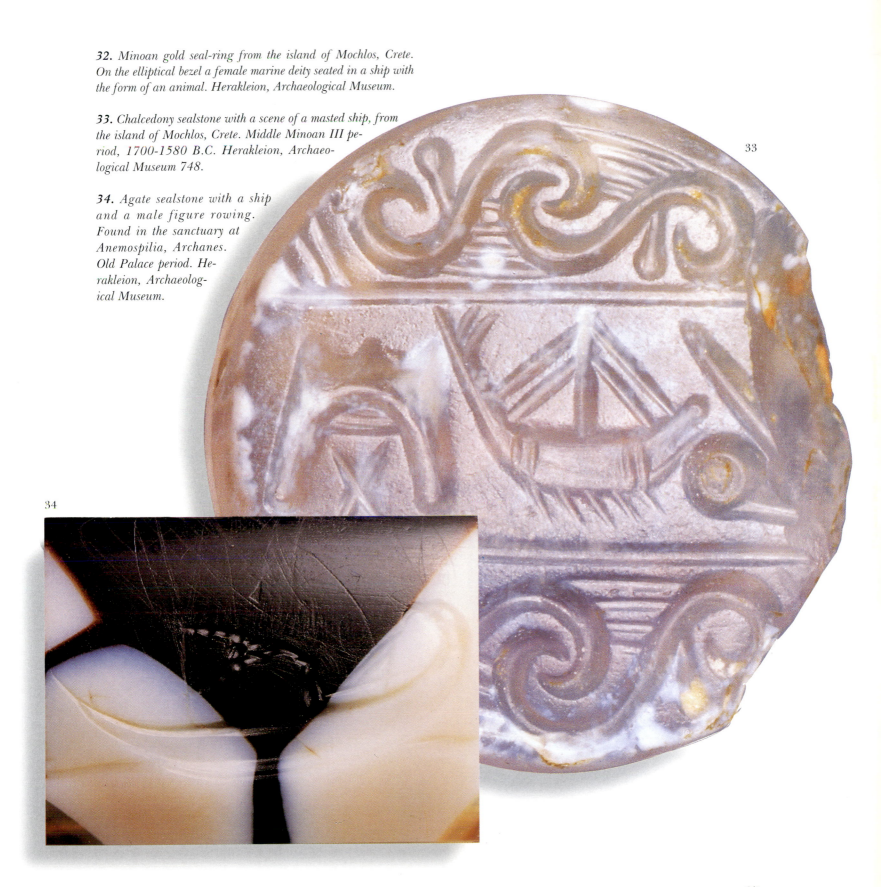

33

34

beginning of the 2nd millennium B.C., a large number of sealstones (fig. 33-39) have scenes of large ships with an elongated hull, a high prow to cleave the open sea, and a projecting, often horizontal, stern. A tall, central mast, supported by two or three sets of ropes, often carries a square, raised sail. Some have three masts, and yet others are oared, with 10-15 oars on either side in addition to the steering paddle. Minoan ships are reckoned to have been 23-30 metres long, and even longer. The Minoans are thought to have been the inventors of the oared ship with sails, which was copied later by the Mycenaeans and the Phoenicians.

The scenes of Minoan boats carved in such minute detail on the tiny surfaces of materials as hard as agate and steatite are evidence for the skill of the Minoan craftsmen, who reproduced the various types of Minoan boat astonishingly accurately. The boat was used in Mesopotamia as a decorative motif on sealstones long before these made their appearance in Crete; it is only on the Cretan sealstones, however, that it is found as an isolated, self-contained motif, and frequently as an emblem, demonstrating the important role it played in the daily life of the Minoans.

There was an ideogram for the ship in the Minoan script. The ship is one of 45 different characters represented by the 241 signs on the Phaistos disc (fig. 40-41), which contains a text written in linear A.

The Cretans also made clay models of ships, or carved them in marble. These representations continue the tradition of the Early Bronze Age, with the sole difference that in place of the oars we have a mast with a square sail and rigging.

*35. Black steatite sealstone from Palaikastro, Crete, with a scene of an oared ship. Middle Minoan period, 2100-1580 B.C. Herakleion, Archaeological Museum 234.*

*36. Goldish-yellow steatite sealstone from Mallia, Crete, with a scene of a raft kept afloat by four vases. Middle Minoan IIB period (1800-1700 B.C.). Herakleion, Archaeological Museum 1823.*

*37. Steatite sealstone with a scene of a masted ship. Late Minoan II period, 1460-1400 B.C. Herakleion, Archaeological Museum 1733.*

*38. Steatite sealstone with a scene of a masted ship from Mallia, Crete. Middle Minoan IIB period, 1800-1700 B.C. Herakleion, Archaeological Museum 1770.*

*39. Steatite sealstone. Middle Minoan period, 2100-1580 B.C. Herakleion, Archaeological Museum 588.*

35

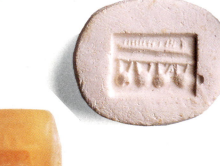

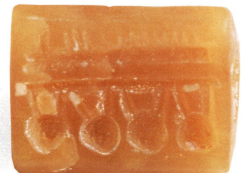

36

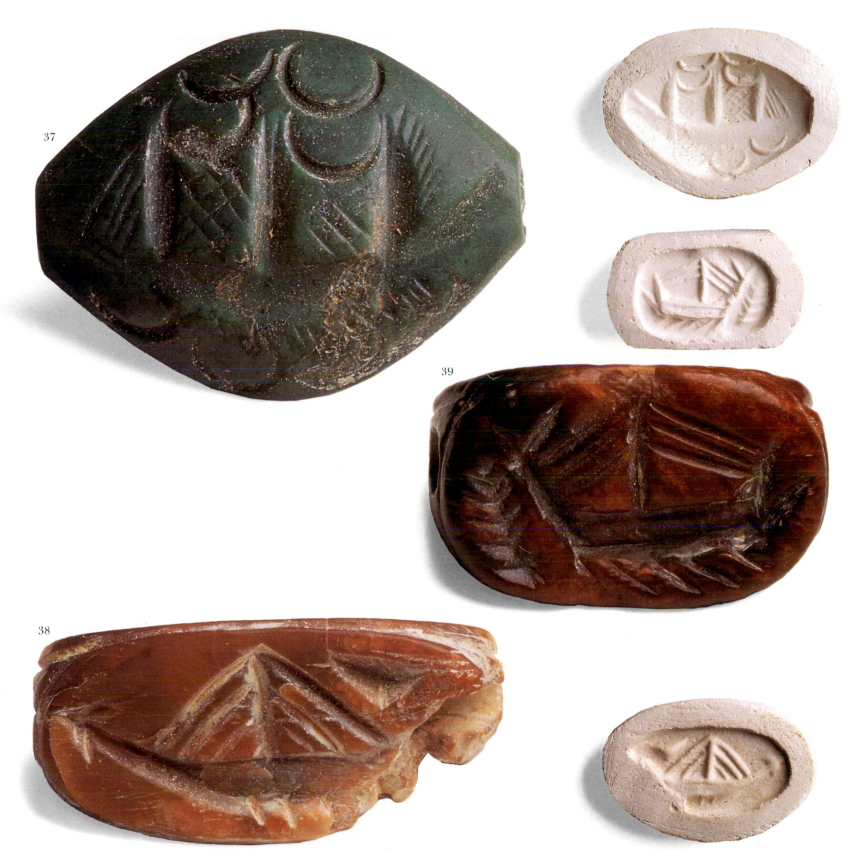

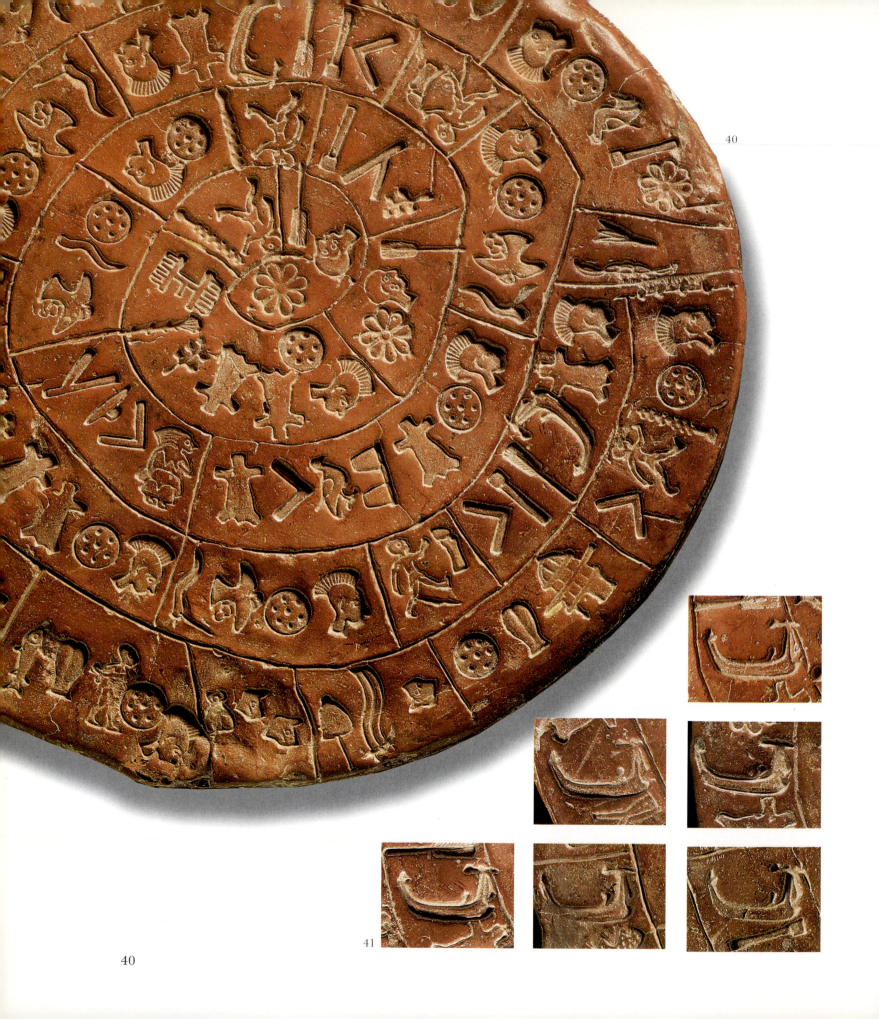

41

A coloured wall-painting on Thera, the ancient island of Strongyli, which was also a Minoan centre, has a scene showing a convoy of ships travelling in procession from one harbour to another (fig. 42-44). Theran ships were crescent-shaped, were fitted with a central mast, and had about twenty oarsmen on either side. These ships give the impression that they have evolved from a simpler type. Their precursor may be sought in the scenes of ships with geometric shapes on pottery sherds found on Aigina, which are dated to 1700-1600 B.C., almost two centuries earlier than the ships on Thera.

About 1450, there was a general collapse at Knossos and in eastern Crete. The passing of the Minoan civilization was due to a series of eruptions of the volcano on Thera which caused two thirds of the island to sink, and produced great earthquakes and tidal waves that reached as far as Crete, leading to fearful destruction.

The priest-king no longer walked amongst the lilies, the bare-breasted women with their gaily decorated dresses and willowy bodies abandoned their dance, and the buds of the sacred lilies, the reeds and the olive branches sank beneath the soft earth, along with the octopus tentacles, dolphins, starfish, blue flying fish, innocent birds and wild cats that the Minoan craftsmen had painted for so many years on their pottery and their walls. The ships, however, continued their voyage on the blue sea, the sea of the Greek coasts and the boundless ocean, travelling even further afield, with other pilots and oarsmen – the Mycenaeans of Achaea.

42

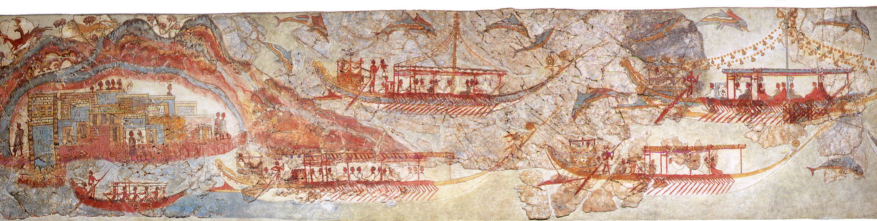

**40.** *The Phaistos disk, from the palace at Phaistos. Middle Minoan I period, 1700-1620 B.C. Herakleion, Archaeological Museum.*

**41.** *Detail of fig. 40. The 241 signs on the Phaistos disk depict a variety of items, including the ship, which occurs seven times.*

**42.** *Wall-painting with a flotilla of ships from the West House at Akrotiri, Thera. Late Cycladic I period, 1550-1500 B.C. Athens, National Archaeological Museum BE 1974, 36.*

**43.** *Detail of the flotilla in fig. 42.*

**44.** *Detail of fig. 42.*

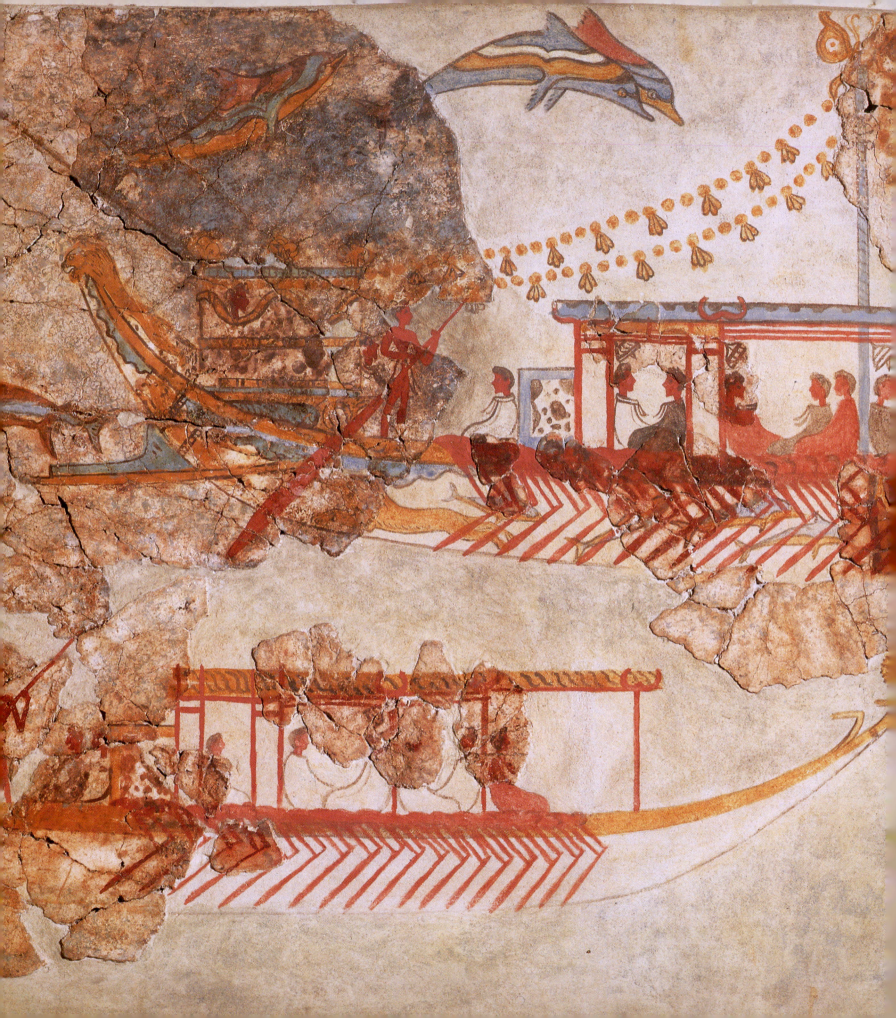

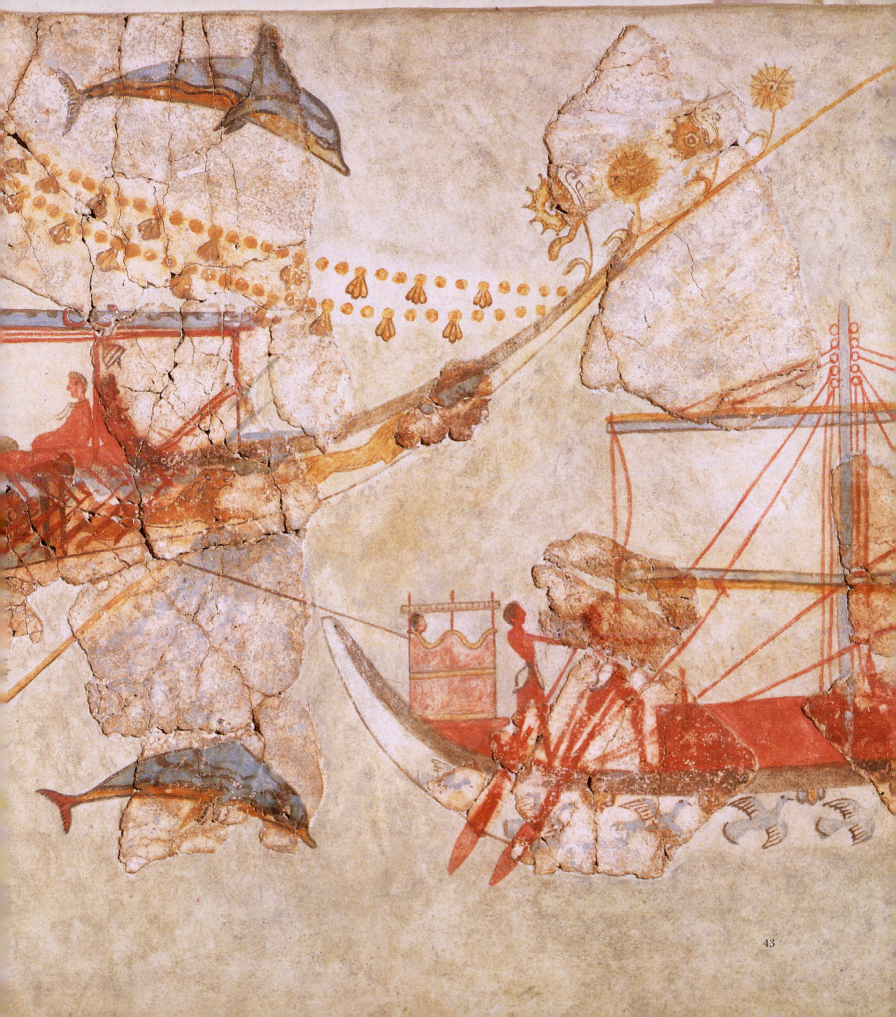

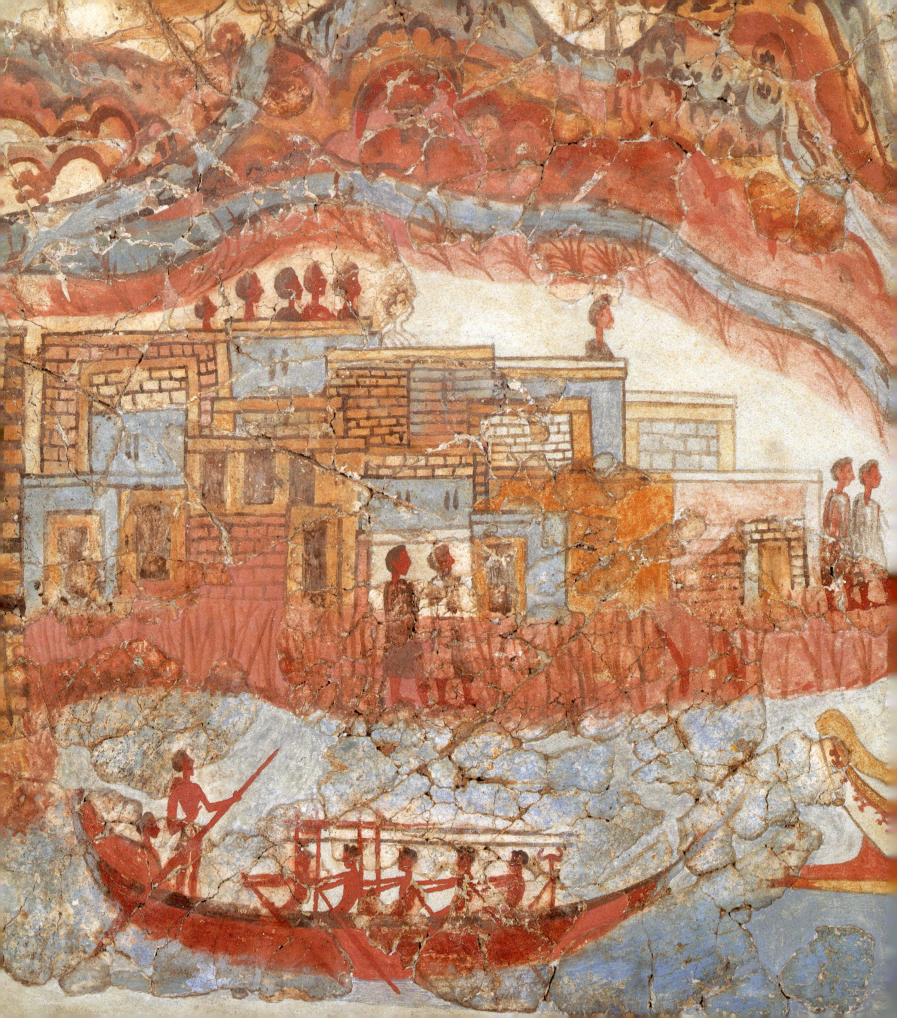

# THE MYCENAEAN THALASSOCRACY

The main body of the Greek peoples invaded mainland Greece about 2000 B.C., at a time when the brilliant Old Palace civilization was already flourishing in Crete. In the immediately following centuries, the two civilizations, divided by the sea, developed at different rates. The Minoans made rapid progress, while the civilization of the Greek mainland advanced at a very slow pace. Progress gradually began to be made towards the end of the Middle Helladic period, when there was a significant acceleration, clearly discernible from discoveries made in tombs, which bear witness to the influence exercised by the Cyclades and Crete on Helladic pottery.

We are now in the 16th century, a period at which Crete had reached the acme of its prosperity and Minoan influence had spread throughout the Aegean. Crete showed an increasing interest in the Greek mainland during these years, and the inhabitants of Greece derived considerable benefit from Cretan influence. The mainland Greeks had the same socio-economic structure as the Minoans, with the Palace at the centre of the economy, the same social and religious life, the same administrative system and the same art, and came under the influences of the civilized Minoan world. The contacts between the mainlanders and the Cyclades and the world around them, especially with Minoan Crete, helped to transform their society and contributed to the creation of the Mycenaean civilization.

This period is called "Late Helladic" or "Mycenaean", after Mycenae, the most important centre in the Achaean world. Mycenaean civilization succeeded the Minoan, after previously having been apprenticed for many years in its school. The Mycenaeans were the successors of the Cretans in the Aegean, though their seafaring activities had begun long before the destruction of Crete.

At first they roved the sea on overseas ventures, along with the Minoans, and their ships furrowed the waters of the Aegean and the eastern and central Mediterranean. Gradually they extended their horizons even further than their masters, and voyaged to the western Mediterranean and the Black Sea. They established permanent settlements in Asia Minor, Cyprus, Egypt, Lebanon, southern Italy and Sicily, and reached the Iberian peninsula, and their products flooded the markets as Minoan goods had once done.

The brilliant grave offerings that accompanied the earliest Mycenaean royal clans in Grave Circles A and B on the acropolis at Mycenae date from the 16th century B.C. Along with the gold and silver vases, gold masks, jewellery, swords and daggers were found works of Minoan art and objects from the distant lands of the Levant and Egypt. All this wealth demonstrates that the Mycenaeans had already entered into relations and engaged in trade with the neighbouring peoples, and had travelled to both East and West. These grave offerings, some of which were probably spoils from successful military enterprises, speak of a majestic, militaristic civilization and a princely way of life, that entertained appropriate beliefs about life after death.

From the middle of the 16th century onwards, the Mycenaeans travelled in all directions to the sources of raw materials, especially of metal, as is clear from Mycenaean objects found throughout the Mediterranean basin and, for the first time, in the hinterland of Europe. The continent of Europe now became acquainted with the cultural programmes of the Mycenaeans. Greece became the first power to influence Europe and for one and a half millennia continued to be a decisive civilizing factor in the life of the continent.

To facilitate communication and contact with geographically remote worlds, the Mycenae-

45

ans created new forms of transportation. Long distances overland were covered in the Early Mycenaean period by carts and horses, much more quickly than in earlier times. Sea-borne communication evolved alongside these overland routes. The Mycenaeans travelled in their ships to distant regions, as is attested by Mycenaean finds dating from the Early Bronze Age in England, and by objects originating in this remote island found in Mycenaean Greece. A sword belonging to the type used by the Mycenaean ruling class, depicting an oared ship, has been found in one of the islands off Denmark. It is a logical conclusion that at this period large ocean-going ships sailed the seas as far as the Baltic. They transported goods and crews, which led to the exchange of ideas between the inhabitants of coastal countries. The Mycenaean world, in its quest for raw materials, played a leading role in the development of trade and cultural progress.

The year 1450 B.C. marks a deep line of

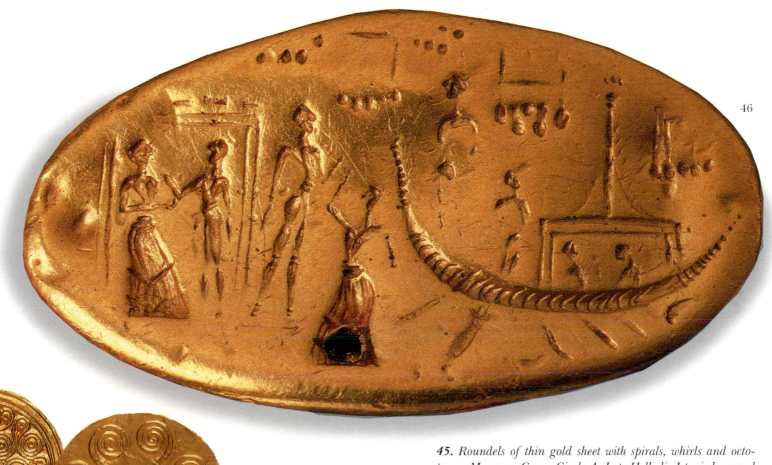

**45.** *Roundels of thin gold sheet with spirals, whirls and octopuses. Mycenae, Grave Circle A. Late Helladic I period, second half of the 16th century B.C. Athens, National Archaeological Museum.*

**46.** *Mycenaean gold seal-ring with a multi-figural mythological scene, depicting the arrival or departure of a ship with a sacred couple on board. From Tiryns, Late Helladic II period, 16th-15th century B.C. Athens, National Archaeological Museum 6209.*

cleavage in the history of the Aegean, and by extension that of the whole of the then known world. Crete experienced a major disaster at this period which caused the Minoan world to go into decline. The Mycenaeans exploited the weakness of the Minoans and gradually made themselves masters of the entire Aegean. The Mycenaean kingdoms were strengthened throughout Greece. During the period when they were at their acme, in the 14th and 13th centuries, the Mycenaean world enjoyed great prestige and in-

fluence throughout the whole of the Mediterranean. This was the period of the famous "Mycenaean koine". The Mycenaeans entered into commercial relations with the Near East, Cyprus and Egypt, as is clear from objects of Near-eastern and Egyptian origins found in Greece; they also traded with the western Mediterranean, particularly Italy and Sicily.

In the middle of the 13th century, however, the atmosphere in the Mycenaean kingdoms changed. The stout fortifications of the major

Mycenaean acropoleis, which were originally intended as a show of strength rather than for defence, were extended and reinforced, and new defences were constructed. There was clearly an overriding fear of some impending danger: internal conflicts, a rising class opposed to the prevailing social system, the threat of invasions from outside the Mycenaean world? The stout fortifications, however, did not prevent disaster. Most of the Mycenaean centres in Greece had been destroyed by the end of the century, and two centuries later had been abandoned forever.

The Mycenaean acropoleis, like the civilization of Minoan Crete, came to a tragic end. The end itself, however, and the beginnings of decline were preceded by the brilliance of the creative history of the Achaeans, the first Greek people. They too, like the Minoans, took to the sea and became masters of the entire Mediterranean basin, founding outposts from Cyprus to the Lipari islands and from Crete to the Black Sea, where, according to tradition, the Argonauts went in search of the "Golden Fleece".

On their voyages they encountered dolphins, octopuses, nautiluses and shell-fish, they contemplated the circles made by the sea, the thousands of spirals created by a wave as it breaks on the shore. And they depicted this entire world, together with their ships, in works of art and on gold finger-rings (fig. 45-46). Masters of the sea by the end of the 13th century B.C., they set out for Troy in merchant vessels and ships of war. Five centuries later the epic tale of their voyage was composed by Homer, who collected together the legends surrounding this naval expedition and created the wonderful epic poetry of the *Iliad* and the *Odyssey*.

The catalogue of ships of the Greek leaders and cities that took part in the campaign against Troy, as preserved in Homer, bears witness to an endeavour to conquer a new, larger world – a project that involved the entire Greek world, whose sphere of influence was continually increasing.

The extent of the Greek sphere of influence is made clear by the travels of Odysseus, a voyage that illuminates the relations of the Greek with the sea, and tells of Odysseus' struggle to conquer it, and the allure of the Sirens who block his route to the West, just as the Clashing Rocks had earlier barred Jason's road to the East.

The wanderings of Odysseus on his legendary voyages to the lands of the Lotus-Eaters, the Cyclopes and the Laestrygonians, and to the islands of Aeolos, the Sun, Calypso and Circe, as recounted by Odysseus himself to the king of the Phaeacians, were mythical, but they were also real, for what myth does not conceal reality? To the Greeks of the 5th century, mythology was the actual history of their ancestors. However much Euripides may have doubted it, the poets believed in myth, even though they modified it.

From the 12th century onwards, after the decline of the major Mycenaean centres, a wave of migration spread to the islands of the Aegean, the Cyclades, the Dodecanese, Crete, and the Asia Minor coasts, reaching as far as Cyprus. But whereas students of navigation in the historical period are able to draw upon written historical sources, depictions in works of art, shipwrecks and naval installations, the interpretation of the evidence in the prehistoric period is much more difficult, and frequently ambiguous. Despite this, the evidence so far uncovered attests to the huge role played by

**47.** *Small stirrup jar from Skyros. The zone on the belly has a scene of a long narrow ship with a strongly curving stern and a straight, elevated prow ending in a bird's head. The other side of the vase has a depiction of a large octopus. Late Helladic IIIC period, 12th century B.C. Skyros, Archaeological Museum A 77. In the background is a scene of an octopus from a Mycenaean vase.*

47

seafaring in the development of the prehistoric civilizations of Greece.

The ship was undoubtedly one of the main factors contributing to the prosperity of the Mycenaeans. It is clear from portrayals of ships at this period that there was not just a single type in Mycenaean Greece, but a wide variety – a circumstance that demonstrates the naval power of the Mycenaeans. It is certain, from the evidence supplied by the archives of the Palaces at Pylos and Knossos and by the "catalogue of ships" in the *Iliad*, that the fleet of the Mycenaeans was under the control of the king. Late Bronze Age ships may be divided into military-transport vessels and merchant ships or ships with other functions. The former had an elongated form, while the latter were more rounded, as may be seen from the stele found at Dramesi. They had oars, sails, a steering oar, a mast, a deck, and an elevated prow and stern. The surviving scenes of ships rarely portray the crew. From the Pylos tablets we know of crews (oarsmen) from five regions of the kingdom, officers and shipbuilders employed by Nestor in his oared warships, ready to counter the threat of external dangers.

The Mycenaean world portrayed its domination of the sea on objects themselves, just as the Minoans had done. Here too, gold finger-rings are adorned with scenes of divine voyages in ships-symbols that are stylized, as in Cretan art, and relate to religion, cult ritual, voyages made by divine figures, and a man and wife who were probably on a sacred honeymoon (fig. 46).

The models of ships and small boats found in Mycenaean tombs, mostly made of clay (fig. 50-51), probably symbolize the dead person's journey to the other world, rather than refer to his naval activity during his lifetime. These models of ships and boats from the Mycenaean period have been found mainly at coastal sites and on the islands, and attest to the contact of the inhabitants of these regions with the ocean. A group of ship models directly influenced by the Minoan tradition has been discovered in tombs of the 13th and 12th centuries. Most of the Mycenaean finds, the majority of them pottery with depictions of ships, date from this same period. The hull of a ship with armed oarsmen is preserved on sherds of a clay pithos from Aigina, dating from the end of the Middle Helladic period (17th century B.C.), and pieces of a large clay amphora have been found at Iolkos depicting two oared ships, on which part of the prow and the ram can clearly be made out (fig. 49). These are the earliest representations of ships so far known from the Mycenaean period. The fact that they were found at Iolkos is possibly an indication of the early evolution of navigation in the Thessalian port from which the Argonauts set forth on their famous expedition.

The tales told by Homer are brought to mind by the ships on another 13th century Mycenaean vase from the tholos tomb at Tragana. Similar ships were probably used by Nestor to

48

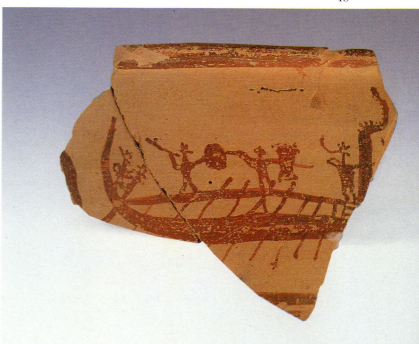

**48.** *Sherd from a krater with a scene of a warship. From Kynos, Livanates in Phthiotis, Late Helladic IIIC period. Lamia, Archaeological Museum.*

**49.** *Sherds from a large clay amphora with a scene of ships. From Iolkos, Late Middle Helladic-early Late Helladic period, 1600-1550 B.C. Volos, Archaeological Museum K 2775 a-b.*

**50.** *Clay model of a ship from Mycenae. Late Helladic IIIA-B period, 14th-13th century B.C. Athens, National Archaeological Museum 3099.*

**51.** *Clay model of a ship from Asine. Late Helladic IIIC period, 12th century B.C. Nafplion, Archaeological Museum.*

49

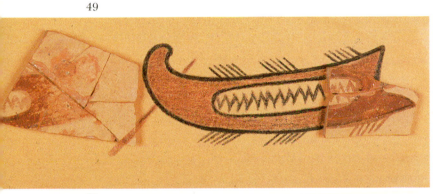

protect his kingdom, or when he set out on the Trojan expedition.

The Mycenaean ship had features that we shall encounter again in the Geometric period (fig. 48). A tall, vertical prow ending in a bird, a tall, curving stern, railings at the sides of the fore and aft decks, a steering oar with a tiller, a parapet along the sides and a slightly projecting keel, which was later to end in a fully formed ram. There is no crew on the ship, exactly as in the well-known vases from Syros, Phylakopi and Asine, which date from the 12th century. The tall, upright prows and sterns, rendered with black glaze on the vases, recall the "ships with upright horns" and the "black ships" described by Homer.

This group of 12th century vases with scenes of ships demonstrates that even after the destruction of the Palaces the Mycenaeans still carried on seafaring and continued their distant voyages to the Levant and Egypt, despite the upheavals created by the appearance of the "Sea Peoples".

50

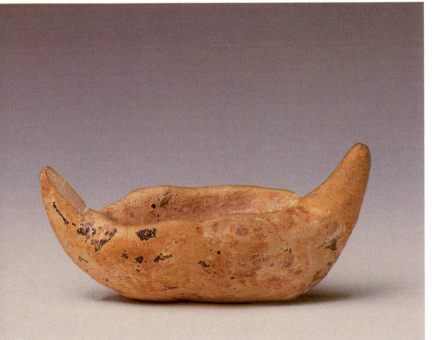

51

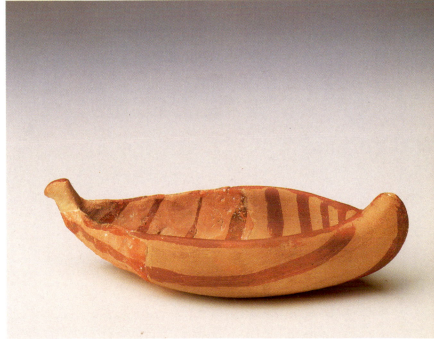

On a small stirrup jar from Asine (fig. 52), the basic lines have been drawn of a many-oared ship with a square sail and mast, an elevated prow, with a long tiller and a stern with a fish painted on it, as in the ships known from the Cycladic "frying-pan" vessels; the deck is indicated by a horizontal line.

A similar, excellently preserved vase from Skyros, dating from the same period, has a stylized depiction of one of the finest of the Mycenaean ships, with a long narrow hull, strongly curved at the stern, and a tall, straight prow that ends in the head of a bird (fig. 47). The triangular steering oar can be seen next to the stern, and the mast rises amidships, secured by two tightly stretched ropes tied to the prow and the stern. Is this a warship, whose figure-head in the form of bird recalls the ships of the "Sea Peoples"? Or is it one of the ordinary sailing ships that ploughed the seas of the Mycenaean world, putting in at the ports of the Aegean or distant Cyprus?

Towards the end of the Bronze Age, the Achaeans extended the projecting prow, which can just be made out on the ships of Syros and takes the form of a ram on a ship on a sarcophagus from Gazi in Crete (fig. 53), and created a warship that found its way to the island of Cyprus, isolated from mainland Greece, at a time when the end was already in sight for the Mycenaean world. This is clear from the production in Cyprus of a series of rhyta in the form of this type of ship in the 12th and 11th centuries (fig. 56, 58). Ever since Cyprus had first made contact with the Minoan world in the Middle Minoan period, the inhabitants of the island had constructed models of boats, including the crews (fig. 57, 59). A clay krater has been found at Enkomi on Cyprus, on which the Cypriote artist has painted a warship (fig. 54-55). Its elevated stern is decorated with a bird, the prow resembles the end of a shoot with flowers, and the mast rises amidships. Two men wearing full-length chitons stand face to face on the deck, while the crew can be seen in the hull. The scene probably portrays warships setting out with their crews and leaders. And these leaders are possibly Achaean warriors who have come to conquer the entire Mediterranean from one end in the East to the other in the West.

The ships of the Achaeans have survived in painted form on vases, in wall-paintings and on sarcophagi, from which it is evident that they are the forerunners of the ships of the Geometric period. The unceasing journey of the Greeks on the sea continued beyond the end of the Mycenaean period, even though between this and the Geometric period there intervened centuries of inactivity, which are known to history as a "Dark Age".

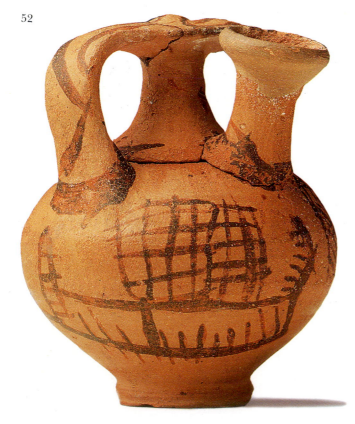

52

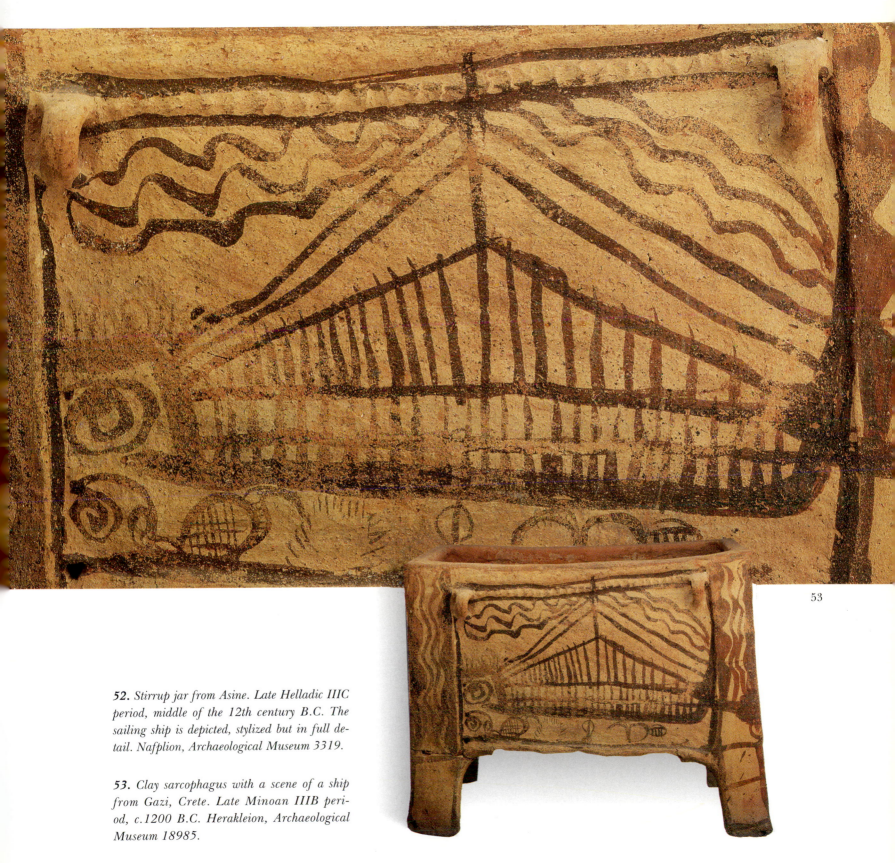

**52.** *Stirrup jar from Asine. Late Helladic IIIC period, middle of the 12th century B.C. The sailing ship is depicted, stylized but in full detail. Nafplion, Archaeological Museum 3319.*

**53.** *Clay sarcophagus with a scene of a ship from Gazi, Crete. Late Minoan IIIB period, c.1200 B.C. Herakleion, Archaeological Museum 18985.*

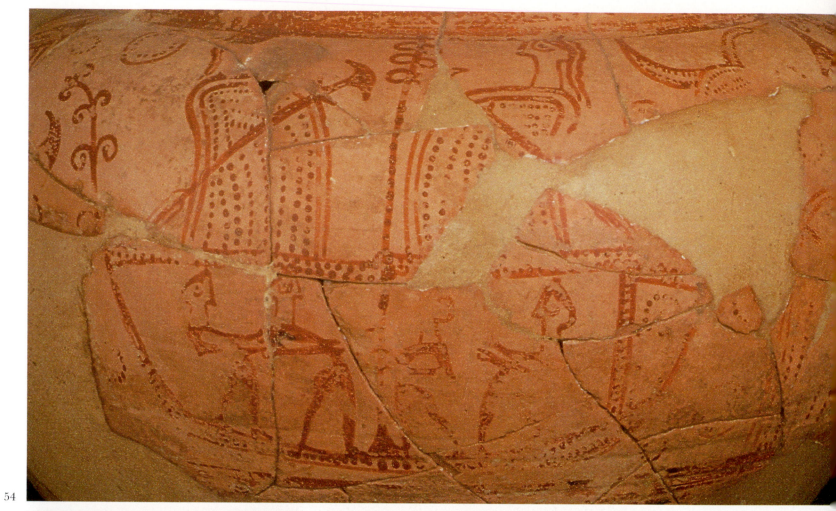

54

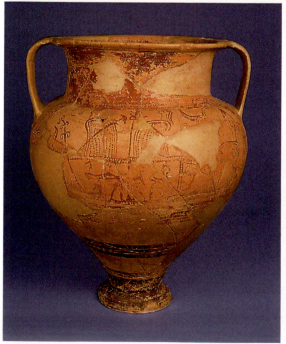

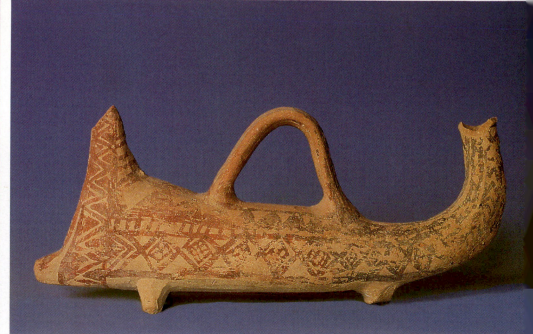

55  56

54

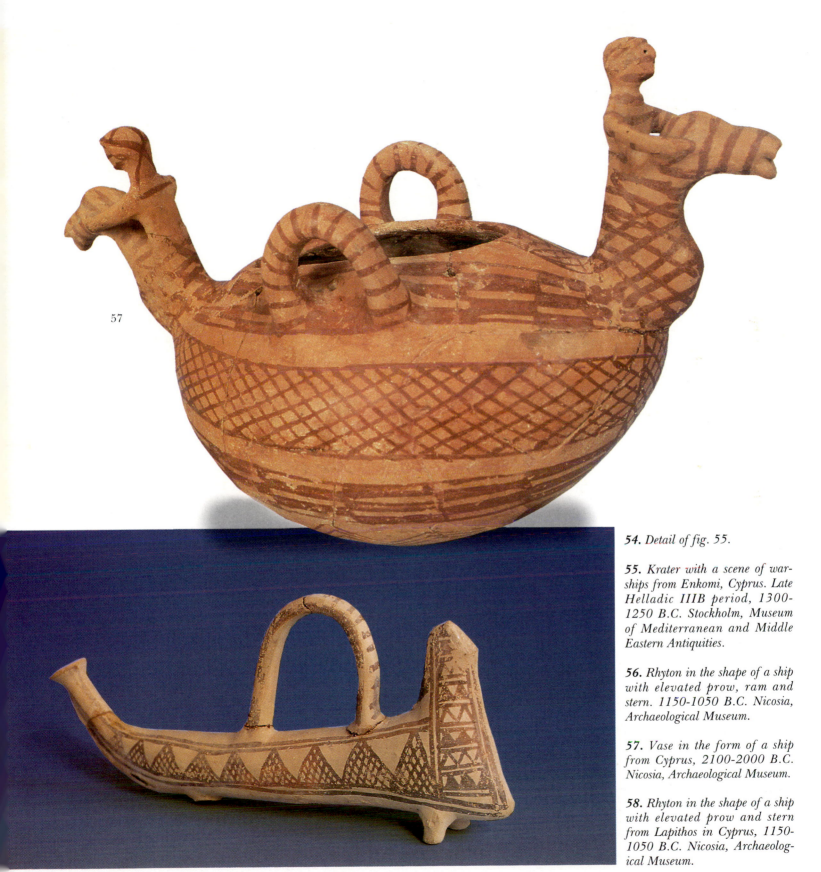

57

58

**54.** Detail of fig. 55.

**55.** Krater with a scene of warships from Enkomi, Cyprus. Late Helladic IIIB period, 1300-1250 B.C. Stockholm, Museum of Mediterranean and Middle Eastern Antiquities.

**56.** Rhyton in the shape of a ship with elevated prow, ram and stern. 1150-1050 B.C. Nicosia, Archaeological Museum.

**57.** Vase in the form of a ship from Cyprus, 2100-2000 B.C. Nicosia, Archaeological Museum.

**58.** Rhyton in the shape of a ship with elevated prow and stern from Lapithos in Cyprus, 1150-1050 B.C. Nicosia, Archaeological Museum.

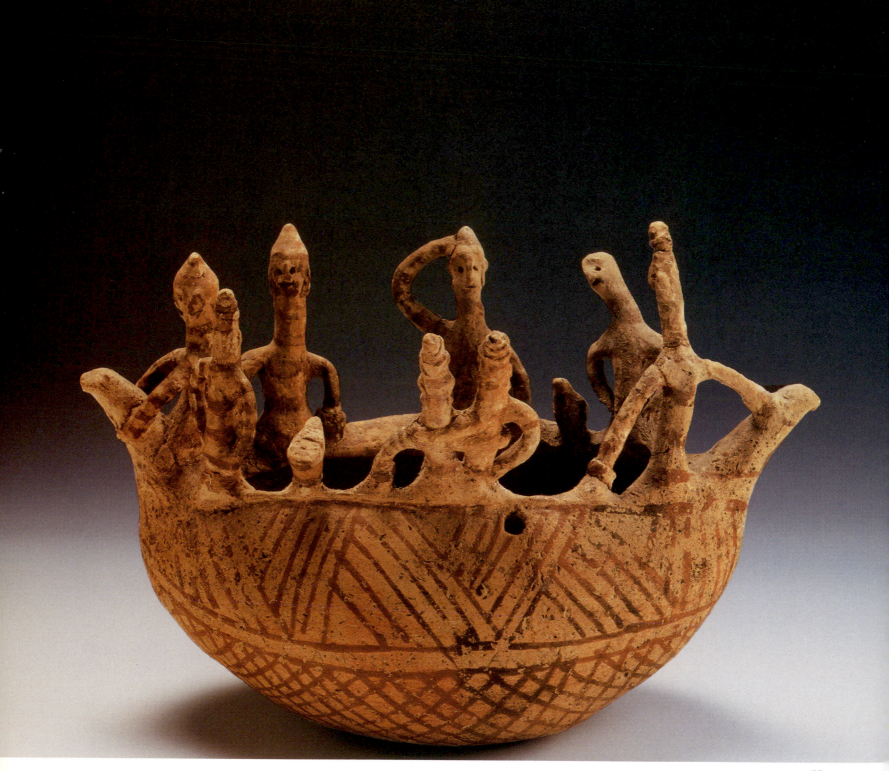

59

# Ships in the Time of Homer

At the period when the brilliant Mycenaean civilization was losing its splendour and gradually entering upon its evening, radical realignments set their mark on the then known Greek world. The causes of this change and the collapse of Mycenaean civilization, which began at the end of the 12th century, are unknown: perhaps the descent of other Greek tribes from the north, known from the tradition and the testimony of ancient writers; invasion by the "Sea Peoples"; climatological or geological changes; destructive earthquakes, or even internal conflicts amongst the ruling establishment or the rise of new social classes. One thing is certain, however: Mycenaean Greece ceased to exist, and the "Dark Age" began. Many centuries were to elapse before the recovery and the laying of the foundations of the Archaic period and Classical Greece.

A series of disasters occurred in the 12th century not only within the Greek world, but also beyond its bounds. The Hittite empire in Asia Minor disappeared, Egypt and Mesopotamia were lost, and on the coast of Canaan, known to the Greeks as Phoenicia, old maritime centres like Ugarit and Byblos vanished and new ones took their place, amongst them Tyre, which became one of the dominant cities. Phoenicia, its face turned towards the sea, awaited the opening of the sea routes to the West. At this period, however, major realignments were occurring at the eastern end of the Mediterranean, which led to the disappearance of the Mediterranean of commercial exchanges. As contacts of this kind dwindled, the Mediterranean basin, which had known such glory in the Bronze Age, gradually went into decline.

The situation steadily deteriorated between 1100 and 900 B.C., and darkness covered the world at the beginning of the Iron Age. In the Aegean, however, sailing and the movement of

*59. Clay model of a ship from Cyprus. 2000-1600 B.C. Paris, Musée du Louvre.*

peoples did not come to an end. The Achaeans fled to coastal areas and islands, in various directions, far and near, and there were movements of large groups by sea, mainly from West to East.

The 10th and 9th centuries B.C. are the period of the great migrations to the coasts of Asia Minor. About 1050 B.C., Attica and Euboea sent out the first colonists, who founded the cities of Ionia, from Klazomenai to Miletos. The Thessalians in turn colonized the island of Lesbos and the coast opposite, Aeolia. It was not only the Achaeans that were on the move. New tribes, the Dorians, or rather the new class that became dominant in some parts of mainland Greece, away from the sea, participated in these migrations. From 950 to 800 B.C. they jumped from the mainland to the Cyclades, to Melos and Thera, Kos and Rhodes, and founded Halikarnassos, Knidos and Phaselis in Asia Minor. In an era of realignments, when nothing is certain, in a period known as a "Dark Age", what evidence can there be of the continuity of the Mycenaean tradition when, about 900 B.C., the Geometric period began to dawn?

During the dark centuries, the only things that did not come to an end were the sea routes, and especially traffic in the Aegean. It follows, therefore, that ships, the means of transport and maritime communication, continued to be built, in a period of general change. In the ship, in its form and construction, we may seek the continuity of the Mycenaean naval tradition and identify those elements that survived and were revived after the 9th century in scenes on Geometric vases.

Greeks reappeared on the sea routes in the 9th century, pursuing a course that was to lead them to the most brilliant period of their history. A feature of this era is the renewed Greek interest in the lands outside the Greek mainland, and in founding colonies in new homelands. This quest led them to cities and islands which had once been occupied by Mycenaean Greeks, cities and regions that had retained their Greek character since the end of the Bronze Age.

At this time, from the 11th to the 9th centuries, one city alone shone like a beacon in the general darkness: Athens, the city of Pallas Athena, which, according to later legend, never fell into the hands of the Dorians. Here, before the end of the 11th century, was born the earliest Iron Age civilization in Greece, and here, too, was created Greek art, a common Greek spirit, a common culture and a common dialect. Art be- <sup>60</sup>

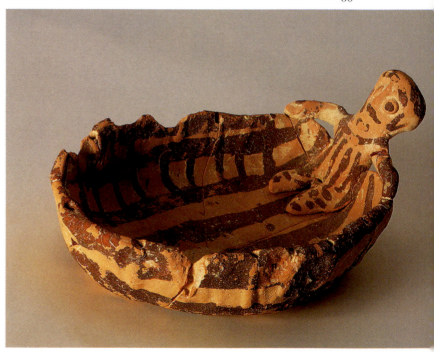

gan with the Protogeometric style, which was succeeded about 900 B.C. by Geometric, a style that lasted two entire centuries until 700 B.C.

The naval power of Athens, which dominated the other Greek communities between 1050 and 900 B.C., evolved as a result of her commercial contacts with the Aegean islands, Crete and Cyprus, where Attic Protogeometric vases were transported. Later, Athenian naval power brought the city her finest hour at the battle of Salamis, and made her the mistress of the Greek seas.

**60.** *Clay model of a ship from Fortetsa (Knossos). Protogeometric period, c.850 B.C. Herakleion, Archaeological Museum Π14813.*

**61.** *Fragment of a Geometric krater from the Dipylon cemetery with a scene of a warship with a large sail. Protogeometric period, 760-750 B.C. Athens, National Archaeological Museum 802.*

**62.** *Cup with a warship and a battle scene from Eleusis, 8th century B.C. Eleusis, Archaeological Museum 910.*

61

62

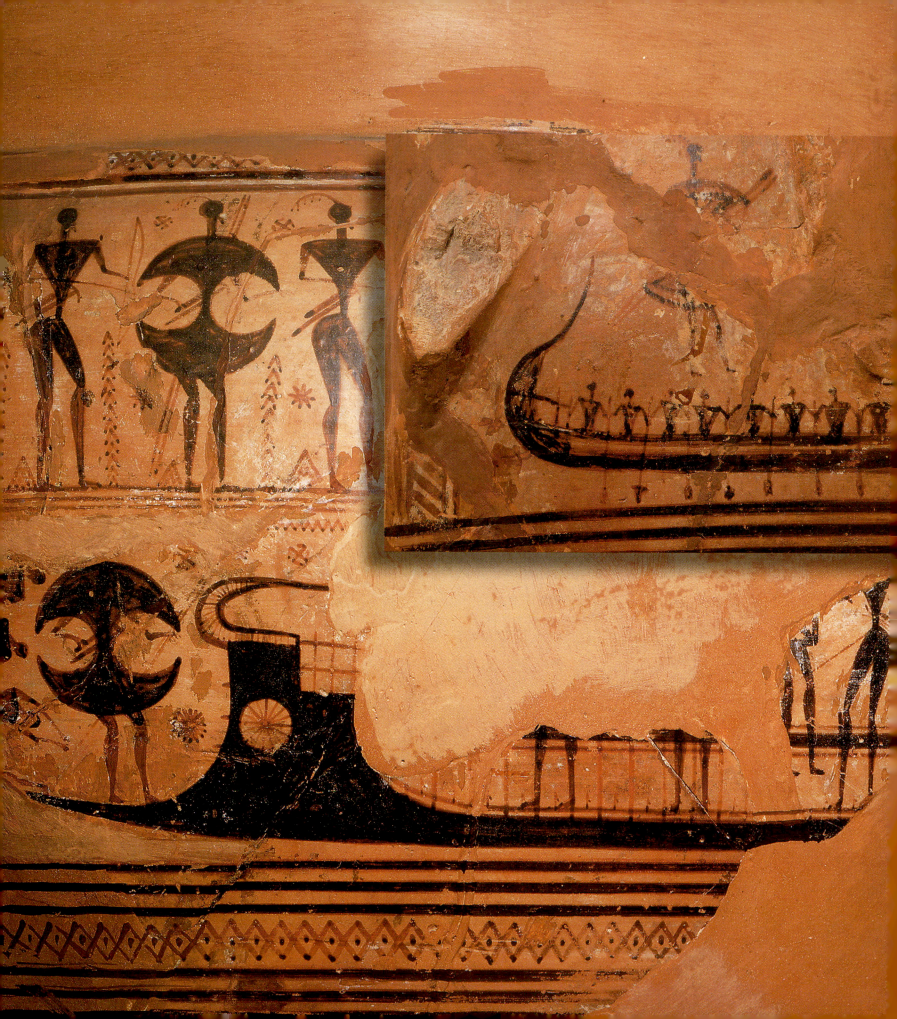

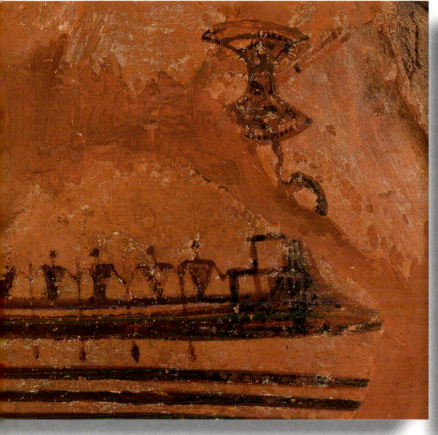

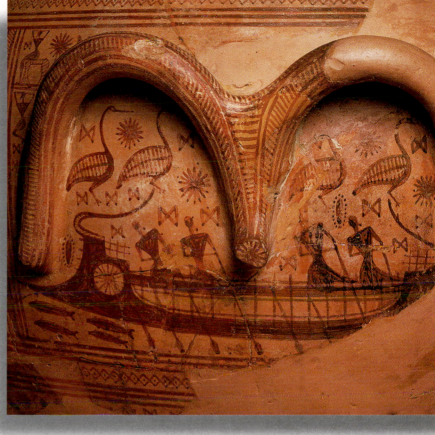

**63.** *Detail of an Attic Geometric Dipylon krater with a scene of a warship. The depiction consists mainly of the prow with the ram, and warriors. 760-735 B.C. Paris, Musée du Louvre A 527.*

**64.** *Detail of an Attic Geometric Dipylon krater with a warship and thirteen oarsmen. 760-735 B.C. Paris, Musée du Louvre A 522.*

**65.** *Detail of an Attic Geometric Dipylon krater with a scene of a warship below the handle. 760-735 B.C. Paris, Musée du Louvre A 517.*

Curiously, not a single depiction of an Attic Protogeometric ship has so far been found from this period, though the naval activities of Athens over a wide radius are attested by discoveries on the islands and in a variety of regions as far afield as Cyprus.

The situation in the Greek world changed in the Geometric period. Pottery workshops were founded in many cities, and Athens lost her monopoly in the market. The city continued to occupy a unique position in artistic output, however, of which it was perhaps the leader. In contrast with the previous period, Athenian vase-painters now immortalized their ships on vases. This series of ships is one of the finest in the iconography of ancient Greek art. It is a striking fact that, although at this period the ship is one of the most popular motifs in Attic art, the Athenians took no part in the new colonization movement in which most of the Greek cities participated, founding colonies throughout the Mediterranean, from East to West.

It was in the 8th century that the Greeks again ventured forth, from Marseilles to the Black Sea and the coast of Syria, establishing the

new horizons of the Greek world. Colonists from Miletos founded Sinope and Trebizond in the Black Sea, and Euboeans set off to the West and created Pithekoussai, the first Greek colony there, about 760 B.C. Ten years later the Chalkidians founded Kyme, Naxos in Sicily (together with the Naxians) and, in 728 B.C., Leontini. Corinth founded Kerkyra in 733 B.C., first driving out the Eretrians, who thereupon settled in Sicily and built its leading city, Syracuse, in 728 B.C. These Greek settlements on the Mediterranean coasts and their naval activity contributed to the development of trade, which flourished greatly at this period. The Phoenicians had taken to the open sea on long voyages slightly earlier than the Greeks, heading for the West and acquiring a reputation as skilled sailors and traders that was to last for about a thousand years.

Evidence for Phoenician and Greek ships is to be found in surviving portrayals of them. Our information in the case of the Greek ships is supplemented by numerous references in the *Iliad* and the *Odyssey*. Homer is describing a war that happened five centuries before his own day. Although he is careful to avoid anachronisms, it is clear that when he is speaking about ships, he is referring to the 8th century vessels with which he was familiar from his travels. The ships of his heroes are "swift" and "hollow".

At this period, ships had an incomplete deck, which took the form of an extension of the prow on which men stood to follow the course of

66

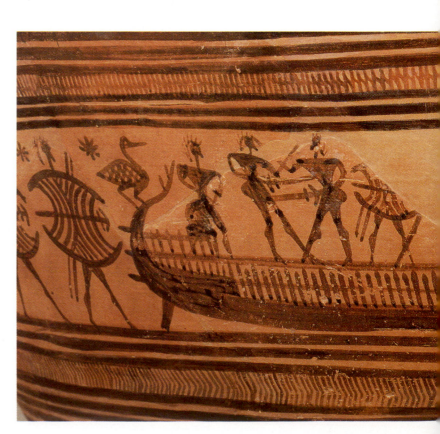

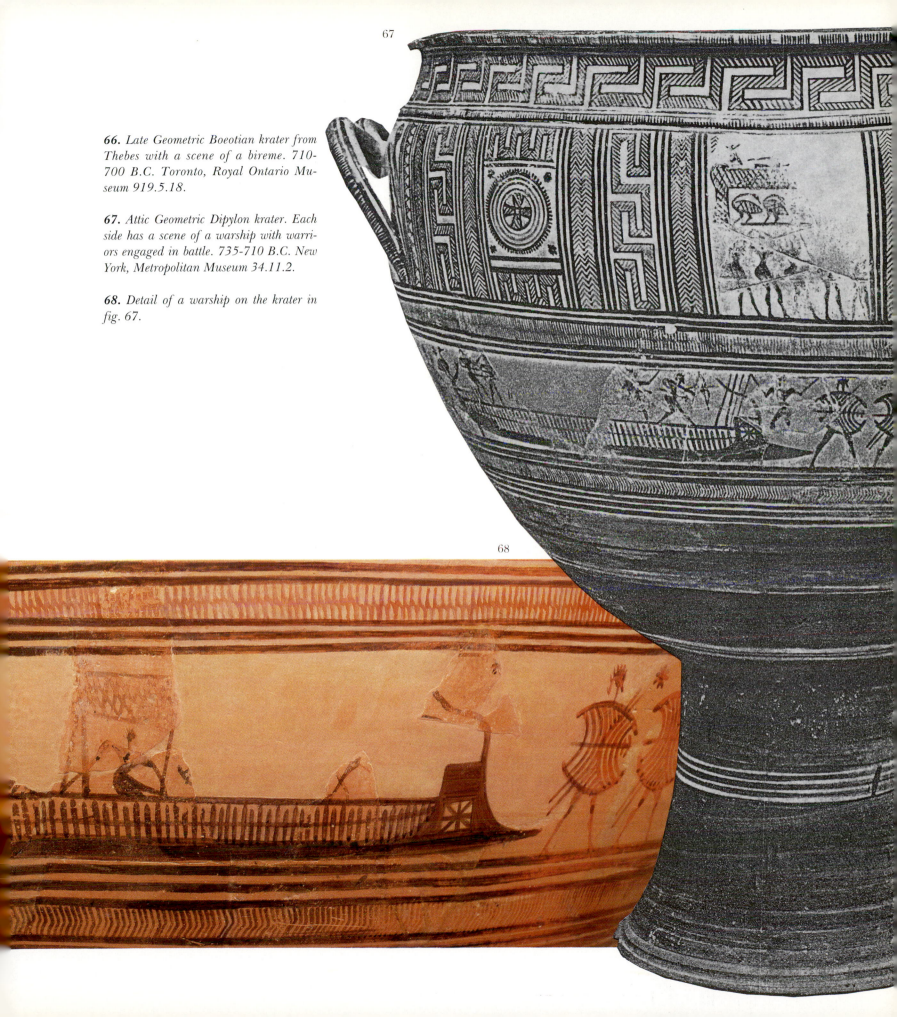

**66.** *Late Geometric Boeotian krater from Thebes with a scene of a bireme. 710-700 B.C. Toronto, Royal Ontario Museum 919.5.18.*

**67.** *Attic Geometric Dipylon krater. Each side has a scene of a warship with warriors engaged in battle. 735-710 B.C. New York, Metropolitan Museum 34.11.2.*

**68.** *Detail of a warship on the krater in fig. 67.*

68

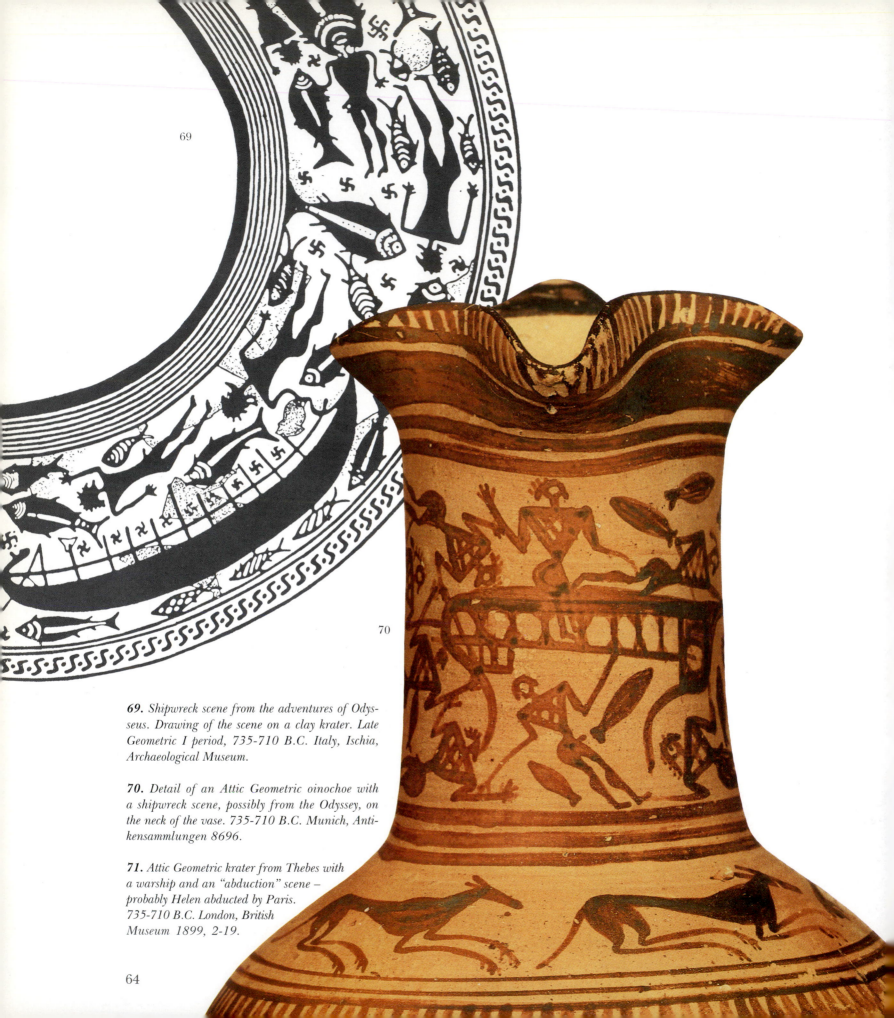

**69.** Shipwreck scene from the adventures of Odysseus. Drawing of the scene on a clay krater. Late Geometric I period, 735-710 B.C. Italy, Ischia, Archaeological Museum.

**70.** Detail of an Attic Geometric oinochoe with a shipwreck scene, possibly from the Odyssey, on the neck of the vase. 735-710 B.C. Munich, Antikensammlungen 8696.

**71.** Attic Geometric krater from Thebes with a warship and an "abduction" scene – probably Helen abducted by Paris. 735-710 B.C. London, British Museum 1899, 2-19.

69

70

the ship, with a larger one at the stern for the captain, or other officer. The crew sat on a lower level, on which the helmsman also sat. The size of the ships varied. Boats for short journeys and trading vessels had twenty oars, and the biggest ship of the period was the *penteconter*, which had 50 oars. This was a long, narrow vessel used as warship and a transport vessel. The hull was black, the prow was normally painted red or blue and adorned with a figure-head, and the stern

hull, black, sea-going, rowed on both sides, with upright prows, equipped with oars, long-oared, twenty-oared".

Geometric art is richer in warships than in merchant ships. On the basis of the evidence at our disposal, three categories of warship can be detected in the Archaic period: (1) Ships with a single bank of oars, with no *parexeiresia* (a vertical extension to the sides of the ship, in which the oars were placed). These had 20 to 50 oars,

71

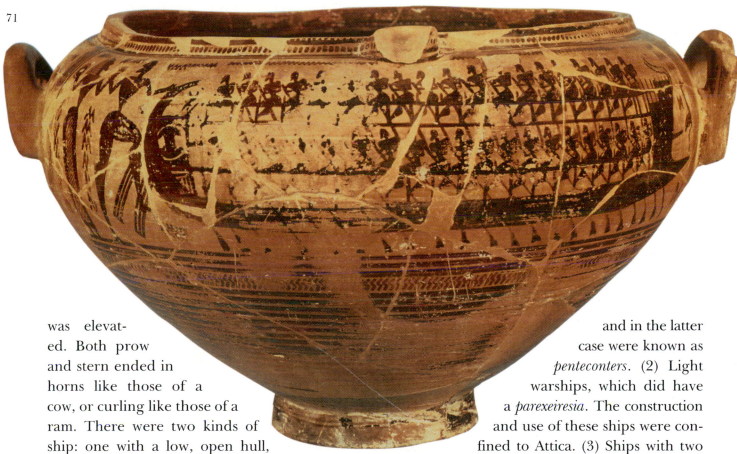

was elevated. Both prow and stern ended in horns like those of a cow, or curling like those of a ram. There were two kinds of ship: one with a low, open hull, and the other with a raised hull. The sails used at this period were of linen cloth and were raised and lowered on the mast. A basic feature was the ram. This had first appeared in the Mycenaean period in the form of a slight projection, and after the 9th century it is fully formed and extends a considerable distance. Homer uses many epithets of ships in his two epic poems. His ships are "swift, quick-going, hollowed, hollow, huge of

and in the latter case were known as *penteconters*. (2) Light warships, which did have a *parexeiresia*. The construction and use of these ships were confined to Attica. (3) Ships with two banks of oars. These had 80 to 120 seats for oarsmen. These types of warship held sway in Greece until the appearance of the trireme at the end of the 6th century B.C.

A picture of a ship sailing the seas or gliding over the waves was always in the mind of the Greeks. The ship was one of the first subjects rendered on clay by vase-painters. On Geometric vases, which were decorated with shapes,

**72-73.** *Bronze Boeotian brooch and detail of the incised scene of a warship with two birds on the prow and stern and a large fish beneath the keel. From Thebes, c.700 B.C. Athens, National Archaeological Museum 8199.*

**74.** *Bronze Boeotian brooch. Detail of the incised scene of a ship, similar to the depiction in fig. 73. From Thebes, c.700 B.C. London, British Museum 121.*

**75.** *Bronze Boeotian brooch. Detail of the incised scene with a warship and two archers. From the Idaean Cave, Crete, c.700 B.C. Athens, National Archaeological Museum 11765.*

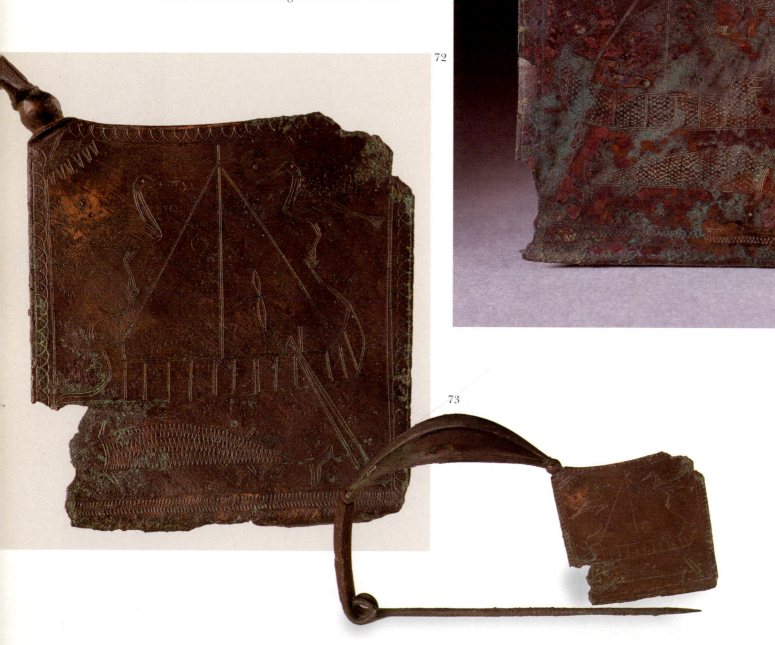

72

74

73

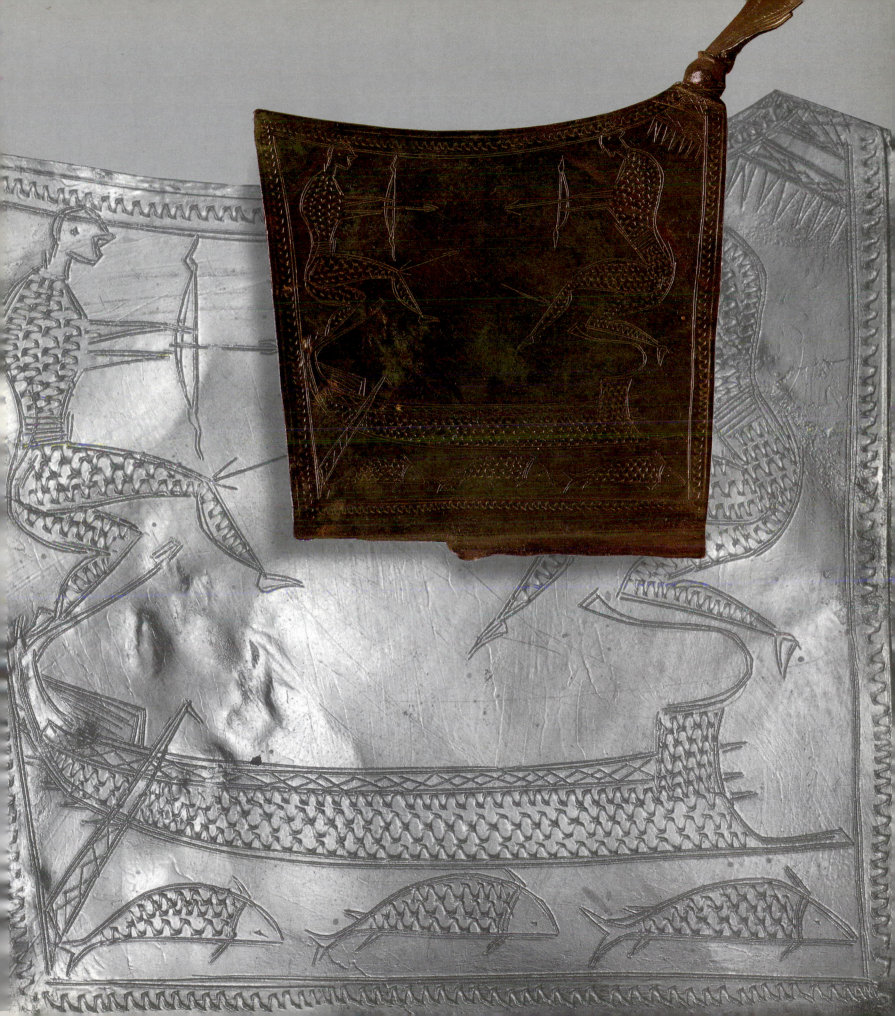

concentric circles or semicircles, the vase-painter ventured to immortalize only two subjects – the ship and the horse. His imagination and memory perhaps retained only the legends of the Argo and the great heroes of Greek mythology, and the Trojan horse devised by the wily Odysseus.

Scenes of ships are rare in early Geometric art; they became more common in the Geometric period (9th and 8th centuries B.C.), when they were used by vase-painters to adorn their pots (fig. 61-71). A long, narrow ship, with banks of seated oarsmen or standing warriors, is delineated on the surface of the vases, along with scenes of the laying out of the dead and processions of chariots. This artistic expression was a response to the wishes of both the artist and the customer. Both experienced pleasure from the depiction of ships, because it called to mind the adventure and excitement of distant voyages, and also the naval strength of their city, which guaranteed an abundance of goods and a better life.

The artist did not confine himself to representations of the ocean-going vessels of his native city, however, but also composed more general scenes inspired by adventures on distant voyages. On the limited surface at his disposal, he depicted the tale of a shipwreck, or a failed military enterprise, showing upturned ships and warriors at the bottom of the sea, along with marine fauna (fig. 69-70). Or, when some honoured person is being buried, a ship may be hammered on a piece of fine gold sheet to accompany him on his journey, or a model of a ship may be made to preserve for eternity his exploits at sea along with one, two or more companions (fig. 60).

Bronze fibulae from Geometric tombs are engraved with scenes of ships with a raised prow terminating in a ram with a protective breastwork and a stern in the shape of a bird, while a tall mast can be seen in the middle of the hull (fig. 72-75).

**76.** *Bronze tripod base with a relief scene of a ship with five oarsmen and two figures on the stern. From the Idaean Cave, Crete. Late 8th century B.C. Herakleion, Archaeological Museum.*

76

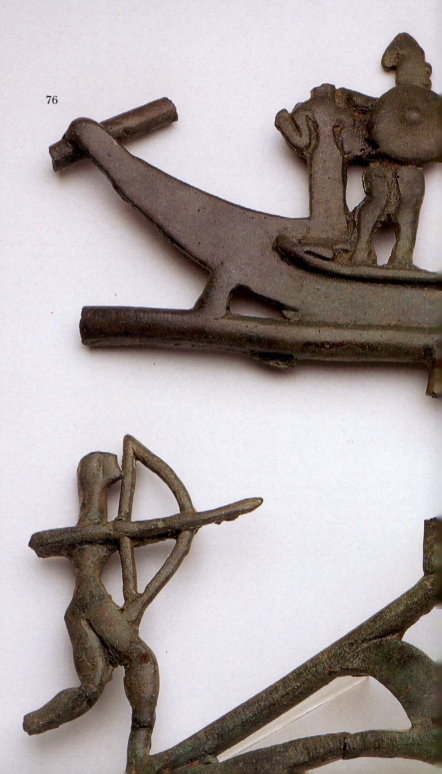

68

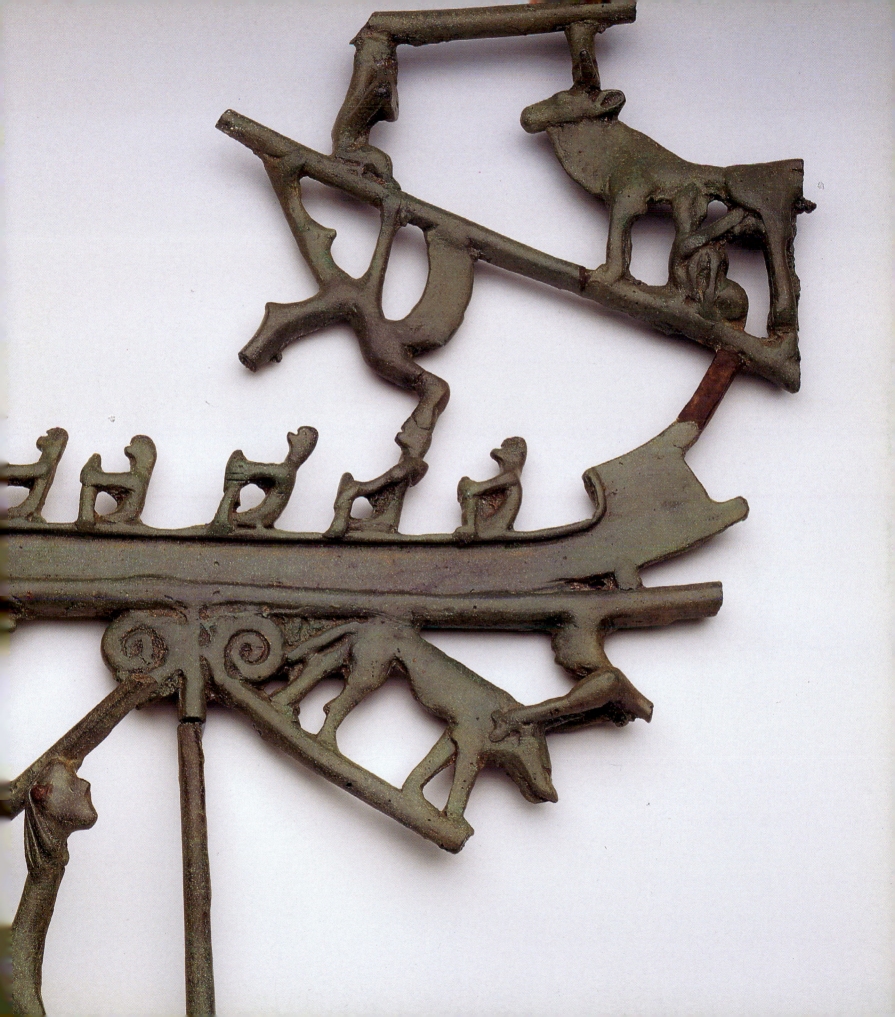

The iron spit-stands found in tombs at Argos (fig. 77) and in the cemetery at Salamis on Cyprus take the form of a long ship ending in a ram with a protective breast-work, and a volute stern-post.

A Cretan workshop produced a bronze ship with the oarsmen rowing, and two figures standing in the stern, recalling the legend of Theseus and Ariadne, or of Paris and the fair Helen (fig. 76).

The eternal sea-voyage of the Greek is attested in every period by the objects that accompanied him to the grave. These are the same over the centuries, the only change being

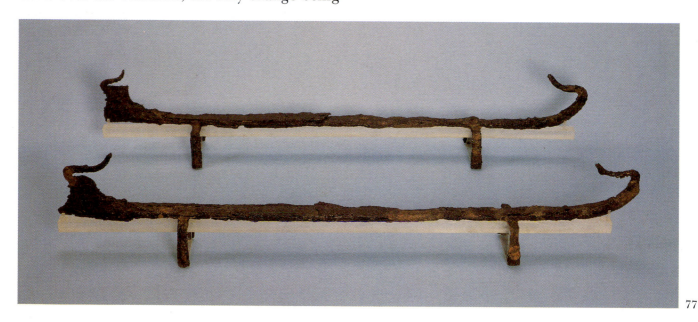

77

the style in which they are rendered: a model of a ship, a vase with a scene of a naval adventure, or some legend connected with the sea, and some funerary ornament. To achieve this artistic expression, the Greek used the materials furnished by the Greek earth – clay, metal, stone and marble. At this period, when man expressed himself through geometric shapes, clay was the most readily accessible material, as is clear from the objects found in every Greek land in the then known world.

**77.** *Geometric iron spit-stands in the form of ships. From a tomb at Argos, 8th century B.C. Argos, Archaeological Museum F10 and F11.*

# THE EXPANSION OF THE GREEK WORLD FROM PHOENICIA TO THE PILLARS OF HERCULES

The 7th and 6th centuries were a period when the Greeks dominated all the coasts of the Mediterranean. Hundreds of colonies were founded around the edge of the Mediterranean basin. During these centuries, Greek seafaring was indissolubly linked with the planting of colonies and the growth of trade and the economy in general. So many Greek colonies were founded in southern Italy that the area is known as *Magna Graecia*. The eastern part of Sicily was equally densely populated with Greek cities, as were the coasts of modern France, Spain and the shores of Libya. In the northern Aegean, colonies were founded in Chalkidiki, Macedonia and Thrace, while a ring of Greek cities was formed in the Black Sea.

Although trade continued with Egypt and the Near East, it was also conducted in this period between mother-cities and their colonies. The seaman's radius of activity continually increased, trade expanded, and the influence of peoples on each other became clearer.

In 638 B.C., unfavourable winds blew a Samian ship off course and drove it beyond the Pillars of Hercules (Gibraltar). On their return voyage, the Samian sailors took on a load of silver from south-west Spain and sold it at a good price in their homeland. Shortly afterwards, in 620 B.C., the Phocaeans ploughed the sea route between Asia Minor and Spain, carrying this precious material in their boats to the markets of the Aegean. On their return journey, they took on board the goods of the Etruscans and the products of Carthage, and traded them in the ports of the Greek colonists. Their example was followed by the merchants who sailed the sea routes from Corinth, Chalkis and Eretria, the islands of Samos, Chios and Rhodes, and the cities of Asia Minor.

Athens founded no colonies at this period. Only Solon travelled abroad at the beginning of

the 6th century B.C., to see and learn and to record his impressions of his journeys. Here we have the first known attempt to improve the mind through travel.

At this period, however, Athens suffered from a deficit of certain products, such as grain, and a surplus of others, like olive oil, wine and her excellent pottery. The city decided, therefore, to construct a merchant fleet for trading purposes alongside the military one. To build this, wood and metal had to be imported. Conflicts inevitably followed, a climate of competition between the city-states was created, and there were disputes with other naval peoples.

Once the Athenian merchant fleet was at sea, alongside the warships, the middle classes began to participate more actively in public affairs. At the same time, the processes intensified that gradually transformed the oligarchic-aristocratic forms of government into timocratic-democratic ones. The 6th century was a critical period for the political, economic and geographical space of Greece and foreshadowed the triumph of the Classical civilization that was to follow.

New paths were opened up in every sphere of life at this period, as a result both of the contacts arising out of the pan-Hellenic games at the major sanctuaries of Olympia, Delphi, the Isthmus and Nemea, and of the colonies. The efforts of the men of the Archaic period to draw the boundaries between myth, epic and rational discourse led to a quest for the truth.

Towards the end of the 6th century, Hekataios of Miletos, a historian and geographer, undertook the first tour of Asia, Libya and Egypt. He travelled to the lands and coasts of the Mediterranean, and in his book *Periodos tes ges* ("Tour of the world"), or *Periplous* ("Circumnavigation"), he recorded his various impressions of his travels on a long, sea-voyage. Other Greeks travelled and described what they saw – men like Skylax, a sailor from Caria, who, in the 6th century B.C. circumnavigated the "sea of the inhabited world".

The ships of the Archaic period inherited their form from their Geometric forerunners. Shipbuilding in the 7th and 6th centuries had nothing new to add, though there was a significant increase in pictorial representations. On ceramic vases and plaques, on sealstones (fig. 113), in clay, bronze and wooden models (fig. 89-90), in sculptures and engravings in stone and marble, on bronze, gold and ivory, the main motif used was the warship or the merchant ship (fig. 86-87). At the same time, scenes of military conflicts are rendered on vases or plaques, reflecting the hostilities and conquests of the city-states of this period.

Western Greece has preserved to us a very valuable piece of evidence for the ships of the Archaic period in a scene of a naval battle painted on a krater by Aristonothos, an artist from *Magna Graecia* (fig. 79). Two ships are depicted, of differing types and full of warriors. One of them has an elongated hull, a straight ram on the prow, and a raised stern ending in the head of a bird, recalling the ships found on Attic vases; the other has a rounded hull and an elevated, curved prow and stern; this resembles the Phoenician ships that came to the West from the Near East a century earlier and founded Carthage on the coast of Africa, the largest naval centre in this region. The reliefs of the Assyrian palaces at Khorsabad, Nimrud and Nineveh (Kujundjik) have numerous scenes of ships with this same form (fig. 78, 81-84). Etruscan ships also had rounded hulls at this period, however (fig. 80). The second ship on the krater by Aristonothos is, therefore, probably a Carthaginian or Etruscan vessel clashing with Greeks. The painter is here possibly recording a scene from the many conflicts that occurred during this period

when the Greeks were expanding and founding colonies in the West.

The main motifs on vase-painting at this time were the warships with single or double banks of oars (fig. 88), though merchant vessels are also found. On the dark, black-figure hull are incised the details of the hull, the oars, the protective breastwork, the ram on the prow, which is usually in the form of a wild boar, and the stern, ending in the figure of a bird. The sails of the ships are usually spread and rendered in white paint, while details of their folds and the rigging are incised, allowing the black glaze to be seen.

*78. Relief from the palace of Sennacherib at Nineveh (704-681 B.C.), depicting a round ship resembling Phoenician vessels and those depicted on vases from Magna Graecia. London, British Museum.*

78

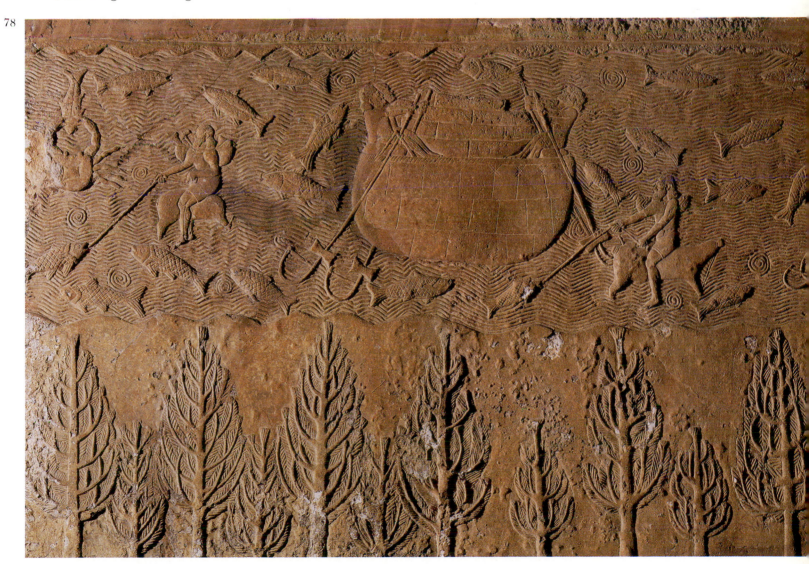

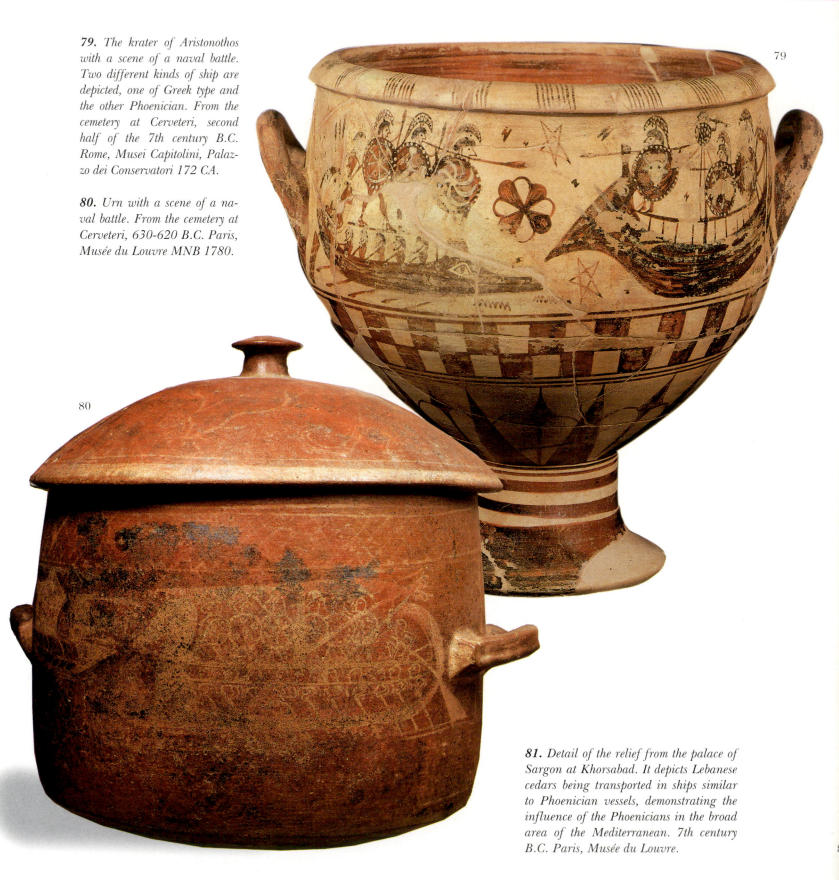

**79.** *The krater of Aristonothos with a scene of a naval battle. Two different kinds of ship are depicted, one of Greek type and the other Phoenician. From the cemetery at Cerveteri, second half of the 7th century B.C. Rome, Musei Capitolini, Palazzo dei Conservatori 172 CA.*

**80.** *Urn with a scene of a naval battle. From the cemetery at Cerveteri, 630-620 B.C. Paris, Musée du Louvre MNB 1780.*

79

80

**81.** *Detail of the relief from the palace of Sargon at Khorsabad. It depicts Lebanese cedars being transported in ships similar to Phoenician vessels, demonstrating the influence of the Phoenicians in the broad area of the Mediterranean. 7th century B.C. Paris, Musée du Louvre.*

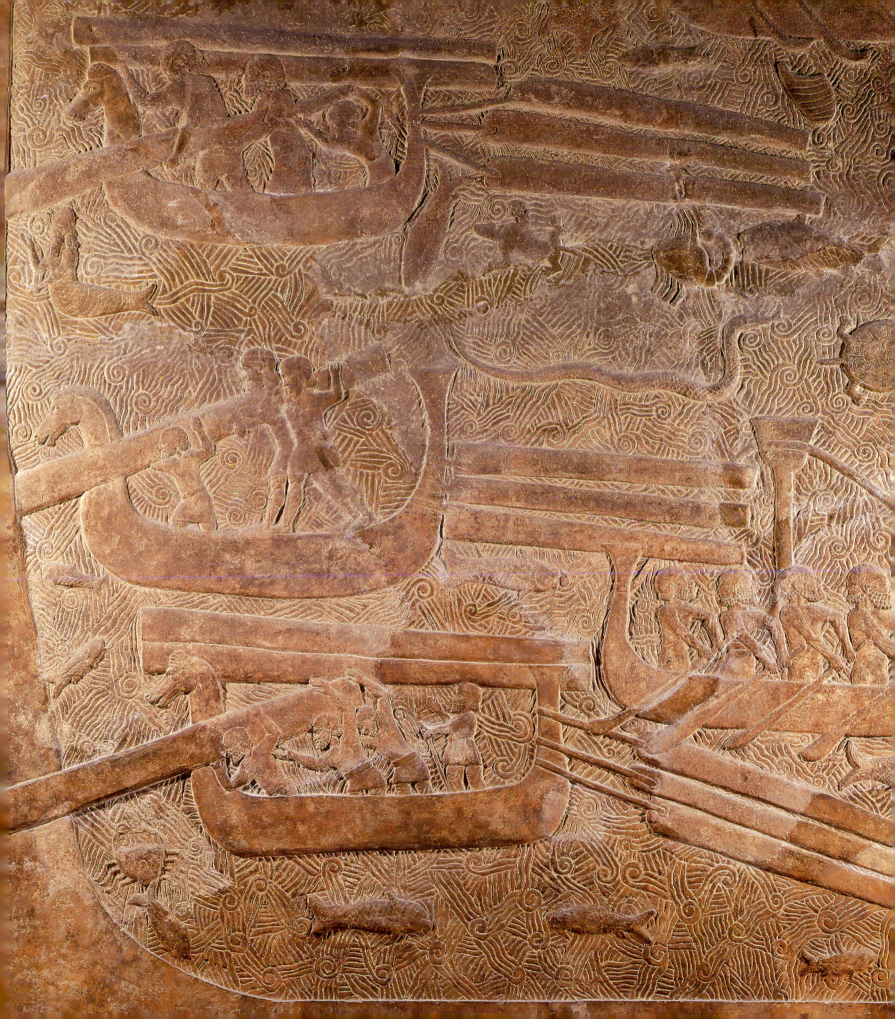

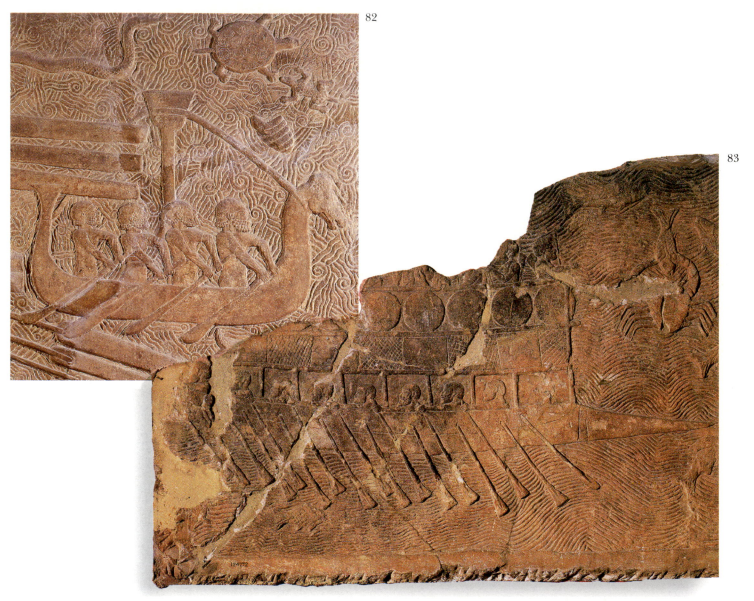

**82.** *Detail of a Phoenician merchant ship from fig. 81.*

**83.** *Phoenician warship. Detail of the relief from the palace of Sennacherib (705-681 B.C.) at Kujundjik. London, British Museum 124772 A.*

**84.** *Scene of commercial transactions. Exchange of goods transported by ship from Tyre to Sidon. Part of the bronze revetment of the gates of the palace at Balawat. 9th century B.C. Paris, Musée du Louvre AO 14038.*

**85.** *Silver plate with a hunting scene. Four Egyptian vessels are depicted amidst thick marsh vegetation. From the tomb of Bernardini at Praeneste, 7th century B.C. Rome, Museo Nazionale Etrusco di Villa Giulia.*

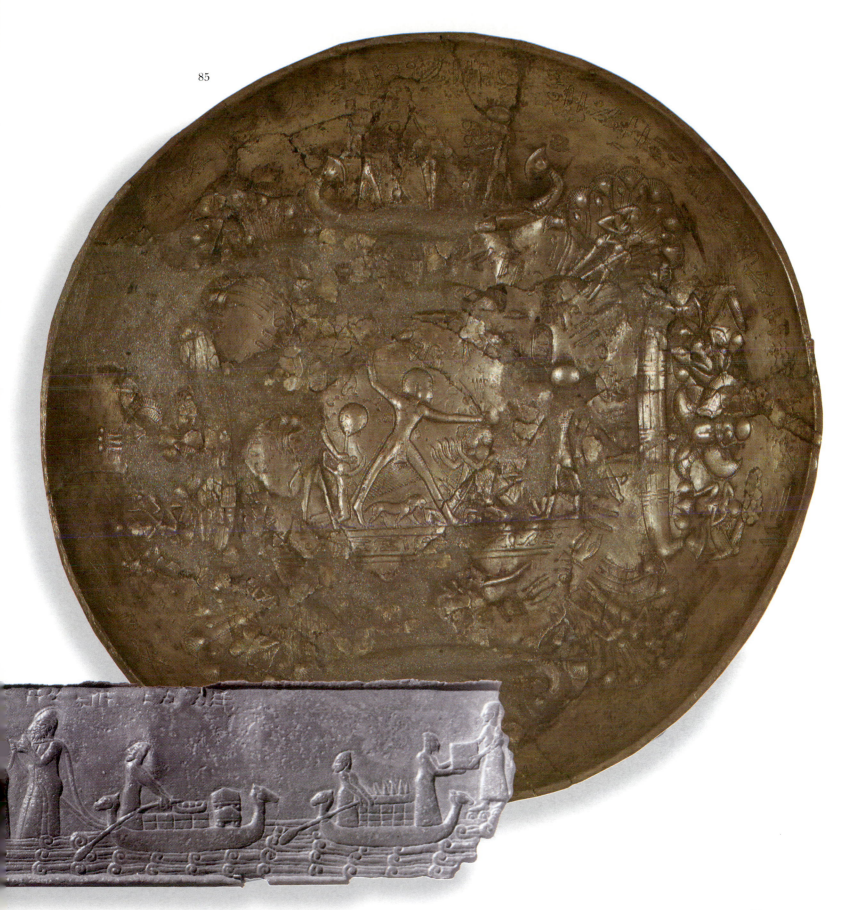

**86.** *Stone relief with a warship. 6th century B.C. Basel, Antikenmuseum und Sammlung Ludwig BS 218.*

**87.** *Ivory relief plaque with a mythical abduction scene. A warship is depicted ready to depart, and a female figure embarks by the stern, where she is received by a male figure. This is probably the abduction of Helen by Paris. From the sanctuary of Artemis Orthia at Sparta, second half of the 7th century B.C. Athens, National Archaeological Museum 15362.*

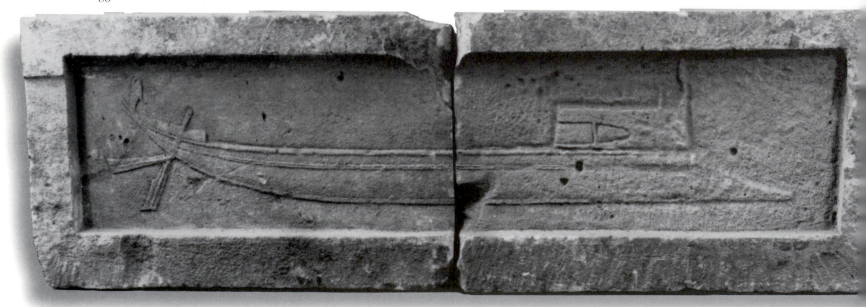

86

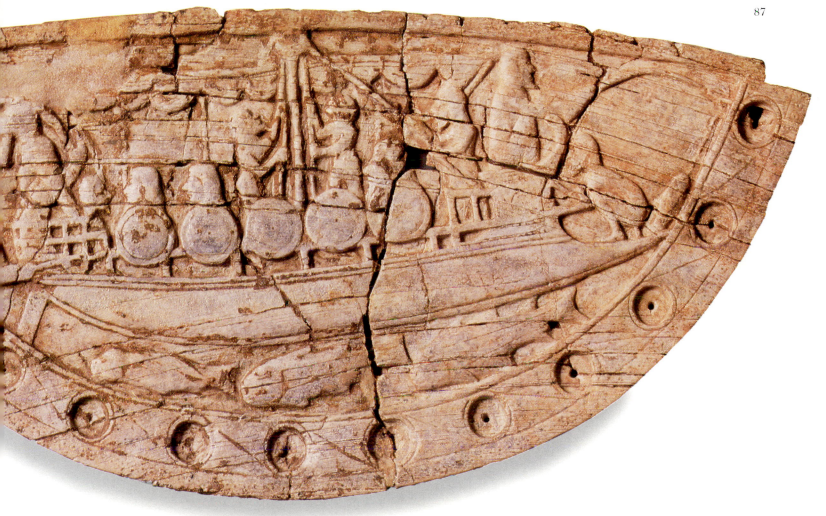

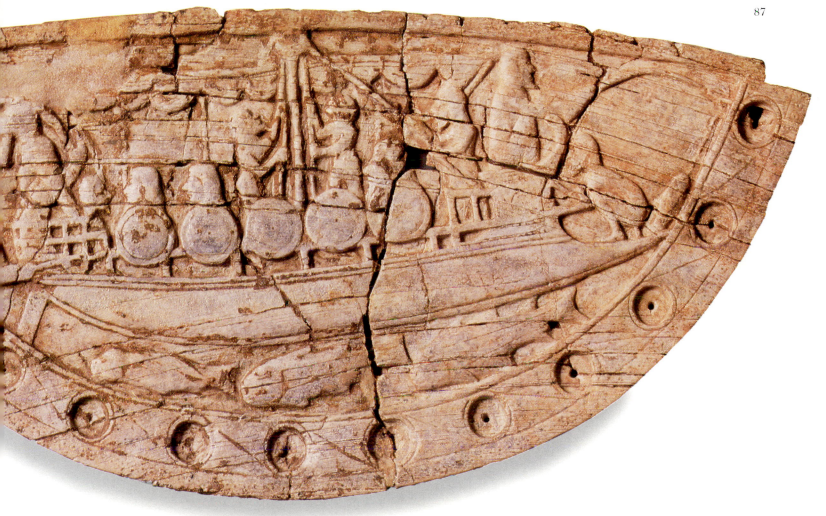

In the first half of the 7th century, the Corinthians painted their ships on vases and ceramic plaques in an "orientalizing" style and with flawless technique, surpassing the Athenians. The latter retrieved the baton, however, in the second half of the century and held on to it throughout the 6th. True to the earlier Attic tradition, they selected the ship as a special motif in its own right, and their portrayals of it form the most wonderful group of naval paintings in the whole of antiquity. The pictures of ships on vases are the work of named painters of the period who departed from the strictly realistic form of the ship and created works of art. On the interior surface of the rims of At-

tic dinoi, kraters, oinochoai and kylikes, they placed friezes decorated with ships, invariably sailing on the waves (fig. 94-99, 104-105). At other times, they covered the entire interior and exterior surfaces of the vase with a mythological scene connected with the maritime adventures of gods or heroes (fig. 91-92, 100-103, 106-109).

The triumphant voyage of Theseus from Crete to Delos is revived by Ergotimos and Kleitias on the François krater which, amongst other motifs, has a depiction of his ship, a *triaconter* ("thirty-oared") according to tradition, full of warriors, as it arrived at the sacred island (fig. 92-93).

**88.** *Fragment of a clay plate by the Analatos painter depicting military training aboard a ship. From the sanctuary of Poseidon at Sounion, early 7th century B.C. Athens, National Archaeological Museum 14935.*

**89.** *Bronze model of a ship with passengers. From the sanctuary of Poseidon at Isthmia, 6th century B.C. Isthmia, Archaeological Museum IM 2090.*

**90.** *Clay models of ships from the sanctuary of Poseidon at Isthmia, 6th century B.C. Isthmia, Archaeological Museum.*

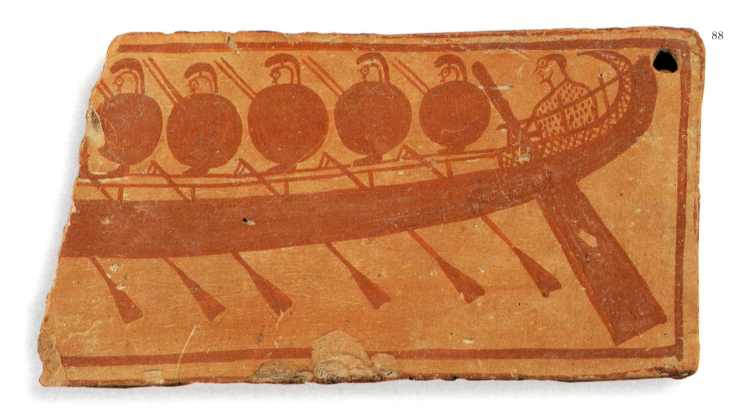

88

Another legendary ship, the Argo, a *penteconter* powered by a crew of warrior-heroes who hold their shields as they row, is depicted on an Attic hydria of the beginning of the 6th century B.C. The same motif is chiselled in marble on a metope of the Treasury of the Sikyonians at Delphi. Next to the mounted figures of the Dioskouroi can be seen the prow of a ship, here too rowed by oarsmen carrying shields, while Orpheus accompanies their voyage with a song.

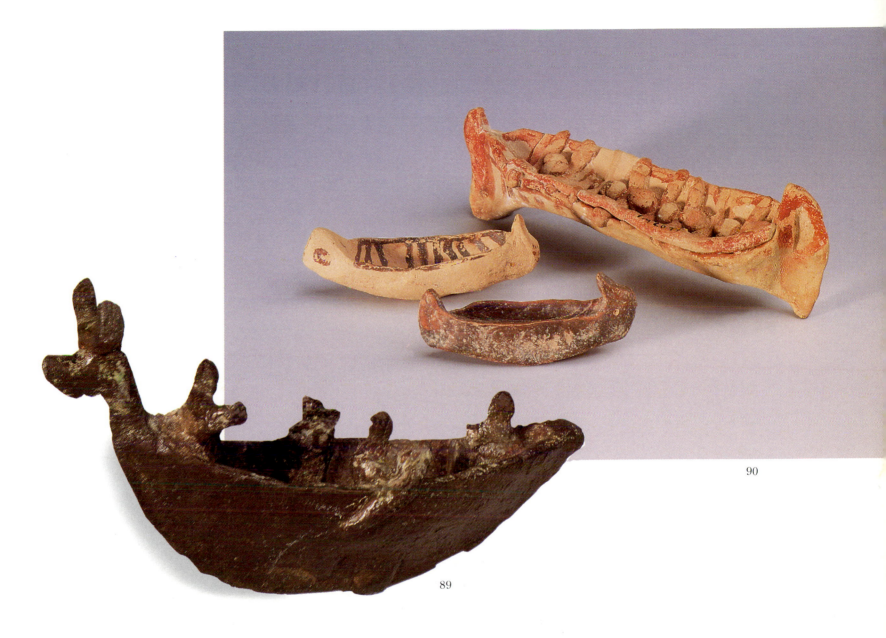

89

90

The abduction of the beautiful Helen by Paris had exercised the imagination of artists since the previous period. A 7th century ivory plaque from Sparta has an engraving showing Helen being carried off in a ship which is full of warriors and is hoisting its sails in readiness to depart, while the two heroes are embarking at the stern (fig. 87).

Subjects drawn from the Homeric poems were immortalized by the painters of this period on black-figure vases. A Corinthian aryballos has a detailed rendering of the famous episode of Odysseus and the Sirens while, on an Attic amphora, the soul of Achilles in the form of a warrior flies above a boat on his journey to the Isles of the Blest (fig. 106).

At this period, the god Dionysos frequently travelled the seas alone or with his band of followers in ships with one or two banks of oars, from inside which grow ivy and vines.

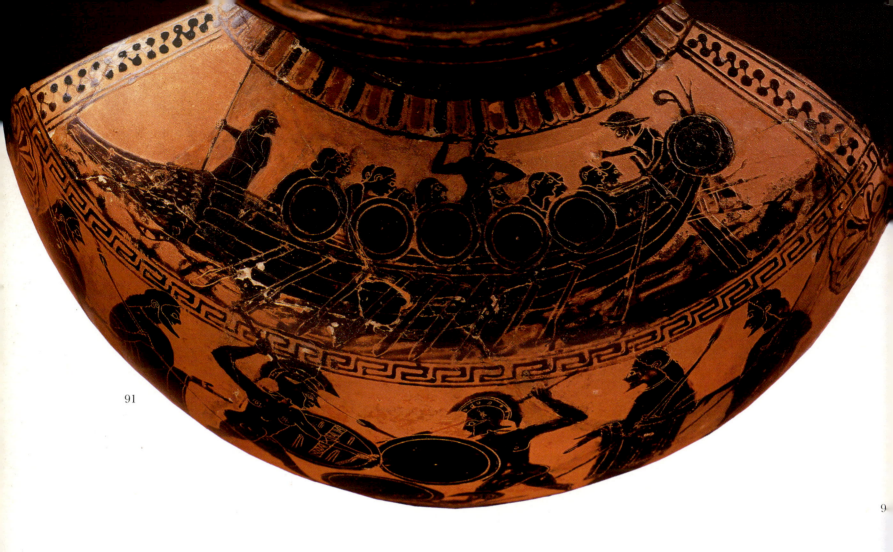

91

9

**91.** *Detail of an Attic black-figure hydria. The warship with warriors depicted on the neck of the vase has been identified with the Argo and Argonauts on their journey to Colchis, the central figure being Herakles. First half of the 6th century B.C. Paris, Musée du Louvre E735.*

**92.** *Detail of the François vase, a black-figure volute krater by Kleitias and Ergotimos. It depicts Theseus and his comrades disembarking at Delos after their triumphant voyage to Crete. About 570 B.C. Florence, Archaeological Museum 4209.*

**93.** *The sacred island of Delos, birthplace of Apollo.*

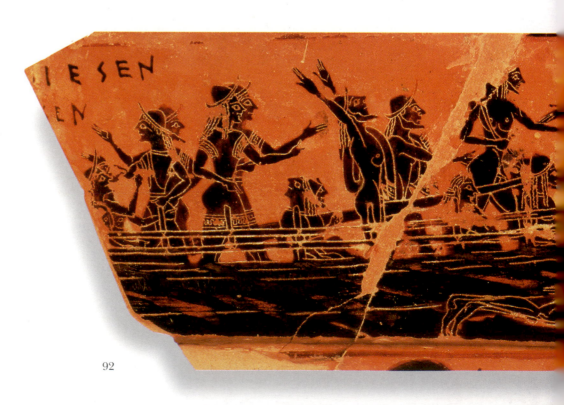

92

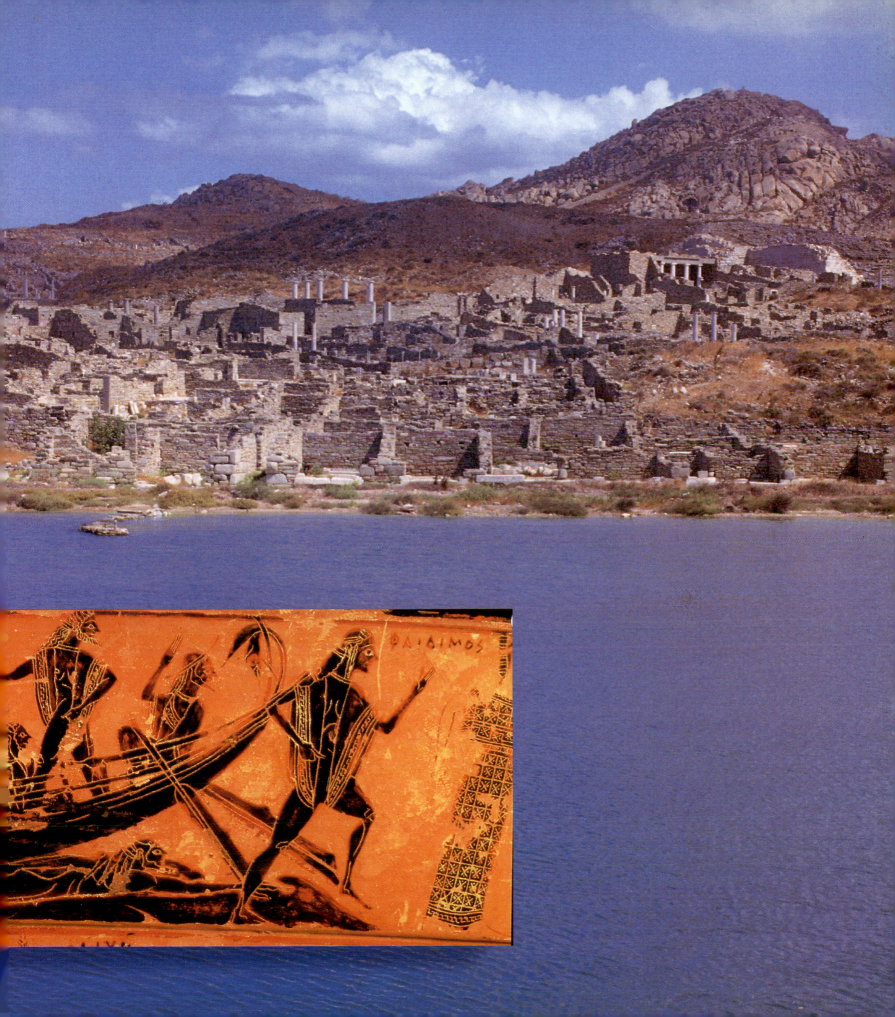

**94.** *Detail of an Attic black-figure dinos with two warships depicted on the inside of the rim. The artist has skilfully drawn every detail of the ship on the dark, black-figure vessel, at the same time creating a work of art. By the Exekias painter, 550-530 B.C. Rome, Museum of the Villa Giulia 50599.*

In the Dionysiac processions featured in theatrical plays, the chariot bearing the god and his troupe takes the form of a ship with a prow and stern, complete with the ivy and vine encircling it.

Exekias painted the voyage of Dionysos and his ship on the interior of a kylix, cruising amongst dolphins, with the ivy growing on the mast to give shade to his journey (fig. 109). And Nikosthenes covered the interior of another kylix with four ships engaged in a naval battle,

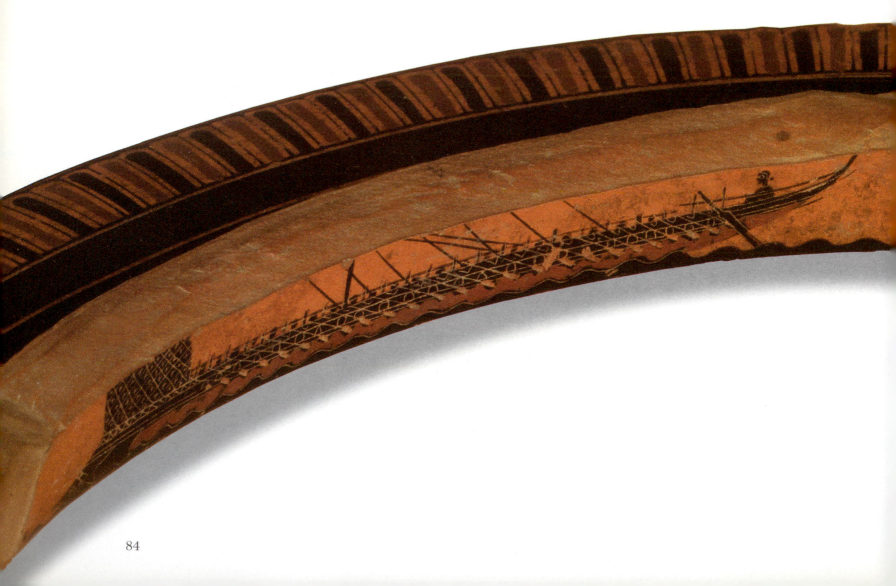

with their sails spread to catch the wind, surrounded by their fellow voyagers, the dolphins (fig. 107).

A merchant vessel painted between two warships on a kylix in the British Museum offers a picture of the voyages made by Greek ships at this period on the boundless Greek seas (fig. 108). The painter has portrayed a moment of everyday life that would have been familiar to the sailors of the Archaic period.

At many of the nautical centres of the Greek world of the time, mainly in the remote island of Cyprus, vases with scenes of ships have been preserved (fig. 118-119), as well as numerous clay models of warships and merchant vessels, and also small boats. If Attic vase-painting at this period can offer a complete series of very fine depictions of ships, Cyprus can rival it with these three-dimensional models of a variety of vessels (fig. 115-117). Large and small ships, both painted and unpainted, and also simple boats, are rendered with all the

94

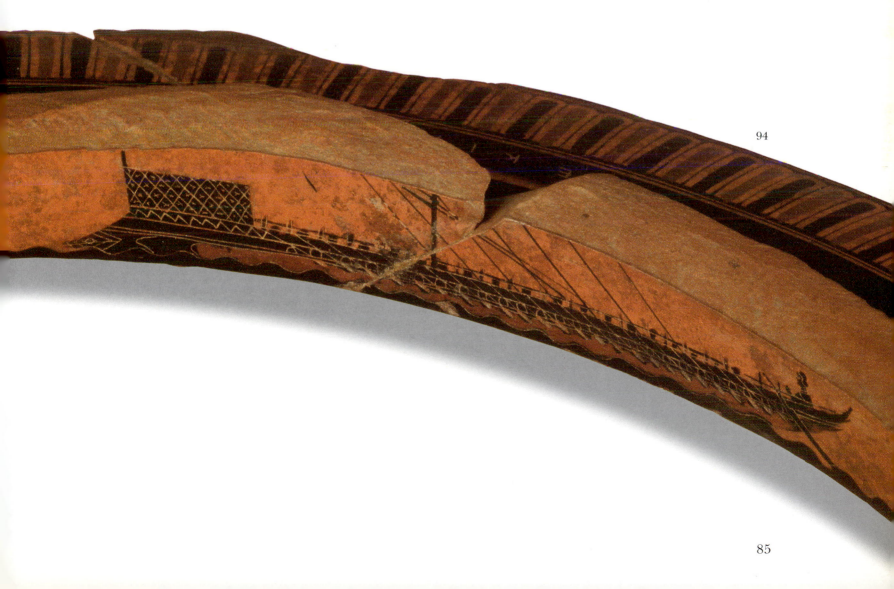

details characteristic of their type at this period. These models, whether votives dedicated by the faithful at some sanctuary of the period, or grave offerings placed in tombs to symbolize the journey of the dead person to the other world, or even simple imitations or models of real ships, reveal once more the relationship of the Greek with the sea, not only in his daily life but also in the voyage of the soul after death to the Isles of the Blest.

A piece of gold sheet found in a tomb at Sindos in Macedonia bears an engraving of a ship that has a long narrow hull and a prow terminating in a ram with a protective breastwork (fig. 114). With its 18 oars moving rhythmically, the two steering oars at the stern raised, and the sail swollen by the wind, it is travelling quote "over the Ocean to the Elysian Fields and the ends of the earth" (*Odyssey*, 4, 563).

Of the wall-paintings in two Etruscan tombs discovered at Tarquinia (Italy), one has a depiction of a merchant vessel (*tomba della nave*) and the other a fishing scene with boats (*tomba di caccia e pesca*). Both are connected with the deceased man's life on earth and his activities as a sailor, rather than with the ship-symbol on which the dead man travels the oceans of the next world.

Whatever the more general significance of the presence of a ship or a nautical scene in a tomb, there was clearly a need for it in the after life, and it thus symbolizes a faith and belief held by every nation.

**95-97.** *Warships painted on the inside of the rim of an Attic black-figure dinos. Fig. 95 shows one penteconter with a single tier of oars and fig. 96 a detail of the stern and rudder of the other. 530-510 B.C. Paris, Musée du Louvre F 61.*

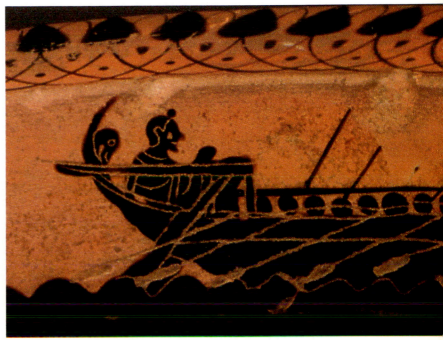

95  96

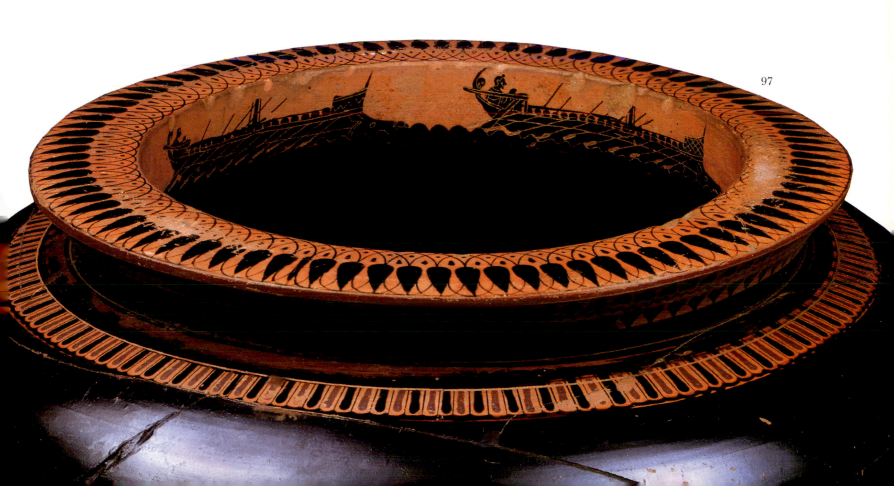

97

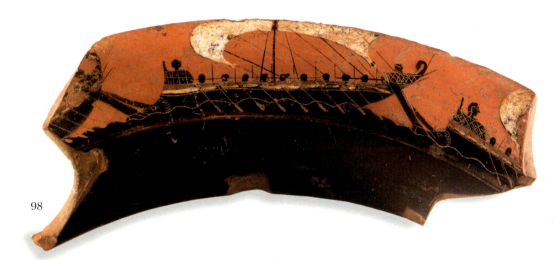

98

**98.** *Fragment from the rim of an Attic black-figure dinos. The upper surface depicts a warship with sails between two others, of which the stern of one and the prow of the other are preserved. 520-480 B.C. Paris, Musée du Louvre C 11248.*

**99.** *One of the five ships decorating the inside of the rim of an Attic black-figure dinos. It is a penteconter with sails and oarsmen rowing vigorously. 550-530 B.C. Paris, Musée du Louvre F 62.*

**100.** *Attic black-figure kylix with four warships forming a kind of frieze around the interior, c.510 B.C. London, British Museum E 2.*

99

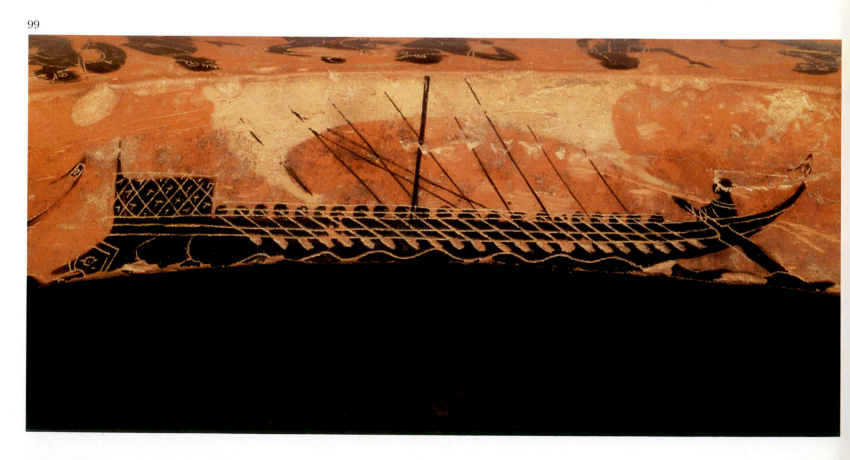

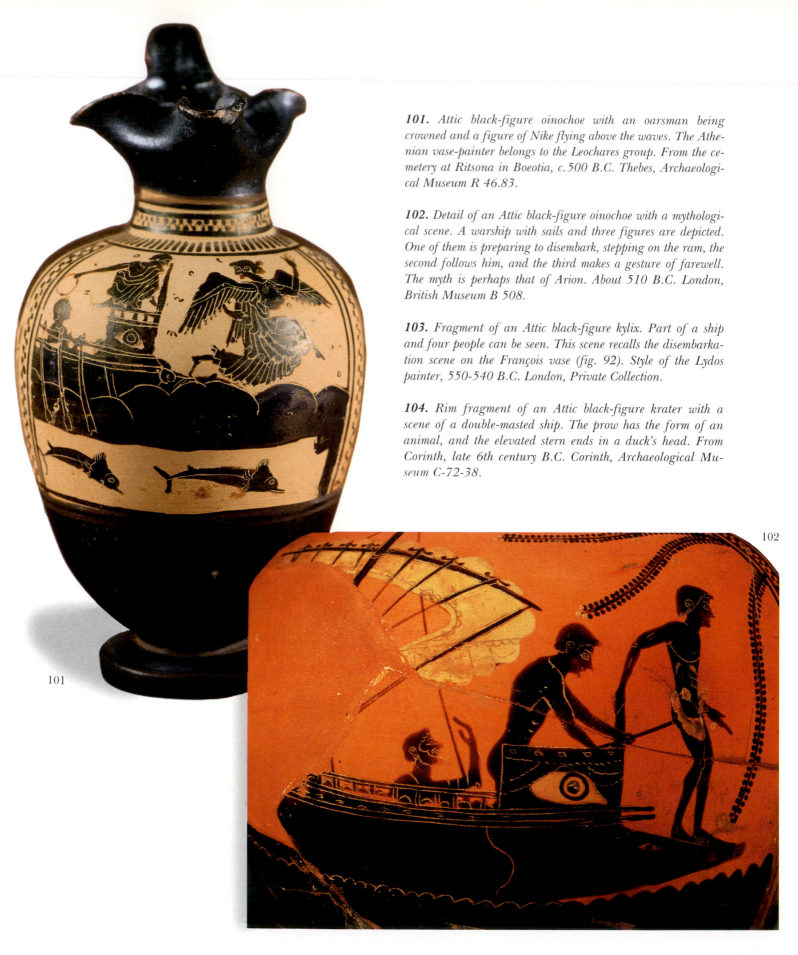

**101.** Attic black-figure oinochoe with an oarsman being crowned and a figure of Nike flying above the waves. The Athenian vase-painter belongs to the Leochares group. From the cemetery at Ritsona in Boeotia, c.500 B.C. Thebes, Archaeological Museum R 46.83.

**102.** Detail of an Attic black-figure oinochoe with a mythological scene. A warship with sails and three figures are depicted. One of them is preparing to disembark, stepping on the ram, the second follows him, and the third makes a gesture of farewell. The myth is perhaps that of Arion. About 510 B.C. London, British Museum B 508.

**103.** Fragment of an Attic black-figure kylix. Part of a ship and four people can be seen. This scene recalls the disembarkation scene on the François vase (fig. 92). Style of the Lydos painter, 550-540 B.C. London, Private Collection.

**104.** Rim fragment of an Attic black-figure krater with a scene of a double-masted ship. The prow has the form of an animal, and the elevated stern ends in a duck's head. From Corinth, late 6th century B.C. Corinth, Archaeological Museum C-72-38.

101

102

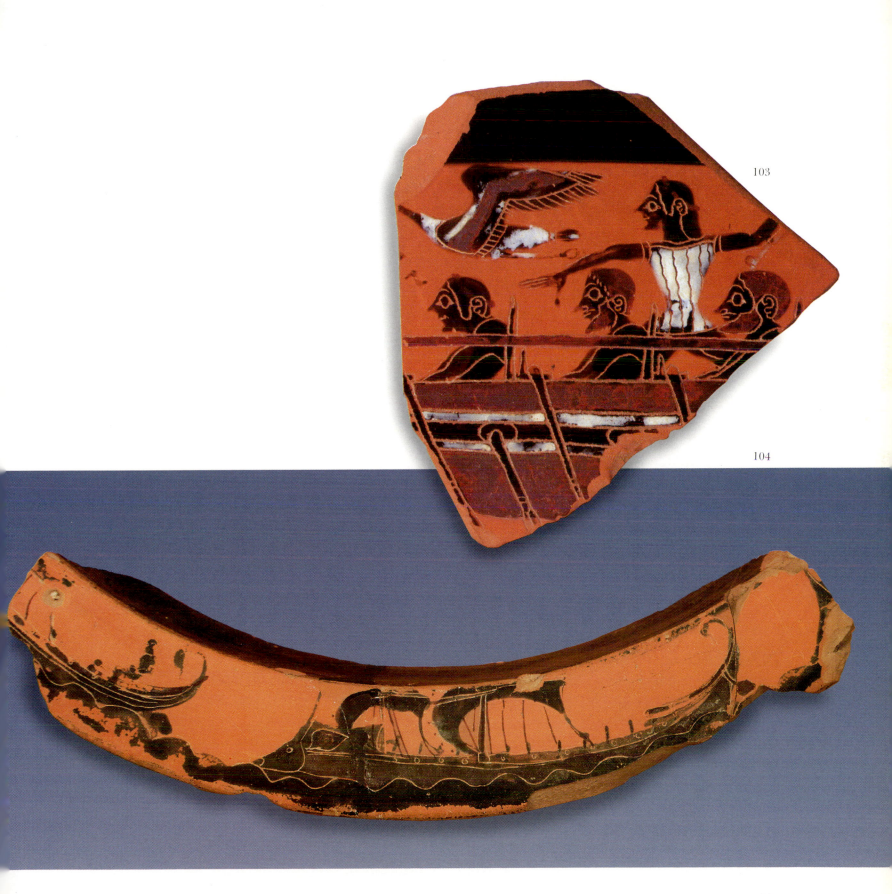

103

104

91

**105.** *Rim fragments of a clay plate depicting a warship. The figures of two hoplites and the helmsman can be seen. These scenes of warships reflect the dynamic Athenian presence at sea during the late Archaic period. From the Athenian Acropolis, 530-510 B.C. Athens, National Archaeological Museum 2414.*

**106.** *Detail from an Attic black-figure amphora. The spirit or soul of Achilles, in the form of a warrior, flies above a warship journeying to the Isles of the Blessed, near Cape Segion. About 510 B.C. London, British Museum B 240.*

**107.** *Detail of two ships, one overlapping the other, from an Attic black-figure kylix with a scene of a naval battle on the exterior. This is perhaps the finest rendering of a naval battle in the history of ancient vase-painting. By Nikosthenes, 530-510 B.C. Paris, Musée du Louvre F 133.*

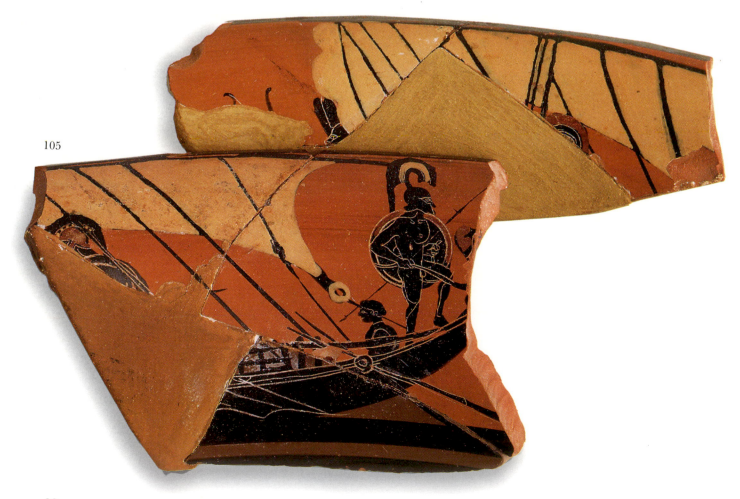

105

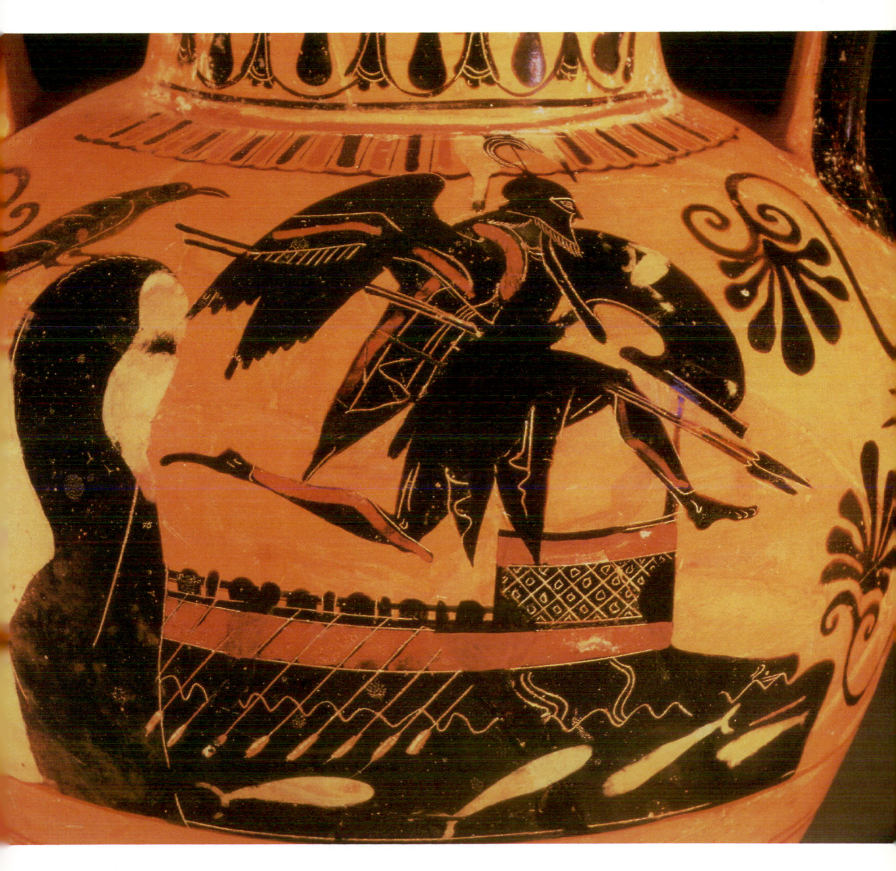

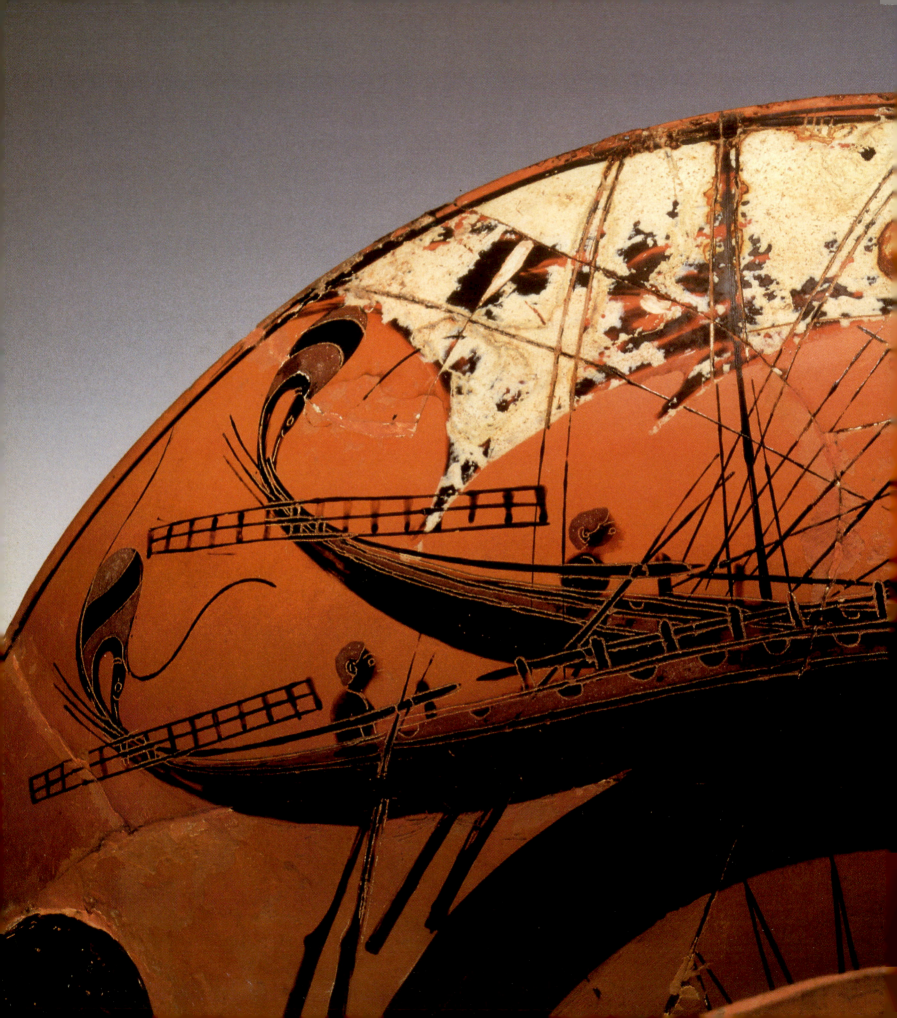

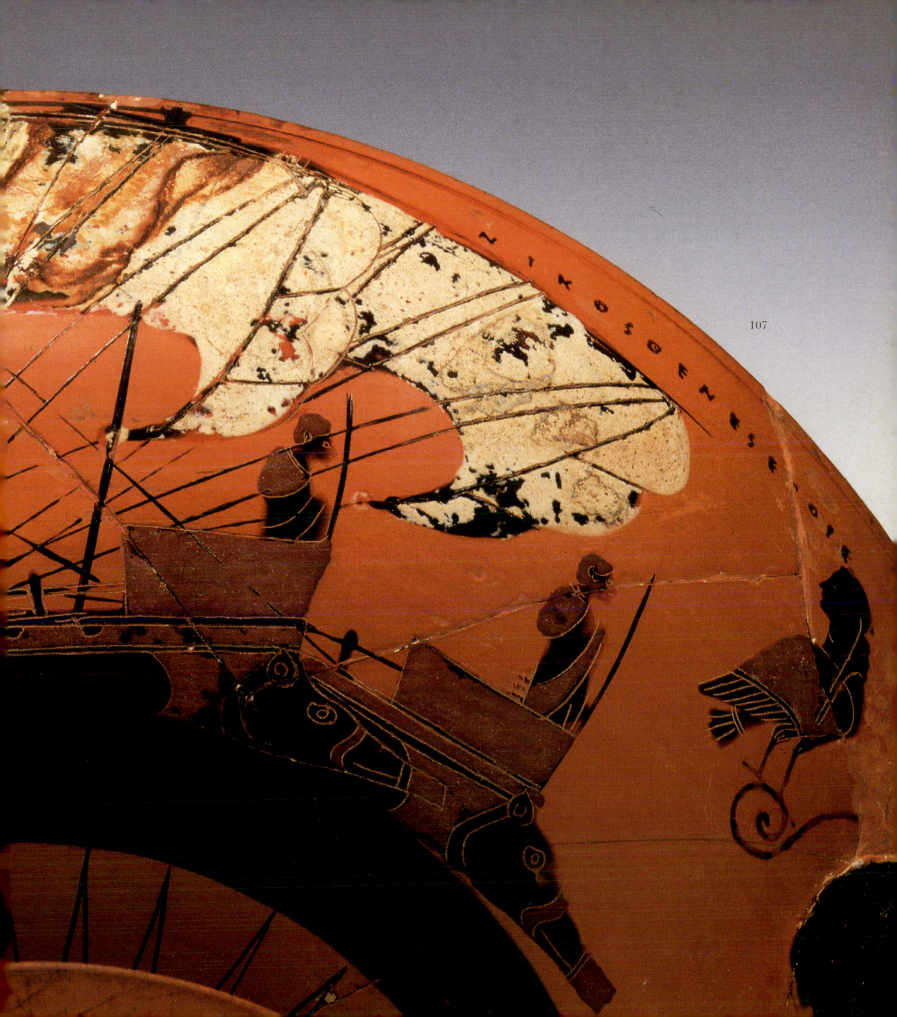

The votives of small ships carved in wood, from the great sanctuary of the goddess Hera on Samos, a major naval power at this period, may well be connected with the belief that the faithful should offer to the god the thing most closely related to their life. This large, densely forested island of the archipelago was one of the leading naval and commercial powers at this period and played an important role in the expansion of the Greeks in the Mediterranean, planting colonies on the three known continents. Outstanding merchants and sailors, and famous pirates, the Samians of the time of Polykrates (539-522 B.C.) aspired to the role of rulers of the Aegean, and undertook major, long-distance voyages.

*108. Merchant ship. Detail of an Attic black-figure kylix with a scene of two merchant ships and two warships on the exterior. About 510 B.C. London, British Museum B 436.*

*109. Attic black-figure kylix with the voyage of Dionysos painted on the inside. By Exekias, 550-530 B.C. Munich, Antikensammlungen 2044.*

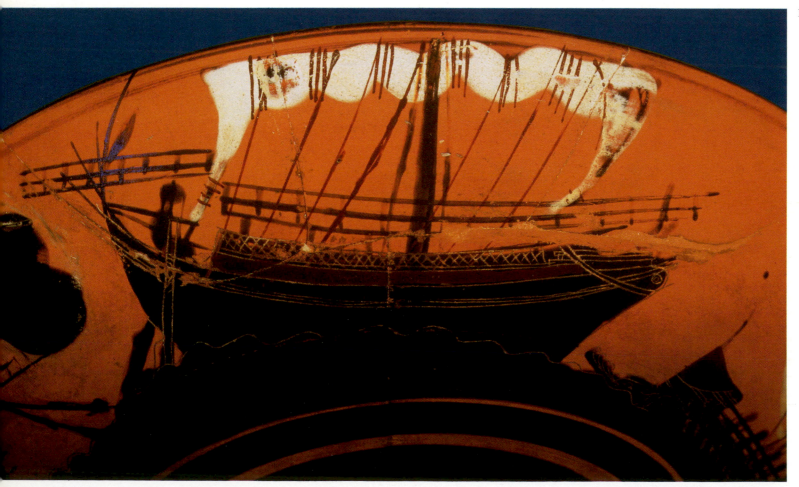

108

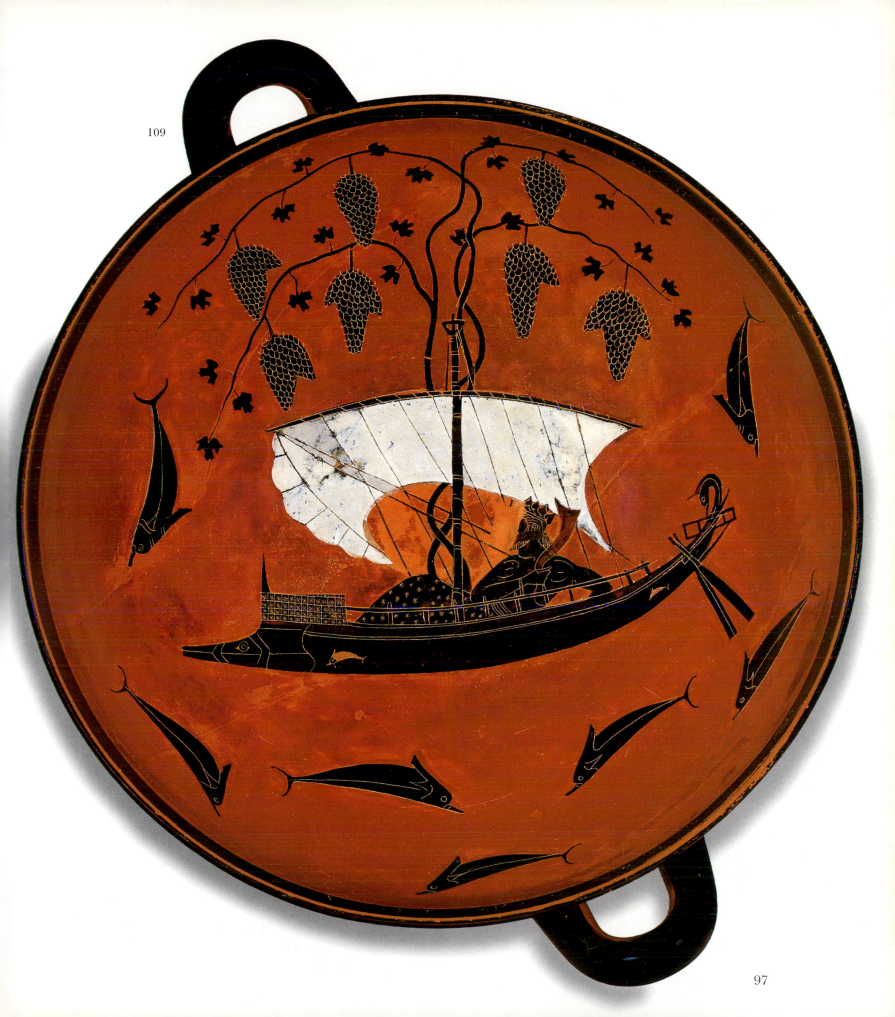

**110.** *Silver stater of Thera with relief dolphins. 530-500 B.C. Athens, Credit Bank Collection.*

**111.** *Silver drachma of Zankle (later Sicilian Messene) with a scene of a dolphin framed by a sickle-shaped border representing the harbour of Zankle. 520-493 B.C. Athens, Credit Bank Collection.*

**112.** *Tetradrachm of Skione, a city in Chalkidiki, with a scene of a helmsman and the stern of a ship. 500-480 B.C. Athens, Credit Bank Collection.*

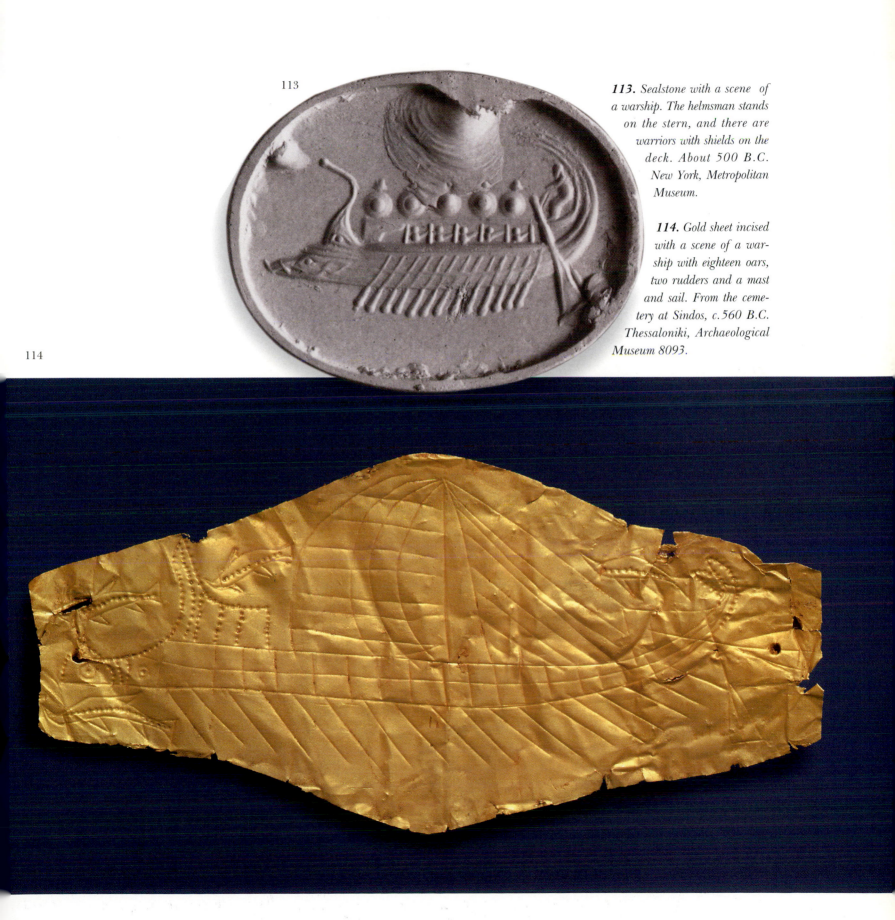

**113.** Sealstone with a scene of a warship. The helmsman stands on the stern, and there are warriors with shields on the deck. About 500 B.C. New York, Metropolitan Museum.

**114.** Gold sheet incised with a scene of a warship with eighteen oars, two rudders and a mast and sail. From the cemetery at Sindos, c. 560 B.C. Thessaloniki, Archaeological Museum 8093.

113

114

**115.** *Clay model of a ship with a helmsman, two oarsmen and an animal (dog or sheep) in the hull. The details are rendered by red and black lines. From Cyprus, c.600 B.C. Nicosia, Archaeological Museum 1946/XII-23/I.*

**116.** *Clay model of a merchant ship with a helmsman and lookout. From Cyprus, c.600 B.C. Nicosia, Archaeological Museum 1953/XII.*

**117.** *Clay model of a ship with a helmsman. From Cyprus, c.600 B.C. New York, Metropolitan Museum 74.51.1752.*

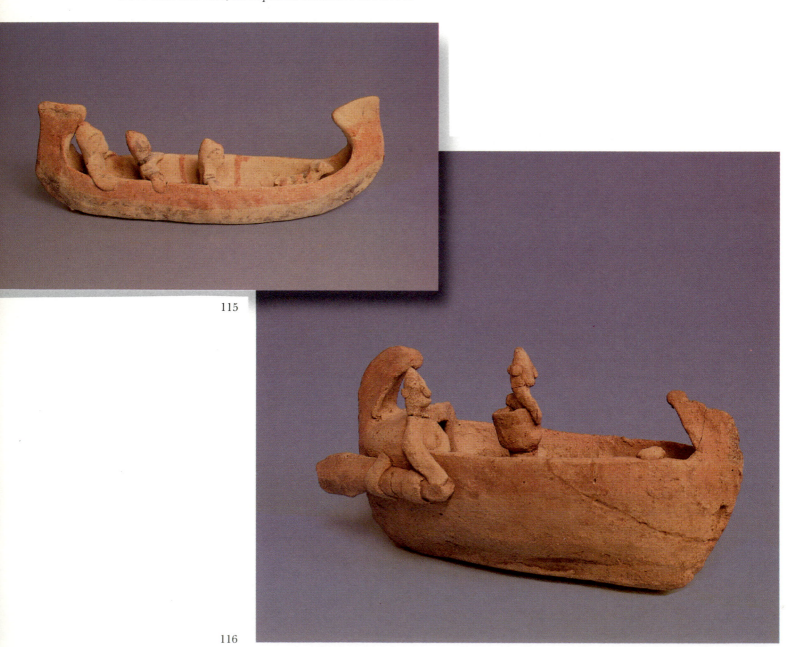

115

116

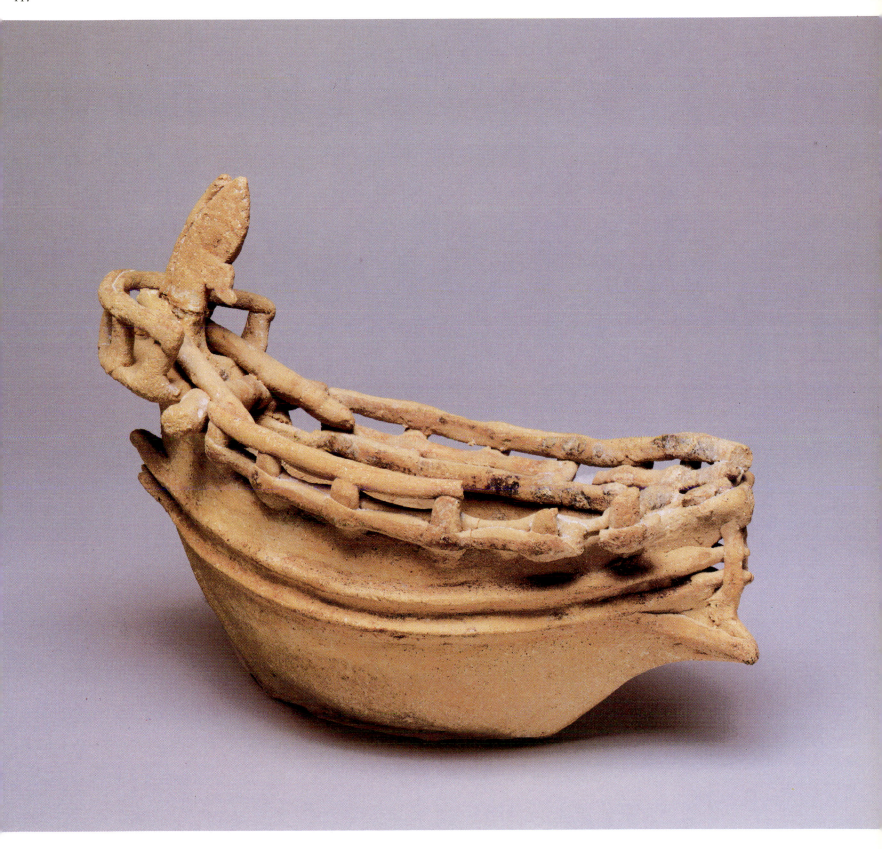

At the beginning of the 5th century they set out on their longest journey, to Sicily, where they captured Zankle (later Messene, fig. 111), and furnished history with coins, later imitated by others (fig. 112), bearing engravings of the prows of ships – the ones on which they crossed the seas at the end of the Archaic period, when, according to Thucydides (I, 13), "Greece began to fit out ships and to apply itself more to the sea."

*118. Cypriote oinochoe with a scene of a merchant ship with a cargo of amphoras riding at anchor. 7th century B.C. London, British Museum 1926, 6.28.9.*

*119. Cypriote oinochoe with a scene of a ship whose stern ends in the form of a bird. 750-600 B.C. Nicosia, Archaeological Museum 1947/I-16/I.*

118  119

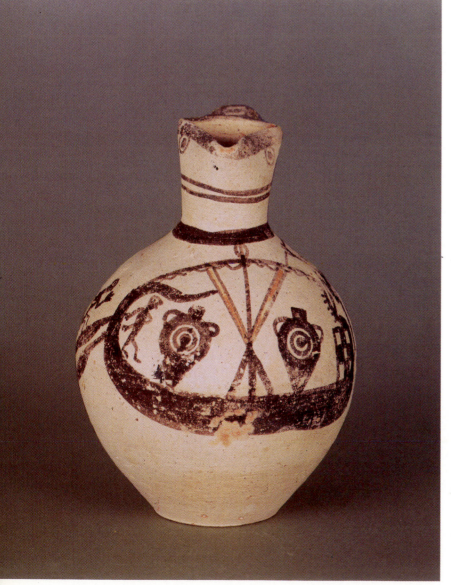

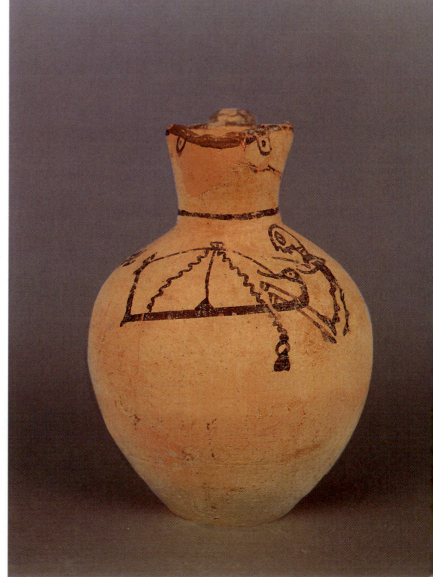

# THE WOODEN WALLS AND ATHENIAN HEGEMONY

The transition from the Archaic to the Classical periods was marked by the repulsing of the Persian threat. At the beginning of the 5th century, in 480 B.C., the long, manoeuvrable Athenian triremes defeated the large, clumsy ships of the Persian king in the straits of Salamis, illuminating the dawn of Athens' domination of the sea and the beginning of Classical civilization. The battle of Salamis undoubtedly decided the fate of Greece and also, in the long term, that of Western civilization.

At this period, Athens became the leading naval power in Greece, with Piraeus as its port, and its defences strengthened by the construction of the Long Walls connecting the two cities. The decision to create the harbour at Piraeus was due to Themistokles, the brilliant victor of Salamis. His work was continued by Perikles, who succeeded in creating a perfectly designed port that was an important naval and commercial centre. Ships loaded with grain from the Pontos, grapes from Rhodes, fabrics from Carthage and other goods from a variety of regions, all dropped anchor alongside its installations. Down to 86 B.C., when it was destroyed by the Roman general Sulla, Piraeus was one of the most populous and vital harbours in the Mediterranean.

Thanks to its naval superiority and flourishing trade, Athens experienced unprecedented growth. Democracy was established on a firm basis, intellectuals and artists achieved greatness in their fields, and the city evolved into the greatest commercial, social, intellectual and artistic centre in the ancient world. Thanks to the prestige and influence of Athens at this period, the 5th century B.C. is known in history as the "Golden Age of Perikles".

The rivalry between the Greek cities, however, and the apprehension of the more conservative of them at the innovative ideas of Athens led

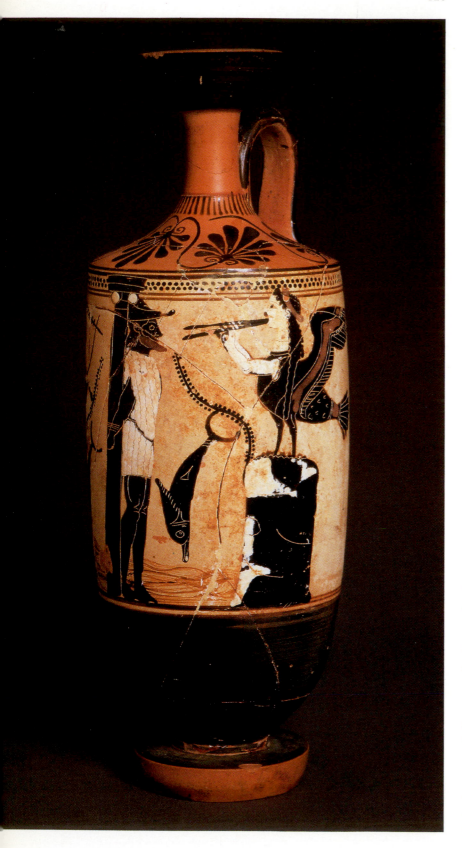

to the creation of two rival camps under the leadership of Athens and Sparta respectively. This, in turn, led to the outbreak of the Peloponnesian War, which lasted from 431 to 404 B.C. and brought terrible suffering to Greece.

At the outset, the Athenian Confederacy possessed the material and military strength that should have secured them victory. The death of Perikles in the third year of the war, however, proved to be a mortal blow. His successors were unable to continue with his plans. Rivalries, realignments and passions undermined the mighty Athenian empire and led to defeat. One result of this war, apart from the loss of forces that seriously affected the history of both rivals in the years that followed, was to protract the division of Greece into city-states and short-lived confederations. It was not until thirty years later that the Athenians succeeded in reconstituting the Athenian Confederacy, and they never recovered their previous strength.

In the 5th and 4th centuries, a period when military strength was directly related to naval superiority, the typical ship was the trireme, which probably first appeared in the Mediterranean at the end of the 6th century. During the Persian Wars, the trireme was the only ship used in both the Greek and the Persian fleets. It was only after the middle of the 4th century that other types of ships made their appearance.

Athenian inscriptions have preserved some interesting evidence as to the number of men carried on triremes. The number of oarsmen

**120.** *Attic black-figure white-ground lekythos by the Edinburgh painter depicting the episode of Odysseus and the Sirens. From Eretria, c.500 B.C. Athens, National Archaeological Museum 1130.*

**121.** *Detail of an Attic red-figure stamnos with a scene of a complete warship, unique in red-figure vase-painting. It depicts the episode of Odysseus and the Sirens. 490-480 B.C. London, British Museum E. 440.*

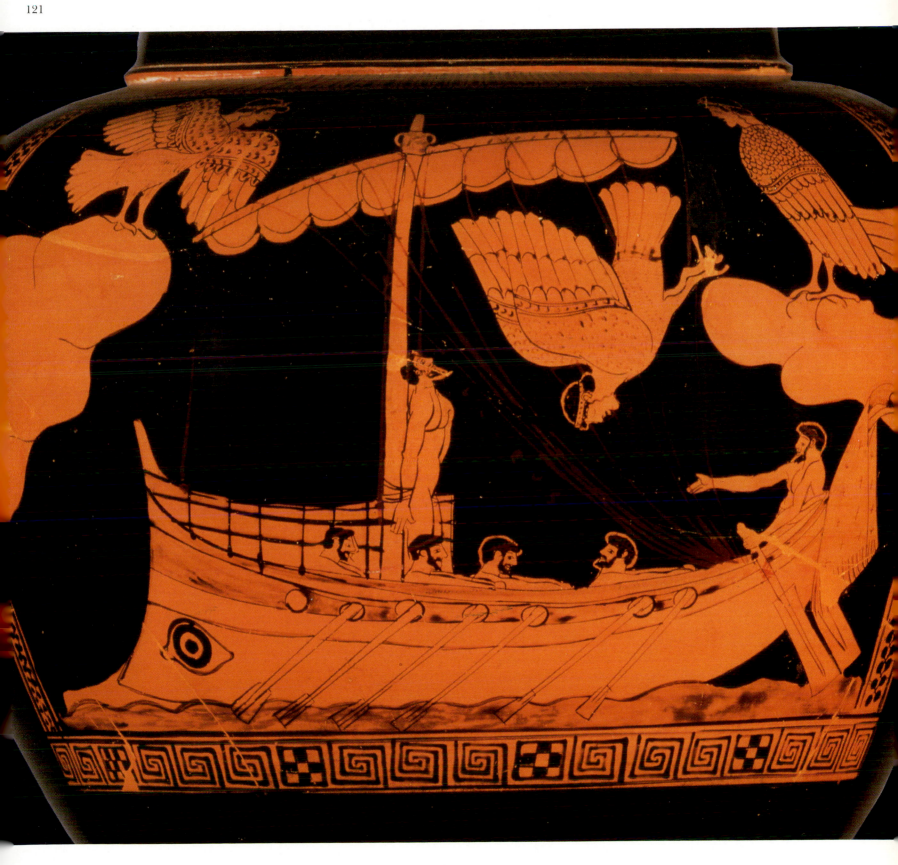

could be as large as 170, and there were also 30 officers, as well as specialist crew members and warriors. The oarsmen took up position in three rows corresponding to the three banks of oars. The men of the lower level were called *thalamitae* ("those that sit in the hold"), those in the middle *zygitae* ("those that sit on the thwarts") and those on the top bank *thranitai* ("benchmen"). The last seem to have been held in greater esteem than the others and to have enjoyed better rowing conditions. They at least had access to sunlight and air. Each oarsman carried his own oar, a cushion to sit on, and a twisted leather thong with which to tie his oar to the thole pin.

In the 5th century, scenes of ships on vases were not very numerous and were not used as a distinct form of decoration, as on 6th century black-figure vases. The 5th century scenes most commonly involve the narration of some episode or myth connected with the sea. At this period, entire ships are seldom depicted. Their presence is usually indicated by a prow, detached from the rest of the hull. What is possibly the only representation of a complete ship in Attic red-figure vase-painting is painted on a jar in the British Museum, dating from 490-480 B.C. (fig. 121).

The ship in question belongs to Odysseus, and the scene tells the story of his encounter with the Sirens, an episode from the Odyssey. Odysseus is shown tied to the mast of the boat, while his companions, heeding the advice of Circe, are rowing with their ears plugged with wax so as not to be enchanted by the singing of the Sirens. The scene depicts the moment when the Sirens, disillusioned at their failure to seduce Odysseus and his companions, are flinging themselves into the sea to drown. Two of them are on the rocks, watching the third as she falls with wings extended. The vase-painter's narrative is consistent with the belief held by many peoples of the world in sea goddesses who lie in wait

for sailors in distant oceans, to drive them insane and make them forget all thoughts of returning to their homelands; old tales that the sailors, on their return, brought to life in their accounts of their voyages on wild seas and their adventures with man-eating beasts that lurked to destroy them.

The same subject is portrayed in black-figure vase-paintings at the beginning of the 5th century. On a lekythos, Odysseus is shown listening to the singing, tied to the mast, which is here depicted in the form of a column (fig. 120). On another black-figure vase, an oinochoe (Stockholm, Throneholst Collection), Odysseus is approaching the island of the Sirens, tied to the mast of his ship, its sails swollen by the wind. His companions are rowing in great haste, while the Sirens sing and Odysseus listens enchanted: the inscriptions on the vase relating to the episode include the word "lyson" ("set me free"), which he is shouting to his companions.

Representations of Odysseus perpetuate the myth from late Geometric times onwards, at every period down to the present day. His adventures are rendered in clay, bronze, marble, carved both in the round and in relief, as well as in Medieval, Renaissance and modern paintings. They are also embroidered on cloth by daughters who, in the figure of Odysseus, are immortalizing the adventures of some seafaring hero from their family, unaware, perhaps, that they are continuing the Greek's journey over the centuries and his exploits on the sea.

Another mythological subject popular in Classical vase-painting is the expedition of the Argonauts. The abduction of Talos by the Argonauts is depicted on a red-figure volute krater. The Argo itself, a trireme, is indicated by only a part of the ship, the prow, and this in an idealized

*122. Argonauts and the Argo. Detail from an Attic red-figure krater. From Ruvo in southern Italy, 400-390 B.C. Ruvo, Jatta Collection 1501.*

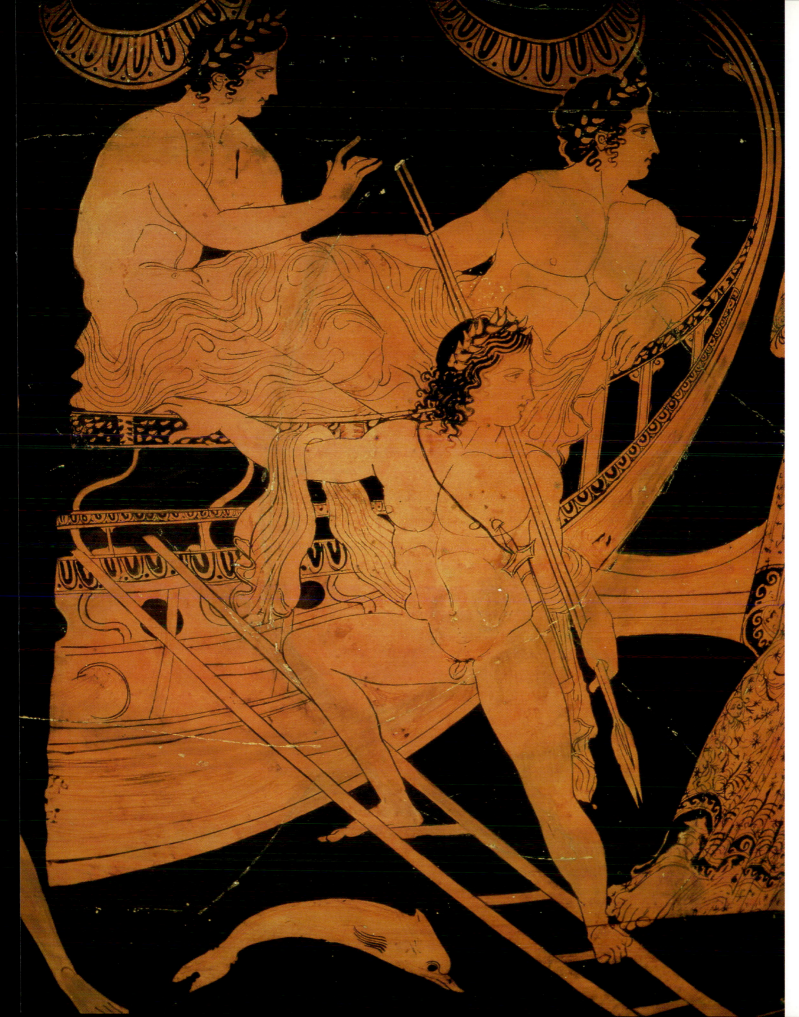

manner, while the figures are painted on a considerably larger scale than the ship (fig. 122).

At this period, idealistic art was interested in the human figure, and there was little space left for inanimate objects. The episode of the abduction thus covers the entire body of the vase, and includes seven of the main characters, while the portrayal of the ship is relegated to the area below the handle.

The same motif, the ship Argo, is engraved in bronze on a cinerary urn (fig. 123-124), a unique object at this period. Five characters are sitting or moving around the elevated prow of the ship, on which can be made out the ram in the form in which it is known in the following period.

The prow and stern of the ship, particularly the former, are also engraved on the coins of this period, in scenes which indicate the connection between various city-states and the sea (fig. 125-127). These coins, which are forerunners of the major series of Hellenistic coins depicting the *tetrereis* and *pentereis* (the words mean "four-fitted" and "five-fitted" respectively, though it is not clear what this means in practical terms) of Alexander the Great's successors, have portrayals of triremes from the end of the 5th and especially of the 4th century B.C. The series begins with a Cypriot stater, possibly from Kourion, which is dated to the late 5th century, with the goddess Athena seated on the prow of a trireme. The various features of the ship – figure-head, projecting beak and ram – can be made out in great detail on this coin. The goddess Athena inaugurates a series of coins on which a seated female figure, a goddess or a nymphe, leads the ships – guiding the ships of Kios to the Black Sea, or those of Histiaia and Phaselis to the eastern end of the Mediterranean.

Athenian triremes were also depicted in marble by the sculptors of the period (fig. 129-

131), who rendered as fully as possible the oarsmen and captains, the passengers or warriors, and the parts of the ship.

Athenian warships are portrayed in votives discovered in ancient sanctuaries, on the Acropolis (fig. 128), or at the sanctuary of Demeter at Eleusis, at the period when the Athenians ruled the Aegean. And whereas on their vases they painted their legendary seafaring forerunners, in marble they immortalized in minute detail the

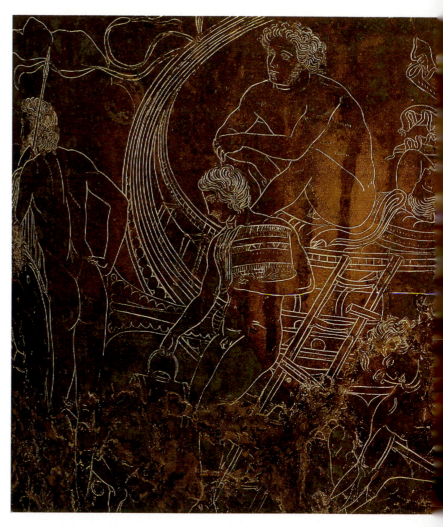

**123.** *Detail of fig. 124.*

**124.** *Bronze urn, known as the Cista Ficoroni, with incised scenes depicting episodes from the expedition of the Argonauts, a unique example of metal-work. From Praeneste in Italy, c.330 B.C. Rome, Villa Giulia 24787.*

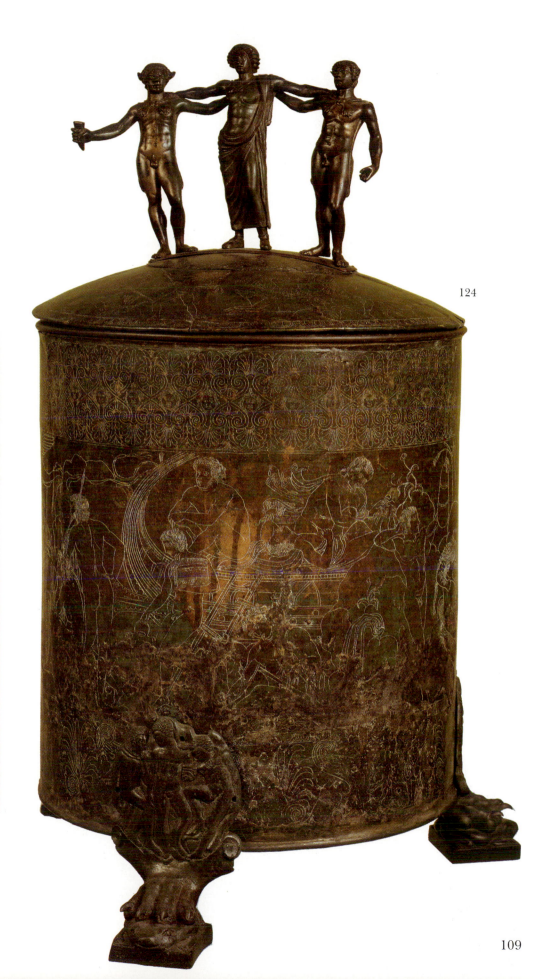

123

124

109

ships that took them to their naval supremacy, thanks to which they succeeded in becoming the leading power in the Greek world.

The Lenormant relief depicts the central section of a trireme with nine oarsmen rowing at speed and gliding over the sea, with the captain and a number of passengers on the deck (fig. 130). We may here have one of the sacred ships of the Athenian state, or one of the ships called "lucky trireme", "mightiest" and "general". A figure at the end of the trireme is restored by the experts as Paralos, the mythical pioneer of seafaring who gave his name to one of the Athenian sacred ships, and whose sanctuary was in the Piraeus. The movement of the oars of the trireme is rendered on the marble in a way that suggests that the ship is moving over the sea with a fixed rhythm, just as in other preserved fragments of dedications. On a two-sided relief from Eleusis, the movement of the oars is even more dynamic, with the three banks, one behind the other, working up the speed with which they are ploughing the sea (fig. 129).

If Classical vase-painting has given us the ancestral myths of the Athenians and votives portray the glorious Athenian triremes, funerary reliefs bring us close to those who were lost in battles at sea, or who were snatched away to the wild depths of the ocean. The Athenian trireme is invariably to be found in these reliefs – amongst them the stele of Demokleides, son of Demetrios (fig. 131). The ship is sometimes depicted in its entirety, overturned in the middle of the sea, and sometimes only the prow is rendered, with its decorative elements, the yardarm, projecting beak and ram, forming a trident that was probably responsible for the death of the sailor, when the trireme collided with the enemy ship and transfixed its hull. Their souls continued their journey in Charon's skiff, their destination the Elysian fields and

*125. Silver stater of the city of Phaselis in Lycia with a scene of the stern of a trireme. 400-330 B.C. Mykonos, Aegean Nautical Museum.*

*126. Silver stater of Byblos in Phoenicia with a Phoenician trireme, the figure-head of which is in the shape of a horse's head. 348-340 B.C. Mykonos, Aegean Nautical Museum.*

125

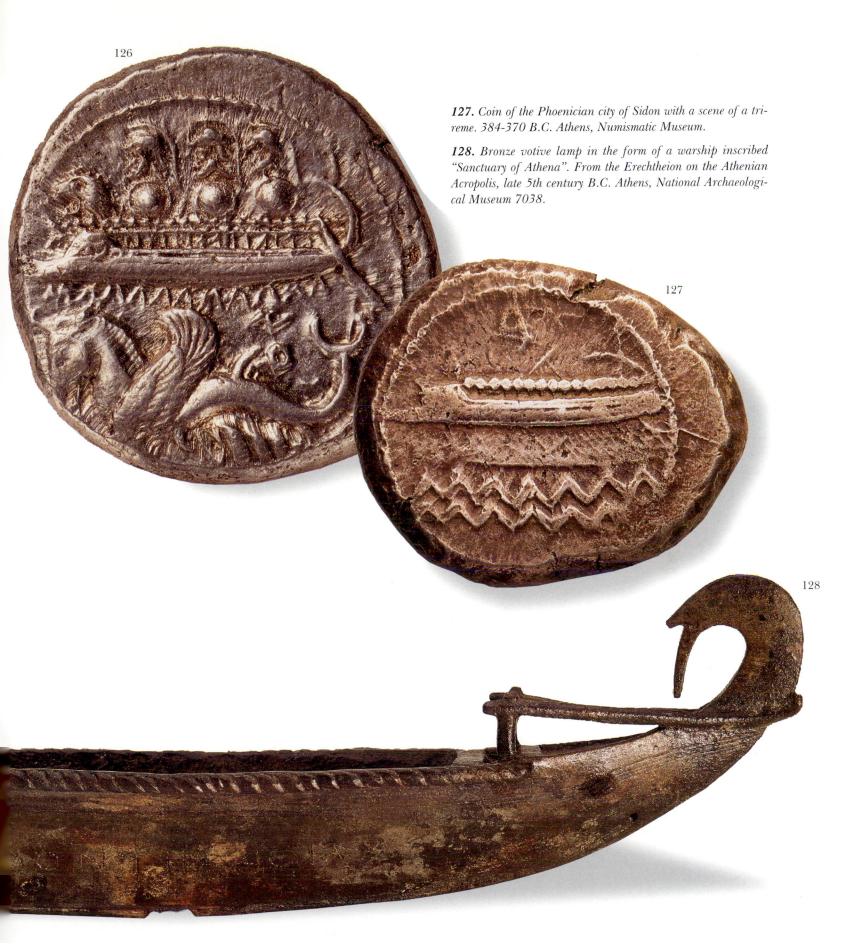

**127.** *Coin of the Phoenician city of Sidon with a scene of a trireme. 384-370 B.C. Athens, Numismatic Museum.*

**128.** *Bronze votive lamp in the form of a warship inscribed "Sanctuary of Athena". From the Erechtheion on the Athenian Acropolis, late 5th century B.C. Athens, National Archaeological Museum 7038.*

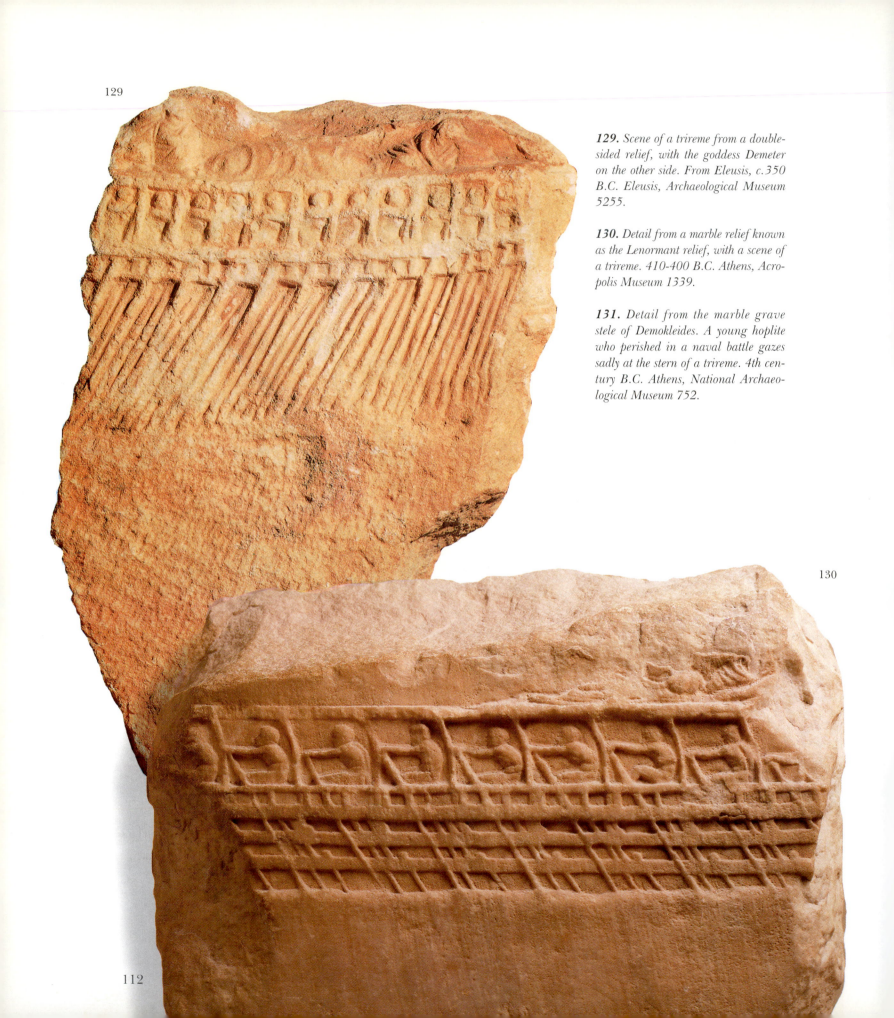

**129.** *Scene of a trireme from a double-sided relief, with the goddess Demeter on the other side. From Eleusis, c.350 B.C. Eleusis, Archaeological Museum 5255.*

**130.** *Detail from a marble relief known as the Lenormant relief, with a scene of a trireme. 410-400 B.C. Athens, Acropolis Museum 1339.*

**131.** *Detail from the marble grave stele of Demokleides. A young hoplite who perished in a naval battle gazes sadly at the stern of a trireme. 4th century B.C. Athens, National Archaeological Museum 752.*

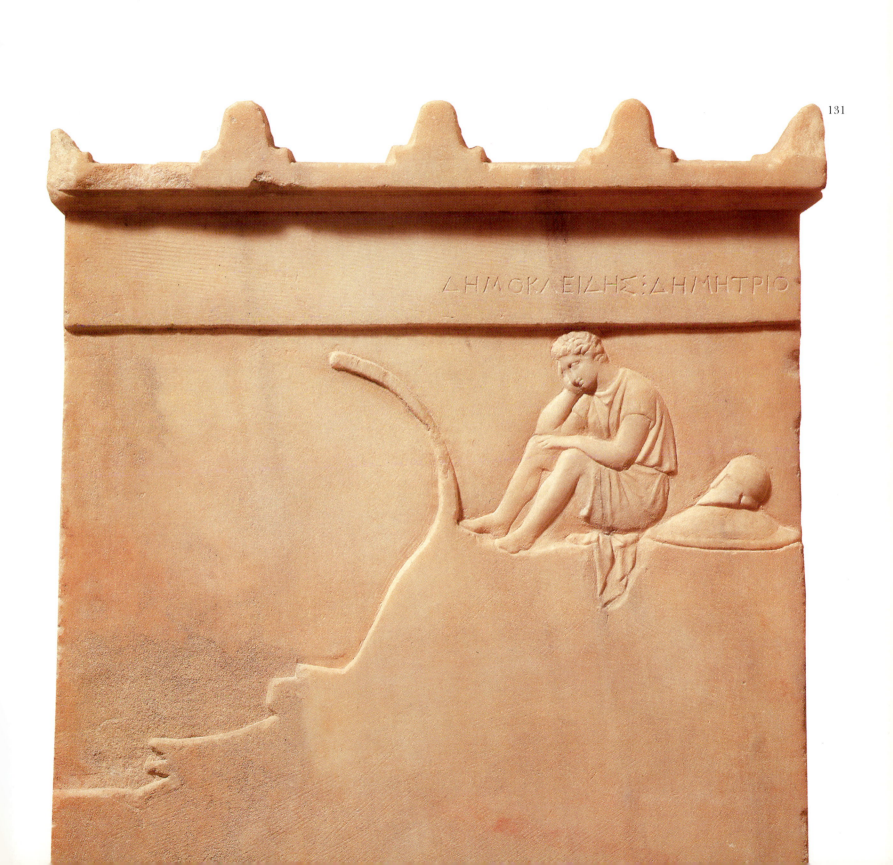

their guide the god Hermes, the escorter of souls (fig. 132-133).

At this period, the main type of ship portrayed in the various representations on vases, sculptures and coins is the trireme, the warship that played a leading role in the creation of the Athenian hegemony. These scenes are so beautiful that they completely justify the Athenian citizen who, when asked where he came from, replied, according to Aristophanes (*Birds*, 108) that he came "from the city that produces beautiful triremes."

**132.** *White lekythos by the Sabouroff painter. Hermes, the escorter of souls, leads a female figure to Charon's skiff, to bring her to Hades. Second half of the 5th century B.C. Athens, National Archaeological Museum 1926.*

**133.** *Drawing of a white lekythos by A.Kontopoulos. Charon's skiff carries a child over the river Acheron, while its parents await on the opposite bank. About 420 B.C. Athens, National Archaeological Museum 16463.*

# The Ships of Alexander the Great at the End of the World

The 4th century B.C., which foreshadowed the Hellenism of the three continents, was the century of the overseas successes of the Greek powers. This period was dominated by the Macedonian kings, first Philip II, followed by Alexander the Great. Despite the conflicts between the city-states of Greece, these rulers attempted to bring reconciliation to the Greeks, so that they could follow a shared destiny.

With the conquest of Asia and Africa by Alexander the Great, the eastern Mediterranean became literally a Greek sea. The great warrior-king reached the banks of the Indus river and carried Greek civilization to the ends of the then known world. The many ships he built sailed along the coast of India, under their admiral Nearchos, and reached the Persian Gulf. Over the course of the centuries, Indian, Persian and Arab merchants travelled between the Persian Gulf and India by the same route first opened up by Nearchos, who covered 1,000 miles in five months. Nearchos's log was so detailed that it could be used by any captain who wanted to sail along this route. At the same period, Pytheas of Massalia, like his compatriot Euthymenes, sailed into the Atlantic ocean and reached the British isles and the island of Thule. He gave an account of his great voyage, with comments, in his book *Ges periodos* ("Tour of the world"), which was for centuries the only source for the navigation of these seas.

Pytheas also accurately calculated the positions of the north pole and Massalia, and investigated the connection between the moon and tides.

A major feature of the Hellenistic period, however, was the creation of Greek cities by Alexander himself on his campaign to the east, beginning with Alexandria in Egypt (fig. 136) and ending with Alexandria Eschate in Sogdiane.

*134-135. Didrachms of Leukas with a scene of the prow of a warship. After 167 B.C. Athens, Numismatic Museum.*

The entire world was hellenized at this period and formed a continuous zone stretching from the western Mediterranean to India and from Crimea to the fringes of Arabia, Nubia and the Sahara. Trade was conducted with Carthage, Ethiopia, Arabia, India, China, Scythia and the Balkan hinterland.

After the death of Alexander the Great, in 323 B.C., this new, mighty empire was divided into three parts by his successors, the Diadochi: Antigonos took Greece and Macedonia, Ptolemy Egypt, and Seleukos Asia Minor and Syria. Although one would have expected Ptolemy to make himself master of the sea, with Egypt becoming the leading naval power, it was in fact Antigonos who, after a long interval, became "lord of the seas".

The rivalry and conflicts between the Successors led to the construction of ever larger ships. For half a century, these warships struggled for domination of the sea and control of the eastern Mediterranean. In 360 B.C., Antigonos's son, Demetrios Poliorketes, won a comprehensive victory in a naval battle against the Ptolemaic fleet for control of Salamis in southern Cyprus. For two decades, Demetrios was master of the seas. When he was obliged by political conflicts to return to Greece, however, the baton passed to the Ptolemies and the Egyptian fleet.

Although the struggle for supremacy by the military fleets was unending, trade became richer at this period. The ports of the Mediterranean were redesigned to cope with the new, larger ships. None of them, however, could compete with the harbour of Alexandria, which had the capacity to play host to 1,200 ships, while others could anchor in the open sea, waiting their turn to unload their merchandise.

Egypt thus became the supplier of the Mediterranean world in this period, with Alexandria a key port in the carrying trade from Asia and Africa to Europe. Myrrh and ivory were transported from Arabia and Somalia, while India supplied cosmetics and spices, cinnamon and pepper.

The movement of so great a quantity of goods over such large distances required ships of large capacity, ranging from 250 to 1,000 tonnes and larger. Merchant vessels, some of them decorated with figures carved at the ends, carried not only goods, but also passengers and merchants who travelled from market to market. These ships sailed from Alexandria to Tyre, Sidon, Ephesos, Gaza, Byblos, Rhodes and other ports, and travelled as far as the easternmost point of the great Mediterranean sea.

In the West, meanwhile, a new state was testing its naval strength at this period. About 200 B.C., its warships were ready to follow the course of the Greek ships in the East. This state was Rome, which was destined to dominate the Mediterranean in the following centuries.

With the emergence of ever larger and ever more powerful states, the form of the world gradually changed, and its scale departed from the Classical mean of the previous period. The area over which both goods and ideas travelled increased, and the new roads, on both land and sea, became ever longer. In consequence, the means of transport were also adapted to this new scale.

The ships of this period were larger, broader and heavier. A variety of needs led to the building of new types of ship from as early as the 4th century B.C. *Tetrereis, pentereis, heptereis* ("seven-fitted") and *octereis* ("eight-fitted") made

*136. The personification of Alexandria, mosaic floor by the artist Sophilos. A female figure holds a mast and a yardarm and is crowned with a diadem in the shape of a boat, probably a copy of the "Alexandris", the ship sent by Hiero II to the Ptolemies. From Thmuis, 2nd century B.C. Alexandria, Greco-Roman Museum.*

their appearance on the seas of the Mediterranean, which were dominated by the Greeks and the Carthaginians. An *octeres*, which had 1,600 oarsmen, had a crew ten times greater than that of the triremes and could carry 1,200 soldiers.

The first appearance of the galley (a *tetreres*), a type of ship that was to dominate the seas for centuries, was a landmark in the history of the ship in the Mediterranean. Aristotle considers the invention of this ship to have been the work of the Carthaginians, while Diodorus Siculus attributes it to Dionysios of Syracuse, who was obliged to construct the earliest *tetrereis* and *pentereis*, in order to counter the hostile raids of the Carthaginians. This type of ship was slow to be adopted on the seas of the Mediterranean, but the continuing confrontations between states led to its acceptance. Thereafter progress was swift from *pentereis* to *hexereis* ("six-fitted"), then to *octereis*, and eventually to *dekahexereis* ("sixteen-fitted") and the super-galleys of the admirals of the fleet. At the battle of Salamis on Cyprus, in 306 B.C., Demetrios Poliorketes had seven *heptereis* and ten *hexereis*, while in 301 B.C. at Issus he had *enneakontereis* ("nine-fitted") and *dekatriereis* ("thirteen-fitted"), and in 288 B.C. he also had a *dekapentereis*

137

("fifteen-fitted") and a *dekahexereis*. At the same period, his rival, Lysimachos, master of the northern Aegean and Thrace, had the *Leontophoros* built at Herakleia Pontica.

The *Leontophoros* is known from a fragment of the Greek historian Memnon, who wrote a history of Herakleia in the imperial period; it was an *octeres* with 100 oarsmen in each bank, making 800 on each side of the ship and a total of 1,600. It also had a large area in the prow to house 1,200 warriors and two helmsmen. Another general, Antigonos Gonatas, the son of Demetrios and king of Macedonia, deployed a flagship against Ptolemy II, the *Isthmia*, at the battle of Kos in 258 B.C. This super-galley was built to replace the flagship *Leontophoros*, which had ended in Ptolemy's hands after his victory over Antigonos in 280 B.C. Antigonos defeated his foe and the super-galley was dedicated as "sacred ship" to Delian Apollo. The large Monument of the Bulls on Delos is a structure specially designed to support a ship, and was probably the base on which the dedication was placed. A third ship mentioned in the sources for this period is the *Syrakosia naus*.

This was built by Hieron II, tyrant of Syracuse (270-216 B.C.), to a design by Archias of Corinth. The colossal size of this ship can be

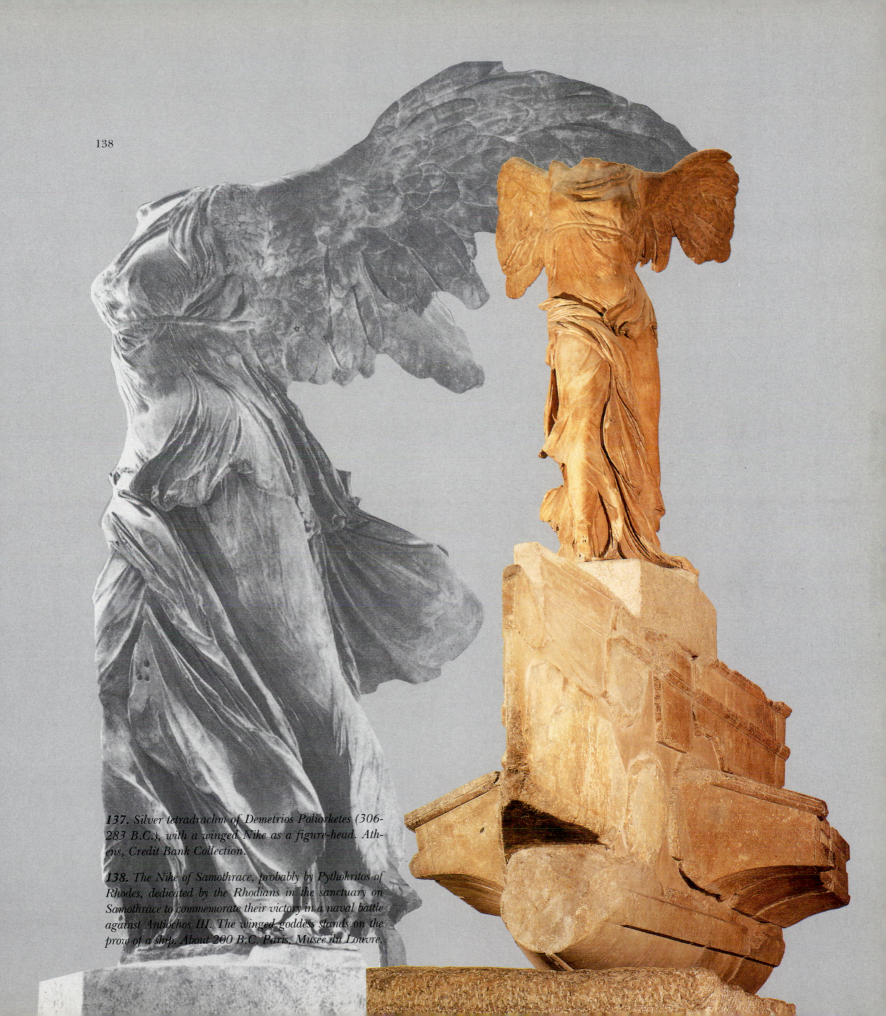

138

137. *Silver tetradrachm of Demetrios Poliorketes (306-283 B.C.), with a winged Nike as a figure-head. Athens, Credit Bank Collection.*

138. *The Nike of Samothrace, probably by Pythokritos of Rhodes, dedicated by the Rhodians in the sanctuary on Samothrace to commemorate their victory in a naval battle against Antiochos III. The winged goddess stands on the prow of a ship. About 200 B.C. Paris, Musée du Louvre.*

inferred from the fact that enough timber was used in its construction to build 20 triremes. The ship had 33 cabins, a large number of other rooms, including restaurants, a huge lounge, libraries, a gymnasium, gardens and baths. The storage space for goods is reckoned to have been 5,200 cubic metres. There were also machines and military defensive and offensive equipment on board. Its huge size – over 100 m long – caused problems in the harbours, since it could not draw alongside the jetty.

This series of super-galleys includes one more ship, that is said to have been made for Ptolemy IV (221-203 B.C.). This had 40 banks of oars (*tessarakontereis*), was 130 m long and 25 m high, had 4,000 oarsmen, 2,850 sailors and 400 officers.

Despite all these attempts to dominate through sheer size, the most successful ships in naval battles were the *pentereis, tetrereis* and triremes. The island of Rhodes, which had developed into a major shipping centre with a notable military fleet, had mainly triremes and *pentereis* – swift, manoeuvrable ships that were capable of dealing with the pirates of the Mediterranean. The latter, who polluted the seas, also travelled in small ships, mainly in the "light pirate boats" that the Rhodians destroyed with their light, undecked ships of war.

The enormous warships that sailed the seas naturally influenced the artists of this period. For the first time in the history of art, monuments with prows or sterns of ships carved in the round were erected at various sanctuaries and maritime cities to commemorate a victory, or as dedications to some god made by the triumphant victors of a naval encounter. These monuments, carved in

*139. A Rhodian trireme carved in the rock of the acropolis of Lindos by Pythokritos, one of the greatest sculptors of the Hellenistic period. About 200 B.C.*

relief as well as in the round, are accurate models of the ships of the period.

The famous Victory of Samothrace is regarded as one of the most outstanding sculptures of the Hellenistic period, alongside the altar at Pergamon and a number of other works. The statue of winged Victory (fig. 138) standing on the prow of a ship was undoubtedly dedicated to the gods to immortalize an important historical event, possibly the victory of the Rhodians in the naval battle against Antiochos III of Syria. The Victory of Samothrace recalls depictions on the coins of Demetrios Poliorketes (fig. 137, 154) in which a Victory (Nike) holding a trumpet is seated on the end of the prow.

Portrayals of prows and sterns are preserved carved on altars or in sanctuaries that overlook the sea. Marble models of ships are known from Rhodes, Carthage, Cyrrhenia, Sperlonga in Italy (fig. 141), and Rome. A Rhodian trireme was carved in minute detail on a rock at Lindos by Py-

thokritos of Rhodes (fig. 139). In the Tower of the Winds in Athens, built in the second half of the 1st century B.C., the south-west wind, *Libas*, is leaning on the stern of a *tetreres*, to indicate that he is a favourable wind for boats (fig. 140).

Pictures of ships have been immortalized on coins by Greek islands and maritime cities such as Leukas, Arados, Demetrias, Tyre, Histiaia, Phaselis and Sidon, and the successors of Alexander the Great used coins to proclaim their naval victories (fig. 134-135, 148-155).

The wilder aspect of the sea could not be avoided, however, even with these enormous ships. Many sailors were lost, either in military conflict or as they travelled with their merchandise. The adventure of the lost seafarer or warrior was depicted on marble grave stones by their relatives (fig. 145-147). These funerary stelai record the history of the sea in the huge Greek realm. And those who were lost had Greek names, such as Demetrios, Archilochos,

140   141

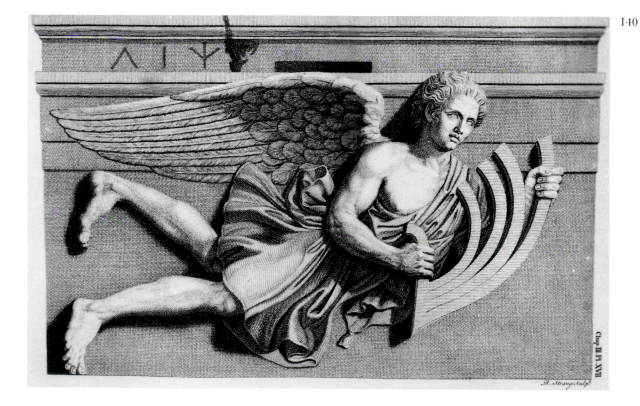

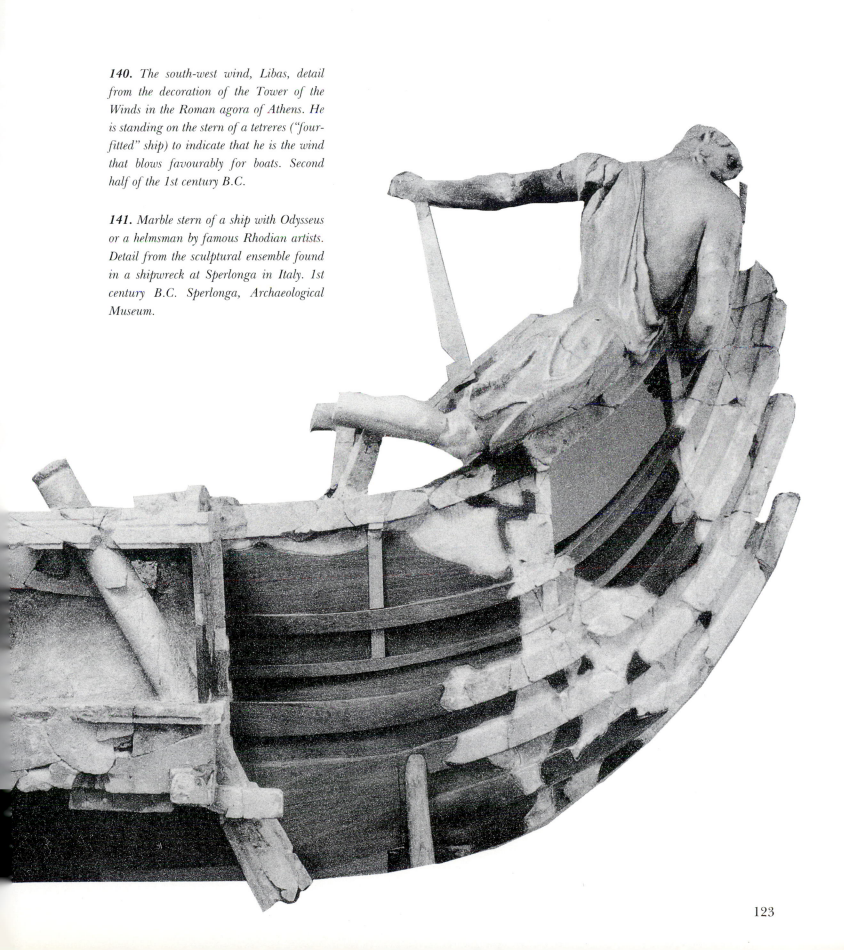

**140.** *The south-west wind, Libas, detail from the decoration of the Tower of the Winds in the Roman agora of Athens. He is standing on the stern of a tetreres ("four-fitted" ship) to indicate that he is the wind that blows favourably for boats. Second half of the 1st century B.C.*

**141.** *Marble stern of a ship with Odysseus or a helmsman by famous Rhodian artists. Detail from the sculptural ensemble found in a shipwreck at Sperlonga in Italy. 1st century B.C. Sperlonga, Archaeological Museum.*

Demokleides or Panaretos, like the ones pre-
served in the nautical tales recorded by the
authors of that period.

The ship as icon plays an important role in
the art of the Hellenistic period (fig. 142). Rhyta,
the ritual vessels of the period, are transformed
into ship's prows, with every detail meticulously
rendered (fig. 159). Other vases may have scenes
depicting some Greek myth connected with the
sea (fig. 156), showing the heroes gathered
around a prow or a stern. Artists of the period
drew inspiration from the shape of the ship or
small boat, and made elegant women's jewellery,
mainly earrings, from gold, silver or gilded clay
(fig. 157-158).

The decoration of some of the houses on
Delos could be regarded as a naval anthology.
The most interesting is perhaps the highly
accurate portrayal by an artist of the period of
various types of ships in the house of Dionysos
(fig. 143-144). His aim was probably not to
create a work of art, but rather to make a
realistic record of the hulls of the ships, their
masts and sails, their prows and sterns, and
their many oars.

In the nautical stories of the period, the
seafaring forebears of the Greeks returned, and
the myths of the sea were revived, speaking of
the eternal youth of Odysseus.

*142. Clay model of a warship with elevated prow and stern,
making it look like a bird. From Ardea, 270-250 B.C. Paris,
Musée du Louvre.*

**143-144.** *Graffiti of ships from the House of Dionysos on Delos. 1st century B.C.*

**145.** *The upper part of a grave stele with a scene of a merchant ship. Two oarsmen and the helmsman can be seen. From Athens, Hellenistic period. Athens, National Archaeological Museum 3240.*

**146.** *Inscribed marble votive stele with a scene of a warship and a young man seated on a rock remembering the moment of the shipwreck. From Reneia near Delos, late 2nd-early 1st century B.C. Athens, National Archaeological Museum 1313.*

**147.** *Inscribed marble grave stele with a scene of a warrior standing on the prow of a warship. From Reneia near Delos, Hellenistic period. Athens, National Archaeological Museum 1294.*

143

144

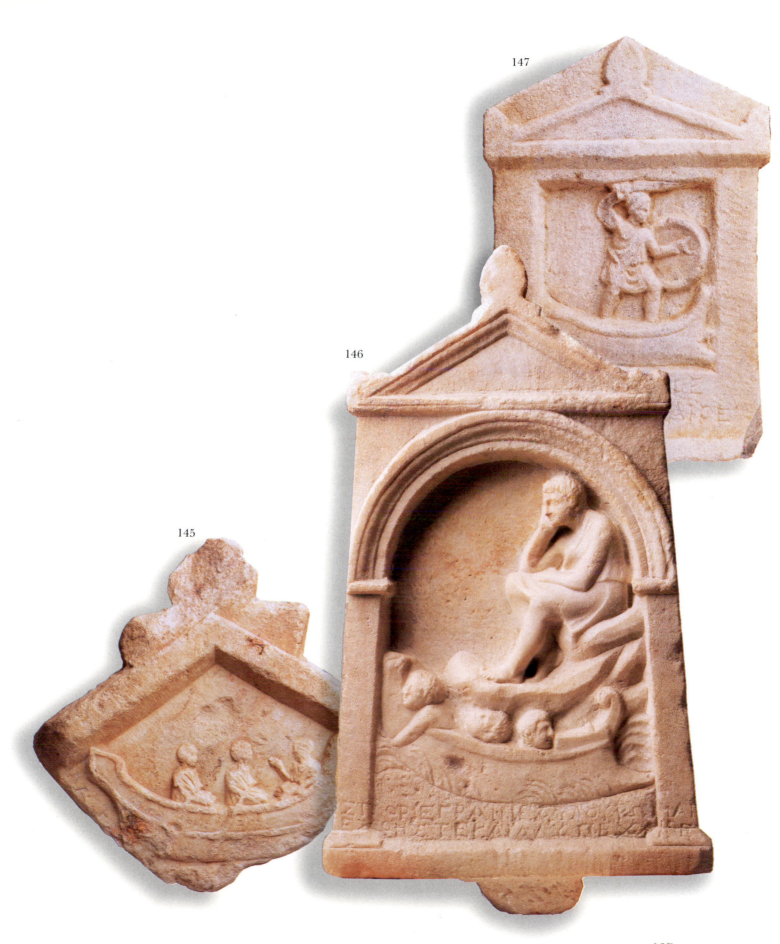

147

146

145

127

**148.** *Didrachm of Leukas with a scene of the prow of a warship. After 167 B.C. Athens, Credit Bank Collection.*

**149-150.** *Triobols of Macedonia, period of Philip V (221-179 B.C.) and Perseus (179-168 B.C.), with a scene of the prow of a warship. Athens, Credit Bank Collection.*

**151.** *Silver tetrobol of Histiaia with the stern of a ship on which sits the nymph Histiaia holding a naval standard. 3rd century B.C. Athens, Credit Bank Collection.*

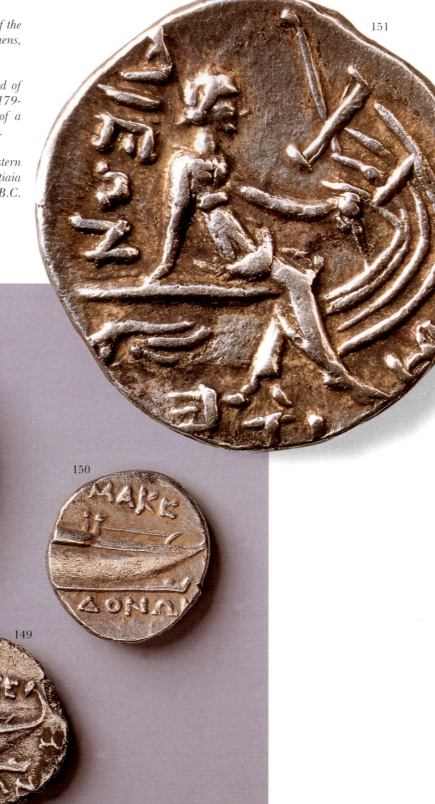

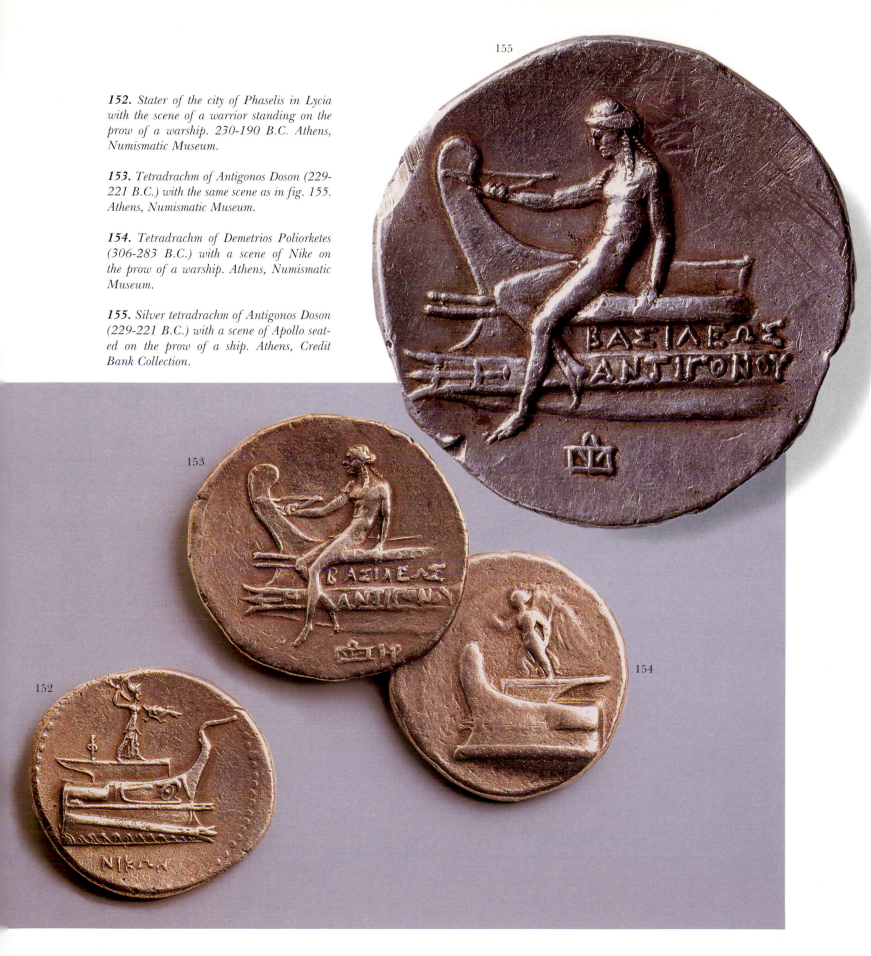

**152.** *Stater of the city of Phaselis in Lycia with the scene of a warrior standing on the prow of a warship. 230-190 B.C. Athens, Numismatic Museum.*

**153.** *Tetradrachm of Antigonos Doson (229-221 B.C.) with the same scene as in fig. 155. Athens, Numismatic Museum.*

**154.** *Tetradrachm of Demetrios Poliorketes (306-283 B.C.) with a scene of Nike on the prow of a warship. Athens, Numismatic Museum.*

**155.** *Silver tetradrachm of Antigonos Doson (229-221 B.C.) with a scene of Apollo seated on the prow of a ship. Athens, Credit Bank Collection.*

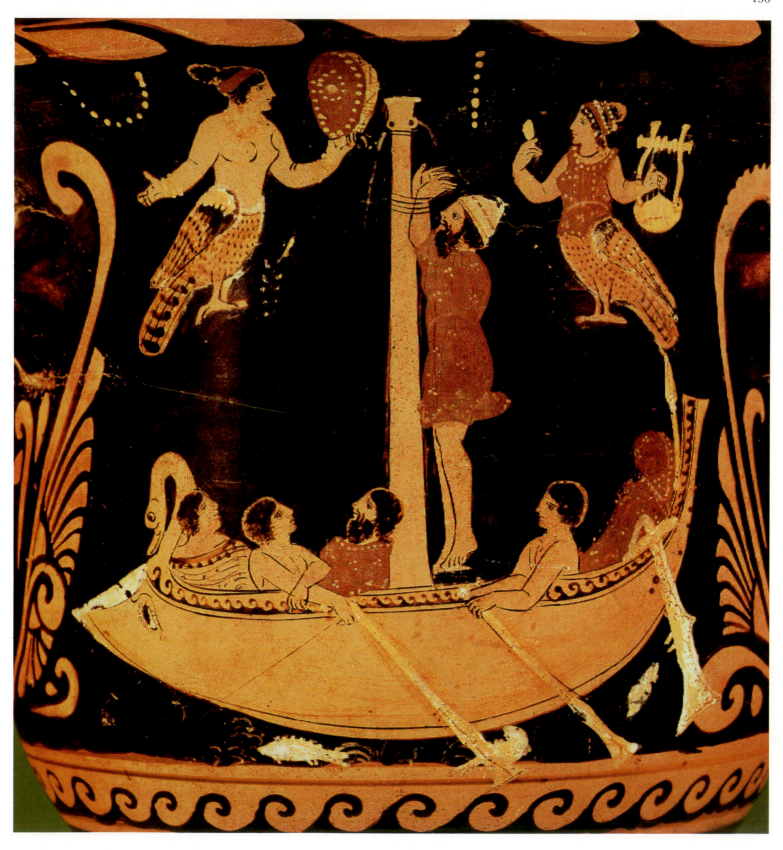

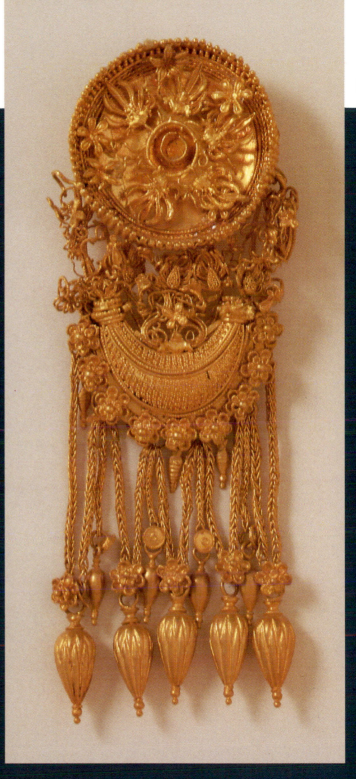

**156.** *The episode of Odysseus and the Sirens, detail of a red-figure amphora. From Paestum, c.330 B.C. Berlin, Staatliche Museen-Antikensammlung.*

**157.** *Gold earrings in the shape of a ship, richly decorated. From*

*Thessaly, 4th century B.C. Volos, Archaeological Museum.*

**158.** *Gold earring with a disc from which hangs an ornament in the shape of a ship. From Derveni in Macedonia, late 4th century B.C. Thessaloniki, Archaeological Museum.*

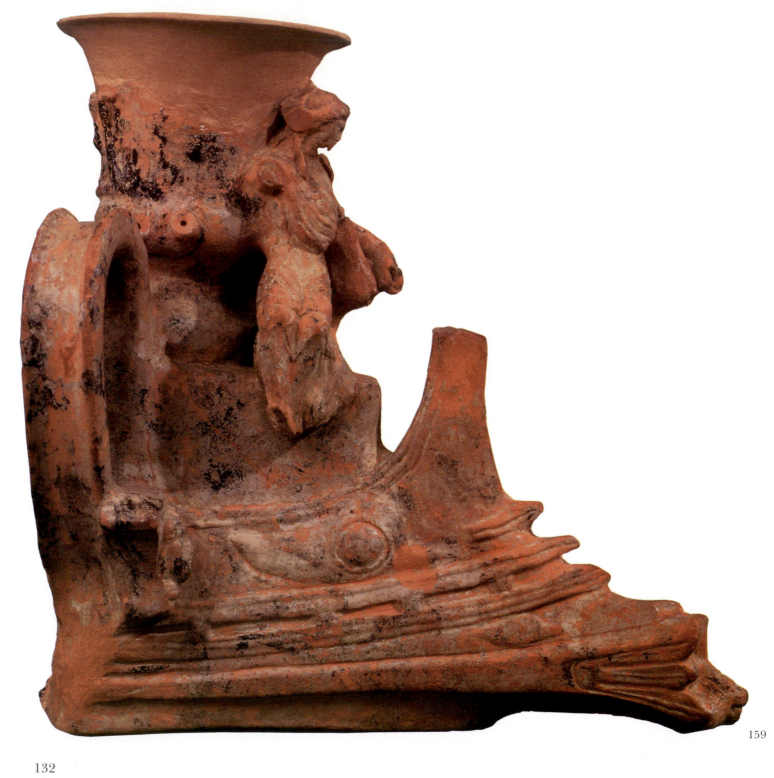

159

132

# ROMAN GALLEYS AND THE IMPOSITION OF THE PAX ROMANA

When the Roman fleet sailed into the eastern Mediterranean in 200 B.C., Rome was already a major naval power. Originally a nation of farmers and soldiers, the Romans had gradually conquered the peoples around them through their army – first the mountain-dwellers of the Apennines, and then the Greeks of southern Italy. At this time, the Mediterranean was dominated by Alexander the Great's successors in the east and the Carthaginians, descendants of the Phoenicians, in the West. The Carthaginians had founded a naval empire based on north Africa, with ports from Tangiers to Tripolis on the coast of Libya, and extending as far as Spain, and they controlled the straits to the Atlantic ocean (Gibraltar) and the large islands of Sicily, Sardinia and Malta.

Rome was powerless against the might of the Carthaginians at this time. She did not own a single ship until 311 B.C., when the Senate decided, for the first time, to equip two fleets of 10 ships to counter the pirates active along the coasts in their sphere of influence. The naval history of Rome at this period was a succession of failures. The problem was solved by transferring the soldiers of the army to the sea. Down to 264 B.C., however, the Roman state did not own a single warship of any importance.

The conflict between Rome and her rival and mighty sea-power, the Phoenician city of Carthage, opened with a descent by the Roman army on Sicily in 260 B.C. and lasted for 23 whole years. The cities in the interior of the island adhered to the military forces of Rome out of fear, while the coastal cities remained true to the Carthaginians, out of a similar fear of the latter's fleet.

In 311 B.C. the Senate passed a vote calling upon the Romans to acquire 100 *pentereis* and 20 triremes within two months, realizing that otherwise they would be defeated in their

*159. Rhyton in the shape of a warship. From Vulci, Hellenistic period. British Museum D 201.*

military ventures, since they possessed neither the sailors to man the ships, nor the knowledge to construct them. The Greek cities of southern Italy at this time were familiar only with the old methods of shipbuilding and had not hitherto constructed *pentereis* which were the backbone of the Carthaginian fleet. Fortune, however, was to assist the Romans to find a model for their ships when they captured a Carthaginian *penteres* in the straits of Messene. Within the space of a century after this event, Rome had made herself master of the western Mediterranean. Peasants were compelled to serve on the new military weapon, since no trained crews existed.

In June, 260 B.C., 120 Roman ships set sail for Sicily. Thanks to an anonymous inventor, they were equipped with a revolutionary machine: a suspension bridge, operated by an engine, was able to link one ship with another and thus transform a sea-battle into an infantry encounter.

**160.** *Silver denarius of the Roman Republic (114-113 B.C.) with a scene of a ship with a row of oars and a bridge upon it, for fighting aboard ship. Athens, Numismatic Museum.*

**161.** *Silver denarius of the Roman Republic (108-107 B.C.) with a scene of a warship. Athens, Numismatic Museum.*

**162.** *Silver denarius of the Roman Republic (32-31 B.C.) with a scene of a tetreres ("four-fitted" ship). Two towers and warriors can be seen on the bridge, with the captain standing in the stern and the helmsman at the lowest level of oarsmen. Athens, Numismatic Museum.*

**163.** *Silver denarius of Q. Nasidius (44-43 B.C.), Pompey's admiral, with a scene of a naval battle. Naples, National Archaeological Museum 3016 FR.*

**164.** *Bronze coin of the Roman Republic with a scene of the prow of a ship, copying the coins of the Hellenistic kings. Middle of the 2nd century B.C. Athens, Numismatic Museum.*

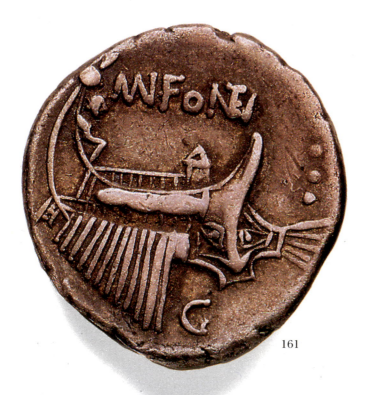

161

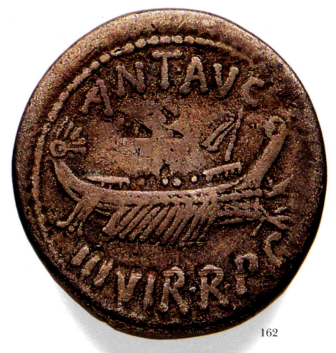

162

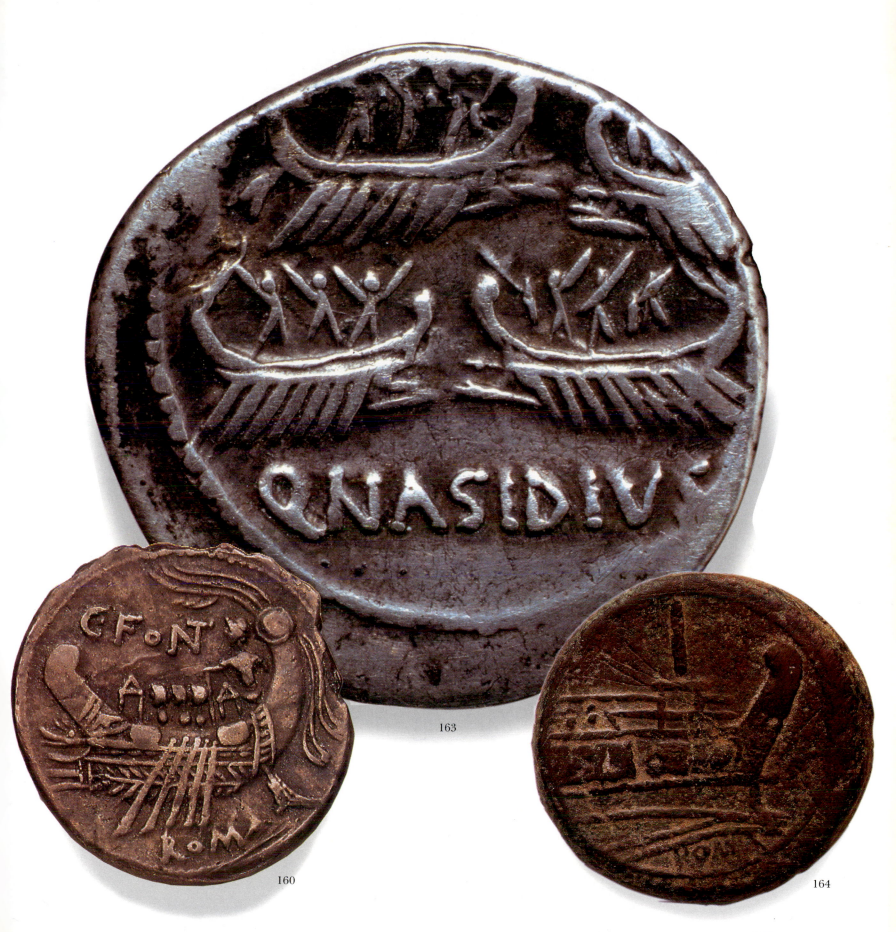

163

160

164

135

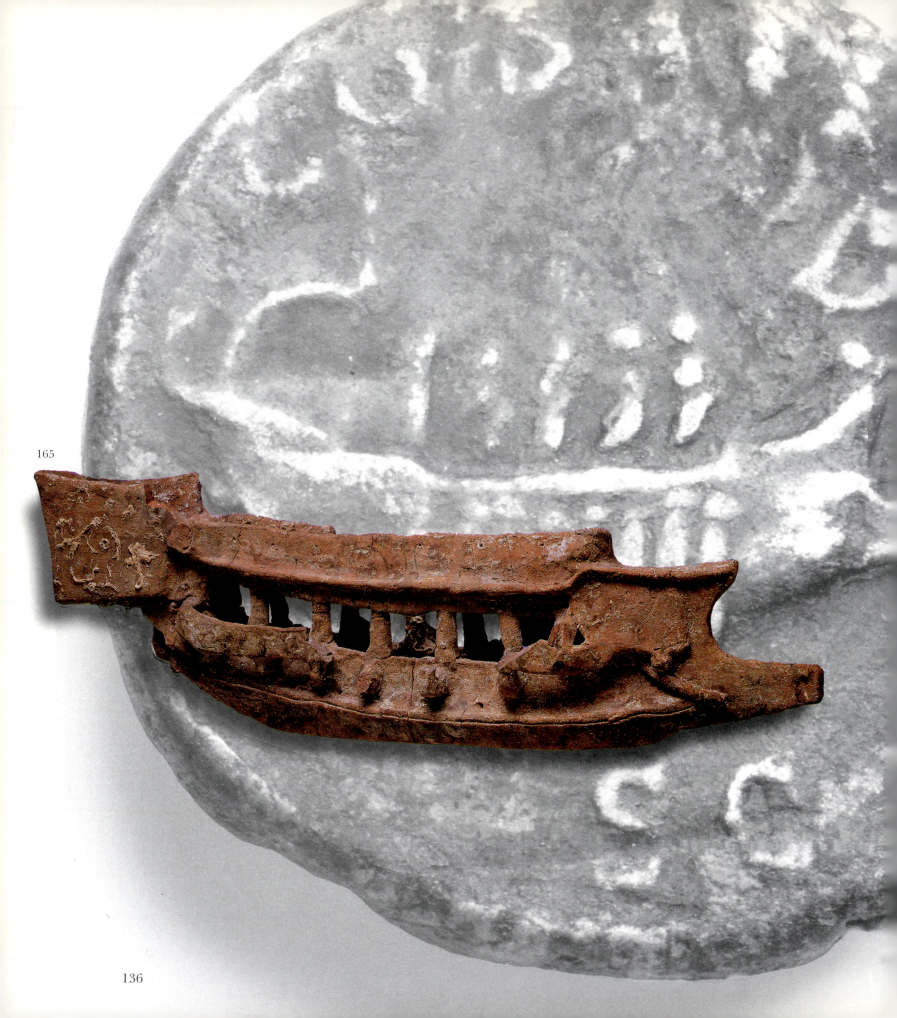

165

136

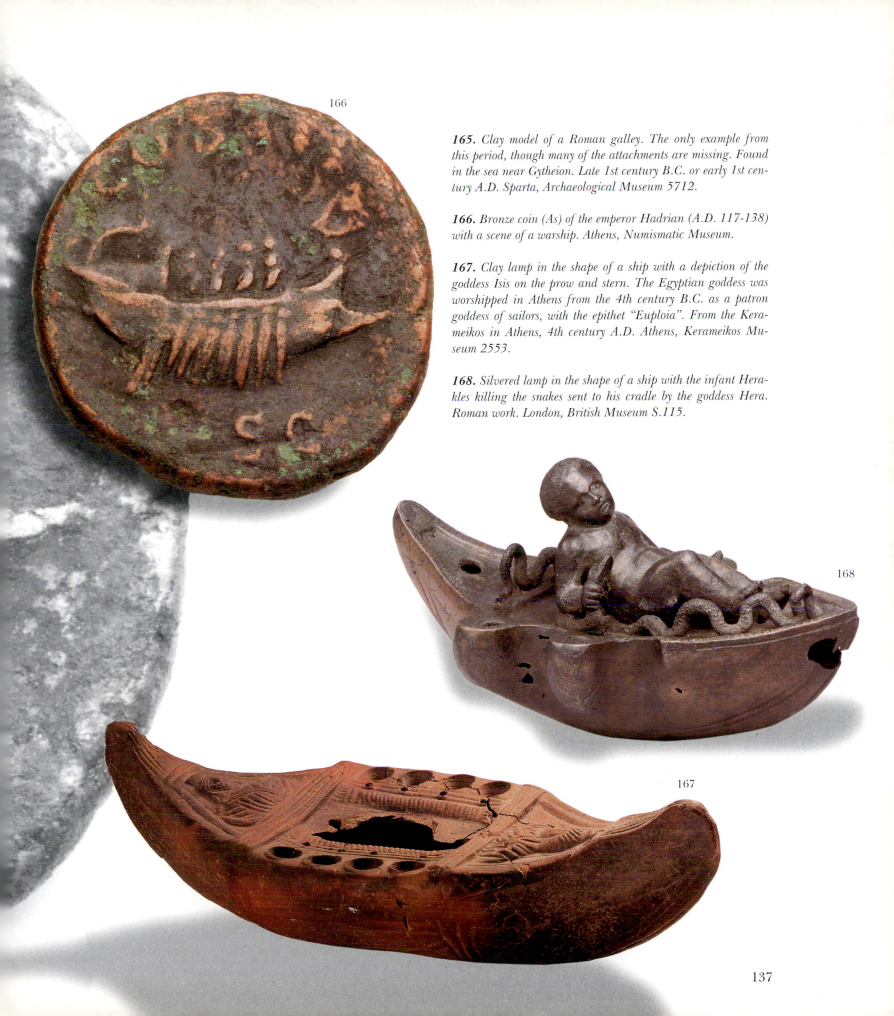

**165.** *Clay model of a Roman galley. The only example from this period, though many of the attachments are missing. Found in the sea near Gytheion. Late 1st century B.C. or early 1st century A.D. Sparta, Archaeological Museum 5712.*

**166.** *Bronze coin (As) of the emperor Hadrian (A.D. 117-138) with a scene of a warship. Athens, Numismatic Museum.*

**167.** *Clay lamp in the shape of a ship with a depiction of the goddess Isis on the prow and stern. The Egyptian goddess was worshipped in Athens from the 4th century B.C. as a patron goddess of sailors, with the epithet "Euploia". From the Kerameikos in Athens, 4th century A.D. Athens, Kerameikos Museum 2553.*

**168.** *Silvered lamp in the shape of a ship with the infant Herakles killing the snakes sent to his cradle by the goddess Hera. Roman work. London, British Museum S.115.*

166

168

167

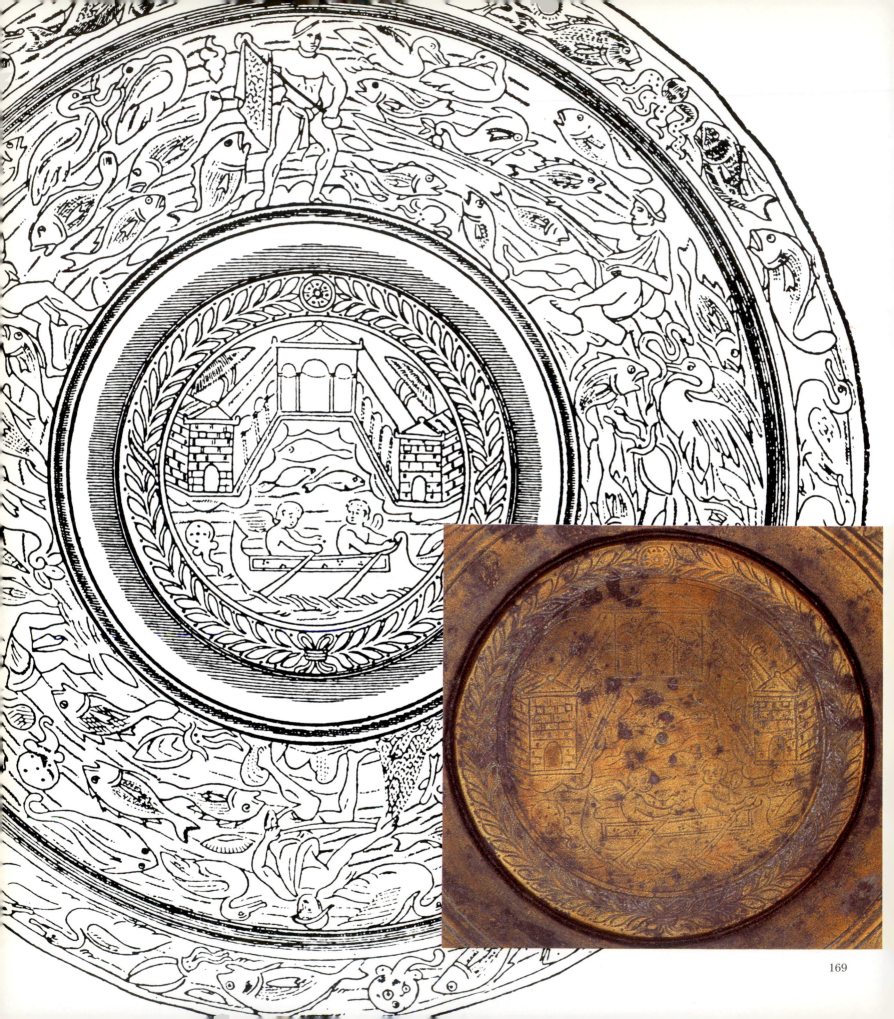

**169.** *Bronze bowl with incised scenes inspired by maritime subjects. In the centre is a harbour with apsidal buildings and a ship with small figures of Eros as oarsmen. Found at Porto d'Anzio in 1782. Roman work. London, British Museum 884.*

**170.** *Bronze cup with impressed gold and silver decoration. Scenes from the foundation of a coastal city. 4th century A.D. Paris, Musée du Louvre B2 4391.*

**171.** *Detail of the decoration of the cup in fig. 170. Two ships with passengers can be seen arriving at the harbour.*

170

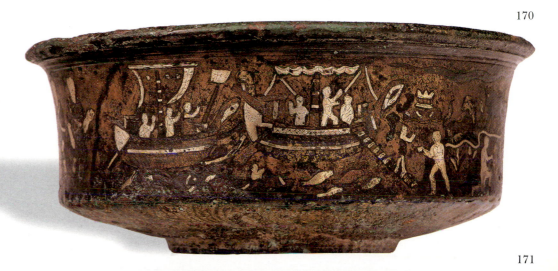

171

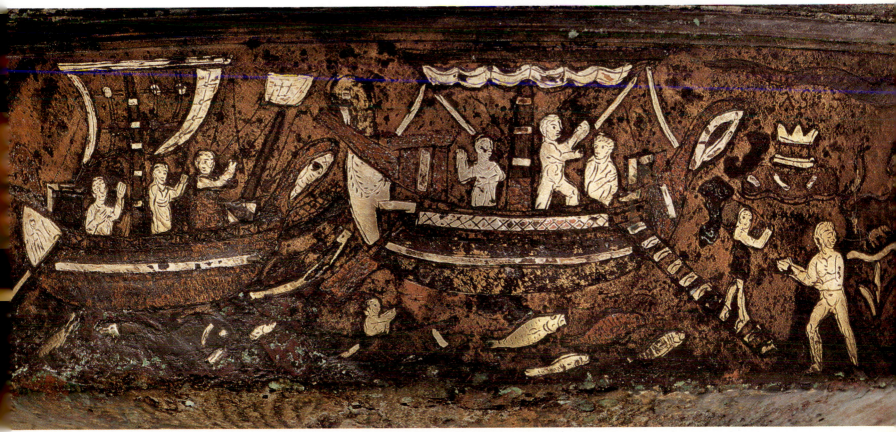

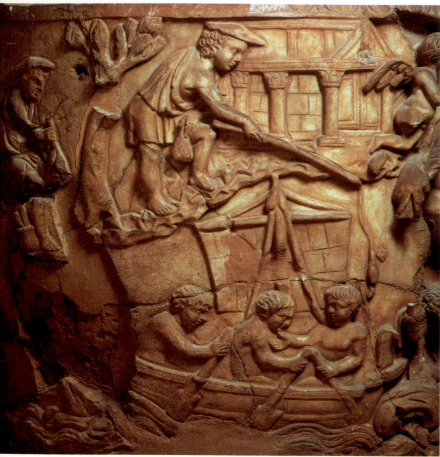

. *Detail from the decoration of the Roman Nereid sarcophagus. A ship with oarsmen and helmsman and with spread sail, passes in front of a harbour, while fishermen stand on the tree-lined shore fishing with reeds. Rome, Pretestato catacomb.*

*173. Detail from the decoration of a marble sarcophagus, depicting a Roman city with a harbour full of large merchant vessels and warships and other smaller boats. Vatican, Pio Clementino Museum.*

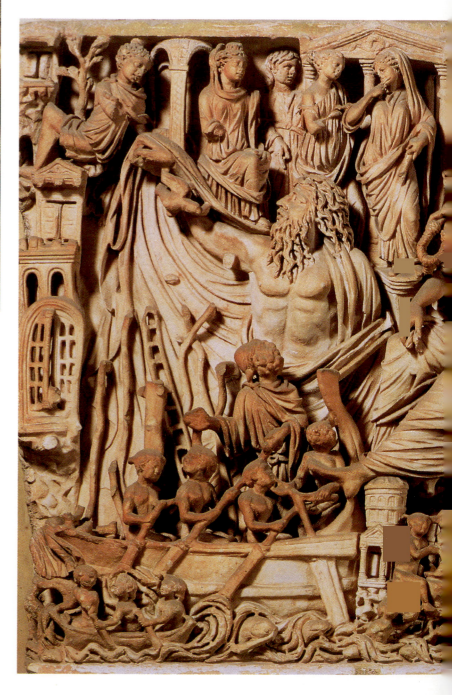

This led to the first defeat of the Carthaginians, and Rome, the land-power, was able to celebrate its first naval victories. Although the stormy sea itself fought against them, causing the loss of their entire fleet, the Romans continued to make advances, even when they met with foes of note, who were hitherto undefeated at sea. In 146 B.C., Carthage, the city that had been lord of the Mediterranean world, was destroyed and was never to trouble the Roman empire again.

At the end of the 3rd century B.C., a Rhodian galley appeared on the Tiber to call upon the rising naval power to intervene in the eastern Mediterranean. Ever since the division of the empire of Alexander the Great, the island of Rhodes had pursued a subtle diplomatic course between the states of Macedonia and Egypt,

playing a game of survival and siding with whichever was the more powerful. At the end of the 3rd century, when Egypt had neglected her fleet and Macedonia became the sole dominating power – which was against Rhodian interests – Rhodes turned to the Romans. With fifty *pentereis* Rome obliged the Macedonians to conclude peace, though she played no further role. However, when her ships returned to base, they had become acquainted with the East, an area which, within a century, would form part of the great Roman empire.

Rome first made contact with the Greek world through trade, and succeeded in winning

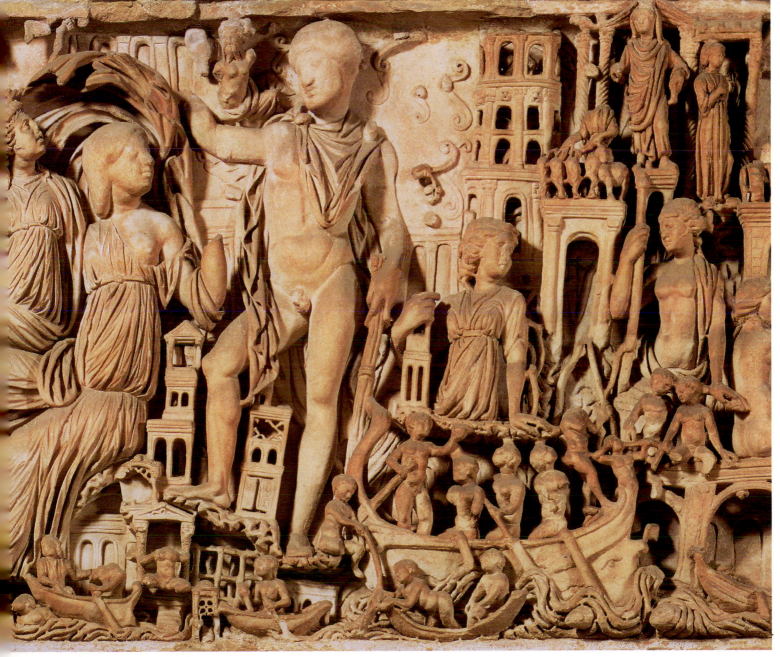

it over by peaceful means. In 167 B.C., the Romans came to Delos, the island at the centre of the eastern Mediterranean, and handed it over to Athens on condition that it remained a free port and not a customs house. Within a very short space of time, all commercial routes led to Delos, and only ships transporting grain and wine called in at Rhodes.

Despite competition from Italian merchants, Greeks continued to travel the Aegean, though they had to face two serious dangers: their lack

*174. Scene of a naval battle. Detail from the decoration of a marble "Attic" sarcophagus. 2nd-3rd century A.D. Thessaloniki, Archaeological Museum 283.*

*175. Marble votive stele with the goddess Isis Pelagia standing on a ship. From the Agora of the Italiotae on Delos, early 1st century B.C. Delos, Archaeological Museum 3187.*

*176. Stone grave stele of Publius Longidienus, a shipbuilder who died at Ravenna in the late 2nd or early 3rd century A.D. He is shown completing the hull of a warship. Ravenna, Archaeological Museum.*

174

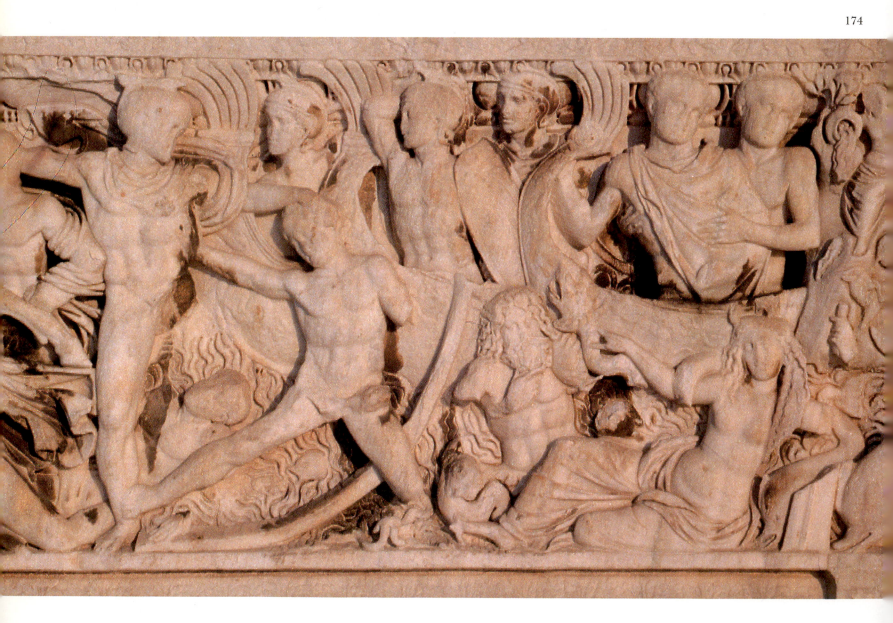

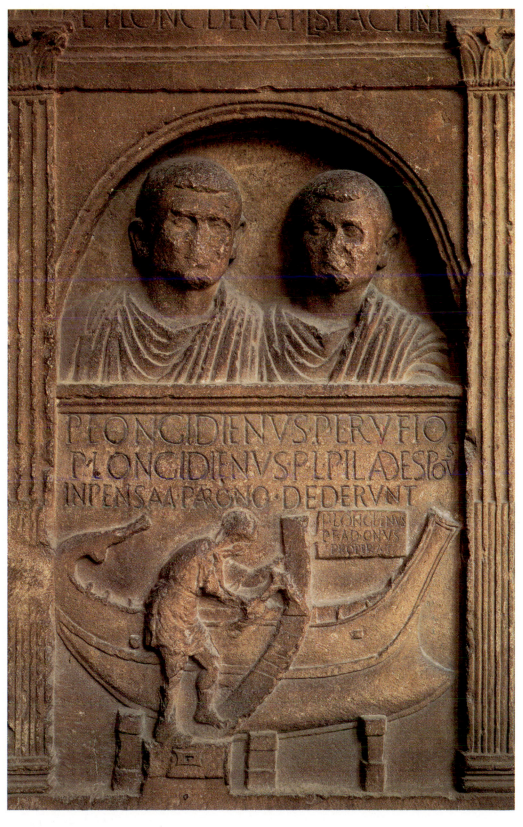

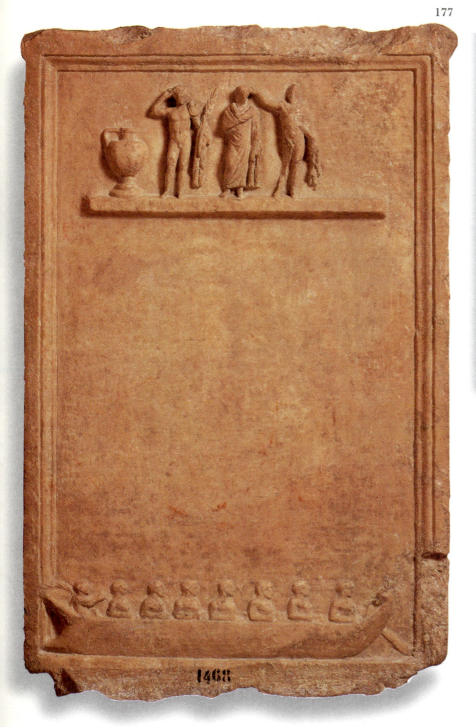

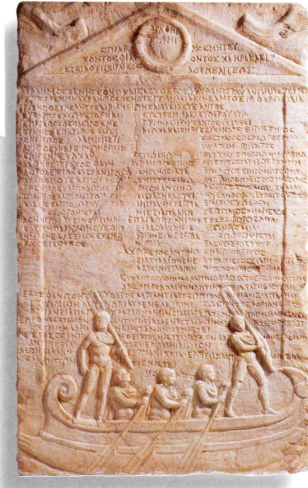

178

**177.** *Marble honorific stele with a space left in the middle for inscribing the text. At the bottom is a warship with a helmsman and oarsmen. From Athens, 2nd-3rd century A.D. Athens, National Archaeological Museum 1468.*

**178.** *Marble stele with a list of ephebes. At the bottom is a warship with oarsmen and a scene of youths taking part in gymnastic contests. From the Gymnasium of Diogenes in Athens, A.D. 163/4. Athens, National Archaeological Museum 385.*

**179.** *Inscribed marble honorific stele depicting a row of warships at the bottom (only two are preserved). 2nd-3rd century A.D. Athens, National Archaeological Museum 1465.*

**180.** *Detail of fig. 179.*

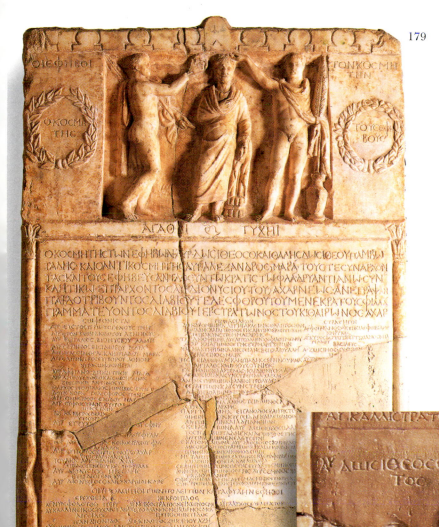

179

of technical expertise in navigation, and the pirates, whose activities intensified after the middle of the 2nd century B.C.

Piracy flourished at this period, for there was no major sea-power in a position to impose order in the Aegean. Rhodes, which had previously assumed this role, was now in decline because of the huge tribute she was paying to the Romans. The latter, on the other hand, looked with some favour on piracy, particularly when it was conducted at the expense of the Seleucids, and they frequently co-operated with the pirates of Cilicia, who supplied them with slaves. In the last quarter of the 2nd century B.C. the pirates of Cilicia and their teachers, the Cretans, continually polluted the coasts of the Aegean, posing a serious threat to Greek merchant ships.

180

It was only about 100 B.C., after a number of unsuccessful attempts to suppress piracy, that a degree of order was imposed in the Aegean by Pompey, using Greek ships and crews. Meanwhile the Roman Republic, on the threshold of its transformation into the Roman empire, was threatened by civil wars. The original

alliance between Mark Antony and Octavian turned into a conflict that ended in a confrontation between two titanic fleets at Actium in 31 B.C. The victory of Octavian Augustus marked the end of the Greek world. Thenceforth, for 200 years, the Mediterranean became a Roman lake – wealthy, united and peaceful.

During the first two centuries of Roman rule, sea-borne trade continued to be one of the basic sources of the Greek economy, despite all the difficulties arising out of the indifference of Rome, the taxes imposed on the harbours, the natural dangers of the sea and, finally, their lack of technical expertise.

During this period, the Greeks were still more skilled sailors than the Romans, and the latter, therefore, relied upon Greek ships in their conflicts with foreign rulers. The fleets used by Pompey against Caesar and by Mark Antony against Octavian had Greek ships and crews. The superiority of the Greeks is indicated by Caesar's confidence in the naval experience of the Rhodians and by the fact that Pompey and Octavian employed Greek officers.

Compared with the first two centuries of Roman rule, matters began to improve for Greek seafaring in the 1st and 2nd centuries A.D. Prosperity followed on the stability brought by the Roman empire, which made the Mediterranean *mare nostrum* – a Roman lake. Octavian had himself proclaimed Augustus and Caesar in 29 B.C., and was the first ruler who considered it his duty to organize the naval powers of his state. At the end of the 1st century A.D., the naval forces protecting the boundless Roman empire reached the Danube and the shores of the Black Sea in the north-east, and the borders of Germany and England in the north-west. The eastern Mediterranean was protected by naval contingents stationed at Alexandria and in Syria, and the Adriatic Sea by a fleet based on Ravenna, while the military fleet that controlled the western Mediterranean anchored at Misenum. The *Pax Romana* benefited the subject peoples as well as the conquerors. Its founder, Augustus, was accordingly worshipped as a god in many ports, with the epithet *epibaterios*. Names of ships such as *Clementia, Pax, Justitia, Pietas* and *Providentia* attest to the stability and order that prevailed throughout the empire, while Greek names such as *Eirene Sebaste* and *Euandria Sebaste* demonstrate that Greek crews, too, paid their tribute.

Another indication of the general confidence felt in the *Pax Romana* is the fact that the harbours remained unfortified and were adorned with grandiose monuments. Harbour facilities were built at some of the coastal cities that were of particular importance to the emperors, such as Nikopolis in Epiros, founded by Augustus himself to commemorate his victory at Actium, Alexandria and Seleucia in Antiocheia in the East.

The interest shown by Hadrian, in the 2nd century A.D., in the harbours of the Cyclades, Ephesos, Trebizond, Pompeiupolis and Hieraton reflected the emperor's philhellenism and liberalism, as well as his realism. Important facilities were also erected by the Severi at Methone, Patrae and Aegina.

There was a considerable expansion of sea-borne trade in imperial times. The merchant fleet was in the hands of the Greeks and the Syrians and other peoples with a naval tradition. Trade was carried on at this time with lands ranging from the Baltic and Ireland to the coast of Ethiopia, India and Malaya. Traders carried metals, iron, gold and silver from Spain, grains and wool from Galatia, geese, hunting dogs, oxen and slaves from Britain, tin from Cornwall, statues and marble from Athens, horses from Thessaly, slaves from Nubia, bronze from Cyprus and leopards, lions, panthers, ebony and ivory from Africa.

The Mediterranean was the heart of the Roman world, but the naval network of the empire stretched far afield. Over the sea-routes came riches and exotic goods from Arabia, Persia and India, to flood the markets of Rome. Incense and aromatic plants from Arabia burned alongside the sacrificial victims on the altars of the gods. From the 3rd century, highly expensive silk was brought to Rome from China, for the secret of silk-production only became known in the West in the 6th century A.D. The voyages of the large merchant ships were beset by countless dangers, as they sailed the seas from the Indian Ocean to the Red Sea, from the Red Sea ports to the Nile, and from there to Alexandria and the Mediterranean. A Greek captain in the 1st century A.D. described his voyage

*181. Marble relief of a Roman tetreres ("four-fitted" ship) or a larger ship. The front part is shown, with all the details of the warships of the period. The crocodile is the ship's emblem. From Praeneste, second half of the 1st century B.C. Vatican, Pio Clementino Museum.*

181

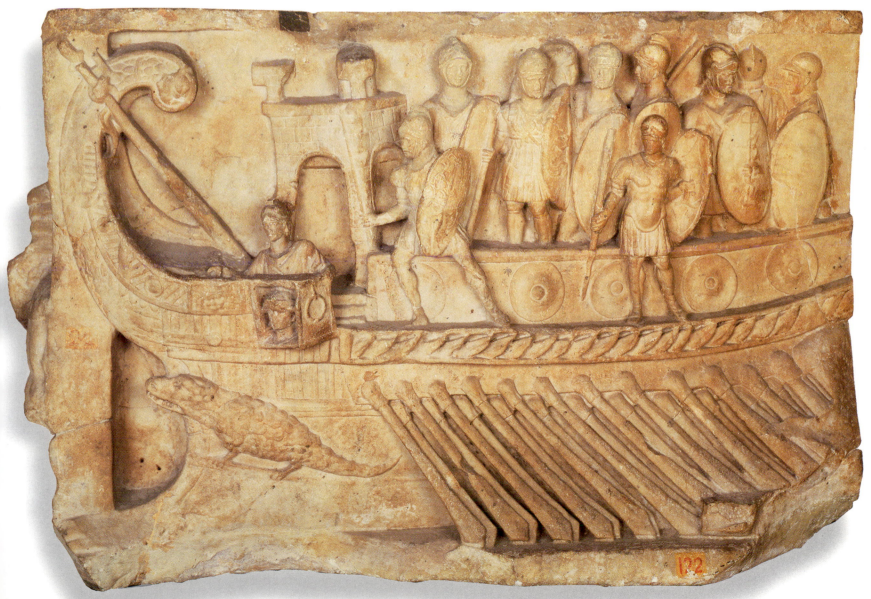

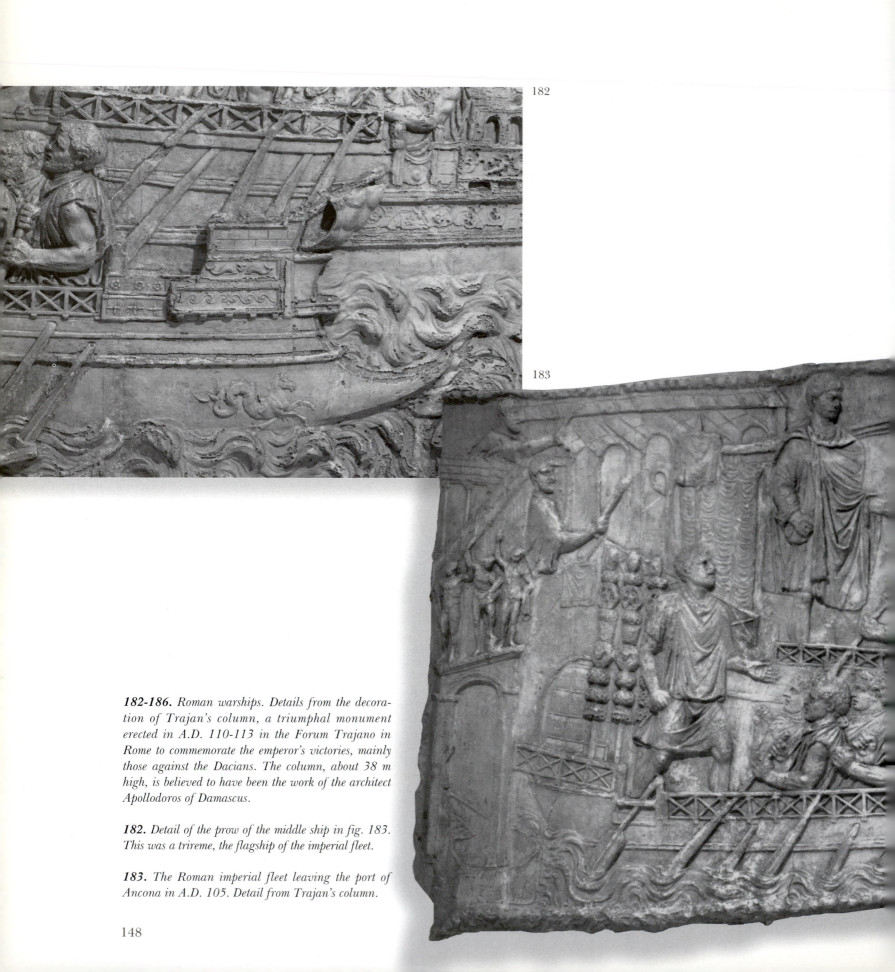

**182**

**183**

**182-186.** *Roman warships. Details from the decoration of Trajan's column, a triumphal monument erected in A.D. 110-113 in the Forum Trajano in Rome to commemorate the emperor's victories, mainly those against the Dacians. The column, about 38 m high, is believed to have been the work of the architect Apollodoros of Damascus.*

**182.** *Detail of the prow of the middle ship in fig. 183. This was a trireme, the flagship of the imperial fleet.*

**183.** *The Roman imperial fleet leaving the port of Ancona in A.D. 105. Detail from Trajan's column.*

around the Red Sea, giving details of the ports, the winds, the produce and the inhabitants – a valuable guide to a world that no longer exists. In A.D. 160 another Greek seafarer, named Alexander, travelled as far as China, crossing the gulf of Bengal. He presented the Chinese emperor Huan Ti with ivory, tortoise-shell and rhinoceros tusks, thereby laying the foundations of the relationship between the West and the Far East, recorded by a Chinese chronicler.

These voyages to distant, dangerous seas led to the growth of cartography, as is clear from the maps made by Marinos of Tyre and Claudius Ptolemy (A.D. 150), which are based on earlier studies. Treatises containing the word *Periplous* ("Circumnavigation") in their title circulated at this period to assist travelling merchants, amongst them the *Circumnavigation of the Black Sea* by Arrian (A.D. 130), and there were also writings called *Stavrophoroi*, giving the distances

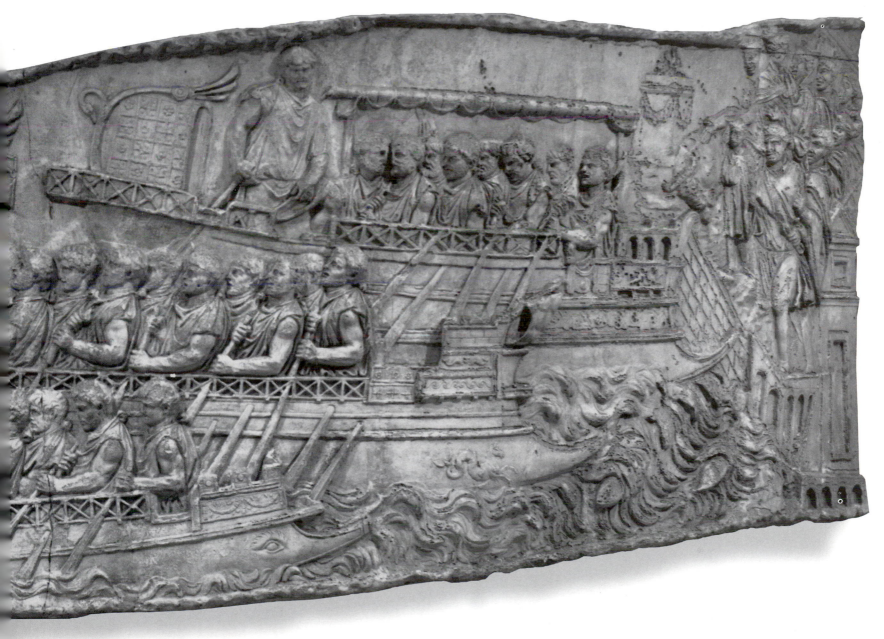

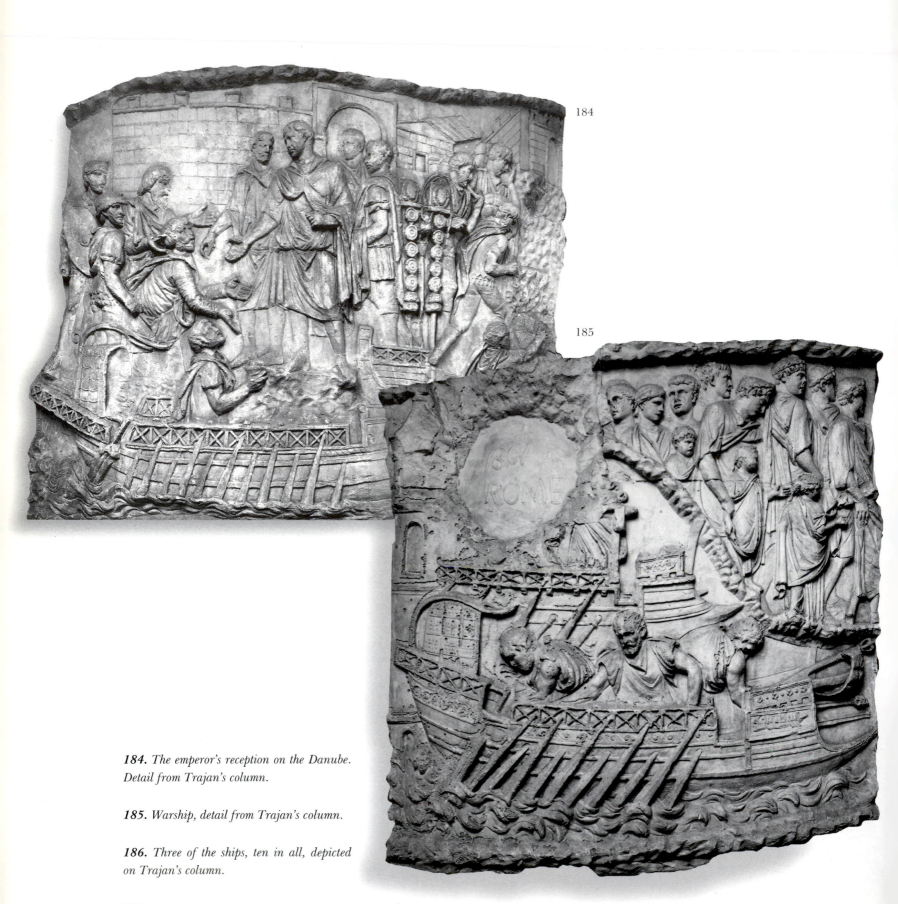

184

185

**184.** *The emperor's reception on the Danube. Detail from Trajan's column.*

**185.** *Warship, detail from Trajan's column.*

**186.** *Three of the ships, ten in all, depicted on Trajan's column.*

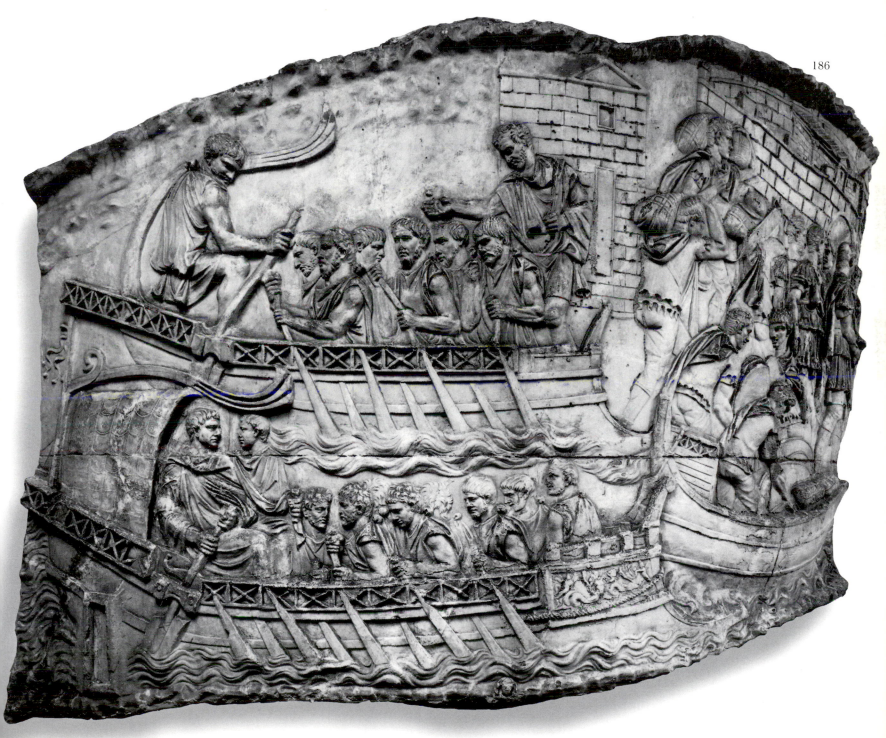

between various sites. The theory advanced by Poseidonios (A.D. 135-150) on the influence of the moon on the daily, monthly and annual tides was an important contribution for seafarers and was included in Strabo's work on the Ocean, of which only fragments survive.

Many authors of this period have preserved for us descriptions of their travels, which make clear the dangers and adventures experienced by these seafarers. In A.D. 144 the orator Aelius Aristides recorded his exploits on an eighteen-

*187-188. Athenian bronze drachmas, depicting Themistokles standing on a warship with a trophy in his left hand and a wreath in his right. A.D. 120-140. Athens, Credit Bank Collection.*

*189. Tetradrachm of Alexandria from the reign of Commodus (A.D. 177-192) with a scene of the Lighthouse at Alexandria and a ship. Athens, Numismatic Museum.*

*190. Coin of Kerkyra from the reign of Septimius Severus (A.D. 193-211) with a scene of a warship. Athens, Numismatic Museum.*

*191. Coin of the reign of Commodus (A.D. 177-192) with a scene of the port of Patrae, with ships and buildings on the shore. Athens, Numismatic Museum.*

187     188

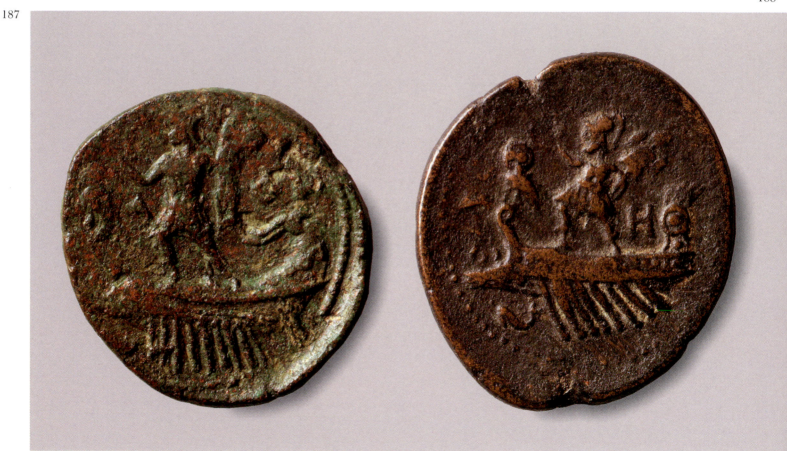

day voyage from Rome to Smyrna, via Kephallonia and Patrae.

The dangerous adventures of sailors are also recorded in epigrams inscribed on grave stones. "The sea is an element hostile to the nature of man," wrote Plutarch in the 2nd century A.D., though this was a Roman view, not a

Greek one. Throughout the entire period that the Romans ruled the world, they never became sailors. They remained landsmen, mere spectators of ships and voyages, just as when they held mock "naval battles" in the amphitheatres, in which the participants were sailors, who did not travel in winter. The large Roman

ships were manned by Greek and Phoenician sailors, or crews drawn from other sea peoples. The end of Roman domination at sea was a natural consequence of the economic crisis of the 3rd century A.D.

This long period of Roman maritime rule left its mark in depictions of ships on coins and medallions, architecture and sculptures, wall-paintings and mosaics, vases and lamps, graffiti and models of boats. In every area of the vast Roman empire, scenes have been preserved that depict the form and type of ships that had developed over the centuries.

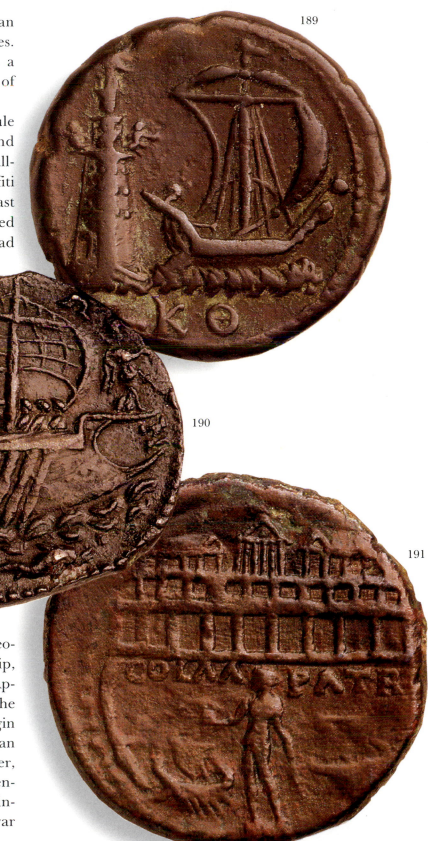

Roman warships were the product of an amalgam of the naval traditions of those peoples that had been active on the seas over the centuries. Depictions of these warships make it clear that they were similar to those of the Carthaginians, and had adopted many features of the Greek ships of the Hellenistic period. Under the influence of neighbouring peoples, the Romans built a type of two-level ship, the *liburna*, known to the Greeks as *libyrnis* (Appian), which made its first appearance off the coast of Illyria. The only ships of Roman origin that antedated the creation of the first Roman fleet were the ones that sailed on the Tiber, known as *lintres*, the origins of which were essentially derived from small boats made from a single piece of wood. When, after four years' war

with the Carthaginians, the Romans realized that in order to rule the sea, and by extension the other peoples of the Mediterranean, they would have to organize a fleet, they built their first *pentereis* on the model of the Carthaginian ships.

After 260 B.C., the Romans created their first large fleet of 100 *pentereis* to which they quickly added 20 triremes. They never abandoned *pentereis* throughout the long period of their empire, as is clear from the surviving depictions, which cover a period of approximately four centuries. A series of Calès plates dating from the end of the 3rd and the beginning of the 2nd centuries B.C. has preserved some very fine examples of Roman ships. Although *pentereis* and *tetrereis* were not the only ships used by the Romans, they never abandoned this type of Greek warship.

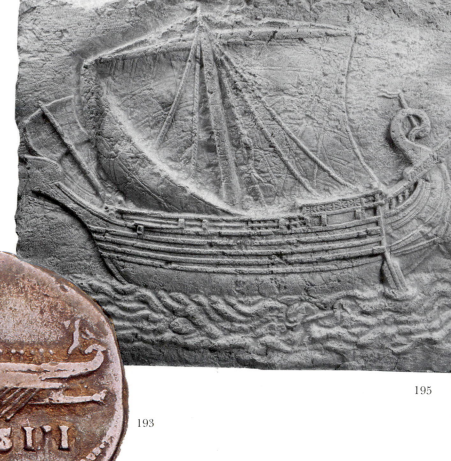

195

192

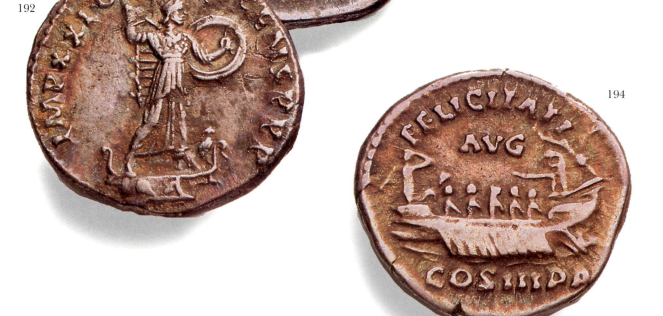

193

194

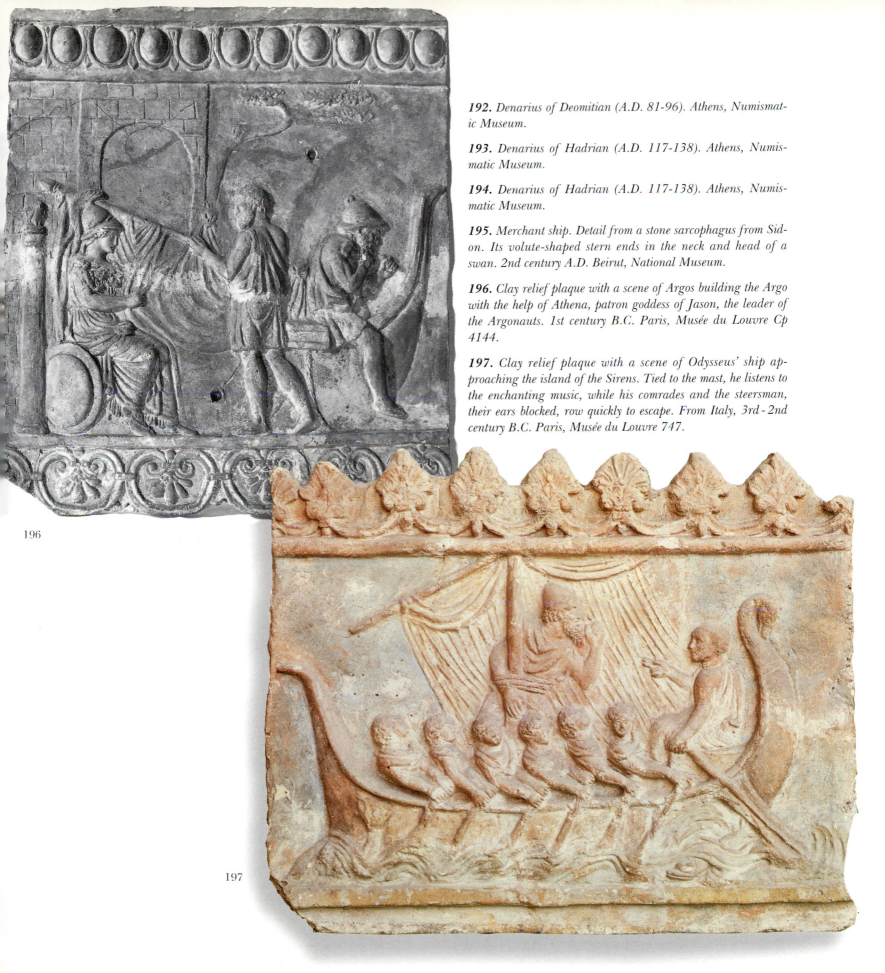

**192.** *Denarius of Deomitian (A.D. 81-96). Athens, Numismatic Museum.*

**193.** *Denarius of Hadrian (A.D. 117-138). Athens, Numismatic Museum.*

**194.** *Denarius of Hadrian (A.D. 117-138). Athens, Numismatic Museum.*

**195.** *Merchant ship. Detail from a stone sarcophagus from Sidon. Its volute-shaped stern ends in the neck and head of a swan. 2nd century A.D. Beirut, National Museum.*

**196.** *Clay relief plaque with a scene of Argos building the Argo with the help of Athena, patron goddess of Jason, the leader of the Argonauts. 1st century B.C. Paris, Musée du Louvre Cp 4144.*

**197.** *Clay relief plaque with a scene of Odysseus' ship approaching the island of the Sirens. Tied to the mast, he listens to the enchanting music, while his comrades and the steersman, their ears blocked, row quickly to escape. From Italy, 3rd - 2nd century B.C. Paris, Musée du Louvre 747.*

196

197

**198.** *Seascape, coloured glass picture (opus sectile) to adorn an interior room. A unique work of art of late antiquity. From Kenchreai, c.A.D. 370. Isthmia, Archaeological Museum.*

The merchant ships through which the Romans succeeded in gathering into their hands the entire carrying trade of the Mediterranean were sailing ships of various types and sizes. The most characteristic were the grain ships, which had a capacity occasionally as high as 1,200 tonnes. Heavily made ships, they moved only under sail. They had a centrally placed mast on which a large square sail was hoisted. In the prow was a sloping mast, the *probolos* ("projection"), on which was hoisted the *artemon*, a smaller foresail that was of help in steering the ship. The earliest depiction of this kind of ship is found on a coin dating from the reign of Nero.

Coins from the period of the Roman Republic have scenes of ships that are identical with the Greek ships of the Hellenistic period. Prows and sterns with Greek features are engraved in bronze and silver, though they are much less elegantly portrayed. The Republic borrowed from Greek ships the curved, volute stern-post, and the ram on the prow in the shape of a trident, while the projecting beak often takes the form of an animal's head. In the 2nd century B.C., scenes on coins are inspired by ships of Greek type. In place of the monotonous portrayal of only a prow or a stern, we now have the entire ship seen from the side. These depictions are the work of Greek artists from southern Italy. The ships on the coins issued by Pompey, Octavian Augustus and Antoninus are many-oared galleys, with or without sails, undecked triremes, *tetrereis* or *pentereis*, that reproduce in great detail the types of ships at this period (fig. 160-164, 166, 189-194).

In the imperial period, we have to wait until the time of Hadrian before we again find entire ships depicted in side view on Roman coins. The distant voyages undertaken by the emperor to various parts of his vast empire, from Athens to Alexandria, and the hazards of the sea once more inspired the artists. The coins invariably bear the inscription *Felicitati Augusti*, and depict a variety of types of ship, and perhaps even the imperial flagship itself, an undecked galley, with or without sails, with a large number of oars, and with decoration on the stern and prow.

Despite the fact that the Romans were not a seafaring people and their major naval battles are almost never immortalized in monumental art, there are a large number of scenes of Roman ships, either incised in rock or carved on marble, both in relief and in the round. On triumphal arches, honorific columns carved in the round, architectural members, column bases or capitals, monuments commemorating the victory of some officer, on grave stones and sarcophagi (fig. 172-174), and also on models and vessels or on lamps (fig. 165, 167-171), Roman ships have found their place in eternity, and alongside them, the ships of the peoples over whom Rome ruled.

The light galleys with two rows of oars carved on the frieze of a tomb transporting warriors on some military enterprise, and those adorning the crowning member of a monument during the period of Augustus, are the works of simple popular artists of the 2nd and 1st centuries B.C. Their prows, usually, adorned with a deity of the sea or a female figure, sometimes end in a sea monster or a serpent, or even, under Egyptian influence, a crocodile, and they sometimes rise to have an enormous stern-post, formed into a volute. Prows and sterns adorn the triumphal arch at Orange; the prows have rams carved in the form of a trident, and are adorned with garlands of ivy, dolphins, and invariably an eye to ward off evil, while the sterns are decorated with astragals and palm branches, curved at the end in the form of a volute, or branching to form the shape of a fan.

**199.** *View of the harbour of an Italian city. Wall-painting from Stabiae. Naples, National Archaeological Museum 9514.*

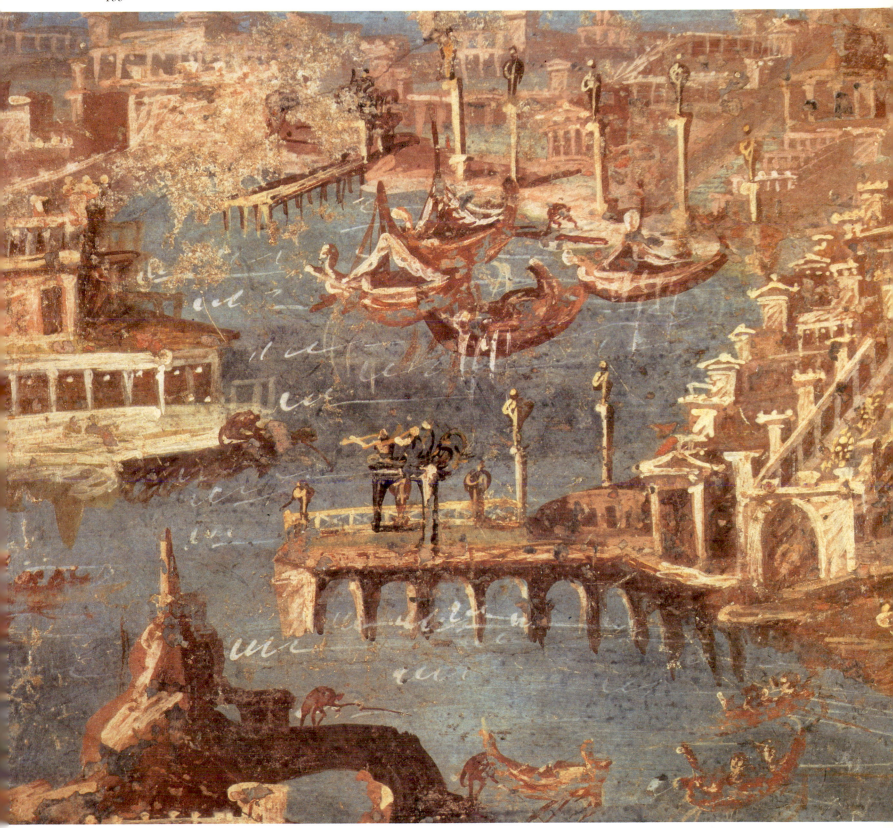

**200.** *View of a harbour. Buildings can be seen in the back-ground in a forested landscape while ships sail on the sea, some with their sails spread, others with oarsmen. Naples, National Archaeological Museum.*

**201.** *Prows of two warships. Their style is Hellenistic and they are presumably copies of works by Greek artists of the previous period. Wall-painting from Pompeii, 1st century A.D. Naples, National Archaeological Museum 8604.*

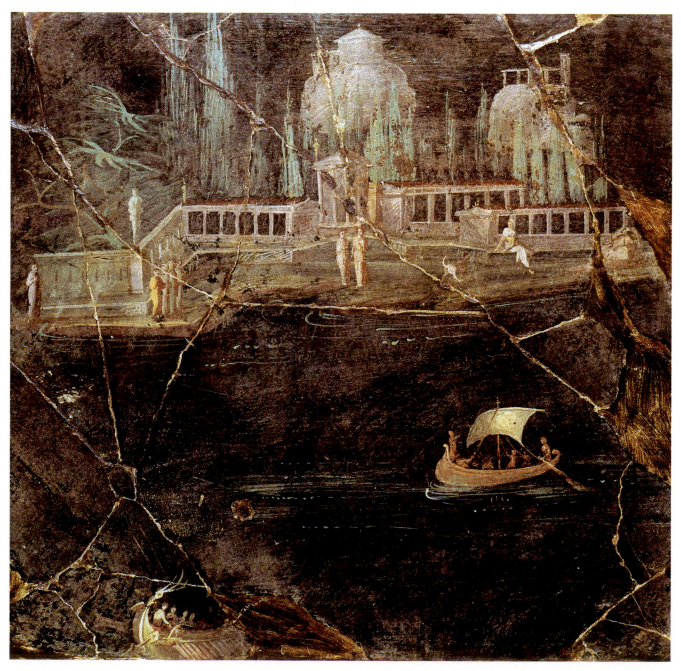

The Roman fleet consisted of decked galleys, most of them triremes, though there were also *pentereis* and *tetrereis*, and more rarely *hexereis*, all lavishly decorated. All these types are engraved in hard materials, pictured as they traverse the sea, with one or two rows of oars, transporting Roman soldiers to the ends of the then known world in order to enforce Roman rule. Very occasionally, victorious naval battles are alluded to or depicted, as in the Puzzoles monument in the 1st century B.C., or the reliefs at Madrid, Medic-onelli and at Praeneste (fig. 181). The role played by the fleet in Trajan's Dacian campaign was portrayed in an extensive narrative on the spiral frieze that winds around Trajan's column (fig. 182-186). Along with the amphitheatres, stoas, army camps, triumphal arches, chariots and bridges, Apollodoros and the craftsmen of his workshop have also engraved ten warships. The imperial fleet is shown leaving the port of Ancona in A.D. 105 and arriving in various ports on the Dalmatian coast, and there are also scenes

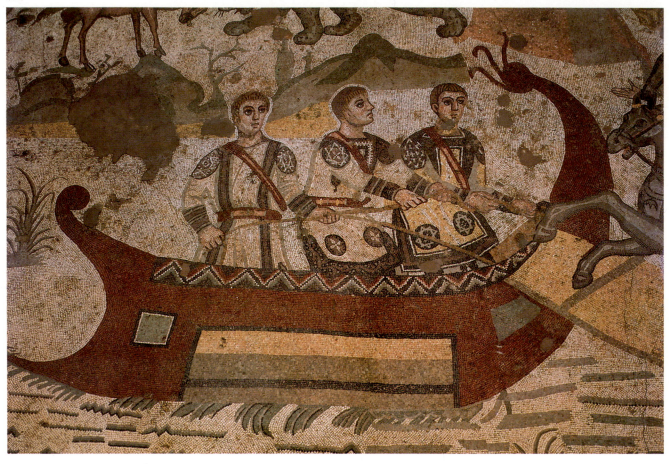

**202.** *Detail from a mosaic with a hunting scene, depicting the loading of the wild animals on to a warship. From the Villa Romana del Casale. Rome, Piazza Armenina.*

**203.** *The god Dionysos and the Etruscan pirates, detail from a mosaic, showing the god's ship and the pirates' fishing boat. Dionysos turns the pirates into dolphins and throws them into the sea. 3rd century A.D. Tunisia, Bardo Museum.*

of ships on the Danube. All these galleys are covered by a bridge, and have two banks of oars and an elevated, curved ram at the end. There are towers on the prow, as was frequently the case in all the large Roman warships, and the prow itself is decorated with garlands and relief motifs drawn from the world of the sea.

Scenes of Roman merchant ships are rarer than those of warships. They are found mainly on grave stones, with their sails hoisted and a distinctly rounded hull. They have a foresail, the *artemon* on the prow, and the stern, where the helmsman sits, ends in the form of a swan, or is slightly elevated (fig. 195).

In every part of the Roman empire, from one end of the Mediterranean to the other, grave stones have been found engraved with depictions of ships, sometimes at the bottom of the stele and sometimes in the middle. An inscription tells the story of the episode at sea that was the cause of death, or bids farewell to beloved relations. Many of these and also votive and honorific stelai have been found in Greece, Asia Minor, Tyre, Sidon and Italy (fig. 175-180).

Subjects drawn from the sea and containing depictions of ships are sometimes drawn from

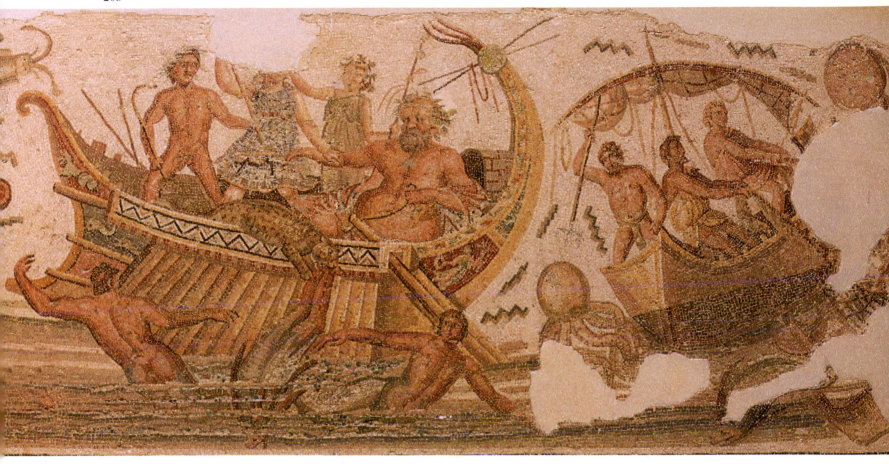

the life of sailors and ports, and sometimes narrate the story of a naval battle, or immortalize a victory. Mythological scenes are rare, though not completely absent (fig. 196-197). Episodes from myth are found in wall-paintings of Roman times, which repeat the motifs of the Hellenistic period. The majority of these scenes of ships have been preserved at Pompeii and Herculaneum. They recount the myth of Perseus and Andromeda, and frequently the travels and adventures of Odysseus. In addition to mythological subjects, the wall-paintings also depict imaginary hunts on rivers, with hippopotamuses and pygmies, or sea-battles with warships. These scenes, however, spring mainly from the imagination of the painters and only rarely represent accurate pictures of ships (fig. 199-201).

The mosaic floors in houses, courtyards and squares, also preserve realistic portrayals of both merchant ships and warships, usually with their sails spread (fig. 202-206). The details of the different parts of the ships are rendered by the use of line, a technique to which mosaic lends itself; in the graffiti of the period, too, all the parts of the boats are faithfully reproduced in simple lines.

In some of the mosaic floors of the 3rd century A.D., found on the north African coast, the oarsmen, sailors and merchants who travelled in the ships of the period are replaced by small figures of Eros; and scenes of daily life, such as goods being carried to the harbour, or wild animals being transported for the games in the amphitheatres, are transformed into fantastic journeys or hunts (fig. 202). For two hundred years, from the 3rd to the

5th centuries A.D., the artist's imagination interwove scenes from life with those of myth, creating very fine images of ships, small boats, harbours and landscapes, together with figures from Greek mythology. Poseidon, the god of the sea, for example, with his wife Amphitrite, wearing the haloes of saints, cross the sea, flying above it in another kind of boat – a chariot drawn by winged horses.

The famous episode involving the god Dionysos and the pirates is brought to life in a mosaic of the 3rd century A.D. (fig. 203). In another mosaic composition, Odysseus continues his eternal journey even at this late period. Tied once more to the mast of his ship, he listens to the unending song of the Sirens, while his companions, who resemble the saints painted on the walls of churches, ignore his pleas and gaze indifferently upon the winged monsters, motionless and silent, perhaps because they have already crossed the threshold of the new epoch that prophesied the triumph of Byzantium.

*204. Asklepios arriving at the island of Kos by ship, welcomed by Hippokrates and a Koan. Mosaic floor from a house on Kos, 2nd-3rd century A.D. Kos, Archaeological Museum.*

*205. Octagonal mosaic floor decorated with ships, buildings and other motifs. Toledo, Museo di Santa Cruz.*

205

# Byzantium and the Sea

Civilizations are not mortal; they survive through all their transformations and destructions and are reborn when the time is right. A good example of this is the Greek civilization, which can count five thousand years, and perhaps more, of life. It is born, develops, suffers destruction, reaches its nadir, recovers and flourishes, decays and revives, because it is immortal.

Greece and the Greek world bowed before the Roman legions. They remained under Roman rule for centuries, until Constantine founded Constantinoplé in A.D. 324/330. Greece was effectively reborn in A.D. 395, when the Roman empire was divided into two large parts, the *pars orientis*, which became the Greek empire of Byzantium and the *pars occidentis*, which succumbed to the attacks of the barbarians. During this phase of its history Greek civilization was to live for over a thousand years as the Byzantine empire, pursuing its long course until 1453, when it was vanquished by the Ottoman Turks. It still did not disappear, however. After 400 years of slavery, it came to life once more in the 19th century when, with the support of the Orthodox Russians, it won its independence through the struggle of its people for national liberation.

During the period of the Byzantine empire, the Greek universe became the Orthodox universe. Constantinople, the new Rome, with its symbol, the church of the Holy Wisdom, Ayia Sophia, was the centre in which ancient Greece seemed to live again as a beacon of Orthodoxy. The emerging Christian world incorporated the fundamental values of Greek civilization, which survived unchanged and formed its basis.

Greek civilization enjoyed a highly significant relationship with the sea, a strong relationship that never died over the centuries. For Greek civilization was created by a nautical people, devoted mainly to trade, whose life was closely bound up with the sea. In the Byzantine period, this sea

*206. A ship departing from or arriving at a harbour. Detail of a mosaic in a house in Rome. 3rd century A.D. Rome, Museo della Civiltà Romana.*

was once more the Mediterranean. The Byzantines referred to it as an ocean, not merely because it included several seas, such as the Aegean, the Ionian and the Adriatic, but because they wished to stress the fact that it was their own sea.

During the years when the Byzantine empire dominated the world, from the 4th to the 7th century B.C., the Mediterranean was a Byzantine lake, bounded by the possessions of the empire on the three continents of Europe, Asia and Africa. Thanks to this lake and its natural extensions, the Propontis, the Black Sea and the Red Sea, Constantinople and the empire assumed the mantle of leader of the then known world, a role it played above all in the reign of Justinian. This was the period when the region stretching from the Pillars of Hercules (Gibraltar) to the

Cimmerian Bosporus (Kerch) and from Lake Tana to the Sea of Azov was under the rule of New Rome. According to Kosmas *Indikopleustis*, all the nations of the earth at this time used the Byzantine coinage as a vehicle for trade, giving some indication of the grandeur of the empire. All the roads of the inhabited world led to Constantinople, as they once had to Rome under the Roman empire. Superiority at sea was tantamount to world domination. The wealth and brilliance of the empire derived from the development of sea-borne communications through the chain of the Aegean islands, the coast of Asia Minor, and the islands of Crete, Cyprus, Sicily, Malta and Sardinia.

The chain of communications was continuous, for every island acted as a harbour or a light-

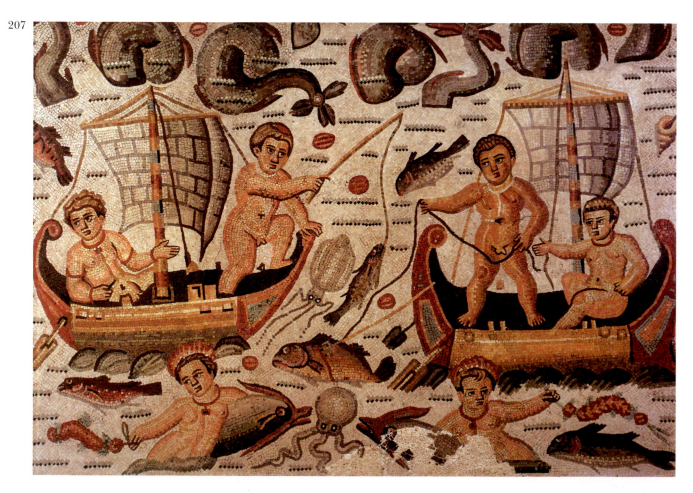

207

**207.** *Detail of a mosaic with a scene of two ships crewed by small figures of Eros. 3rd or 4th century A.D. Paris, Musée du Louvre.*

**208.** *Part of the rim of a tray. The rear section of a boat can be seen with two small figures of Eros, and a large fish. From Egypt, late 4th - early 5th century A.D. Athens, Benaki Museum 12407.*

**209.** *Detail of the decoration of a mosaic floor with a scene from the life of Jonah. The rich world of the sea – fishes, octopuses and shells – is depicted, with a boat with small figures of Eros fishing and part of another boat. Decoration from the central part of the sanctuary of the Basilica of Theodoros at Aquileia, A.D. 310-320.*

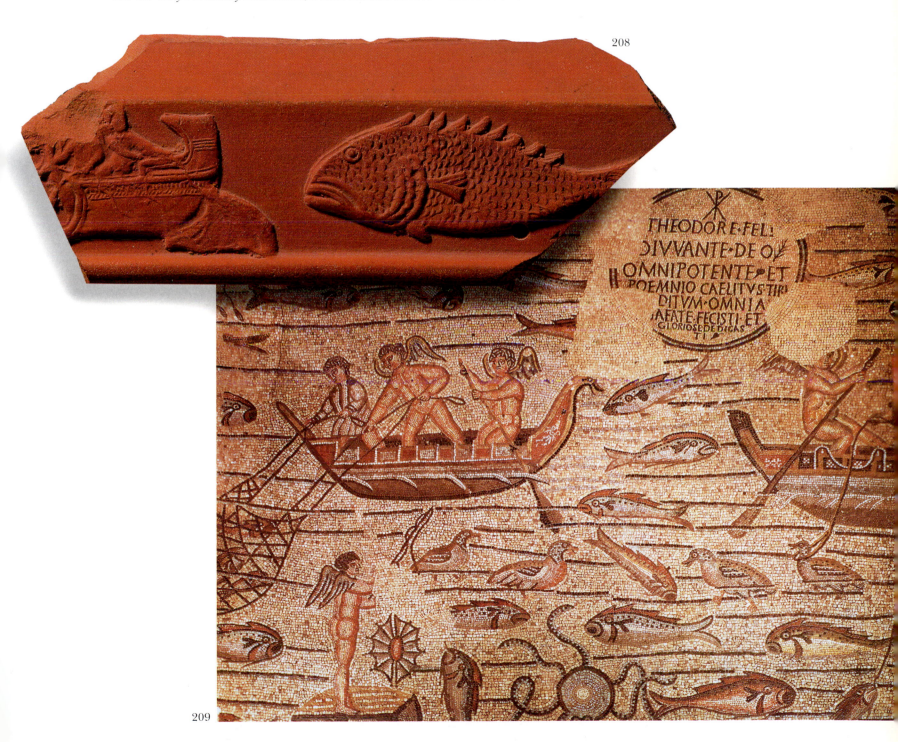

208

209

house, guiding imperial or private merchants on their voyages. The islands were also centres of navigation, at which gathered the *dromons*, the *chelandia* and the other ships of the Byzantine state.

The sea that is familiar from the voyages of Odysseus and the other seafarers of antiquity, the sea on which the Romans imposed the *Pax Romana*, now became a Byzantine sea. It formed the connecting link between all the Byzantine possessions, a link that "unites rather than divides," as the sailors used to say. The ships, whether merchant, fishing boats or warships, were the ties between the provinces and acted as channels by which the influences of the multifarious population of the empire were transmitted. The predominance of the empire was undoubtedly secured by Byzantine naval power. Constantinople depended upon the sea, for the grain to feed its population was transported in special ships from Egypt. Byzantine boats also transported merchandise and agricultural produce such as wine to the distant markets of the Roman world and the lands occupied by the barbarians (Goths, Visigoths etc). Trade was carried on by merchants acting as middle men, and shipowners, the *naukleroi*, and their powerful guild, which acted as a merchant bank. Ships cruised from one end of the Mediterranean to the other. They put in at the ports of Constantinople, Alexandria, Thessaloniki, Corinth, Smyrna, Trepizond, Dyrrhachium and Ravenna, loaded with wood and iron, the raw materials for shipbuilding. Ships were constructed by *ploimoktistai* ("shipbuilders") in the shipyards and naval bases of the empire.

*210.* Coin (*follis*) of Constans (A.D. 337-350) with a scene of a warship. Athens, Numismatic Museum.

*211.* Coin (*follis*) of Gratianus (A.D. 367-383) with a scene of a warship. Athens, Numismatic Museum.

210

Constantinople owed its leading position to the empire's extensive network of sea-borne communications and its many ports. It was once described by a poet as afloat between two continents, Europe and Asia, and between two seas, the Mediterranean and the Black Sea. In the 4th century A.D., when Constantinople was founded, there were two very famous port-cities, Alexandria and Antioch. The ports of the "Queen of Cities" gradually developed into international commercial centres, to which led all the sea routes linking the Danubian lands with Asia and Africa. The sea roads (*hygra keleutha*) of Homer, that connected the peoples of the eastern Pontus and those of central Asia, Africa and continental Europe with each other, the silk routes, the trade routes along which travelled perfumes, and all the other commercial arteries, led to the City. Constantinople was port for the trade of the entire world, an active bank, a cosmopolitan city, the major link in the network of maritime and intercontinental communications, an important naval base and customs house that controlled the various luxury products known as "forbidden goods". It inevitably became the capital city – the mind and the heart of the empire, drawing its strength from its position, which gave it complete control of the sea and the traffic that moved upon it.

The belief of the Greeks of the Middle Ages in the power of the sea is registered in a 10th century book of dreams: "You can dream of the sea, the waves, those omens, a wonder from which you can draw power and glory." The

211

171

same view was held by the Arabs, who fought for naval domination. The strong Byzantine belief in the sea as the means of dominating the world is revealed by the words of Nikephoros Phokas to Liutprand, the emissary of the German emperor Otto: *Navigantium fortitudo mihi soli inest* ("I am the sole possessor of naval power").

The dream of the Byzantines became a reality during the period when the *dromons* dominated the sea, setting sail from bases at Abydos, Dyrrhachium, Rhodes, Attaleia, Kalari, Septem and Carthage to control the entire Mediterranean and protect their merchant fleet.

This situation changed in the 7th century, when hostile forces burst into the Mediterranean. Communications and trade between the neighbours of Byzantium were severely damaged at this time. Byzantine control of the sea was put at risk, and a new period was inaugurated in Byzantine history.

The state of the Ommiads, the Caliphate of Syria, which was to threaten the Byzantine empire before the end of the 7th century, came into being with its centre at Damascus in A.D. 645, and was equipped with a fleet from the early years of its history. It contested the coasts and islands of Asia Minor, captured Byzantine Africa and even threatened Constantinople itself. In A.D. 717, when the Arabs laid siege to the "Queen of Cities" by land and sea, the capital survived only thanks to the famous "Greek fire" that destroyed the enemy's ships. The 8th century saw the beginning of a long struggle between Byzantium and the Arabs for domination of the Mediterranean, which lasted for over three centuries, and ended in the partition of the sea between the Cross (north coast of the Mediterranean) and the Crescent (south coast, in north Africa).

The conquest of Byzantine Italy by the Normans in 1071 ushered in a new period in the history of Byzantium. The Norman invasion inaugurated a series of plundering wars waged by Western powers against Byzantium that culminated with the Crusades and the capture of Constantinople by the Franks in 1204. By the terms of the alliance of 1082 between the Byzantine empire and Venice, the Venetians were accorded rights of *isopoliteia* (equality of rights, including that of unrestricted trade and exemption from customs dues), which in time led to the loss of economic independence by Byzantium. The Byzantine fleet lost its ability to intervene as early as the beginning of the 14th century, while the Turkish emirates dominated Byzantine Asia Minor and expanded towards the Aegean. The capture of Constantinople by the Ottoman Turks in 1453 marked the end of the gradual decline of Byzantium.

The Byzantine fleet was called the *Vasilikon ploimon* (Royal fleet), and the overall commander of it originally had the title of *strategus of the Carabisiani* and later, after the 11th century, *drungarius* of the fleet. From the 4th to the 7th century, there was only a single naval force – the fleet of the capital. After the appearance of the Arabs, however, Leo III the Isaurian reorganized the navy and decentralized the naval forces, allocating them to the *themes*, the large administrative districts created by Heraclius; Leo's measures enabled the empire to survive. From the 8th century onwards there are three divisions in the navy: (1) The main, imperial fleet, which consisted of heavy ships, the *dromons*. This was anchored at Constantinople, the capital of the empire, and undertook distant missions, being the fleet of the "open sea". (2) The provincial fleet, *ploimon*, that included light military units. Its mission was to safeguard the coasts of the province, and was essentially a defensive

**212.** *Part of a glass vessel with a scene in a medallion showing Jonah's ship being swallowed by the whale. Gold leaf on glass, 4th century A.D. Paris, Musée du Louvre S 2053.*

formation. (3) The fleet which was found only in the administrative districts that included the coasts of the empire. This fleet, the *stolos*, possessed ships of every kind, including *dromons* and light vessels, and it was equipped and maintained in the provinces. It had bases, shipyards and dockyards, and its crews were drawn from the province in which it was stationed. The Byzantine fleet continued to be organized in this way until the 9th century, and there was a gradual advance in shipbuilding and tactics, especially during the period of Romanos Lakapenos or Lekapenos, and of Constantine Porphyrogennetos. In his book *Peri thematon*, the latter states

173

that the emperor of Byzantium and Constantinople is the lord of all the seas as far as the Pillars of Hercules. The general Katakalon Kekaumenos later recommends that the fleet should be kept in peak condition and at an adequate level at all costs, for it is the glory of Romania (that is, the empire).

Byzantium's strategic position made it the commercial centre of the then known world. The harbours on its coasts evolved into staging posts that served the regions in the interior of the empire. The Byzantine merchant fleet experienced great adversities, but its decline did not begin before the 12th century. It was protected by special legislation, like the merchant fleet of Rhodes before it. Laws such as one forbidding the lending of money at interest were made more flexible to satisfy the shipowners. The maritime trade routes were also protected by the Byzantine fleet at all their sensitive points.

The large ships that had been constructed mainly to transport cargoes of grain from the ports of Alexandria to Rome were no longer needed, since most cargoes were now carried to Constantinople. The new route followed a course between the Aegean islands, and through the narrows into the Golden Horn, for which the ships of the period needed to be smaller and more manoeuvrable. The large ships were cumbersome, and this meant that they were also unable to escape the small ships of the pirates who, in this period and particularly after the 11th century, were a serious menace to seafaring.

These new needs led to the construction of a light, flexible and swift cargo ship, the *dorkon*, which had a capacity of 130-140 tons and lateen (triangular) sails, which were made for easier steering and greater manoeuvrability.

The *dromon*, which made its appearance in the 6th century A.D., was a type of light, flexible,

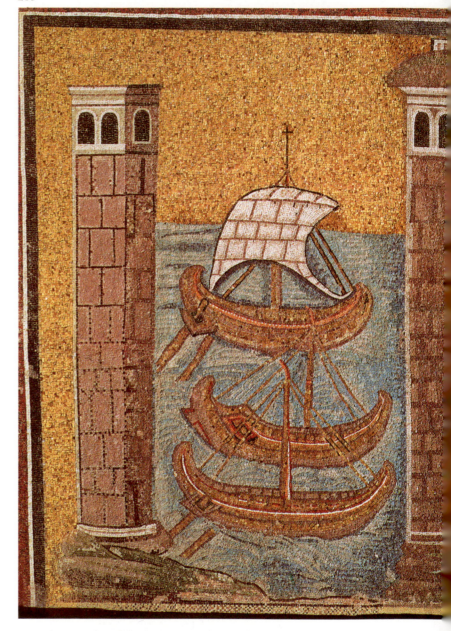

213

oared vessel, with lateen sails and a protective deck over the oarsmen. *Dromons* were mainly warships, though they were also used as merchant on distant voyages. The smallest *dromon* was called a *chelandion*, and the largest *meizon dromon*, while the flagship of the fleet was a *pamphylos dromon*. Very little information is available about the merchant fleet in the Byzantine period, most of it deriving from descriptions in the written sources or references in manuscripts.

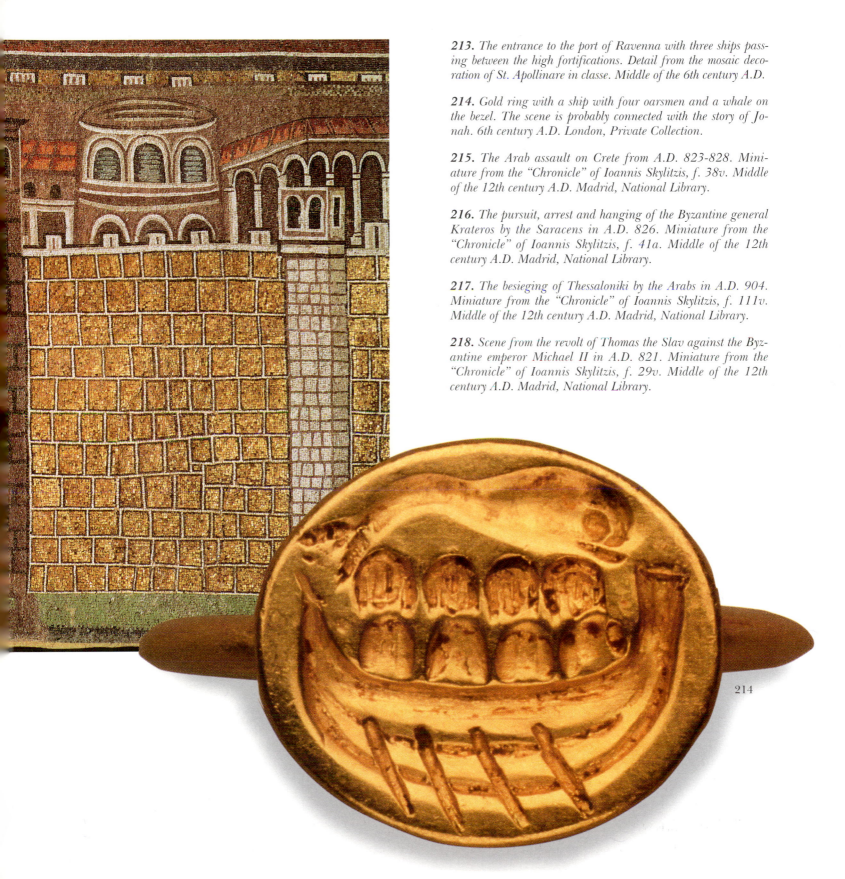

**213.** *The entrance to the port of Ravenna with three ships passing between the high fortifications. Detail from the mosaic decoration of St. Apollinare in classe. Middle of the 6th century A.D.*

**214.** *Gold ring with a ship with four oarsmen and a whale on the bezel. The scene is probably connected with the story of Jonah. 6th century A.D. London, Private Collection.*

**215.** *The Arab assault on Crete from A.D. 823-828. Miniature from the "Chronicle" of Ioannis Skylitzis, f. 38v. Middle of the 12th century A.D. Madrid, National Library.*

**216.** *The pursuit, arrest and hanging of the Byzantine general Krateros by the Saracens in A.D. 826. Miniature from the "Chronicle" of Ioannis Skylitzis, f. 41a. Middle of the 12th century A.D. Madrid, National Library.*

**217.** *The besieging of Thessaloniki by the Arabs in A.D. 904. Miniature from the "Chronicle" of Ioannis Skylitzis, f. 111v. Middle of the 12th century A.D. Madrid, National Library.*

**218.** *Scene from the revolt of Thomas the Slav against the Byzantine emperor Michael II in A.D. 821. Miniature from the "Chronicle" of Ioannis Skylitzis, f. 29v. Middle of the 12th century A.D. Madrid, National Library.*

214

το Ϳϲϲαρ ακηνῶν έξειϲικαταρωμαίων ϲγητῶαυτάρχηπαμρ
μοτμηη κϳ βίροιϲκαιάλλοιϲτ προϲχωρήϲαϲιναϳτῶ·

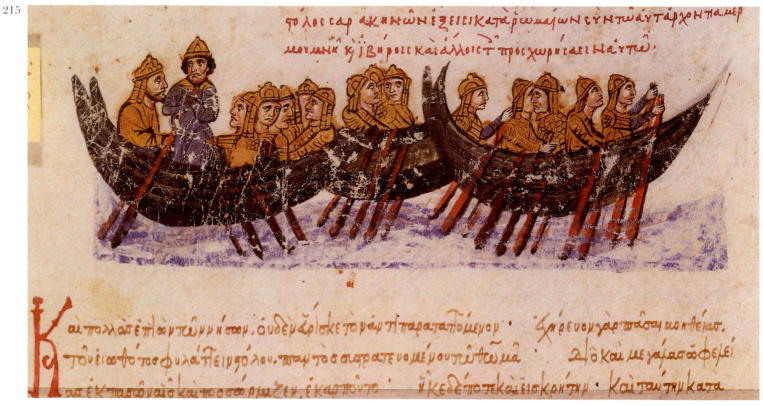

Καιπολλάέπῲρτῶνήϲωον· ούδὲνάρίϲκετονράντ͠ηπαραταπόμενον·     ἐμήρεύονγαρπᾶϲαιμοηθεῖαϲ·
τονέϲωτότοϲφιλάϊπειρϳόλου·παντοϲϲτρατευομένουτῶτῶμᾶ     διόκαιμεγάϲαϲωφελεῖ
αϲέκπαϲὀναϳοκαιτοϲϲάορμιζεν· ἐκαϲρτοϳτο·     ἤκεδέποτεκαειϲιοκρήτην· καϳτανιτηκατα

Μ ομοϲοδϲραϲηϲοϲεμπορικόντιηοϲέπϲαϲπλοίου· τηνορίαμεωντεϲέμμηϲεύϲατο·     ϲωϲϲοϲπολχα
Ἐκτηϲαϲοτοϲροαράκηνϲωαρχηϲοϲ τουτοϲμοιχύριϲκεν· ουῢρτοῖϲϲάϲοιχϲ ουῢρτοῖϲάχιλϲκωτοι
ἐμαϲεϲὁντϲφιλαϲὦχετο· τοϲικαταϲϲύξαρταϲέπεμϲερ· οϲικαϲκαϲαμόηϲϲαϳτουϲἐϳκωϲτην
ϲω· ξϳλωϲκρεμάϲαϲπεϲαϲεκτεϳραϲ
οἰ άϲαϲηνοἱ· Ἀϲοϲαμϲὀϲοϲὁντεϲ· οϳϲϲϲαϲτϲηνϲέϲαμϲϳτοϲκραϲϲϲ·     ξϳλοϲκρεμϲ͠μ

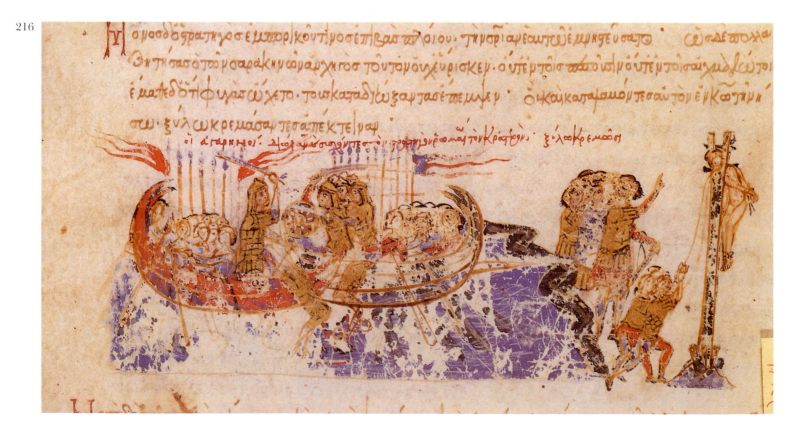

Καὶ λέον τοσ του φραγγουέναωτι· ώχατζιλακιοσ τοεπαγμμον· έχετοδεχιοσαι μαχεωτοχλι·
Καὶ αἰχμάλωσία
ἡ Θεσσα
λονίκη
αχκιλω·
αιρωμε
στόλος αγαρηνών

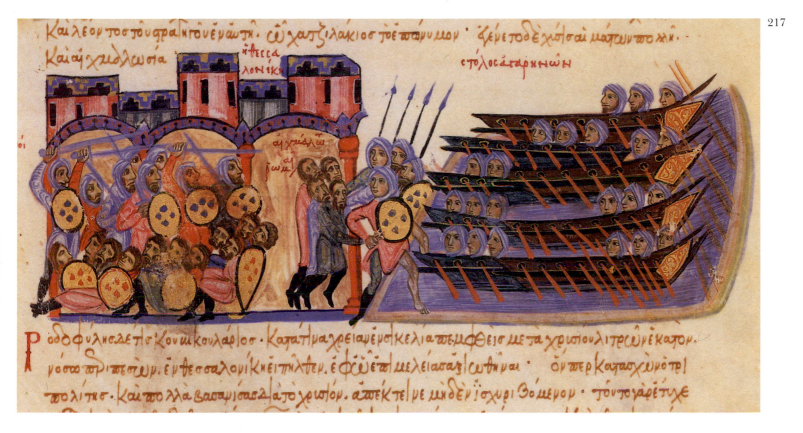

Ρ όδοφυλησδεπο Κομικουλαριοσ· Καραπραχρειαμεροκελιαπεμφθεισ μετα χρυσιουλιτεώρεκατον·
ρ οστοπρισπετωρ. ενθεσσαλονίκη ειπλτερ. εφ᾽ ᾦ επλμελειαπαξιωτῆναι· ὅνπερ καραοχυμοτρι
πολίτησ. Καιπολλαβασαμίσασαπο χρυσίον. απέκτειρε μηδένιοχυρι θομενον· τόντογαρέτχε

αιεπειεφοραθη. μηοιοσ πεωρταορειδηφερειν· δεδοικωσδε και πασεπηρτημεναστεωρ
τοιούτωνπο|Ναστ τολμηταισ. φυγασ προστοισαγαρηνοισυπηρεται·
ὅτωνφαιπερτσφρη

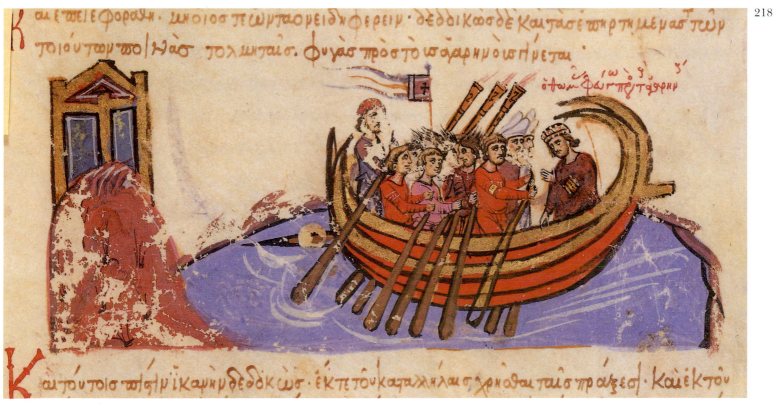

Κ αιτούτοισ πολεμρικαρηνδεδοκως· εκπετουκαταχληλαισχρισθαι παισπραξεσ· καιεκτον

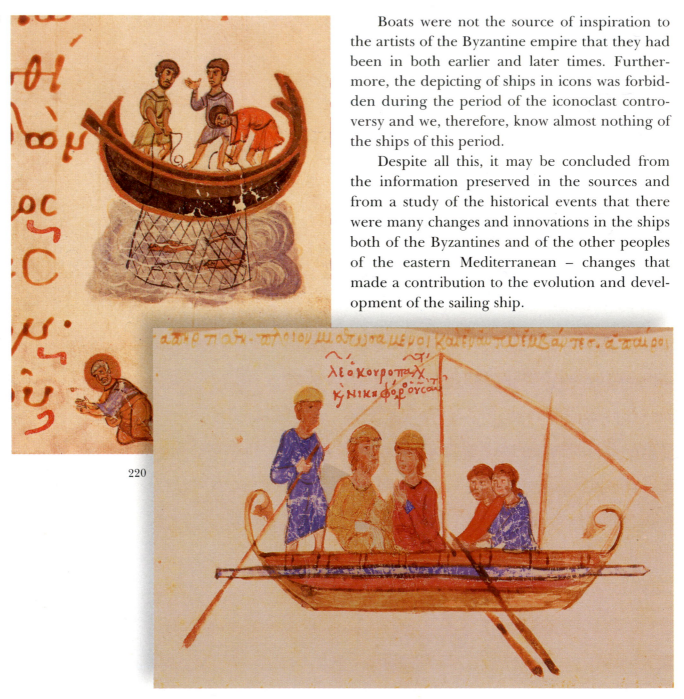

Boats were not the source of inspiration to the artists of the Byzantine empire that they had been in both earlier and later times. Furthermore, the depicting of ships in icons was forbidden during the period of the iconoclast controversy and we, therefore, know almost nothing of the ships of this period.

Despite all this, it may be concluded from the information preserved in the sources and from a study of the historical events that there were many changes and innovations in the ships both of the Byzantines and of the other peoples of the eastern Mediterranean – changes that made a contribution to the evolution and development of the sailing ship.

**219.** *"Hunting for fish". Miniature from a Gospel Book, f. 148a. 13th century A.D. Venice, Greek Institute of Byzantine and Post-Byzantine Studies.*

**220.** *Byzantine ship. Miniature from the "Chronicle" of Ioannis Skylitzis, f. 168v. Middle of the 12th century A.D. Madrid, National Library.*

**221-222.** *Bucolic and marine scenes. Miniatures from the manuscript "Sixteen Speeches of Gregory the Theologian". Mount Athos, Monastery of Panteleimon, cod. 6.*

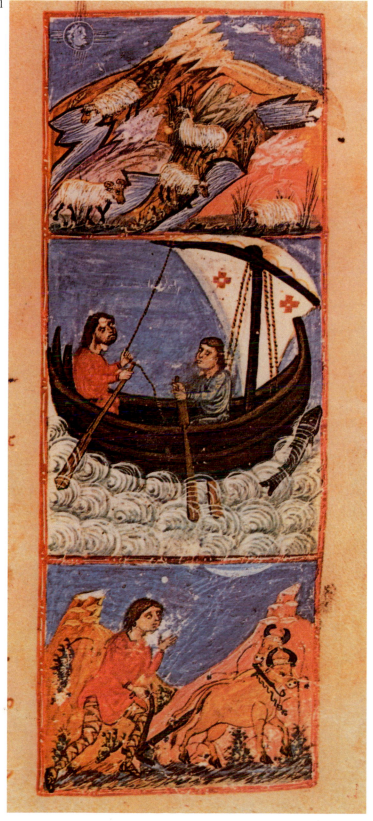

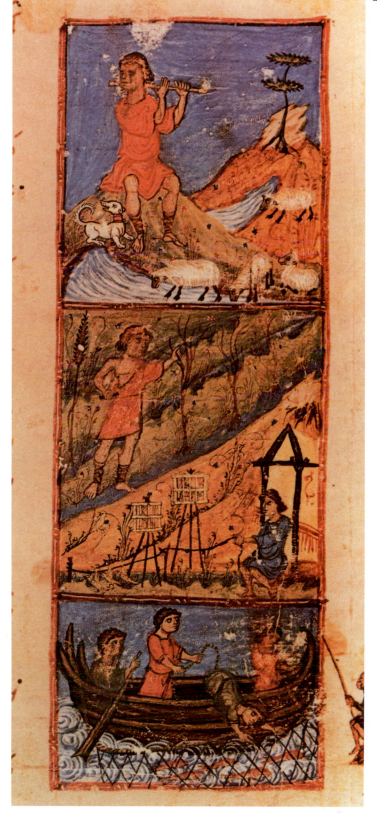

**223.** *St. Mark saves a three-masted ship with an aged priest and three sailors from a storm. Detail of a mosaic from the Basilica of St. Mark in Venice. 12th century A.D.*

**224.** *The arrival of St. Mark in Alexandria. Detail of a mosaic from the Basilica of St. Mark in Venice. 12th century A.D.*

The ship's rudder was an Arab invention that replaced the two side steering-oars of previous times. The evolution of the square sail, too, made it possible to build ships of larger dimensions.

Another kind of sail was the lateen, or triangular sail, the use of which is attested in the 4th century A.D. It is mentioned by Procopius in his description of the Vandal War, and there

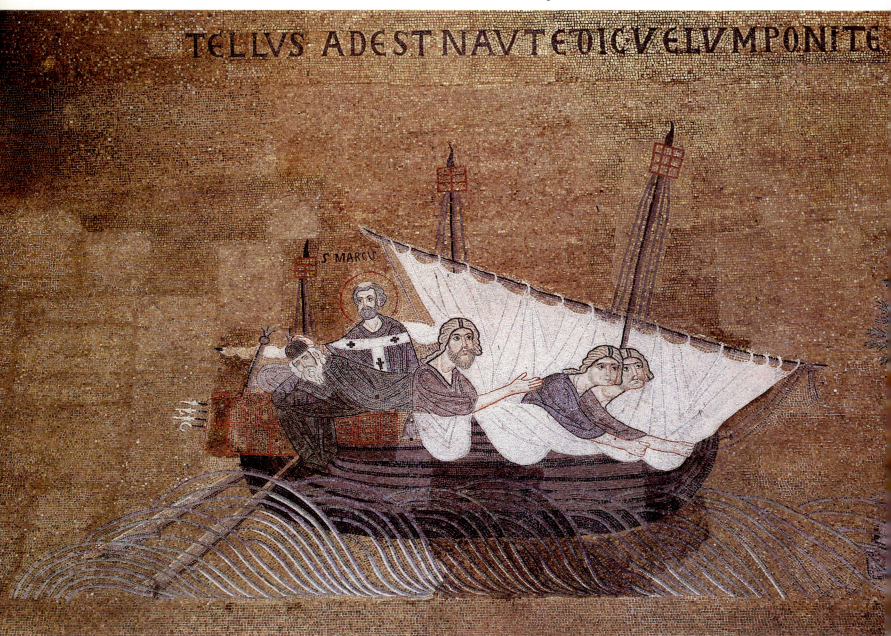

are also several depictions of it. The Byzantines were the first to exploit the advantages of the triangular sail on ships of large displacement. Its use is known from manuscripts and contemporary wall-paintings. The Byzantines referred to all sails as *armena*, and divided them into *armenopoula* (*dolones* and *phlokoi*), and large *armena*. They also distinguished two kinds of *lembos*, or small boat: the boat with three lateen

and churches. In later times too, when Byzantium was no longer the mistress of the seas, the subject of Jonah inspired other peoples, who worked it in glass and ivory, and depicted it in manuscripts.

The ships in these scenes are those of the artist's own time, and the episode of Jonah's body and the whale is invariably given a realistic treatment. Another subject drawn from the

23    224

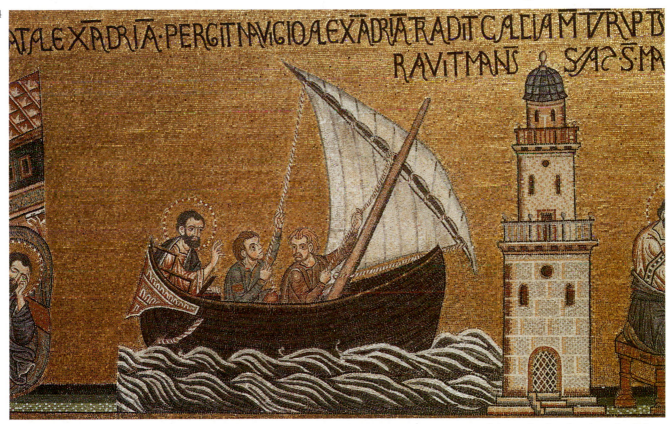

sails (*lembos triarmenos*) and the *lembos-lateen*, or lateen skiff.

The main source of subjects for the art of this period was religion, and representations of ships in wall-paintings and mosaics are therefore usually associated with passages from the Old and New Testament. The prophet Jonah and the sea were often a source of inspiration for painters and artists after the 4th century (fig. 209, 212, 214), who rendered this symbolic subject in mosaic floors, on walls, in catacombs

Old Testament, Noah's Ark, is depicted either as an open square box, or as a huge ship.

In the Early Christian period the sea and its world make their appearance in mosaic floors (fig. 207, 209), as well as maps on which the positions of the famous cities of the period are marked. A variety of scenes relating to the sea was carved on the obelisk that was taken from Egypt during the reign of the emperor Theodosios and erected in the great Hippodrome in Constantinople. One side has a scene showing the obelisk being carried

**225.** *The miracle of St. Nicholas, detail of a wall-painting. A.D. 1310-1320. Thessaloniki, Church of Ayios Nikolaos Orphanos.*

**226.** *The personification of the sea, detail of the wall-painting of the Last Judgement in the church of Panayia Forviotissa. Cyprus, Asinou, 14th century A.D.*

in a specially built boat. The huge monument began its journey at Karnak in the reign of Constantius II (A.D. 337-361), was brought to Alexandria, where it was loaded onto the ship which was then compelled to put in at Athens by a great storm. There it remained until the reign of Theodosios, when it again set out for Constantinople. At this period ships conveyed not only merchandise from one country to another, but also the works of art created by different civilizations.

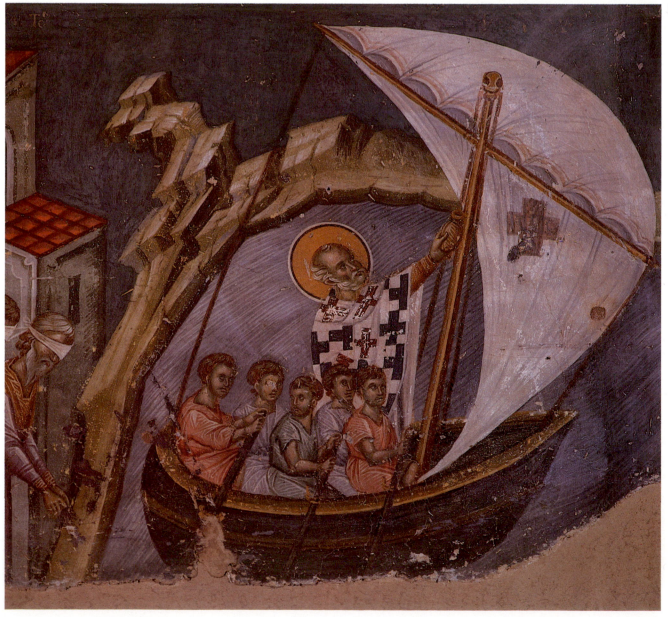

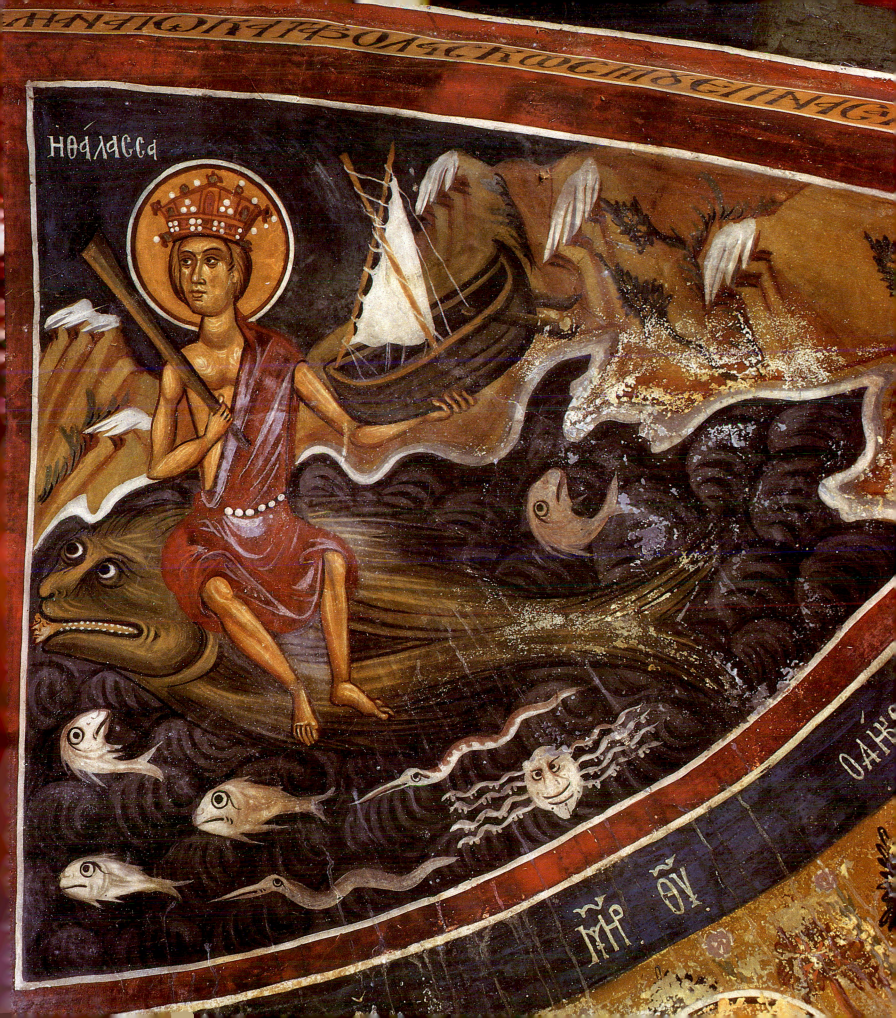

Ηθάλασσα

ΜΡ ΘΥ

ΘΑ...

227

The entrance to the port of the fortified city of Ravenna adorned the walls of Saint Apollinarios in the harbour (*St. Apollinare in classe*). The buildings of the city can be seen projecting above the walls, and three boats are passing on the sea, one with its sails swollen by the wind. Beautiful, delicate pebbles are used to shade the various planes and add an element of perspective, in a superb example of the art of the reign of Justinian (fig. 213).

A few centuries later, another artist used similar materials to immortalize scenes from the life of Saint Mark (fig. 223-224) and of Christ and the Apostles, as well as Christ's miracles on the walls of the church of Saint Mark. Manuscripts recording a variety of Chronicles also contain illustrations of historical events such as sieges of cities or harbours (fig. 215-222). The artist remains true to the text and reproduces the ships in great detail, whether they be those of the Byzantines or of their enemies. The manuscript containing the "Homilies" by Gregory Nazianzenos (Paris, National Library no. 510), is adorned by ninety-three miniatures which are of importance mainly for the mythological elements and the rural scenes that they contain. In them can be found detailed renderings of fishing boats and merchant ships travelling amidst the world of the sea.

A variety of different kinds of ships and small boats are preserved in a large number of icons of Saint Nicholas, the "most nautical of the Saints", in which scenes from his life are

**227.** *Early majolica plate*
*with a scene of a Byzantine ship with two masts and triangular sails. About A.D. 1200. Corinth, Archaeological Museum C-38-521.*

**228.** *The Last Judgement, icon with the Deesis, the Judgement of the World and a Band of Saints. Egg-tempera on wood, middle of the 14th century A.D. Athens, Kanellopoulos Museum 96.*

**229.** *The personification of the sea, a half-naked female figure on a whale holding a ship in her hands. Detail of fig. 228.*

228

illustrated (fig. 225). They sail under his protection, sometimes with tall masts, sometimes with sails swollen by the wind, and sometimes in the waves. Ships are also depicted in icons of the Last Judgement (fig. 226, 228-229); in other icons, boats are blessed by the Virgin, as they spread their sails and set out on a voyage (fig. 230-231). On ceramic plates (fig. 208, 227), coins (fig. 210-211) or lamps, ships sail for some port, bearing to the present day the produce of a great period of Greek civilization.

229

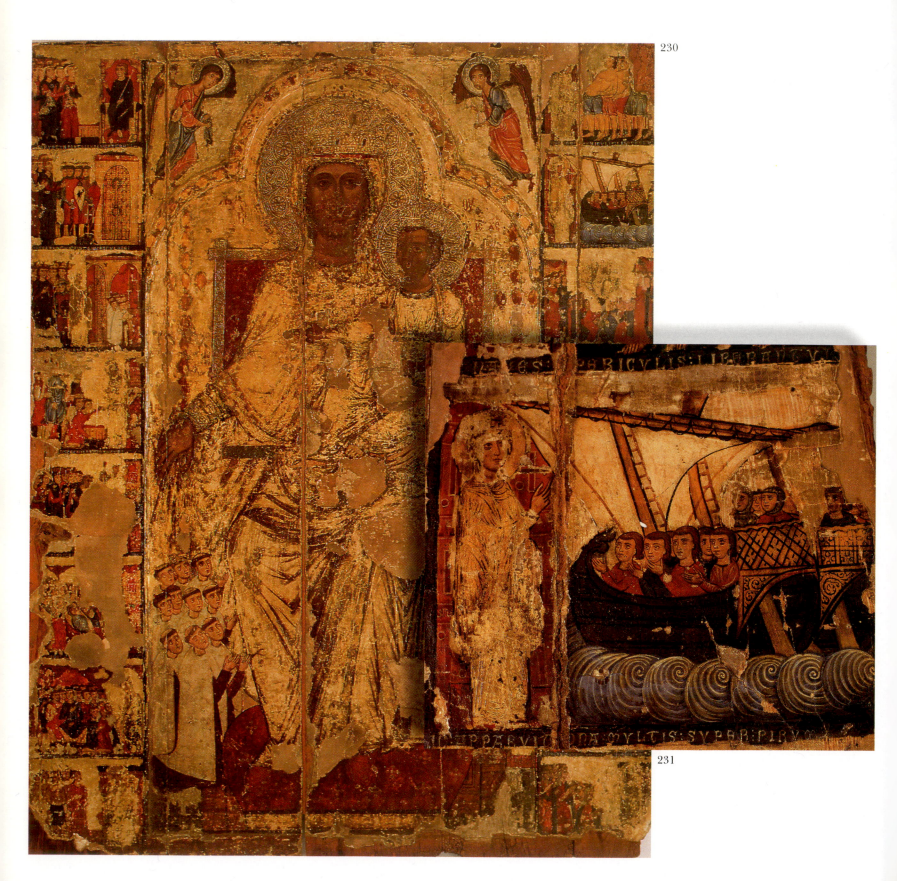

230

231

# THE GREEK SEAFARER
# IN THE POST-BYZANTINE PERIOD

The Greeks, a seafaring people, continued to travel the sea, to tame it, and to make themselves masters of its routes, even after the conquerors had subjugated their land. In the post-Byzantine period, two city-states, Genoa and Venice, fought for sovereignty, ploughing the sea and attempting to assert their supremacy over it. So, too, did Islam. Western Christendom fought the Ottoman Turks who set out from the cold deserts of Asia and succeeded in encircling the eastern Mediterranean and conquering part of Europe for a long period.

In the post-Byzantine period the Mediterranean, the birthplace of ancient civilizations, was no longer the centre of the world. Activity now reached beyond it. Greece, anchored to her geographical space (fig. 234), with a mature civilization, bowed the knee to the conqueror for four hundred years. After their capture of Constantinople (fig. 232-233), the Turks proceeded to complete their subjugation of the whole of Greece and the Balkan peninsula, in which Greek Orthodox civilization was predominant. Four hundred years later, when the Ottoman Turks were obliged to withdraw from this territory, Greece was able to rediscover herself and recover from this long period of imprisonment, thanks to her cultural heritage.

During these years, the struggle between a naval power and a land power that had been played out earlier between Greece and Rome, was re-enacted, the protagonists on this occasion being the Greeks and the Ottomans. The Ottoman Turks, a rising power with a completely alien civilization, subjugated a people inextricably connected with the boundless sea, from the Aegean to the shores of Phoenicia and further afield, to India and the Pillars of Hercules. Greece's relationship with the sea is eternal, but always fresh and young. It is the same

*230. The Virgin and Child from the church of St. Kassianos in Nicosia. Late 13th century A.D. Nicosia, Byzantine Museum of the Makarios III Foundation.*

*231. Detail of the ship in fig. 230.*

relationship described by Homer and has survived until the present day, the epoch of the astronaut and space travel.

The Fourth Crusade in 1204 basically marked the beginning of the end for the Byzantine empire. Under the leadership of the Venetians and with the blessing of the Pope, the Crusaders overcame the Byzantine defences and made themselves masters of the empire. The recovery of Constantinople by the Byzantines in 1261 did not essentially change the situation, since the Venetians and the Genoese controlled trade. Many of the fortresses in Greece, moreover, were in the hands of the Venetians and/or Greek royal houses, who were independent of the empire, and at the same time the Serbs and Bulgars occupied sizeable areas of it in the north. Byzantine sove-

**232.** *Sailing ships in the Bosporus, detail of fig. 233.*

**233.** *Constantinople. Copperplate engraving, by B. Hogenberg, 1574. Athens, Private Collection.*

**234.** *Map of Greece. Copperplate engraving with later colouring, by Ortelius, 1595. Athens, Society of the Greek Literary and Historical Archive.*

**235.** *The north part of the city of Rhodes with the Tower of St. Nicholas and the Palace of the Grand Master in 1480. Miniature from the manuscript "Obsidionis Rhodiae urbis descriptio" of G. Caoursin. Paris, National Library.*

reignty had now come to an end. The Italian city-states were the new lords of the commercial sea routes.

Palaiologan art travelled to the West along these routes, as booty carried by the conquerors, or as gifts, or as an object of trade. In the city of Florence, in 1438, despite the failure of the Catholic and Orthodox churches to unite, a lively interest was shown in the empire as it succumbed. In Mystras, the last bastion of the Byzantine empire, art and philosophy gave their best. The great teacher, Gemistos Pletho, attempted to revive the teachings of the ancient philosophers, on which the edifice of Byzantium was erected. The seed sown by him bore fruit somewhat later, with the renaissance of the West through the Byzantine and Greek heritage.

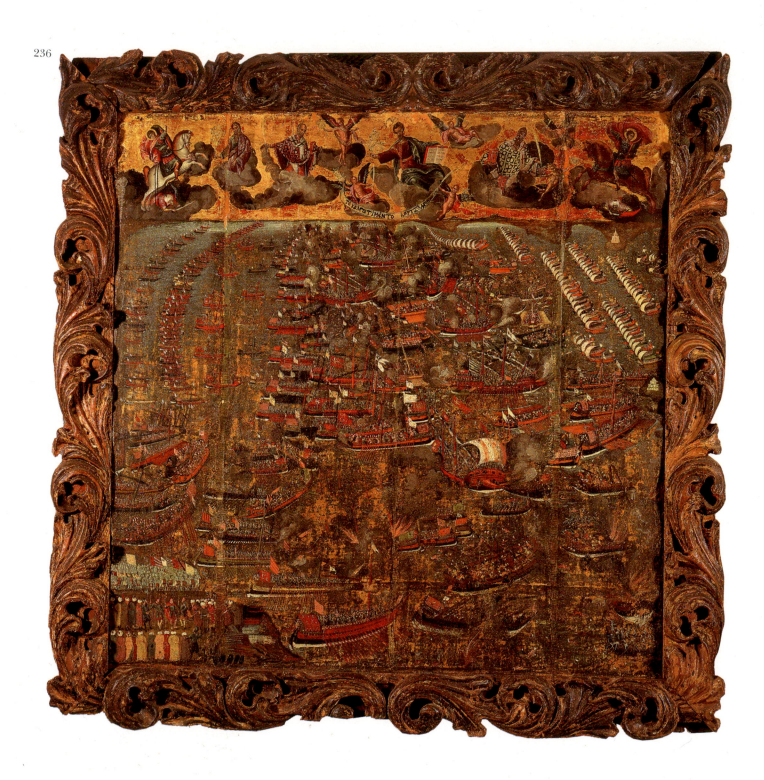

**236.** *The battle of Lepanto, 1571, between the Christian powers and the Ottoman Turks. Egg-tempera on wood, 1571-1608, probably by G. Klontzas. Athens, National Historical Museum.*

**237.** *Detail of fig. 236 showing the famous large Venetian galleens attacking the ships of the Ottoman fleet. The entire composition may be regarded as an anthology of warships.*

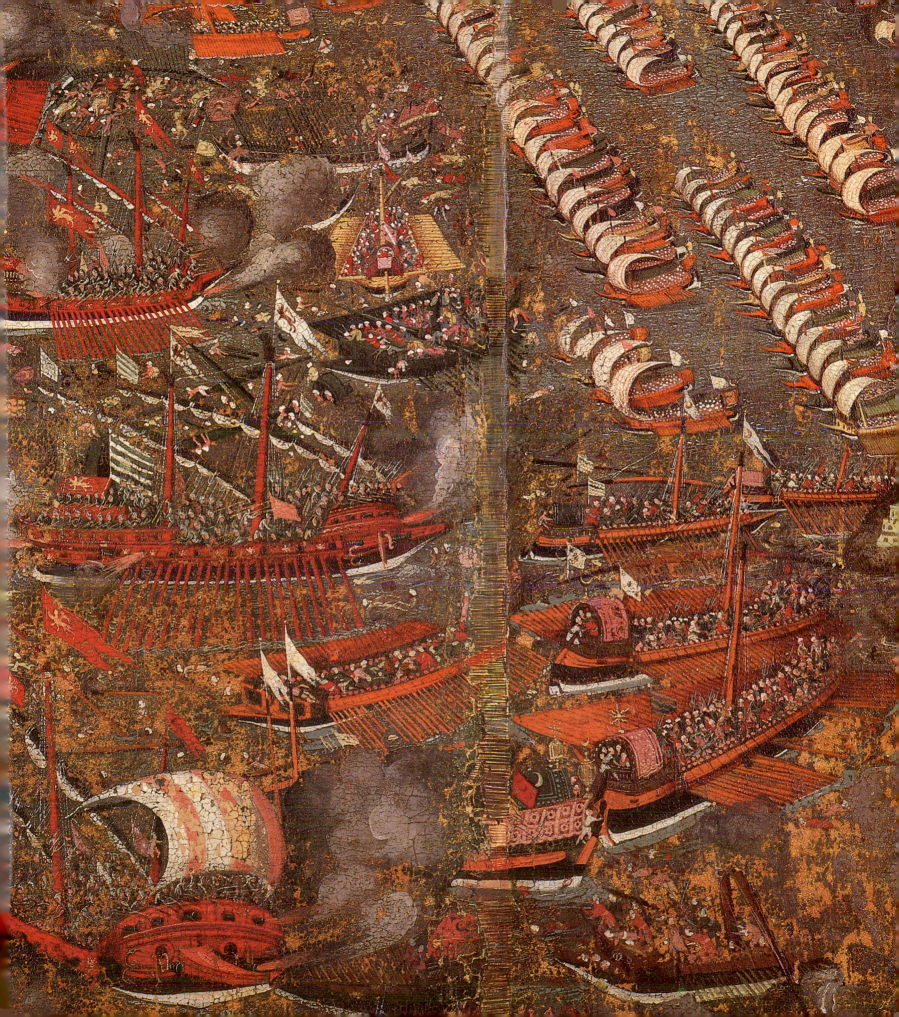

The fall of Constantinople to the Turks in 1453 marked the end of the Byzantine world. The Greek mainland and the Peloponnese fell into the hands of the Ottomans, while other parts of the empire, such as Crete (fig. 239-243), Cyprus, Euboea, the Ionian islands, and a number of ports, including Naupaktos, Nauplion, Methoni, Koroni and Monemvasia found themselves under the Venetian yoke. Chios was occupied by Genoa, and Rhodes by the Knights of Saint John (fig. 235).

The Ottoman conquest was brought to completion in 1715, with the defeat of the Venetians, after a long and exhausting period of warfare. The fall of Rhodes in 1522, and of the castles of the Peloponnese and Cyprus in 1571 deprived the Venetians of control of the eastern Mediterranean.

In the post-Byzantine period, Hellenism lived under Turkish influence and Latin, mainly Venetian, supremacy. Despite the fact that they were under the suverainty of the great naval powers of the West, the Greeks continued their seafaring activities in some parts of the Aegean, mainly using small boats that they constructed themselves with great difficulty.

238

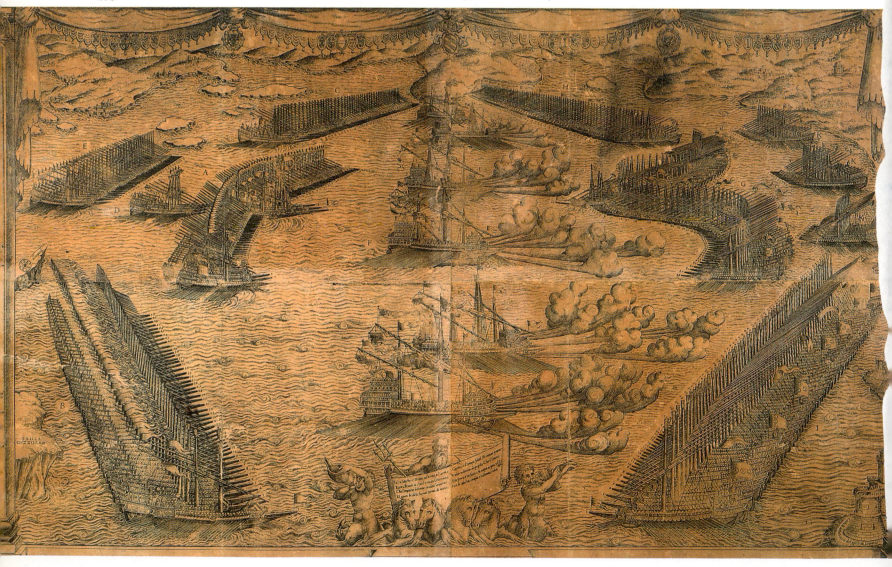

239

**238.** *The battle of Lepanto (Naupaktos), 1571. Wood-engraving by Bonastro, pupil of Domenikos Theotokopoulos (El Greco). Athens, National Historical Museum 4669.*

**239.** *The routing of the Ottoman naval forces by Francesco Morosini at Fraskia, south of Crete, 1668. Copperplate engraving. Herakleion, Historical Museum of Crete.*

**240.** *View of Candia (Herakleion). Copperplate engraving, 17th century. Herakleion, Historical Museum of Crete.*

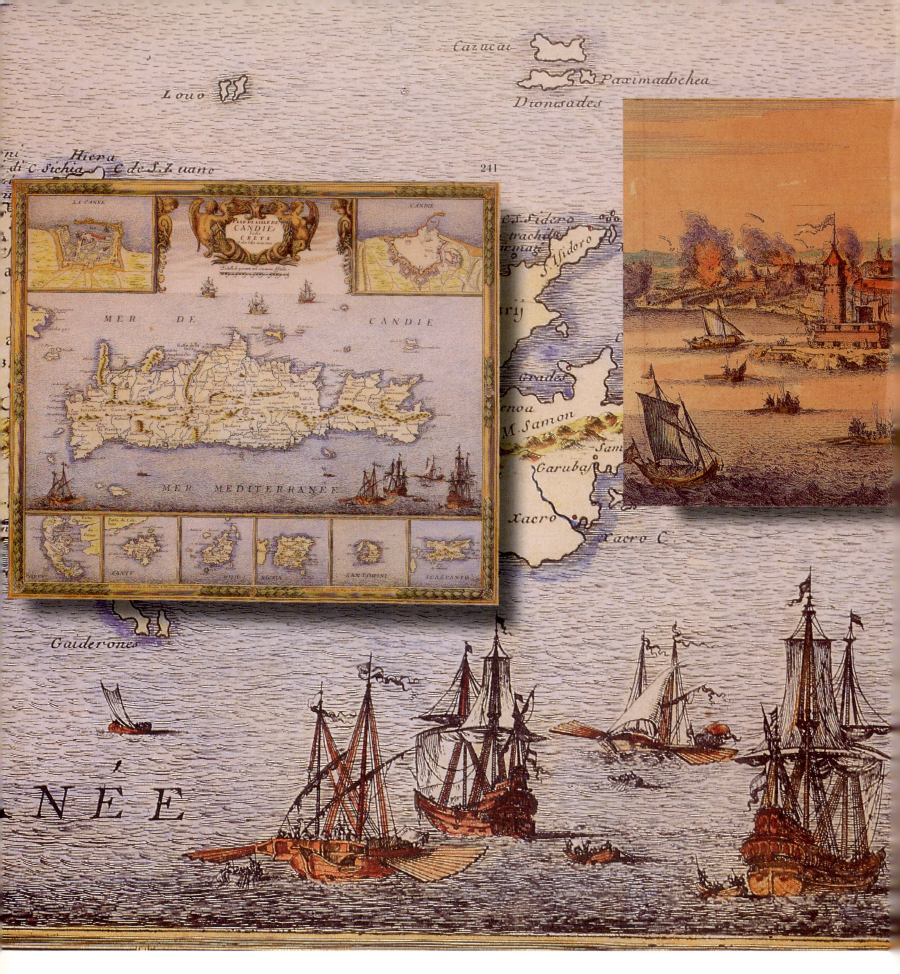

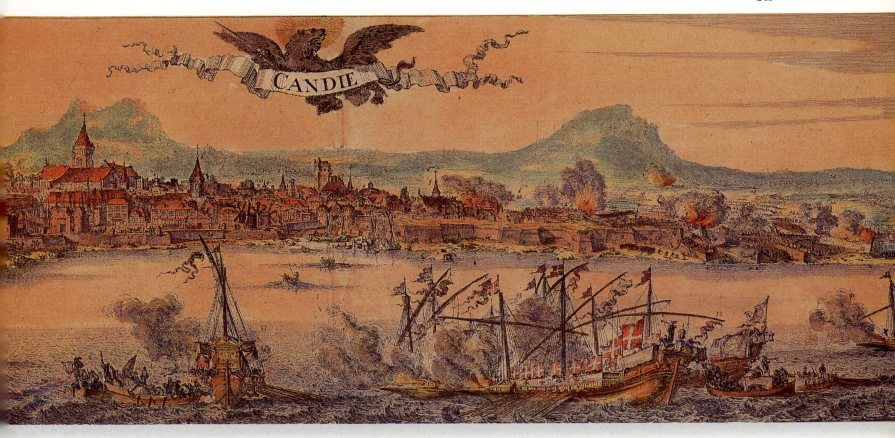

241. *Map of Crete and the surrounding islands. Piraeus, Greek Naval Museum.*

242. *Detail of fig. 241.*

243. *View of Candia (Herakleion) from the sea. Copperplate engraving with later colouring, 17th century. Herakleion, Historical Museum of Crete.*

The Venetians were lords of the sea until 1715, their main sphere of action being the Aegean, which belonged to the Duchy of the Aegean until 1637. They lost their possessions when the fearsome pirate Hairedin Barbarossa drove them out with the support of the Sultan. Only the Ionian islands remained under Western control, to form part of the modern Greek state much later, in 1864.

For the most part, the Greeks coexisted peacefully enough with their Latin conquerors. Despite all their differences of religious belief, they had a common foe in the expanding power of the infidels and the fearful storm of the pirates. For at this period piracy continued to be the scourge of the Aegean, with many of the islands becoming nests of pirates. Piratical raids alternated with invasions by the Vandals, Arabs, Venetians, Franks and Ottomans. Piracy was not a profession reserved exclusively for eastern peoples, but was also practised by westerners. The pirates of the west, indeed, frequently received titles of nobility in return for the assistance and services they offered to western monarchs.

The inhabitants of the coastal cities and the Aegean islands underwent indescribable suffering at the hands of the pirates. Ios was reduced to ruins in 1528 by fourteen Moslem pirate galleys, Samos was deserted for a hundred years, Aegina was devastated by Hairedin Barbarossa in 1537, and in 1570 the Algerian pirate Kemal Reis, known afterwards as Kapudan Pasha, ravaged Skiathos, Skopelos and Kythera.

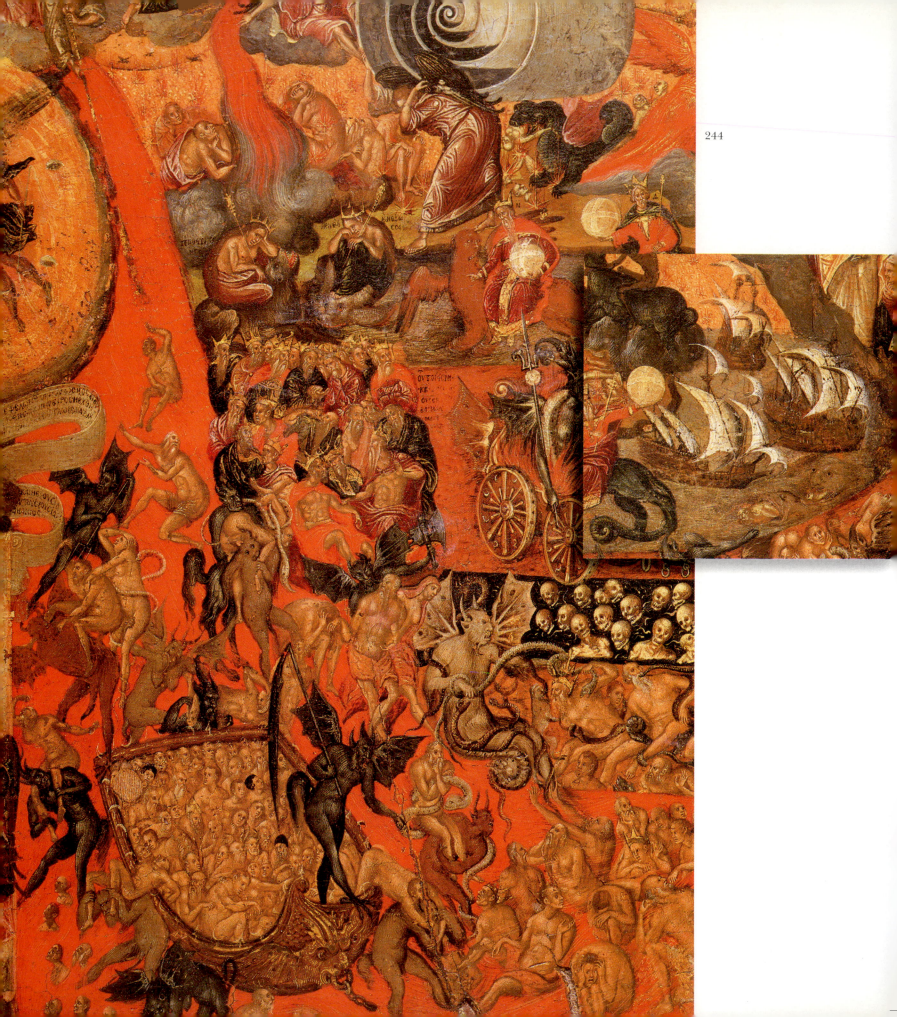

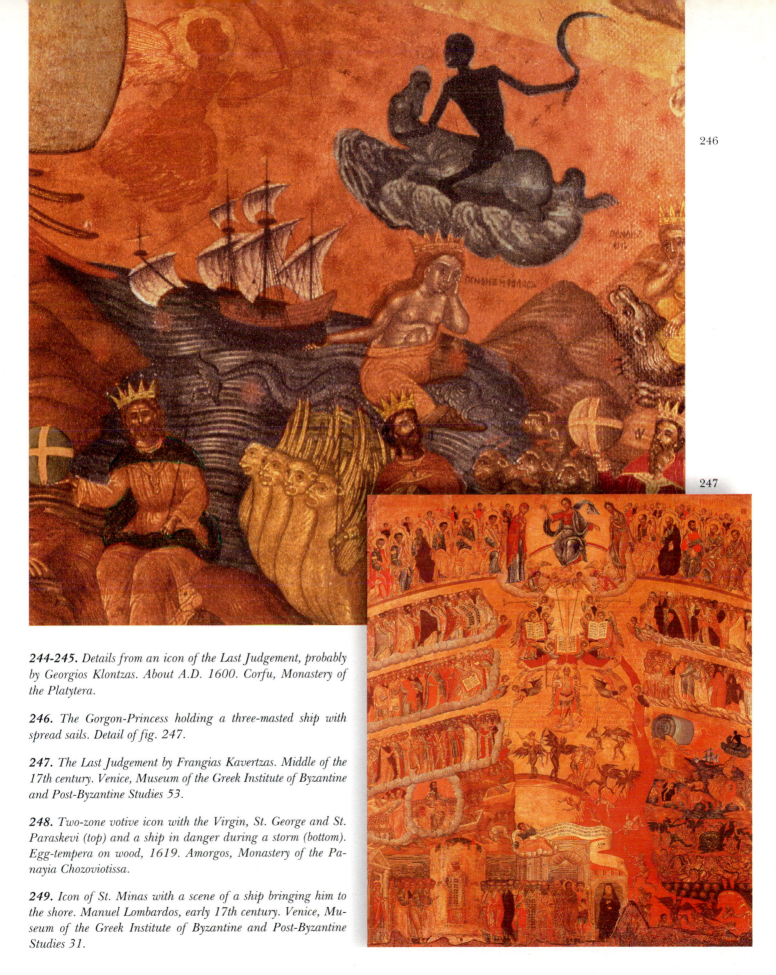

**244-245.** *Details from an icon of the Last Judgement, probably by Georgios Klontzas. About A.D. 1600. Corfu, Monastery of the Platytera.*

**246.** *The Gorgon-Princess holding a three-masted ship with spread sails. Detail of fig. 247.*

**247.** *The Last Judgement by Frangias Kavertzas. Middle of the 17th century. Venice, Museum of the Greek Institute of Byzantine and Post-Byzantine Studies 53.*

**248.** *Two-zone votive icon with the Virgin, St. George and St. Paraskevi (top) and a ship in danger during a storm (bottom). Egg-tempera on wood, 1619. Amorgos, Monastery of the Panayia Chozoviotissa.*

**249.** *Icon of St. Minas with a scene of a ship bringing him to the shore. Manuel Lombardos, early 17th century. Venice, Museum of the Greek Institute of Byzantine and Post-Byzantine Studies 31.*

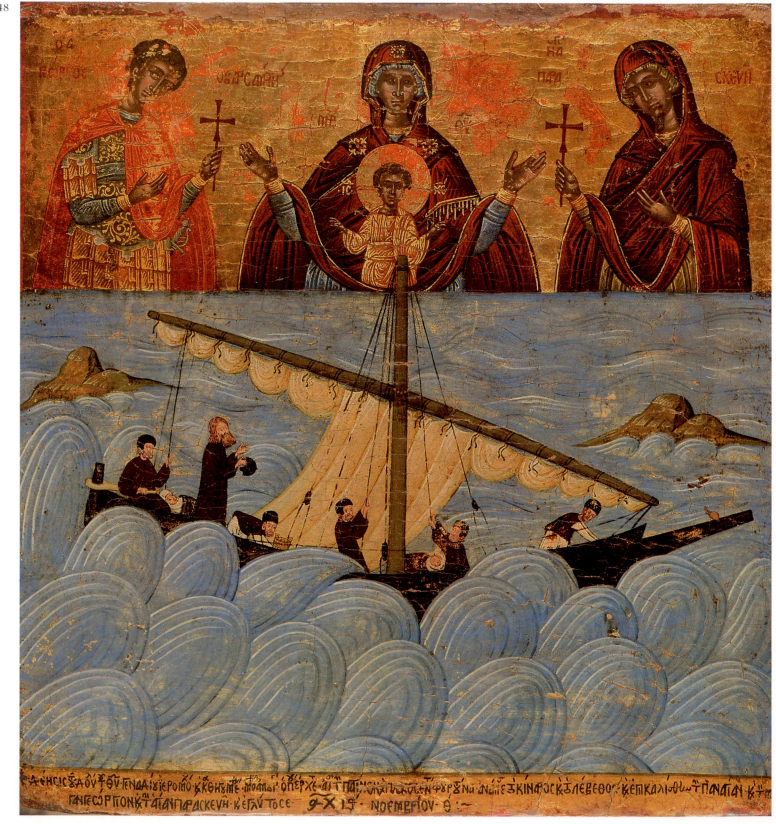

The pirates, who were popularly known as *spantitoi* (bandits), *barabaressoi*, *palikaria*, Algerians, or Corsairs, became "heroes in power" at this period in the Aegean. The growth of piracy on the Greek seas obliged the Greek islanders, the shipowners and the sailors to arm their ships with cannon, and to practise methods of warding off piratical attacks. The sense of outrage inspired by piracy and the abuse of land and life led to a serious attempt to deal with the problem. Anti-pirate galleys or fishing boats were built and armed, the expenses for their maintenance being shared by the trading islands of the Aegean.

In their geographical space, the Greeks had to deal on the one hand with the pirates and on the other with the great powers of the time (the Venetians, Russians, Turks, Franks, Dutch and Anglo-Saxons), and also the conflicts between East and West. This space belonged to them, however, even though the trade routes at this period were dominated by foreign rulers. The special relationship between the Greek and the sea, and his inventive genius led him once more, amidst repeated disasters, to devise all kinds of defensive strategies. Initially, he sought, through his knowledge of the sea, to make himself indispensable to the powers of the period, serving in the Venetian and Ottoman fleets. In the shipyards, it was the Greek who built the ships, using his experience and knowledge.

The struggle between the Great Powers for possession of the islands of Greece and control of the sea routes was ultimately beneficial to the Greeks, especially from the 18th century onwards. The sailors of the islands became acquainted with the new technology through their contacts with other seafaring peoples, and in time changed the design of their ships, producing some notable examples of the latest technological advances. The art of shipbuilding contin-

ued to play an important role, and ships built by the Greeks were famous, especially in the period immediately prior to the Greek Uprising.

Through having to face the dangers of the sea, the Greeks succeeded in acquiring expertise in techniques useful from this point of view. Through having to repel pirates, they became famous as raiders and experts in breaking blockades, and this experience proved invaluable when the national liberation struggle began in 1821. And through taking part in the military enterprises of the Great Powers, they also acquired new knowledge of a variety of naval matters. They learned how to build and use swift, manoeuvrable ships and to adapt them successfully to new technological advances.

**250.** *"The miracle of Kephallonia", icon of 1628. Athens, Byzantine Museum T 787.*

**251.** *Two-zone icon with the Virgin and Child (top) and the rescuing of Master Ardavanis from shipwreck (bottom). Egg-tempera on wood, 17th century. Athens, Byzantine Museum T 781.*

250

251

There are three landmarks in the history of the evolution of ships in the Mediterranean prior to the advent of steamships and iron vessels: the use of a steering oar with a tiller in the 12th century, the clinker-built boat about the 14th-15th centuries, and the ship of the line from the 17th century onwards.

The steering oar with a tiller, the first major discovery in seafaring, is the rudder with which we are familiar. From the 16th century onwards, it was equipped with a wheel which allowed the helmsman to control its movement. This new type of rudder made it easier to sail against the wind, and made it possible

252

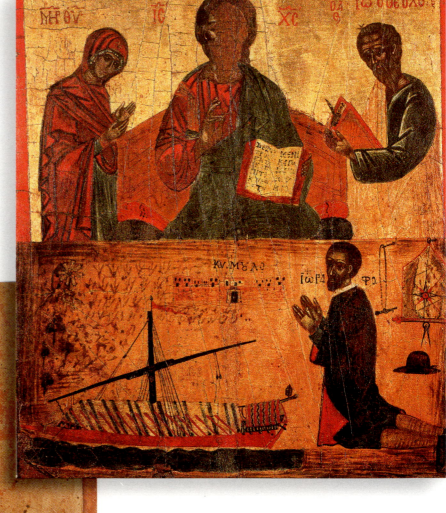

**252.** *Detail of a galley from the icon with the Virgin (Madonna del' Orto), 1648. Corfu, Church of the Panayia ton Xenon.*

**253.** *Two-zone icon with Christ, the Virgin and St. John the Theologian (top) and the Miracle of Kimolos (bottom). Egg-tempera on wood, 17th century. Athens, Byzantine Museum T 783.*

**254.** *Three-zone icon of St. John Chrysostomos and the removal of his remains. 17th century. Athens, Byzantine Museum T 794.*

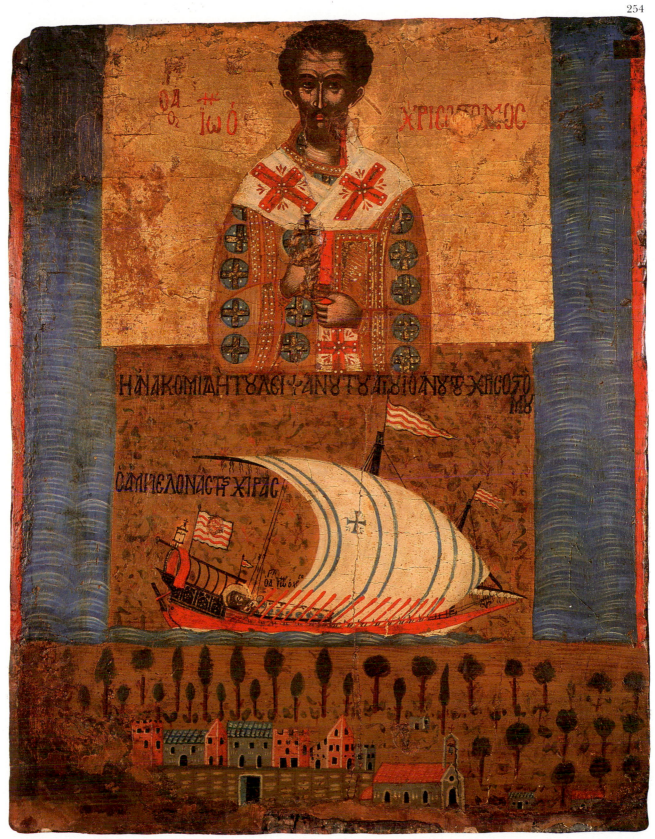

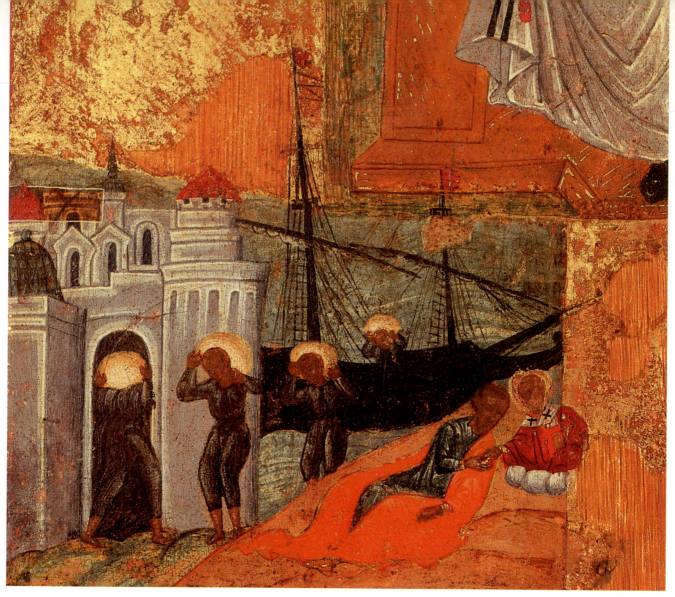

255

for the cannon to fire from the sides of the ship.

The second discovery came from the northern seas. The new type of vessel was a fairly large transport ship weighing hundreds of tons, which later became even bigger. Its characteristic feature was that the timbers of the hull overlapped each other, just like schist slabs on roofs. This made these ships stronger than the traditional round boats, so that they could withstand large waves and the bad weather in winter. This permitted regular communications, which led to a revolution in transportation of goods.

The Mediterranean became full of all kinds of vessels. Genoese *karakes* were sometimes as large as 1,000 or 1,500 tons. These were the giants of the inland sea. The sailing transports of Ragusa approached 1,000 tons in the 16th

century, and carried the heavy, bulky cargoes: seeds, salt, bales and iron, which were transported to the Sea of Marmara or to Varna on the Black Sea.

These large ships travelled as far as England and Flanders and were lords of the sea in the 15th and 16th centuries, though they declined in the 17th.

The third change was the replacement of the galley by the ship of the line. Its future had already been threatened, however, in the time of Don John of Austria. In the famous sea battle of Lepanto, Naupaktos (7-10-1571), in which five hundred Turkish and Christian ships were drawn up against each other, 250 on each side, the galley made its final triumphant appearance (fig. 236-238).

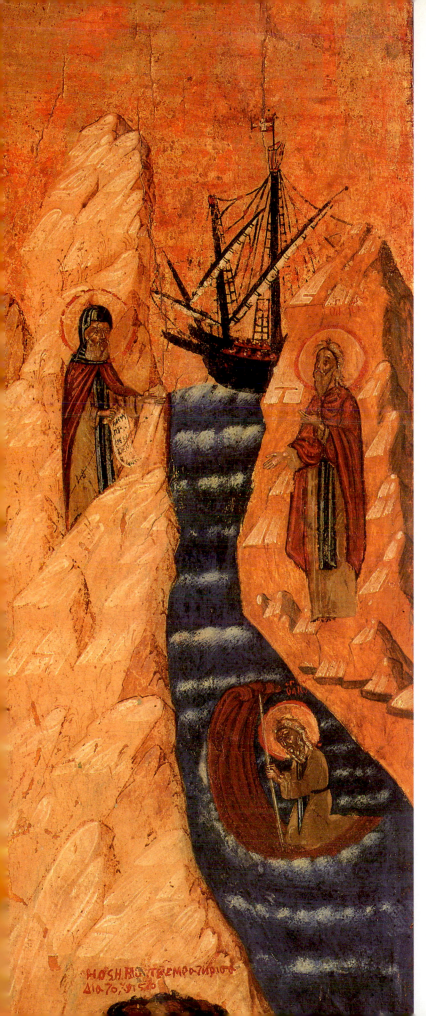

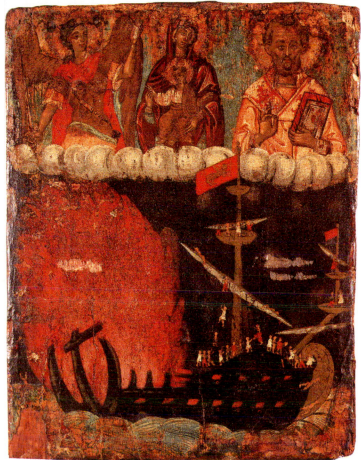

**255.** *Scene of a ship, detail from an icon of St. Nicholas with four scenes of his miracles. Second half of the 17th century. Athens, Kanellopoulos Museum 117.*

**256.** *Three-masted boat with its sails furled, detail from an icon of St. John the Hermit with scenes of his life. Second half of the 17th century. Athens, Byzantine Museum T 124.*

**257.** *Two-zone icon with the Virgin, the archangel Michael and St. Nicholas (top) and the blowing up of a Venetian ship (bottom). 18th century. Athens, Byzantine Museum T 1636.*

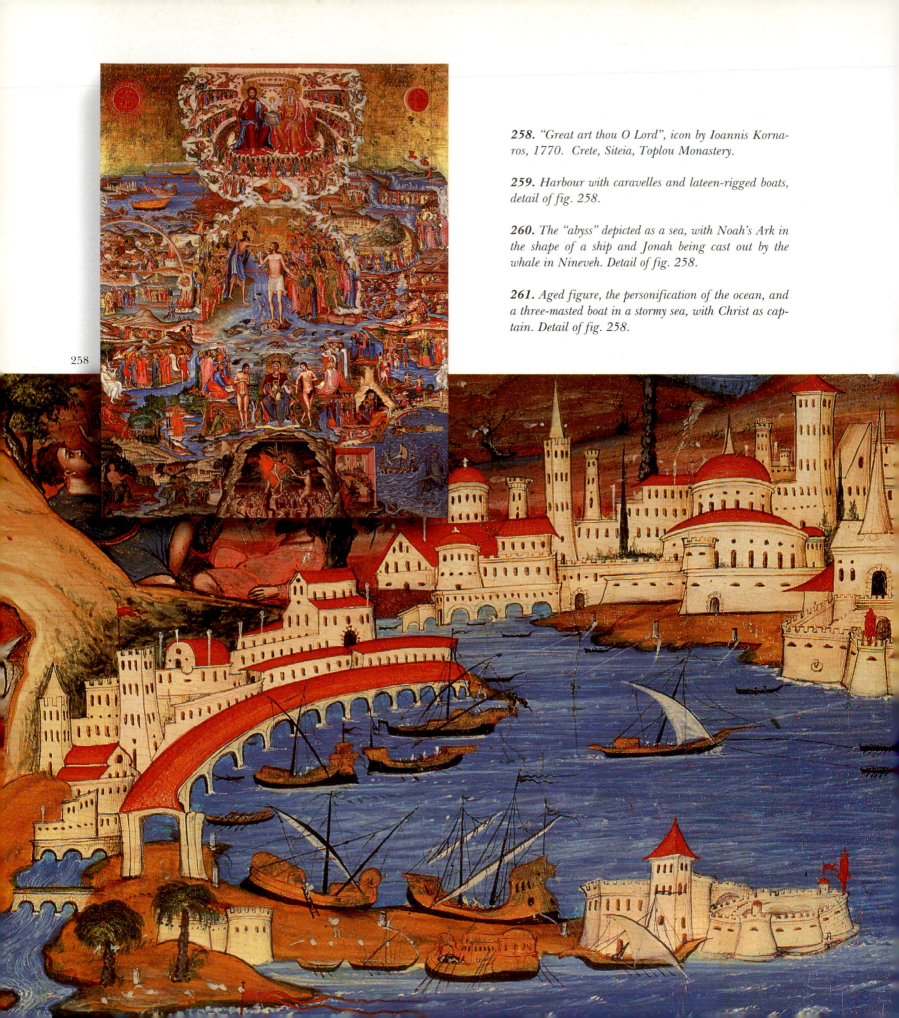

**258.** *"Great art thou O Lord", icon by Ioannis Kornaros, 1770. Crete, Siteia, Toplou Monastery.*

**259.** *Harbour with caravelles and lateen-rigged boats, detail of fig. 258.*

**260.** *The "abyss" depicted as a sea, with Noah's Ark in the shape of a ship and Jonah being cast out by the whale in Nineveh. Detail of fig. 258.*

**261.** *Aged figure, the personification of the ocean, and a three-masted boat in a stormy sea, with Christ as captain. Detail of fig. 258.*

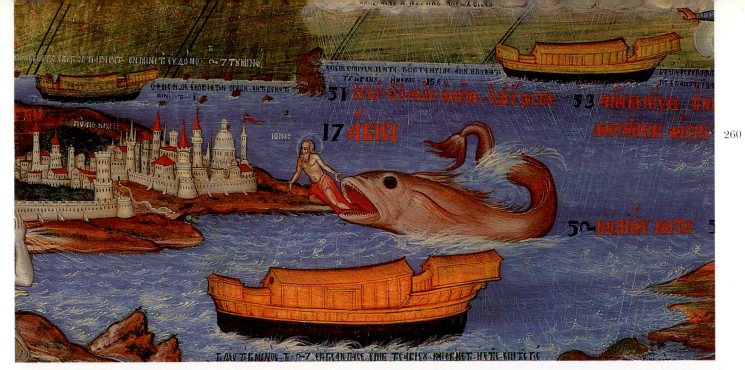

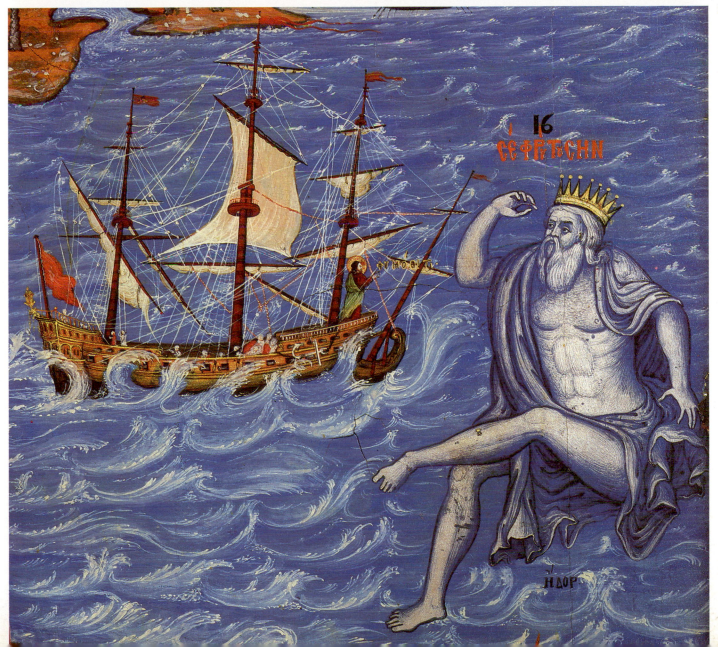

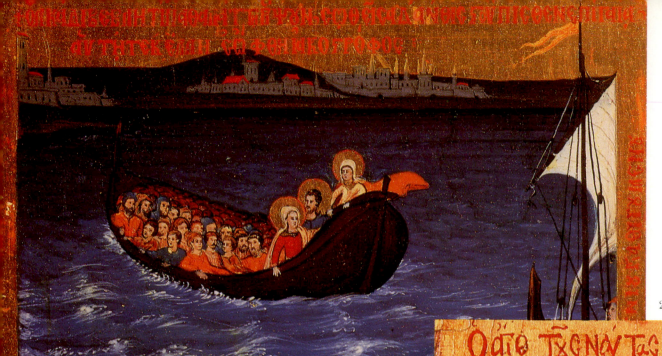

262

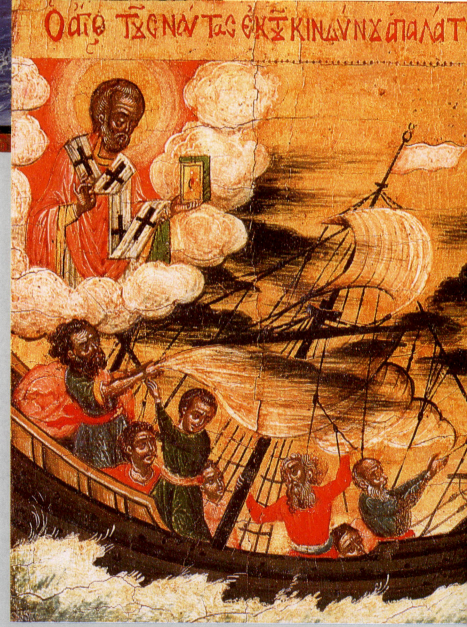

263

**262.** *Detail of an icon of St. Anastasia Farmakolytria by Ioannis Kornaros, 1765. Crete, Siteia, Toplou Monastery.*

**263.** *Ship in a storm, with the patron-saint of sailors. Detail of an icon of St. Nicholas enthroned with scenes from his life by Th. Poulakis, 17th century. Corfu, Museum of the Panayia Antivouniotissa.*

**264-265.** *Ships in danger, with the sailors being rescued by St. Nicholas. Details from an icon of St. Nicholas enthroned with scenes from his life, 18th century. Athens, Byzantine Museum Λ. 304-Σ.Λ. 258.*

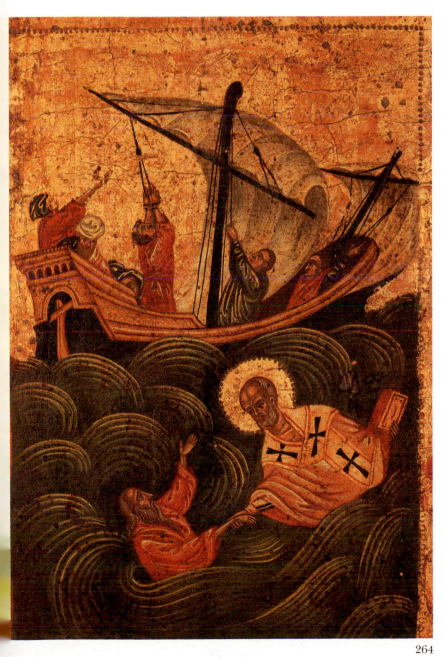

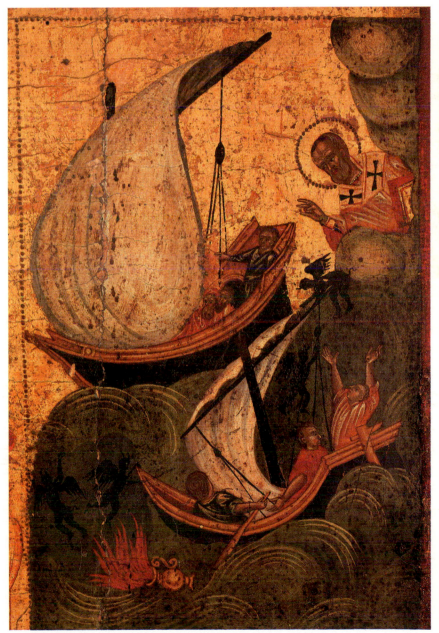

264    265

hulls were reinforced by protective sheets of bronze; these vessels were masterpieces of the shipbuilder's art, and cost legendary sums.

Given these kind of developments in Western seafaring, it is reasonable to ask how the Greeks managed to survive in their own space during the four centuries of Turkish rule. In the beginning, they built small, manoeuvrable boats, but soon moved on to construct large ships that could rival those at the disposal of the Mediterranean powers. The French Revolution and the Napoleonic Wars gave the Aegean islanders the opportunity to exploit the decline in French trade and to extend their voyages as far as Spain. They took the opportunity to compete in the carrying trade and identify the Mediterranean markets. Hydra, Spetses, Psara and other Greek islands were able to construct large merchant ships, suitably equipped for defence and for raids, which made their mark in all the ports of the Christian world. They carried grain and raw material from Turkey to Italy, the Adriatic, France and Spain, and ventured beyond the straits of Gibraltar. In 1804, three ships from Hydra crossed the Atlantic to Montevideo. It is said that their trading activities were so successful that

266

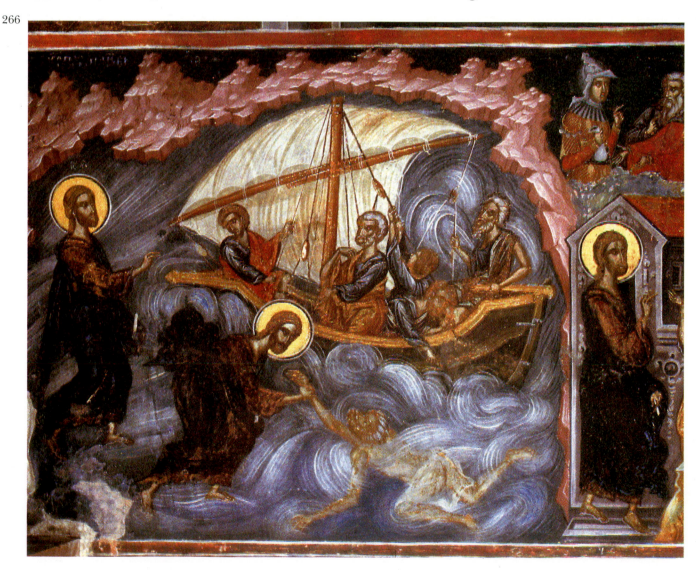

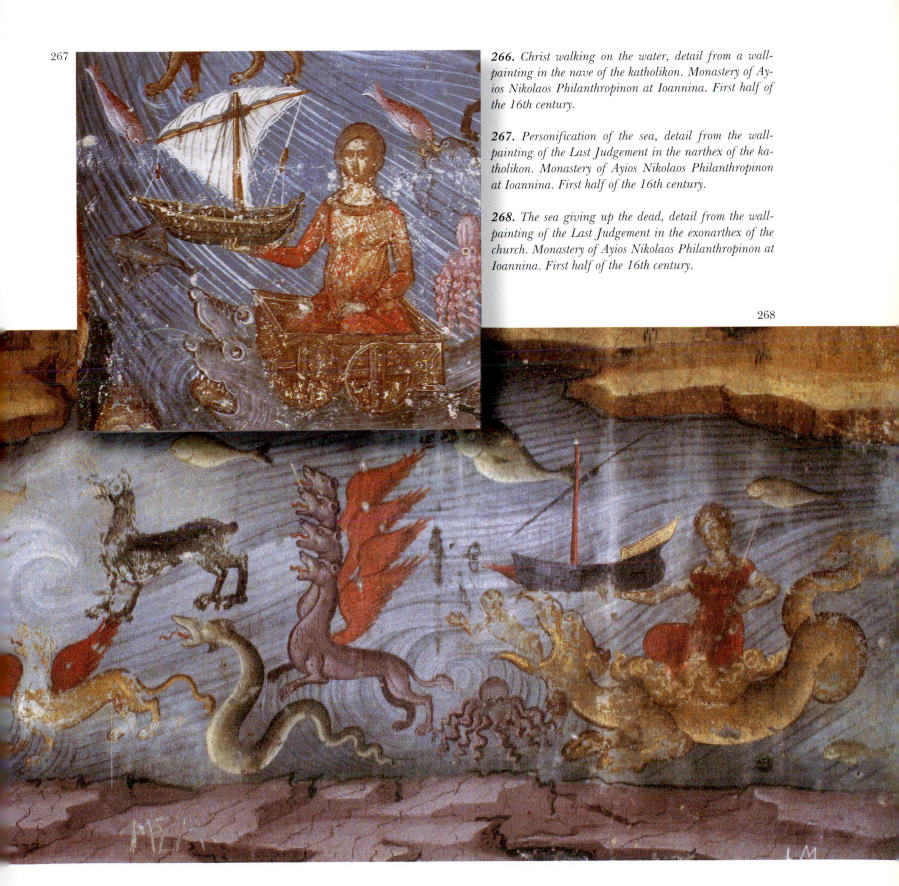

267

**266.** *Christ walking on the water, detail from a wall-painting in the nave of the katholikon. Monastery of Ayios Nikolaos Philanthropinon at Ioannina. First half of the 16th century.*

**267.** *Personification of the sea, detail from the wall-painting of the Last Judgement in the narthex of the katholikon. Monastery of Ayios Nikolaos Philanthropinon at Ioannina. First half of the 16th century.*

**268.** *The sea giving up the dead, detail from the wall-painting of the Last Judgement in the exonarthex of the church. Monastery of Ayios Nikolaos Philanthropinon at Ioannina. First half of the 16th century.*

268

**269.** *Ship in danger, detail of fig. 270.*

**270.** *The Virgin Chrysorrhoiatissa and Eleousa. Copperplate engraving of an icon by Ioannis Kornaros the Cretan, 1801. In the centre the Virgin with the Christ Child, to her left St. Lucas the evangelist, both framed by ten scenes from the life and miracles of the Virgin. Paphos, Monastery of the Panayia Chrysorrhoiatissa.*

**271.** *"Description of the Sacred Monastery of Kykkos". Copperplate engraving designed by Michail tou Apostoli, engraved by In. and P. Scattaglia. In the centre the Virgin and Child above the Monastery, framed by scenes and miracles connected with the icon and the Monastery. Cyprus, Museum of Kykkos' Monastery.*

**272.** *The icon of the Virgin being transported by ship, detail of fig. 271.*

**273.** *Scene of one of the Virgin's miracles, detail of fig. 271.*

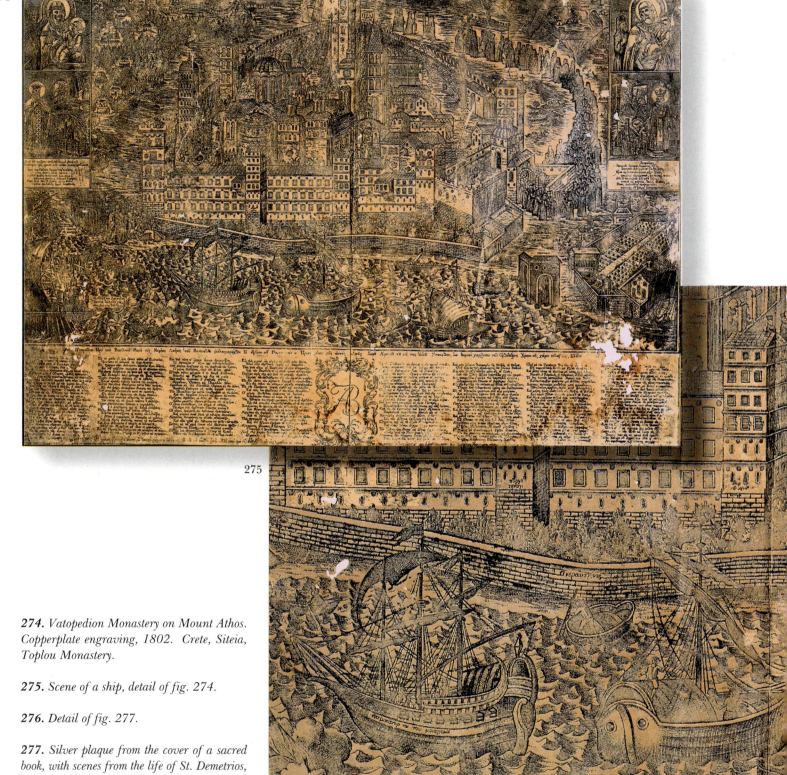

274

275

**274.** *Vatopedion Monastery on Mount Athos. Copperplate engraving, 1802. Crete, Siteia, Toplou Monastery.*

**275.** *Scene of a ship, detail of fig. 274.*

**276.** *Detail of fig. 277.*

**277.** *Silver plaque from the cover of a sacred book, with scenes from the life of St. Demetrios, 16th century. Athens, Byzantine Museum.*

when they returned from each voyage, they carried gold and silver as ballast.

The early years of the 19th century were the golden age of Greek navigation. It was at this period that the great Greek companies were founded and flourished on Syros and Chios, in Constantinople, Odessa, Marseilles, London and a number of Spanish and Italian ports. During the first six years of the century forty ships were built on Hydra, and the Greek islands between them mustered a fleet of 615 merchant ships with a capacity of 153,580 tons, with 17,526 crewmen and with 5,878 cannons. The Greek merchant fleet continued to grow and just before the Greek Uprising in 1821 had 700 ships with 18,000 men.

277

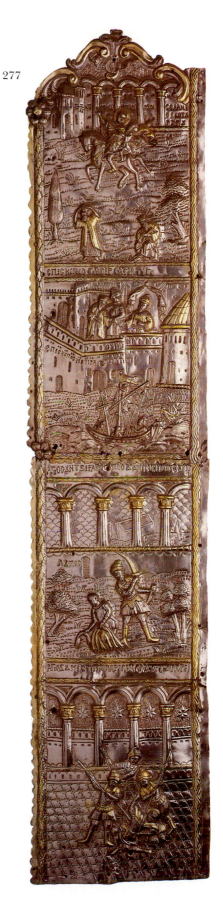

276

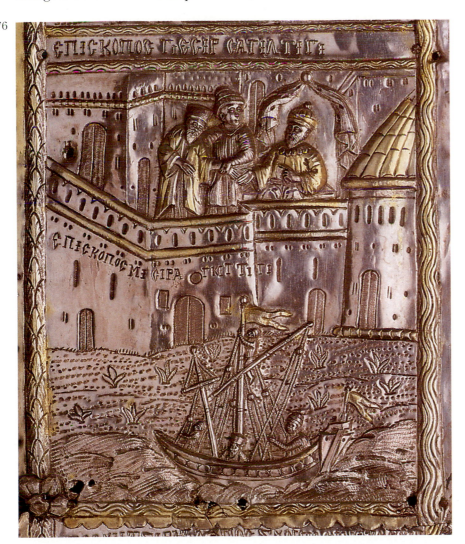

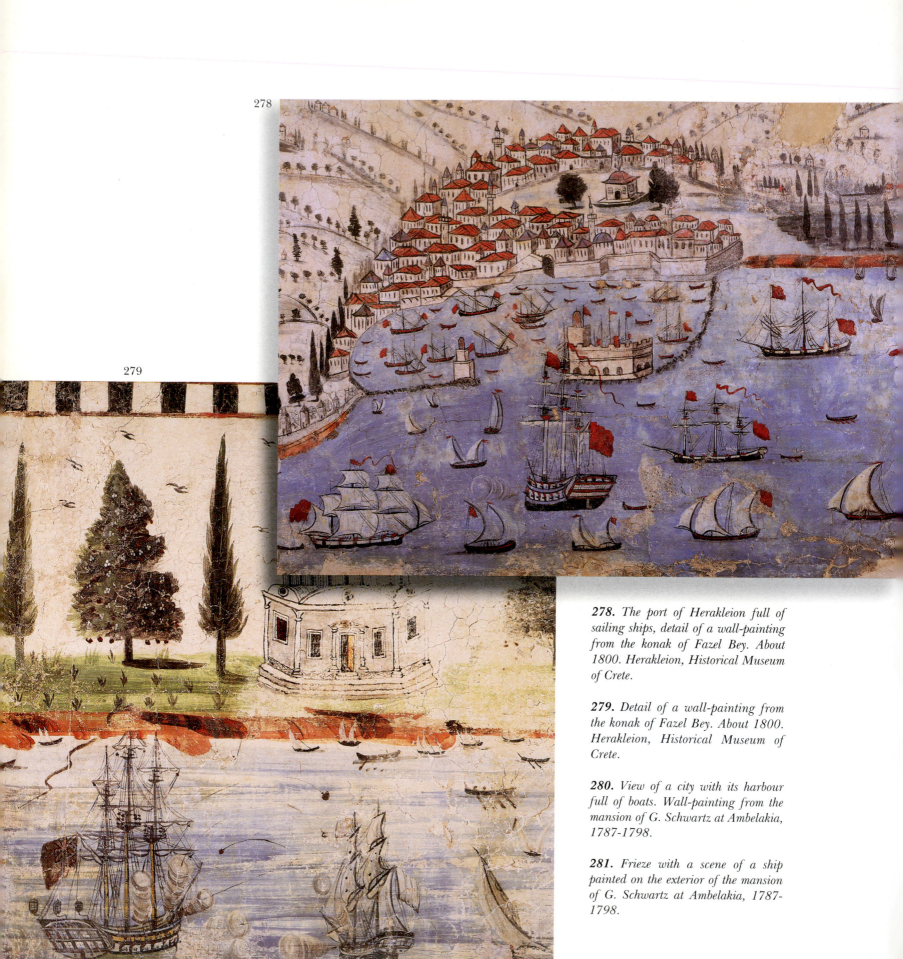

**278.** *The port of Herakleion full of sailing ships, detail of a wall-painting from the konak of Fazel Bey. About 1800. Herakleion, Historical Museum of Crete.*

**279.** *Detail of a wall-painting from the konak of Fazel Bey. About 1800. Herakleion, Historical Museum of Crete.*

**280.** *View of a city with its harbour full of boats. Wall-painting from the mansion of G. Schwartz at Ambelakia, 1787-1798.*

**281.** *Frieze with a scene of a ship painted on the exterior of the mansion of G. Schwartz at Ambelakia, 1787-1798.*

280

281

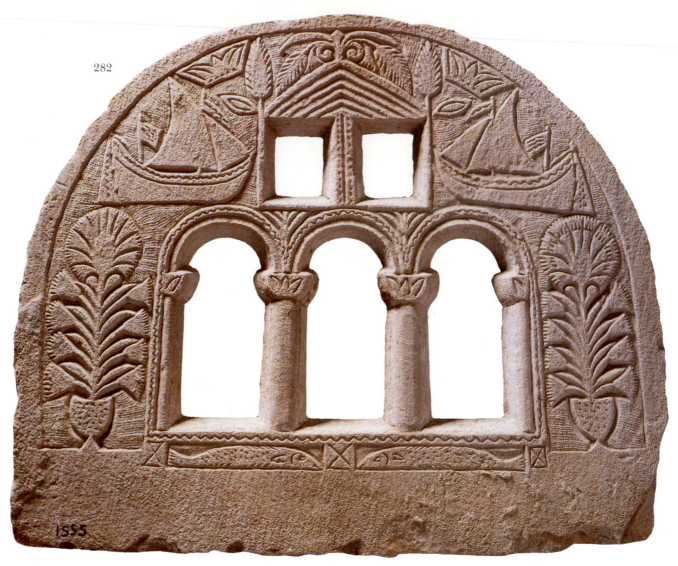

282. *Stone fanlight with incised scenes of two merchant ships. From Tinos, 18th century. Athens, Byzantine Museum T 1555 BM 899.*

283. *Ceramic Kioutacheia plates. The centre of them is decorated with caravelles. Rhodes, 18th century. Athens, Museum of Greek Folk Art.*

During the unending period of subjugation, the four hundred years of Turkish domination, the Greek language and Orthodox religion were the cohesive elements that enabled the Greek world to preserve its identity and survive, and to transport its culture by migrating to other lands, far from the enslaved homeland. Greek civilization loaded its artefacts onto the ship that was used as a means of transport between its islands and the Western lands on the shores of the Mediterranean sea, and traded them for the products of other civilizations.

On wood, clay and metal, on objects of everyday use, he immortalized scenes of the ports in which he anchored, of the cities that impressed him, and of the boats that conveyed him to them. He also impressed these subjects on paper, together with his knowledge and his exploits at sea. Ships and ports adorned the walls of his houses (fig. 278-281), roads, springs, and the floors of the courtyards of his home. And the daughters and wives who waited for the return of their loved ones embroidered on cloth the boats that had taken them far away from their homeland, but which would also bring them

back again (fig. 295-302). And when the time arrived for the great journey at the end of live, a craftsman would engrave, on the stone slab above the grave, the ship that would accompany them in the life hereafter.

The sea, and the ship as the symbol of the sea, exercised a strange fascination on the popular imagination at this period. Popular craftsmen were particularly fond of subjects drawn from the world of the sea. They used the boat as a decorative motif on stone (fig. 282), on pottery (fig. 283-284, 286), on metal objects and on gold and silver (fig. 291-294), in wood-carving (fig. 285, 287-290), and in the attractive pebble floors

*285. Different types of ship in a scene of a naval battle. Decoration of the interior of the lid of a wooden chest. From Folegandros, 16th century. Athens, Benaki Museum 8720.*

*284. Ceramic plate decorated with a sailing ship and other motifs. From Nikaia (Iznik), Asia Minor, 17th century. Athens, Museum of Greek Folk Art.*

*286. Ceramic plate decorated with lateen-rigged boats and a galley at the centre. Second quarter of the 16th century. London, Victoria and Albert Museum 713-1902.*

285

that adorned courtyards and pavements in coastal towns. And the same motif was woven in expensive, delicate embroideries.

It was at this period that the influences on the popular artist from East and West were adapted to the heritage of the Byzantine religious tradition. The most eloquent witnesses to these influences are the wall-paintings and the icons (fig. 244-273). The popular painter, reared in a religious atmosphere, applied to secular art the same techniques and the same decorative motifs that he had learned in painting the divine. He reproduced nature to decorate the walls of the houses, using stylized designs, and adapting his repertoire to the requirements of the patron and the artist and to the local customs and way of life. The main subjects chosen by him are scenes of cities and ports (fig. 278-280), castles or monasteries, and scenes drawn from Greek mythology. It is clear that these depictions are a blend of fantastic landscapes and recollections of secular or religious scenes of a western, or monastic origin, which they had seen in the copperplate prints or woodcuts that circulated in great numbers at this time.

In addition to these various expressions of popular art, a new type of portrait of ships, known also in other Mediterranean countries, became very popular with the growth of the carrying trade in the 18th and 19th century. These paintings were the work of specialized artists in centres like Genoa, Venice, Livorno and Marseilles. They can be found in Greece in houses, private collections and a number of nautical museums. One well-known artist who produced them was Antoine Roux from Marseilles who, with his son, painted likenesses of Greek ships to commission (fig. 314-315).

287

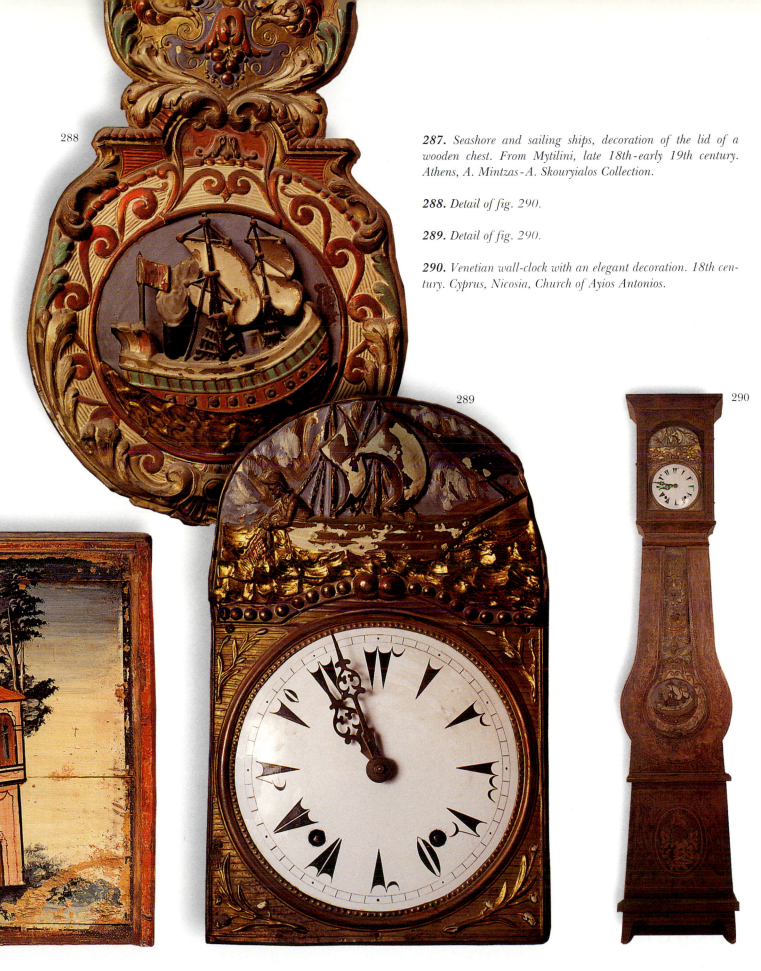

**287.** *Seashore and sailing ships, decoration of the lid of a wooden chest. From Mytilini, late 18th-early 19th century. Athens, A. Mintzas-A. Skouryialos Collection.*

**288.** *Detail of fig. 290.*

**289.** *Detail of fig. 290.*

**290.** *Venetian wall-clock with an elegant decoration. 18th century. Cyprus, Nicosia, Church of Ayios Antonios.*

288

289

290

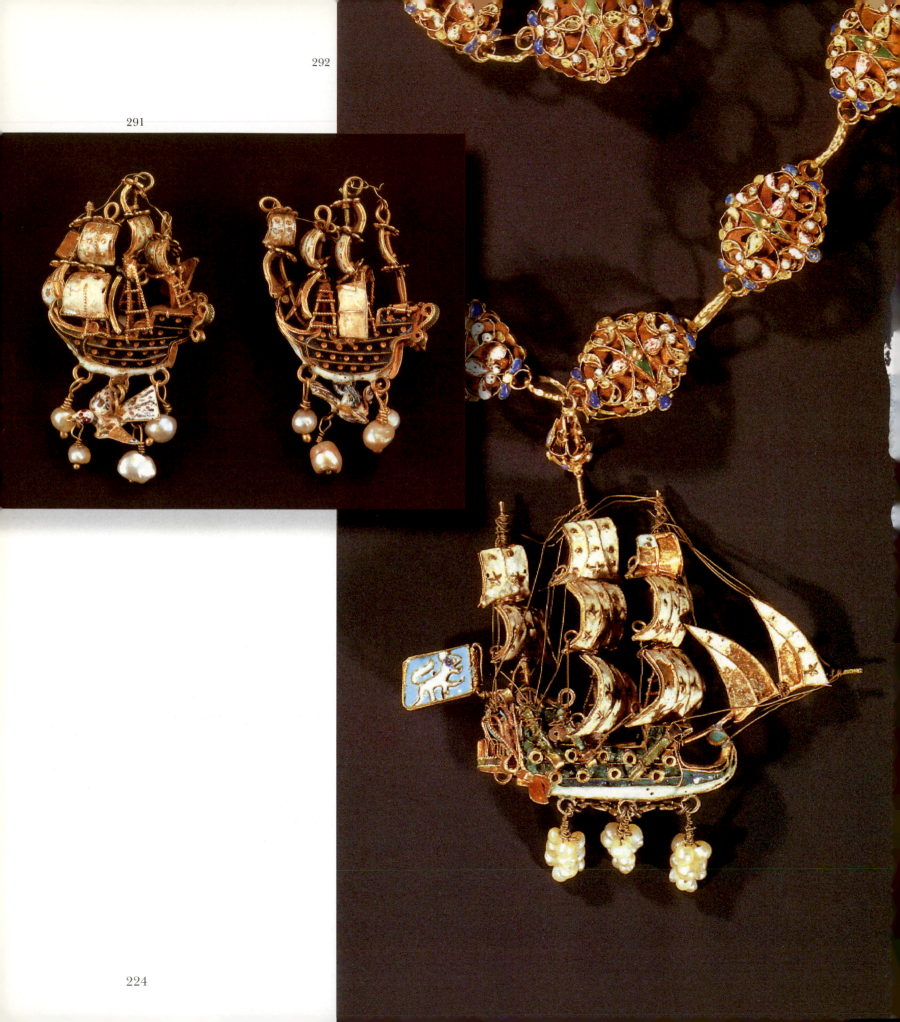

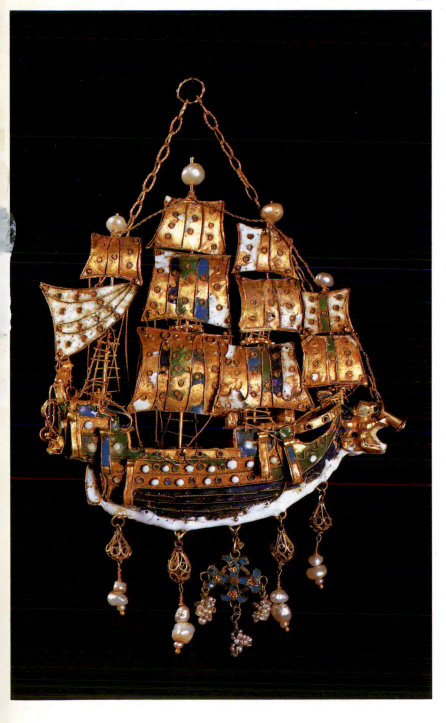

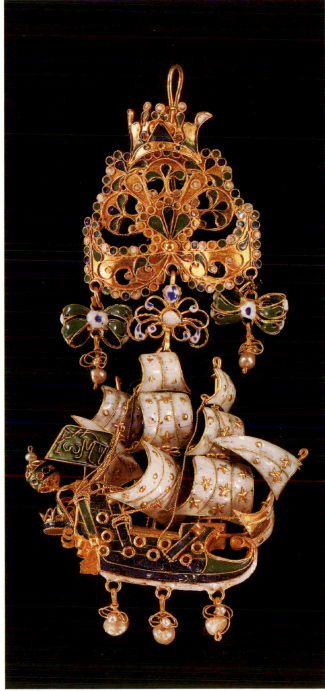

**291.** *Pendant earrings in the shape of a caravelle. Gold with enamel and pearls. From the Greek islands. Athens, Benaki Museum 1995-1996.*

**292.** *Piece of jewellery in the shape of a caravelle. From Patmos, 17th-18th century. Athens, Benaki Museum 1994.*

**293.** *Piece of jewellery in the shape of a caravelle. Gold with enamel and pearls. From Patmos, 17th century. Athens, Benaki Museum.*

**294.** *Pendant earring in the shape of a caravelle. Gold with enamel and precious stones. From Siphnos, 18th century. Athens, Benaki Museum 7670.*

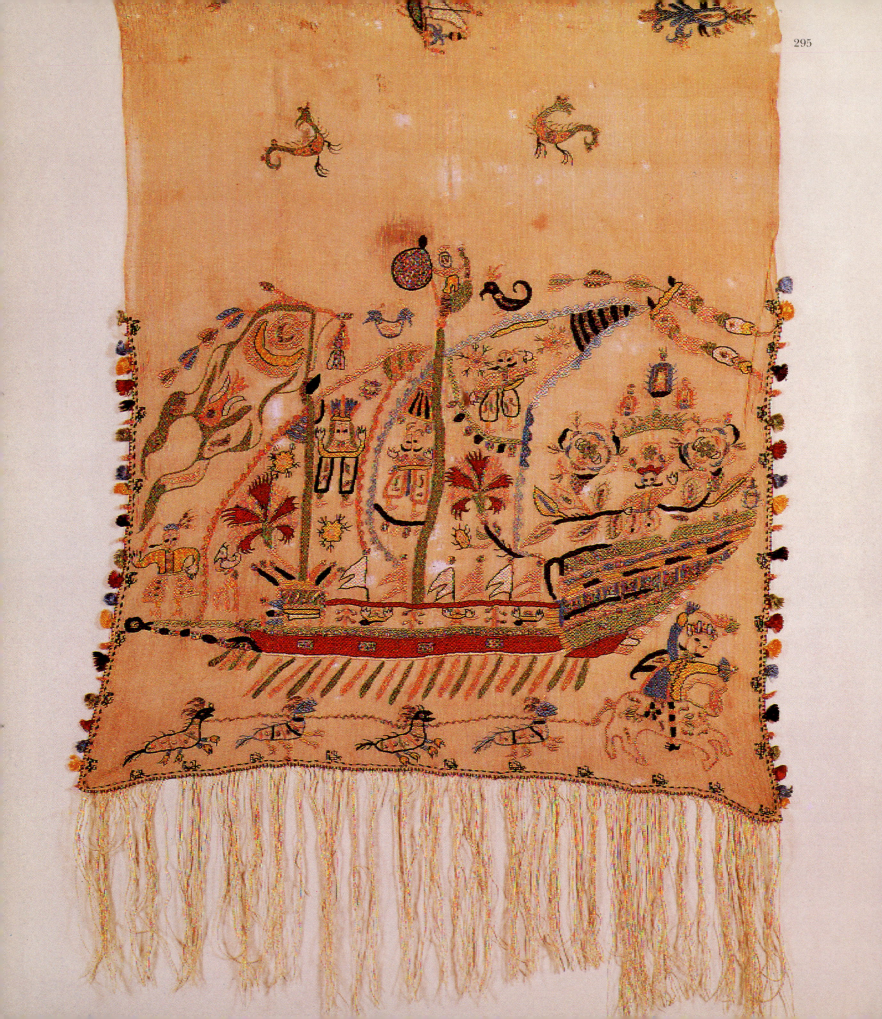

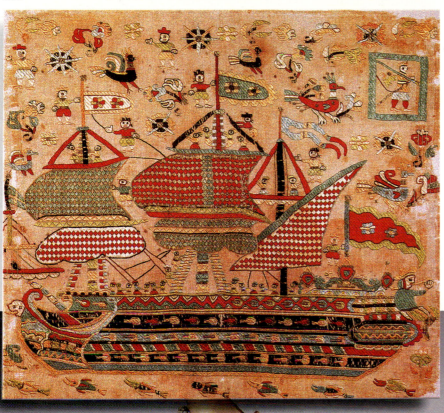

**295.** *Napkin with a many-oared sailing ship. From Skyros, 18th-19th century. London, Victoria and Albert Museum.*

**296.** *Cushion cover with a three-masted boat. From Skyros, 18th century. Athens, Benaki Museum 6389.*

**297.** *Serviette with a three-masted boat and other designs. From Chios, 18th-19th century. Athens, Museum of Greek Folk Art.*

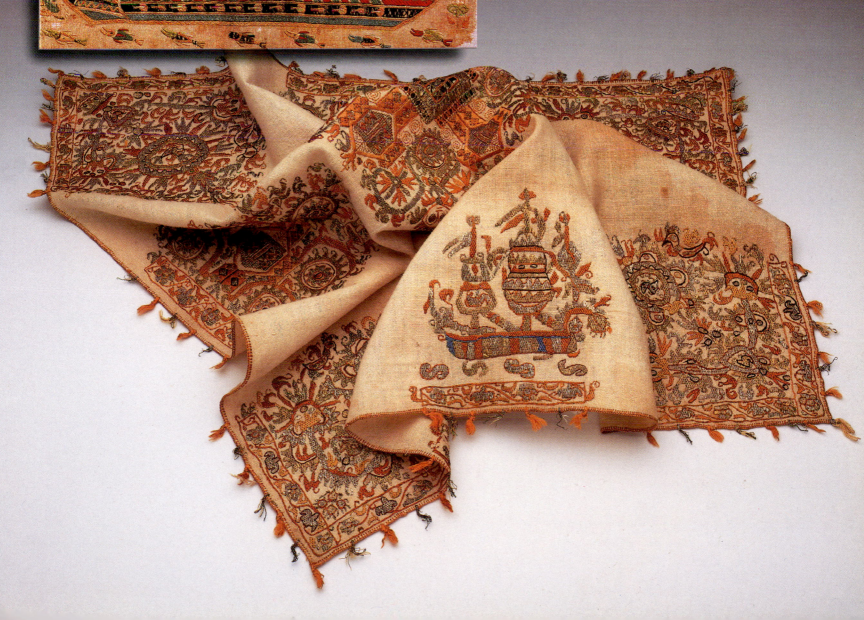

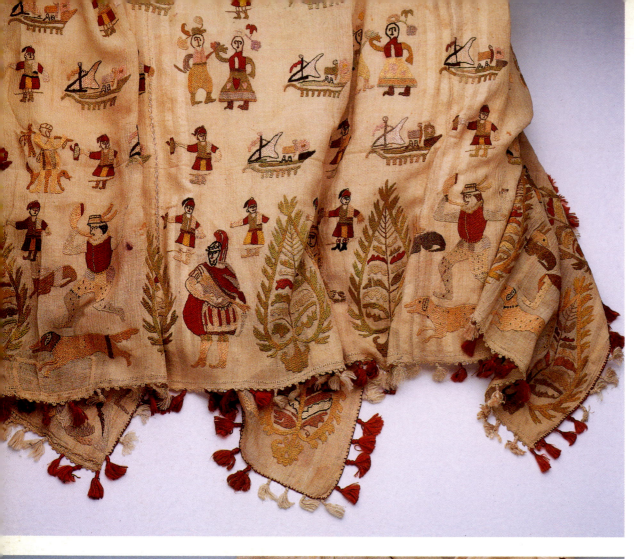

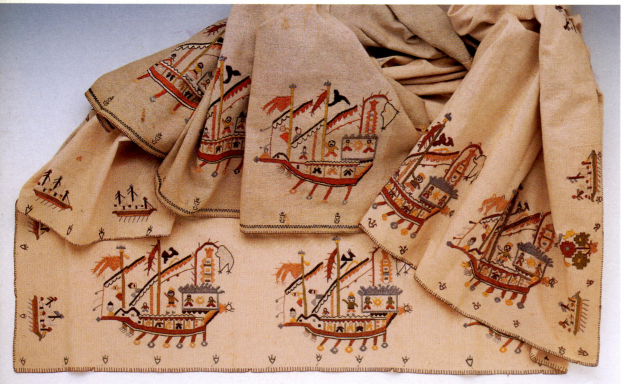

**298.** *Napkin with human figures and ships. From Skyros, 19th century. Athens, National Historical Museum.*

**299.** *Sheet with boats embroidered on the hems. From Skyros, 19th century. Athens, National Historical Museum.*

**300.** *Detail of the bedspread (sperveri) from a bridal bed embroidered with boats. From Kos, Dodecanese, 18th-19th century. Athens, Museum of Greek Folk Art.*

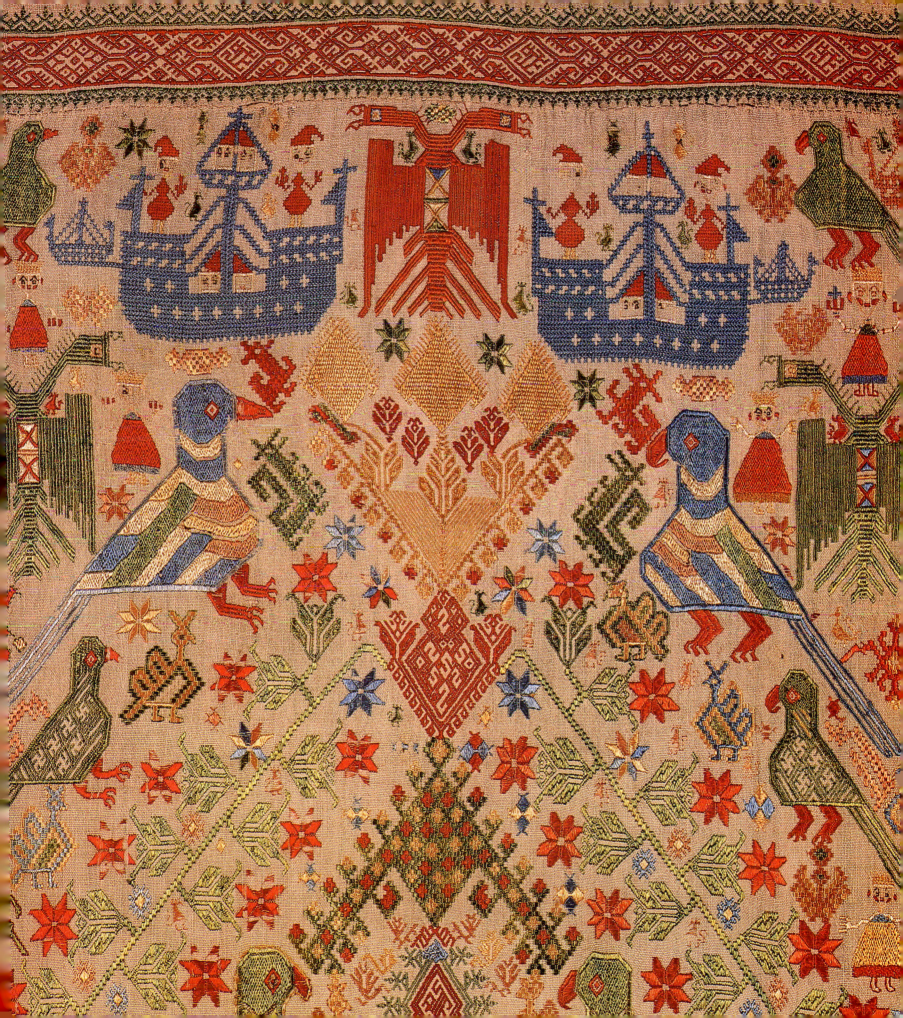

In time, this technique was learned by Greek craftsmen, who usually took Roux's paintings as a model for their works.

These works of art, which were made to decorate the captains' cabins, portrayed the owner's ship on the open sea, or off some port, Marseilles, Venice or Constantinople. They are usually painted in tempera on cardboard or glass panels. The artist concentrates on detailed description, rendering the ship in a side view, with masts and sails, and including the name of the ship and the owner, and occasionally also his own. In some paintings the picture includes other subjects, as well as the ship, such as naval battles or scenes from mythology.

*301. White napkin with boats and flowers. From the Cyclades. Athens, Benaki Museum 6570.*

*302. Napkin with various kinds of stylized boat. From Thrace, 19th century. Athens, National Historical Museum.*

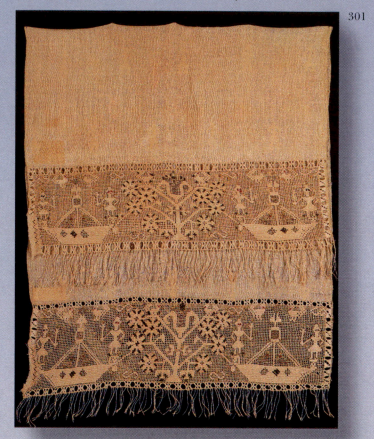

301

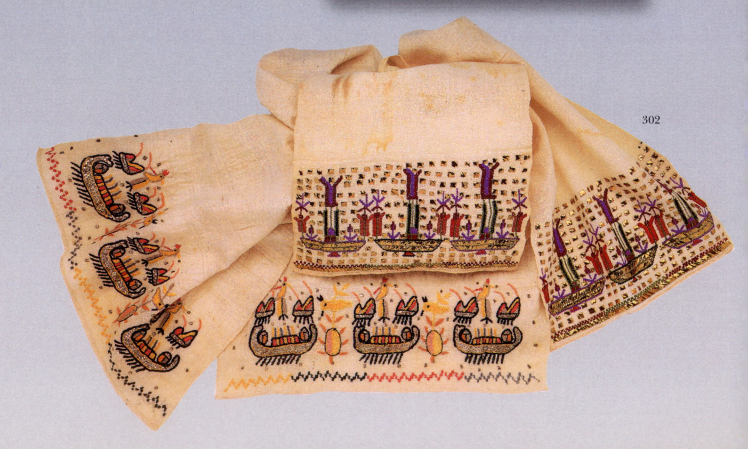

302

230

# THE STRUGGLE FOR INDEPENDENCE

A long time had to pass before the ideas of freedom and justice acquired form, and before the independence of the subjugated Greeks became a reality, through revolution and war. Though it is beyond question that the Greek Uprising of 1821 was inspired by the proclamation of Rigas Pherraios (fig. 303-305) and the revolutionary ideas of the time, its foundations were laid by economic progress, in turn the result of the advances in shipping and commerce in the late 18th and early 19th centuries.

The beginning of the War of Independence found the Greek seamen prepared for military operations. The merchant vessels were converted into warships and played their part, supporting the struggle on land.

In his famous speech in Athens, on the Pnyx hill in 1836, General Theodoros Kolokotronis commented characteristically that "grainships fought against the king".

The majority of the ships were brigs with two large masts and sails, with a displacement of about 250 tons, and 8-16 cannons. There were even larger vessels than these, of course, with towering masts and a great number of sails (fig. 313-315). Of the total of 1,000 merchant vessels owned by Greeks at the beginning of the Uprising, 150 were deployed as warships, forming the fleets of Hydra, Spetses and Psara. The aim of the Greek seamen was to gain control of the Aegean, an aspiration in which they succeeded for a long period, by means of a number of impressive victories.

The burning of a Turkish frigate in the harbour of Eressos on Mytilini (Lesbos), on 27 May 1821, by D. Papanikolis of Psara, was one of the greatest feats of the War of Independence. He was emulated by Konstantinos Kanaris, the captain of a fireship, who blew up another Turkish vessel at Tenedos and fired the Turkish flagship in the harbour of Chios.

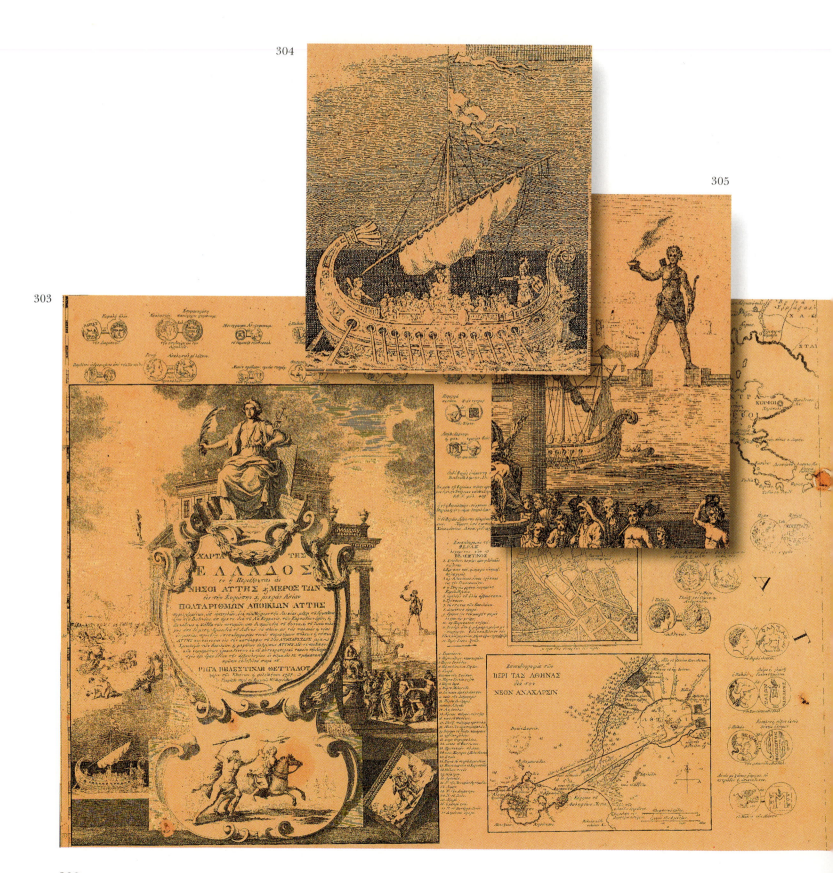

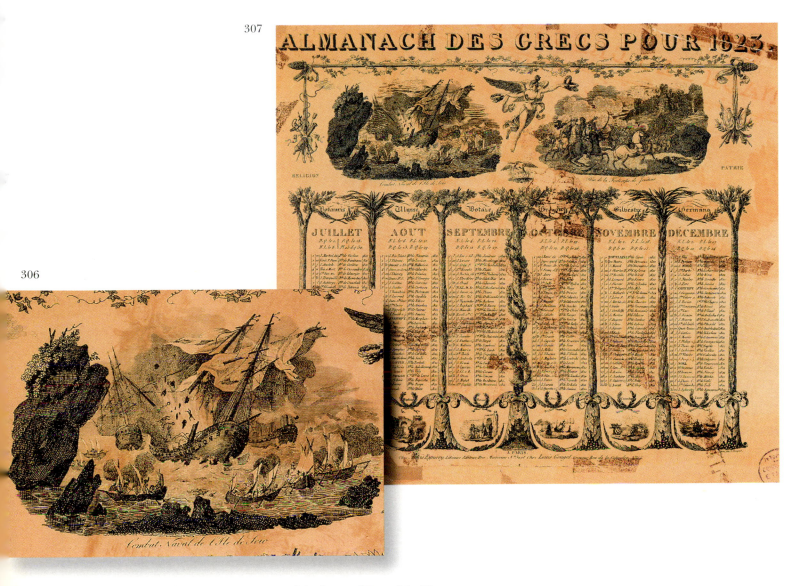

303. *Detail from the frontispiece of the "Map of Greece" by Rigas Velestinlis Pherraios. This showed the places in which ancient, medieval and modern Hellenism flourished, in twelve pages. Lithograph with later colouring, Vienna, 1797. Athens, National Historical Museum.*

304. *Ancient Greek trireme, detail of fig. 303.*

305. *The harbour of Rhodes with the statue of the Colossus, detail of fig. 303.*

306. *Scene of a naval battle near Chios, detail of fig. 307.*

307. *Scenes from the Greek War of Independence on a page of the "Almanach des Grecs pour 1823". Copperplate engraving by Louis Gouget. Athens, National Historical Museum.*

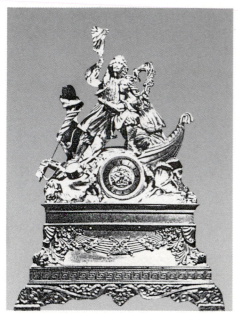

308

309

310

**308.** *Gilded copper clock with a ship worked in the round and a pair of Greek refugees. Russian work, 1825-1830. Cologne, M. Krasakis Collection.*

**309.** *Copper clock with Konstantinos Kanaris on a fireship. French work, 1835-1840. Athens, Angeliki Amandry Collection.*

**310.** *Gilded clock with Konstantinos Kanaris on a fireship. French work, 1830. Athens, Angeliki Amandry Collection.*

**311.** *Plates decorated with naval subjects inspired by the Greek War of Independence. French works, from the Montereau workshop, the product of philhellene activities. Athens, National Historical Museum.*

**312.** *Plate with a scene of A. Miaoulis capturing a Turkish ship. French work, from the Montereau workshop. Athens, Angeliki Amandry Collection.*

312

311

235

**313.** The "Wellington", a ship owned by Captain Ioannis Orlandos of Hydra during the Greek War of Independence. Watercolour. Athens, National Historical Museum.

**314.** The "Ayia Trias", a ship owned by G. Kriezis. Early 19th century. Copy by A. Kriezis of a painting by Roux. Piraeus, Greek Naval Museum.

**315.** Hydra ship (Captain K. Skourtis). Copy by A. Kriezis of a painting by A. Roux (1818). Piraeus, Greek Naval Museum.

313

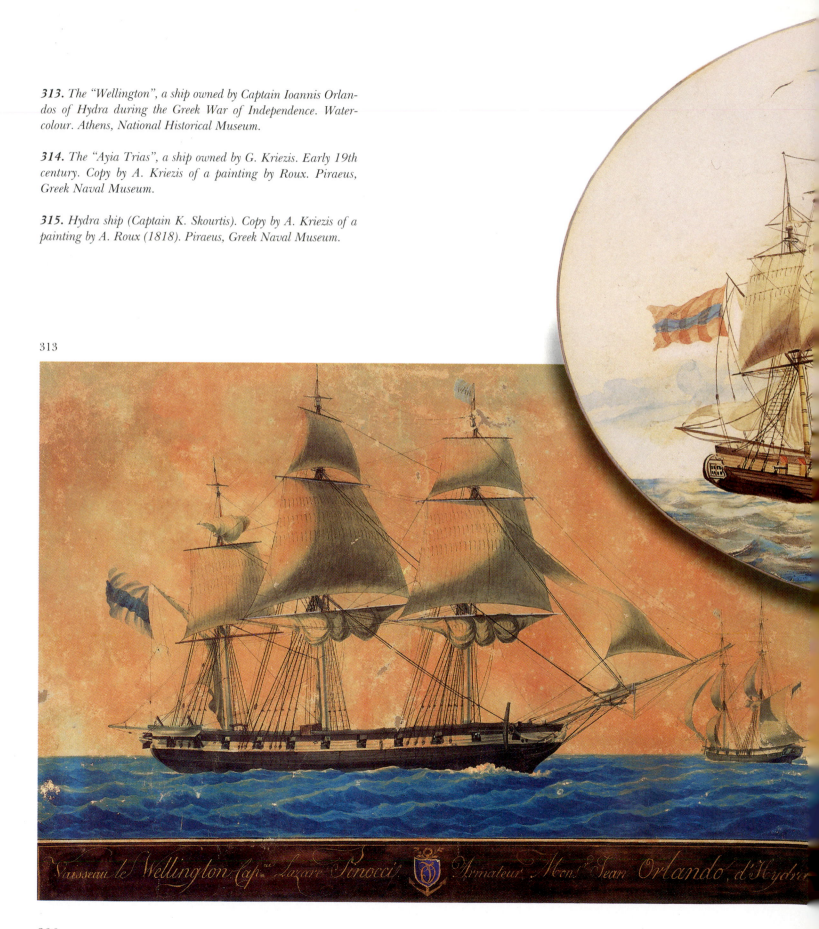

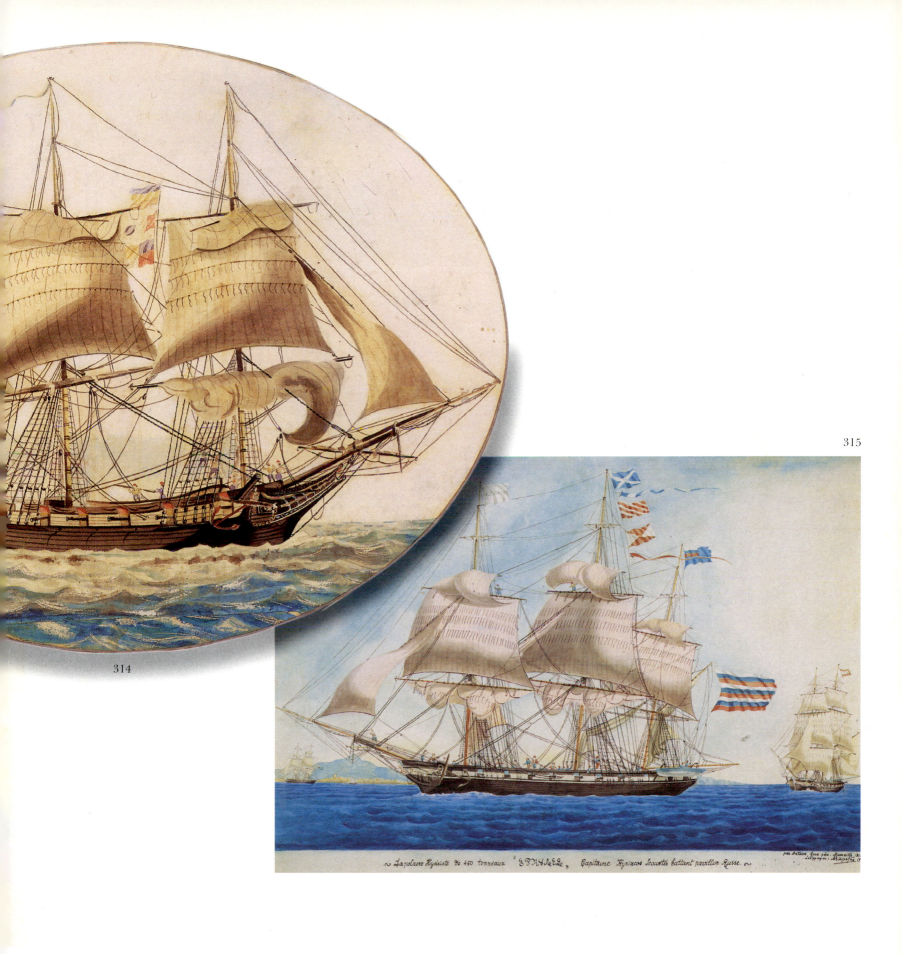

314

315

~ *Lapolacre Hydriote de 450 tonneaux* "ΣΠΑΝΕΖ", *Capitaine Kyriacos Scourtis battant pavillon Russe.* ~

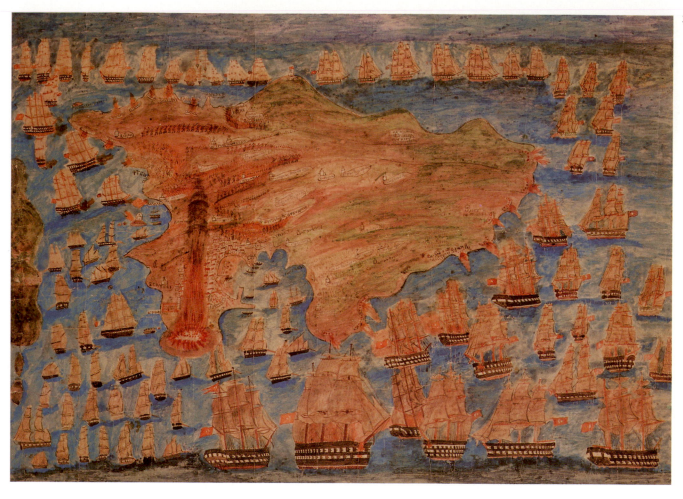

**316.** *The burning of Psara on 21 June 1824, by N. A. Koutso-dontis. Water-colour on paper, c.1824. Athens, Benaki Museum 23146.*

**317.** *The battle of Samos and Crete, by D. Zographos, following the narrative of General I. Makriyannis. Water-colour on cardboard. Athens, National Historical Museum.*

Another hero of the War of Independence, Admiral Andreas Miaoulis, crushed the Turks in several naval battles, and lent support to the besieged Greek forces blockading the enemy fleet. Sachtouris, Tombazis, Tsamados and many others harassed the Turkish fleet, conducting a maritime version of guerilla warfare and registering some notable naval exploits.

Through these and similar achievements,

the Greeks succeeded in winning over European public opinion, which in the end came to look favourably on the Greek cause. Demonstrations of philhellenism were organized not only in Europe but also in America, gaining the support of the bigger part of society. During the War of Independence and afterwards, art made a significant contribution to promoting philhellene views and securing economic support for the revolt of the Greek people. The illustrating of the struggle became a revolutionary proclamation, and a cry of protest against the position adopted by the Holy Alliance. Europe reacted to the awakening of the subjugated Greek people initially with curiosity, followed by sympathy, and later by substantial support. Famous painters and writers, and also

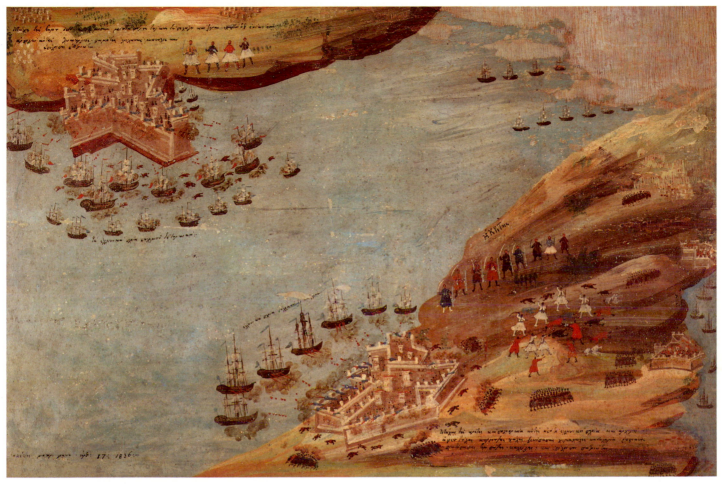

317

humbler artists, lent the support of their art to the Greek Uprising.

In addition to painting itself, an important part was played by lithography, copperplate engraving, and the more popular pictures printed by the Epinal press, both as an independent art and as illustrations for the daily press. A vast number of engravings circulated in the West during the period of the revolution and later. The predilection for anything Greek assumed various forms. In 1823, the French saw in the "Almanach des Grecs" figures of the ancient Spartan king Leonidas and the 1821 Souliote warrior Markos Botsaris, the naval battle of Chios (fig. 306-307), the blowing up of the Turkish flagship by Kanaris, and the capture of a fortress, with the names of ancient Greeks along-

side those of the heroes of the War of Independence. At the same time, plates, vases, clocks and ornaments were adorned with heroes and scenes from the Greek Uprising (fig. 308-312).

The exploits at sea of Konstantinos Kanaris and Andreas Miaoulis were a particular source of inspiration for art. Three faience workshops in France, at Choisy-le-Roi, Montereau and Toulouse, produced plates decorated with black and white or coloured scenes inspired by the Greek Struggle.

The great naval encounters of the war were the subject of paintings created mainly after the end of the conflict by both humble and famous Greek and foreign painters.

At the instigation of those who had taken part in the struggle, the thrilling events experienced by

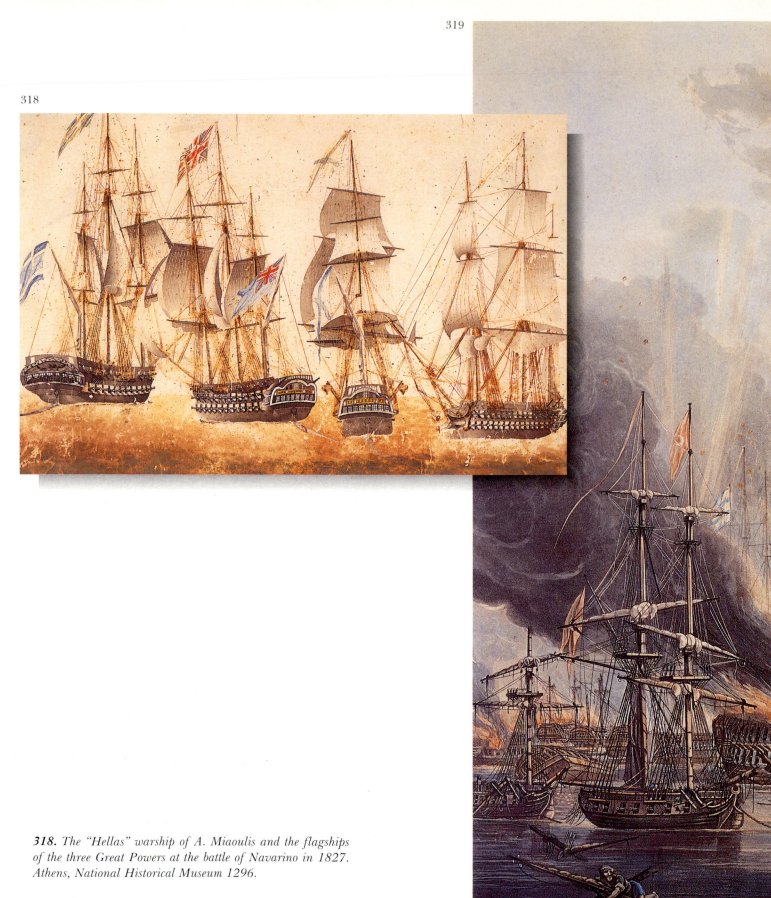

**318.** *The "Hellas" warship of A. Miaoulis and the flagships of the three Great Powers at the battle of Navarino in 1827. Athens, National Historical Museum 1296.*

**319.** *The battle of Navarino, 1827. Copperplate engraving by Smart and Ryall. Athens, National Historical Museum.*

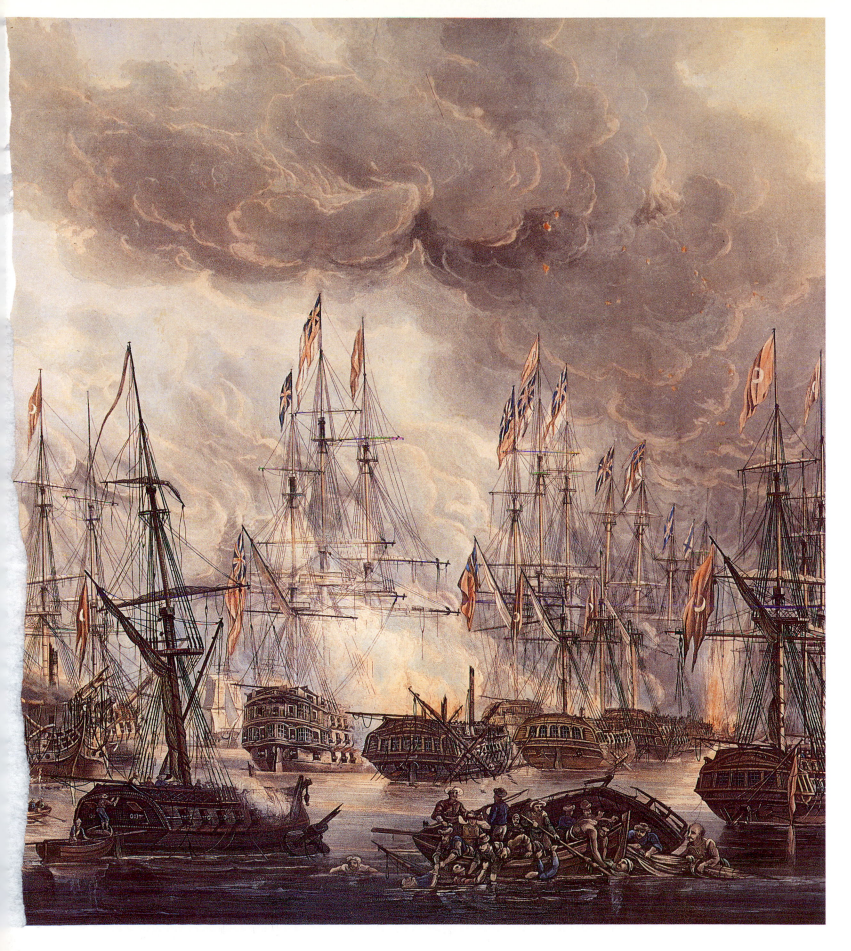

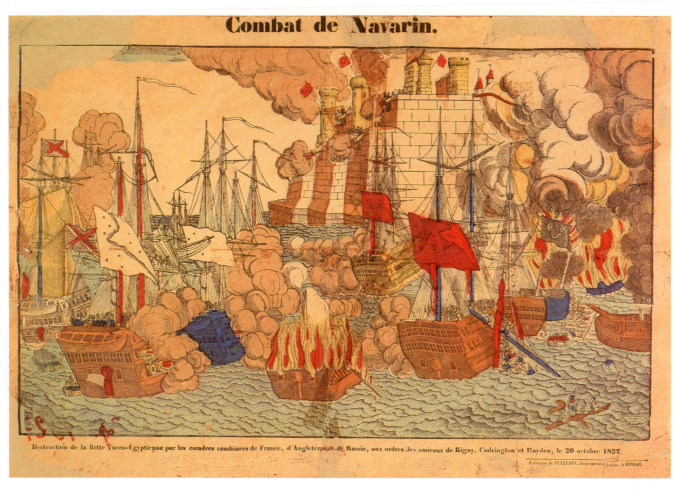

**Combat de Navarin.**

Destruction de la flotte Turco-Egyptienne par les escadres combinées de France, d'Angleterre et de Russie, aux ordres des amiraux de Rigny, Codrington et Hayden, le 20 octobre 1827.

Fabrique de PELLERIN, Imprimeur-Libraire, à EPINAL.

**320.** *The battle of Navarino, 1827. Popular lithograph, printed by Epinal. Athens, National Historical Museum.*

Greece were immortalized accurately and vividly, though with the naiveté of the popular artist (fig. 316). General Makriyannis chose Panayotis Zographos, a popular artist, and his sons to enliven his narrative with illustrations of the land and sea battles. Zographos painted in great detail the ships engaged at the battle of Myloi, the sieges of Samos and Crete (fig. 317), and the battle of Mesolongi.

The great encounters at sea, and the "sacred actions" of the captains of the fireships provided subjects for the 19th century academic painters. N. Lytras painted Kanaris burning the Turkish flagship and K.Volanakis, an important seascape artist, portrayed the firing of a Turkish frigate at Eressos

on Mytilini by Papanikolis, and also "Ares escape at the naval battle of Pylos in 1825". Another seascape artist, I. Altamouras, painted the naval battle fought at Patrae in 1822, and many other famous and anonymous artists portrayed a variety of ships that participated in the Struggle and their exploits.

The naval battle of Navarino in 1827 was a source of inspiration to both Greek and foreign painters (fig. 318-320). Paintings, lithographs and copperplate engravings all immortalized the great confrontation between the Greek ships and the fleet of the three Great Powers – England, France and Russia – on the one side and the Turkish and Egyptian ships on the other. The artists of the day viewed the intervention of the Great Powers through romantic eyes, as a just act in support of the ideals of equality and freedom.

# WITH SAIL AND STEAM IN THE PROGRESS OF GREEK SHIPPING

Greek civilization changes and assumes different forms with the passage of time, invariably incorporating the old values, which survive eternally. During the long course of 5,000 years there have been countless destructions, abandonments and disasters. Nothing of what has gone before is forgotten, however. And it is to this very heritage that modern maritime Greece is adding its own history.

In the 16 and more years since the foundation of the Greek state in 1828, Greece has experienced many vicissitudes. The course pursued by modern Greek shipping, however, despite the fact that it has followed historical events and has often been harmed by them, is an upward one. The Greek merchant fleet, for all the adversities it has had to face, now occupies first place in world shipping.

After the end of the War of Independence, and the founding of the Greek state, only a few, badly damaged ships survived. Of the 700 vessels of the fleet from before the Uprising, only 150 remained to form the kernel of the first free Greek merchant navy. Throughout the course of the Struggle for Freedom, for ten whole years, Greek ships took no part in the carrying trade of the Mediterranean and Black Sea. The consequences of this absence were realized only after the end of the war, when the Greeks saw that their place had been taken by other merchant fleets. Several important Aegean harbours had also been lost, such as those at Kasos, Chios, Mytilini, Lemnos and in the region of Thessaly and Argyrokastro; under the settlement negotiated by the Great Powers, these had been ceded to the Ottoman empire.

This was the difficult position in which the Greek merchant fleet found itself at the time of the creation of the modern Greek state, which was originally confined to southern Greece (the Peloponnese and mainland Greece) and some of

the Aegean islands, Euboea, the Cyclades and the northern Sporades.

The importance of Greek merchant shipping, and the decisive role it had played in every historical period, was realized by Ioannis Kapodistrias, the first governor of the newly liberated Greek state. Kapodistrias was responsible for the enactment of the first law relating to the organization of the merchant fleet, on 3rd February, 1828, only a few days after his arrival in Greece. This law is still regarded as one of the most important passed by the Greek state to promote Greek and international shipping. His aims of reconstituting the merchant fleet and introducing a new system of registering of the merchant vessels were supported by a second, supplementary law.

The peace and security that were features of the following period enabled the merchant fleet steadily to recover its strength over the next decade. In the ports of Greece, Piraeus (fig. 326, 329-330), Syros (fig. 331), Nafplion, Hydra, Spetses and Poros, ships came and went with great frequency. During the following years, Greek merchant vessels again made considerable progress, as a result of the foundation of the monarchy in Greece (fig. 327-328). Within twenty years, the ships of the period before the War of Independence had been surpassed in number and tonnage.

The presence in the Mediterranean of the foreign merchant fleets of England, France, Austria and Italy led to intense competition. Despite this, the Greeks succeeded in increasing the number of their ships, and the ports of the Black Sea and Europe bustled with sailing ships transporting grain from southern Russia to western Europe. In 1855, the Greek merchant fleet numbered 5,063 ships with a capacity of 296,801 tons, manned by 30,000 sailors.

The factors explaining why the Greek sailors again assumed a leading role on the seas were the same as those that prevailed in ancient times. The commercial sea lanes from East to West now called in at the Greek ports, and the exchange of cereals from the East with industrial goods from the West was conducted by means of Greek sea routes. This process paved the way for the development of trans-oceanic mercantile trade, and by extension of Greek shipping.

Greeks had a monopoly on grain from the Black Sea, which played a major role in their progress and development. Greeks, residents abroad, also played their part, investing funds in Greek merchant ships.

. About the middle of the 19th century, a new type of vessel, the steamship, made its appearance on the Greek seas.

321

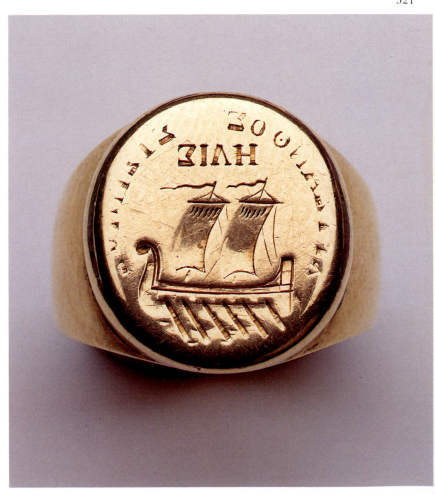

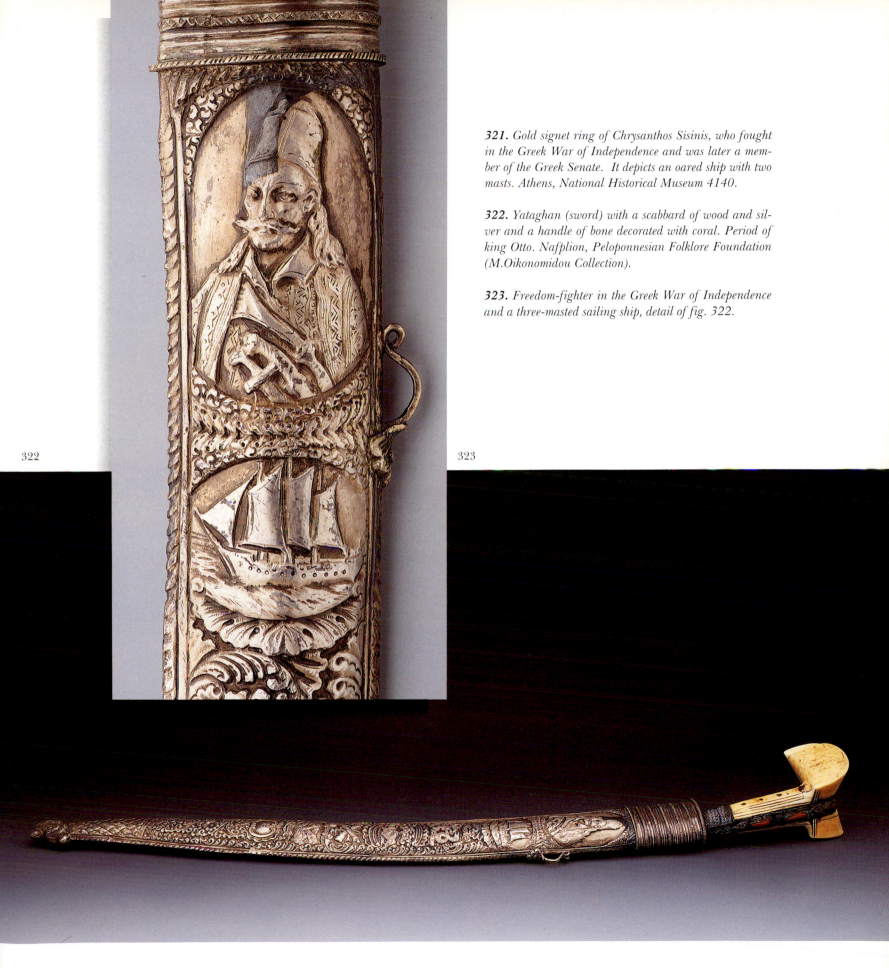

**321.** Gold signet ring of Chrysanthos Sisinis, who fought in the Greek War of Independence and was later a member of the Greek Senate. It depicts an oared ship with two masts. Athens, National Historical Museum 4140.

**322.** Yataghan (sword) with a scabbard of wood and silver and a handle of bone decorated with coral. Period of king Otto. Nafplion, Peloponnesian Folklore Foundation (M.Oikonomidou Collection).

**323.** Freedom-fighter in the Greek War of Independence and a three-masted sailing ship, detail of fig. 322.

322

323

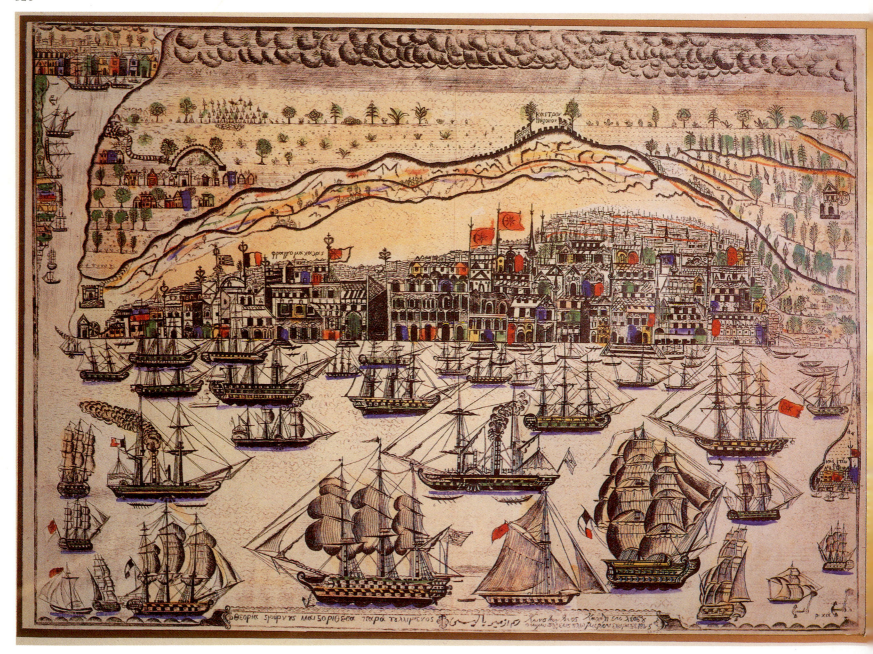

**324.** *General view of Smyrna with the fortress, the city and the harbour full of sailing ships. Copperplate engraving by K. Kaldis, 1845. Crete, Siteia, Toplou Monastery.*

**325.** *General view of Constantinople from the Propontis to the Black Sea, with the Bosporus and the Golden Horn. Copperplate engraving by K. Panayotou, 1851. Crete, Siteia, Toplou Monastery.*

325

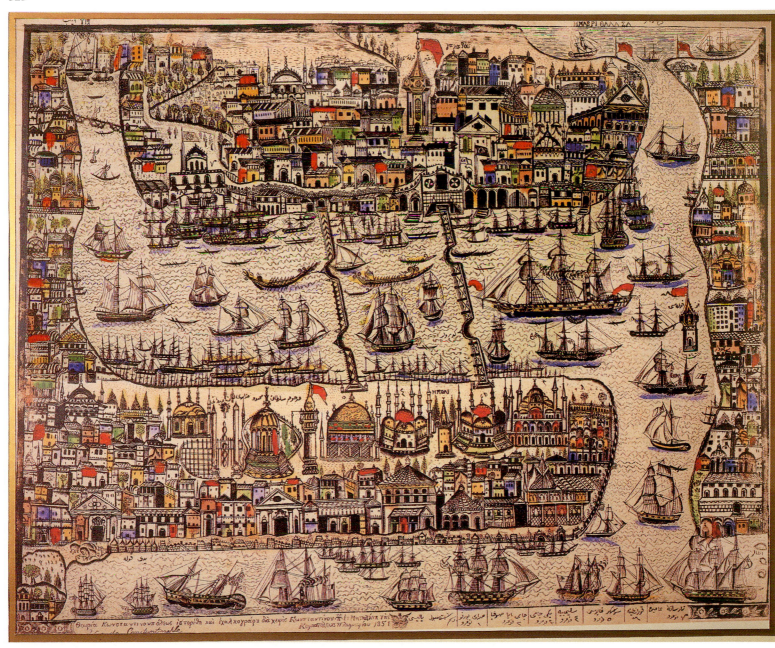

**326.** *View of Piraeus with the Dogana (custom's house). Copy of a water-colour of L. Köllenberger, 1837, by H. Hanke. Athens, National Historical Museum.*

**327.** *The disembarkation of Bavarian soldiers in Greece. Popular postcard, copy of a water-colour. Athens, National Historical Museum.*

**328.** *"The exiling of the first king and queen of Greece, Otto and Amalia" on the frigate "Skylla". Popular lithograph with later colouring, by Polli and Diamandis. Athens, National Historical Museum.*

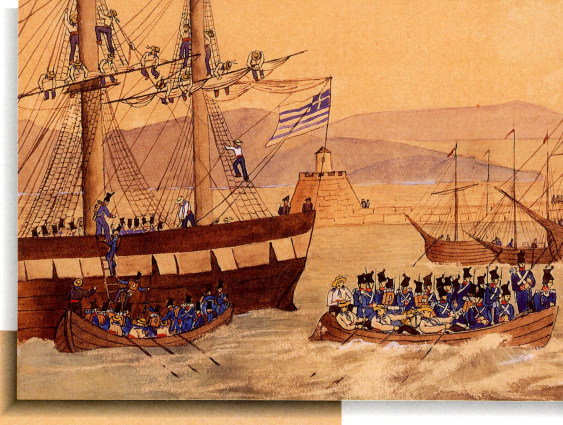

327

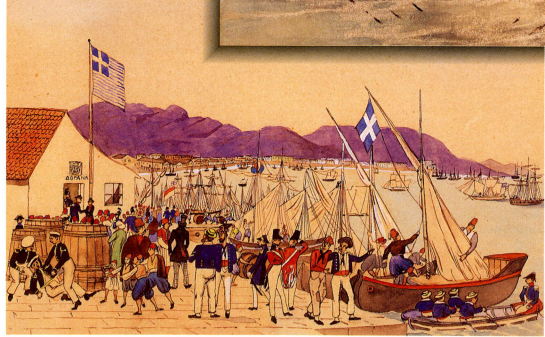

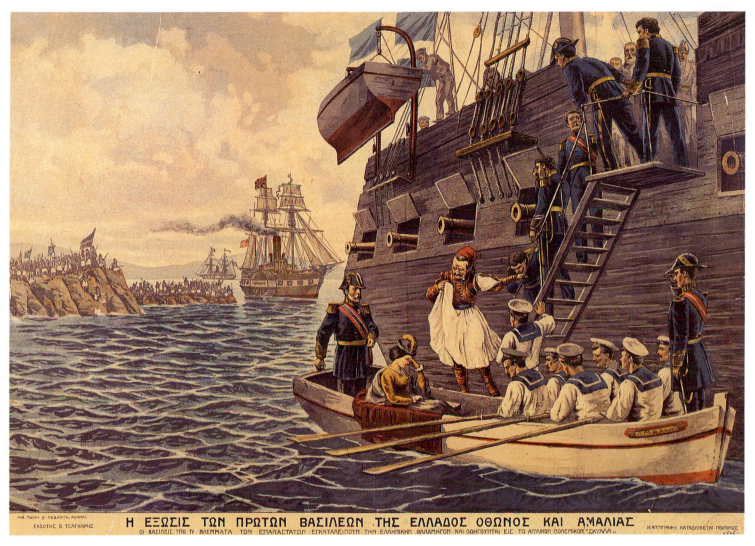

Η ΕΞΩΣΙΣ ΤΩΝ ΠΡΩΤΩΝ ΒΑΣΙΛΕΩΝ ΤΗΣ ΕΛΛΑΔΟΣ ΟΘΩΝΟΣ ΚΑΙ ΑΜΑΛΙΑΣ
ΟΙ ΒΑΣΙΛΕΙΣ ΥΠΟ ΤΕ ΒΛΕΜΜΑΤΑ ΤΩΝ ΕΠΑΝΑΣΤΑΤΩΝ ΕΓΚΑΤΑΛΕΙΠΟΥΝ ΤΗΝ ΕΛΛΗΝΙΚΗΝ ΘΑΛΑΜΗΓΟΝ ΚΑΙ ΟΔΗΓΟΥΝΤΑΙ ΕΙΣ ΤΟ ΑΓΓΛΙΚΟΝ ΠΟΛΕΜΙΚΟΝ "ΣΚΥΛΛΑ"

Steam had been used as a motive power from the end of the 18th century, leading to a revolution in technology. Steam-powered engines were to be found everywhere, including in sea-borne transportation.

At the beginning of the 19th century, ships appeared equipped with a steam engine that drove two wheels attached to the middle of each side of the ship.

The construction of these vessels required the use of both iron and steel. In the early steam-powered ships, masts were retained, since the combination of steam and sail pro-duced the greatest speed. The first ship to cross the Atlantic Ocean, in 1819, was the *Savanah*, a wheel-driven sailing ship, and the first wheel-driven steamship acquired by a Greek was the *Karteria*, whose captain, the philhellene F.A. Hastings, had fought at the battle of Navarino in 1827.

The great naval powers swiftly adjusted to the new demands of shipbuilding, but the Greek shipowners initially received the new steamships with some distrust, especially in traditional centres such as Galaxidi, which later paid dearly for its lack of foresight.

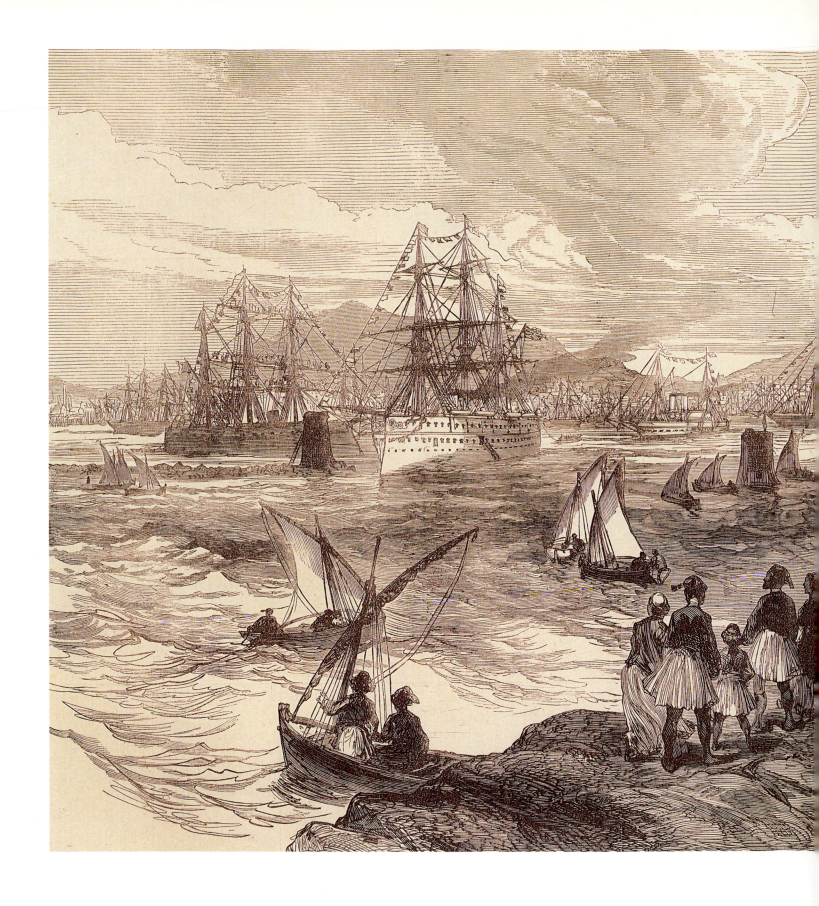

**329.** *The port of Piraeus and the departure of the royal yacht "Serapis" carrying the Prince of Wales. From "The Illustrated London News", 1875.*

**330.** *Two views of Piraeus in 1833 and 1900. From the newspaper "Sphaira", 1st January 1901. Athens, Society of the Greek Literary and Historical Archive.*

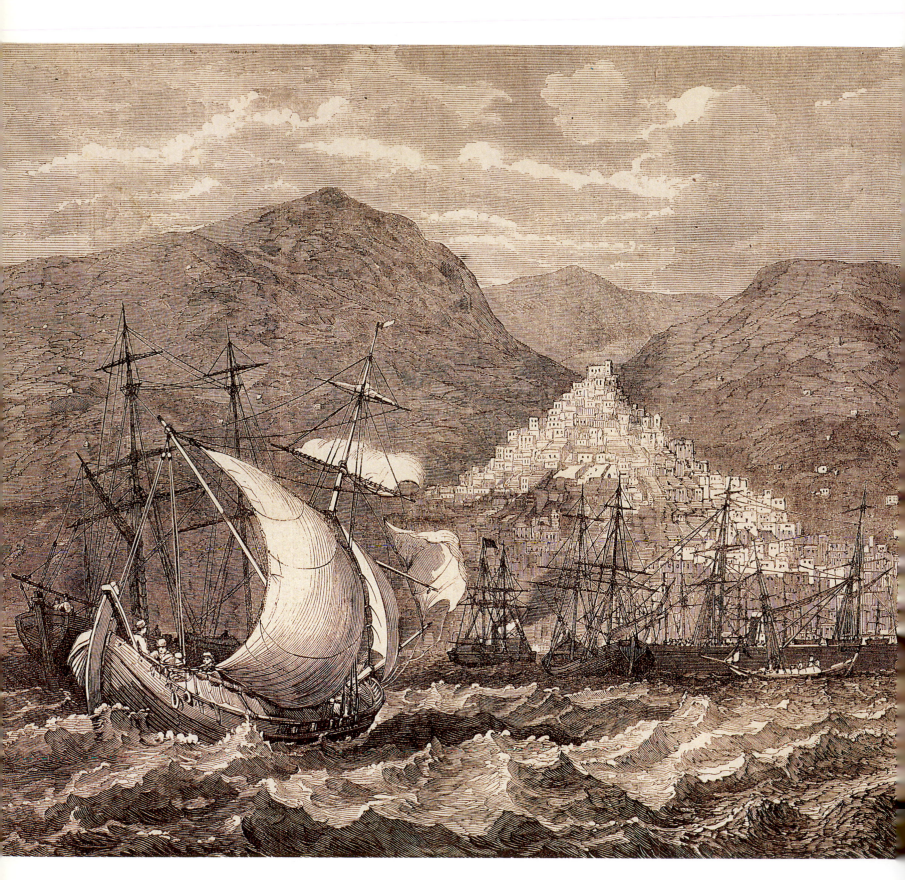

252

**331.** *The harbour of Syros with Hermoupolis and Ano Syra in the background. From "The Illustrated London News", 1863.*

**332-333.** *Sailing ships. Wall-paintings from the decoration of the Rallis mansion in Hermoupolis, now the Offices of the Syros Metropolis. Second half of the 19th century.*

**334.** *The ship "Enosis", famous from the battle fought against the Turkish fleet off the harbour of Syros in December 1868. Athens, National Historical Museum 1568.*

333

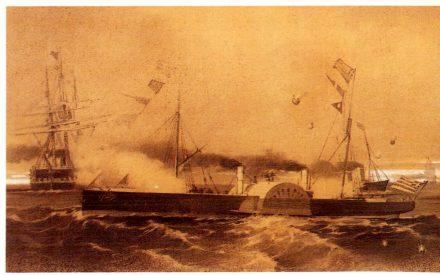

334

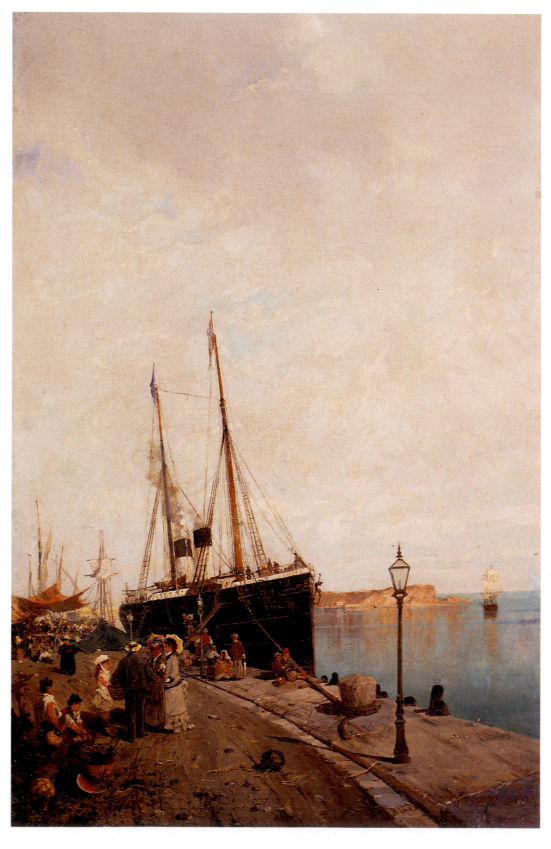

**335.** *On the quay, by K. Volanakis. Oil on canvas. Athens, National Gallery.*

**336.** *The harbour of Volos, by K. Volanakis. Oil on canvas. Athens, Private Collection.*

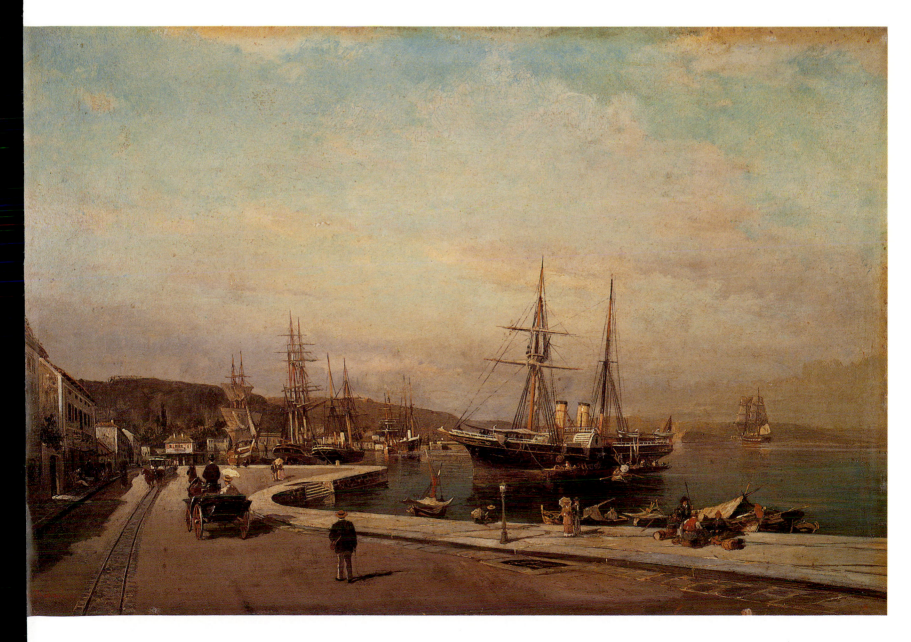

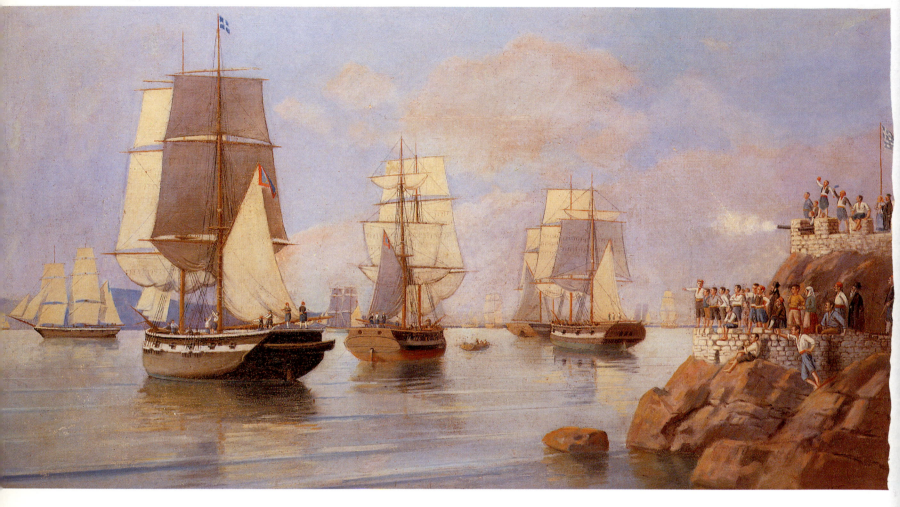

*337. Admiral Miaoulis welcomed on Hydra, by E. Prosalendis. Oil on canvas. Athens, A. G. Levendis Collection.*

*338. The "Ares" escape through the Turkish fleet at the naval battle of Pylos in 1825, by K. Volanakis. Oil on canvas. Athens, National Gallery.*

*339. The battleship "Averoff" in Constantinople after the truce of Moudros, 1918. Athens, National Historical Museum 3913.*

The first Greek steamships, the *Vasilissa tis Ellados*, *Hydra*, *Panellenion*, *Arkadi* and the *Enosis* (fig. 334), were purchased by the "Greek Steamship Company", which was founded on Syros in 1856. The creation of a modern mercantile fleet required the existence of steelworks capable of meeting the demands for the construction and repair of ships. In 1861, the first workshop for the repair of ships was built on Syros, and developed into the first shipbuilder's yard in the eastern Mediterranean.

It was only around 1870 that the first Greek merchant steamship was launched – the first seven steamships were all passenger vessels – which was indicative of the unwillingness of the Greek shipowners to renew and modernize their fleet.

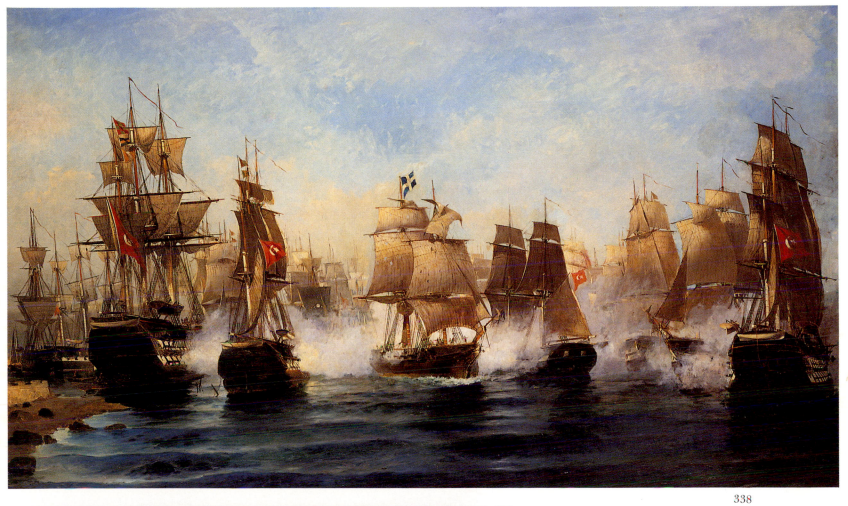

338

339

After 1887, it became increasingly clear that the sailing ship was in decline, and bulk orders were placed for steamships (fig. 358-360). After a temporary setback to the steady advance and expansion of the merchant fleet in 1897, due to the Greco-Turkish War, the Boer War in South Africa afforded many opportunities for new orders for ships.

In the space of three years, Greece acquired 66 new ships, with a capacity of 173,776 tons, thereby more than doubling the steamship capacity of the merchant fleet. The end of the Boer War led to a fall in the value of ships on the market, but Greek shipowners from Syros, Chios, Andros and Oinoussai bought large numbers of vessels at low prices and, with the aid of a new law passed in 1910 (institution of the guaranteed loan system), multiplied several fold the number of Greek ships.

The Turko-Italian War of 1911, and the Balkan Wars of 1912-13 revived the market in ships and brought a number of decommissioned vessels back into operation.

A new period of intense commercial activity began, though it lasted for only a short time, since the outbreak of the First World War in 1914 ushered in a very difficult period for merchant shipping on a world scale.

Greece was not involved in the conflict from the outset. The stance she adopted, however, led to an impasse, since the foreign powers prevented ships from putting in at Greek ports.

340

**340.** *Masted steamship painted on the outside of the lid of a wooden chest, late 19th century. Nafplion, Peloponnesian Folklore Foundation.*

**341.** *Pendant earrings in the shape of a boat. Gold, enamel and pearls. From Patmos, c.1930. Nafplion, Peloponnesian Folklore Foundation.*

**342.** *Wooden jewellery-box with rich painted and incised decoration. From Ioannina, Epiros, early 20th century. Peloponnesian Folklore Foundation.*

341

342

**343.** *Masted steamship with funnel, embroidered on cloth. Piraeus, Greek Naval Museum (A.Papayannopoulos-Palaios Collection).*

**344.** *Ceramic plate with sailing ships. From Italy, second half of the 19th century. Athens, Benaki Museum 8631-8632.*

**345-346.** *Silver votives inscribed with the name of the ship*

*("Evangelistria"). From Chios, late 19th-early 20th century. Athens, M.Païdousis Collection.*

**347.** *Ivory model of a ship with an embroidered sail. From Asia Minor, 19th century. Athens, Benaki Museum T. A. 1020.*

**348.** *Ceramic plate with a ship . From the Aegean islands, second half of the 19th century. Athens, Benaki Museum 8641.*

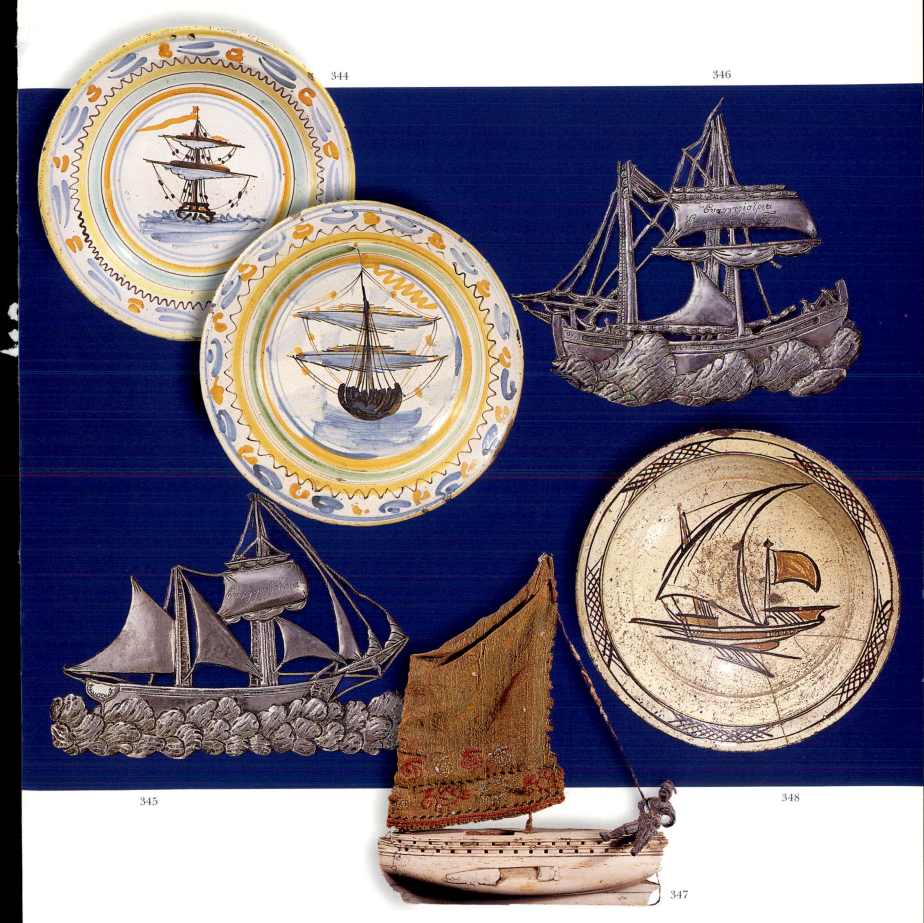

344

346

345

347

348

349

349. *Ship entering harbour, detail from "May's Wellcome", by Theophilos, 1910. Volos, Kitsos Makris Collection.*

350. *"The Admiral of the Fleet takes leave", by Theophilos, 1932. Vareia, Mytilini, Theophilos Museum.*

351. *The sailor and the girl, by Theophilos. Petra, Mytilini, T. Eleftheriadis Collection.*

350

It was then, in 1914, that the "Union of Greek Shipowners" was founded, its aim being to protect the interests of its members in periods of crisis, and particularly in their relations with the Greek state and with foreign competition.

In 1917, Greece was obliged to enter the war, and paid a heavy price. Within five years the Greek mercantile fleet lost 56.8% of its vessels. The main causes of this were the activities of enemy battleships and submarines, and mass sales of Greek ships to foreigners. With the concluding of peace in 1918, Greece succeeded in reorganizing the merchant fleet in a climate that was favourable to it.

On September 1st 1939, the day of the outbreak of the Second World War, it had achieved ninth place amongst the maritime countries, and had a fleet with a capacity of 1,833,000 tons. During the war, however, Greek shipping once again lost 73% of its fleet.

A new start was made after the war, with the provision by the American Government of 100 Liberty-type cargo ships and seven T/2 tankers, and by about 1963, the mercantile fleet had recovered its pre-war strength. At this same time, the fleet of Greek shipowners flying foreign flags occupied third place in world shipping, and in thirty years, it had succeeded in capturing first place.

351

*352. Detail of fig. 355.*

*353. The sailing ship "Alexandros III" owned by the Anatsitos brothers and built in Trieste in 1866. It is shown crossing the waters of Venice in front of the Square of St. Mark and the Doge's Palace. Water-colour by Vincenzo Luzzo, Venice 1873. Galaxidi, Galaxidi Museum.*

*354. The ship "Omonoia" owned by E. G. Tsipouras, built in Galaxidi in 1867. Water-colour by Vincenzo Luzzo, Venice 1879. Galaxidi, Galaxidi Museum.*

*355. Paddle-driven steamship with four masts and sails. I. Vorres Collection.*

There are a large number of interesting depictions of ships from the 19th and 20th centuries. Academic painters and popular artists painted naval battles and historical events, or seascapes (fig. 335-339, 349-351), and the ship was frequently the main subject of their paintings (fig. 353-358). Copperplate engravings and lithographs with views of historical cities and harbours were also produced (fig. 324-325) and circulated at accessible prices amongst a broad section of the population, while the world of the sea, and the ship, were popular motifs in the wall-paintings that adorned neoclassical houses (fig. 332-333).

In modern times, just as in previous periods, the ship is for the Greek at once a common decorative motif and a part of his life and history. Objects of everyday use, jewellery and weapons, painted wood-carved chests, ceramic plates, embroideries and votives (fig. 321-323, 340-348) immortalize the ship and its voyage through time.

353

354

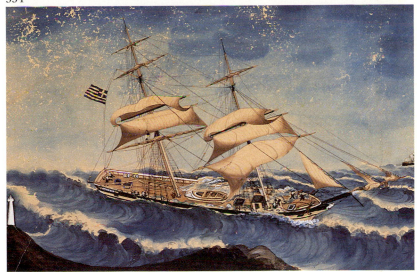

355

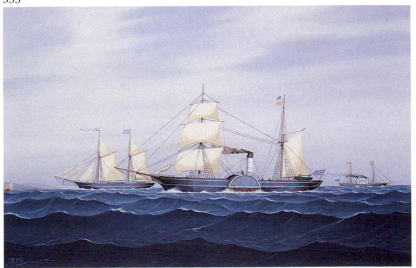

**356.** *The ship "Giovana Lignou" owned by G. Lignos. Water-colour, 1900. Oinoussai, Naval Museum.*

**357.** *The ship "Ayios Nikolaos" owned by the Kanelo brothers, which was lost on 8 November 1916. Water-colour by A. Glykas. Oinoussai, Naval Museum.*

**358.** *Passenger ship, painted by A. Glykas, early 20th century. Piraeus, Greek Naval Museum.*

356

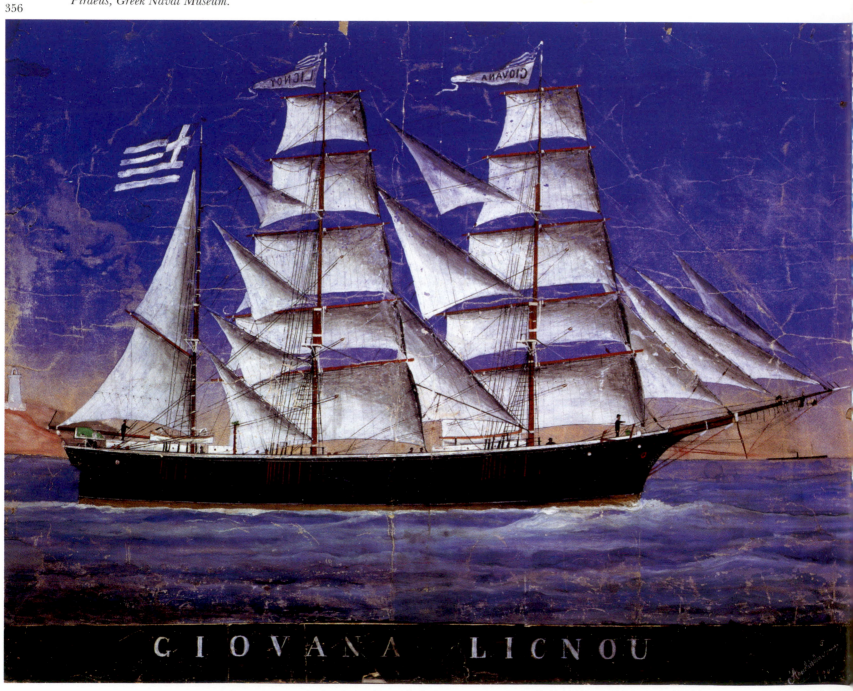

GIOVANA LICNOU

357

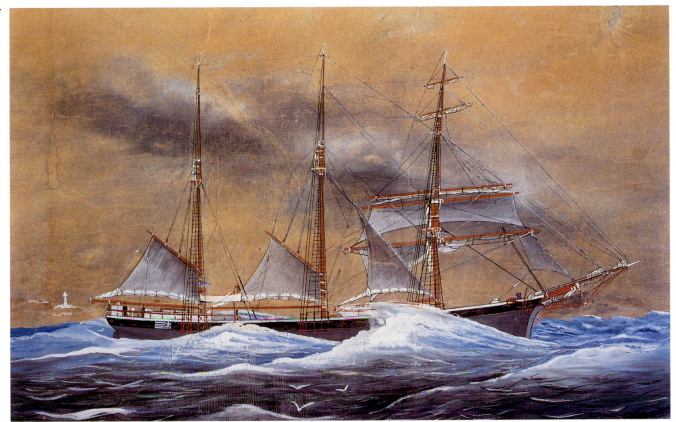

358

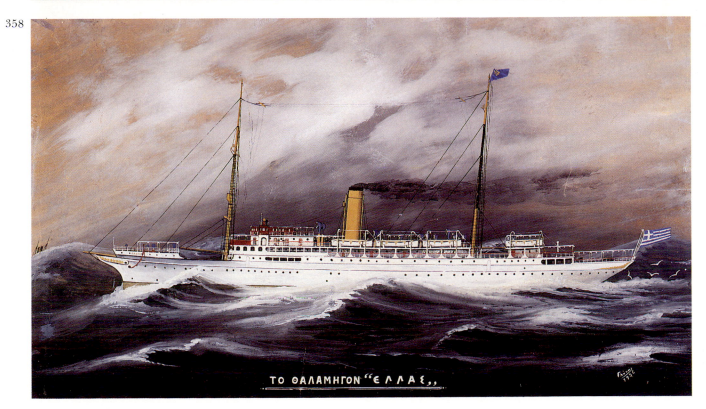

ΤΟ ΘΑΛΑΜΗΓΟΝ "ΕΛΛΑΣ„

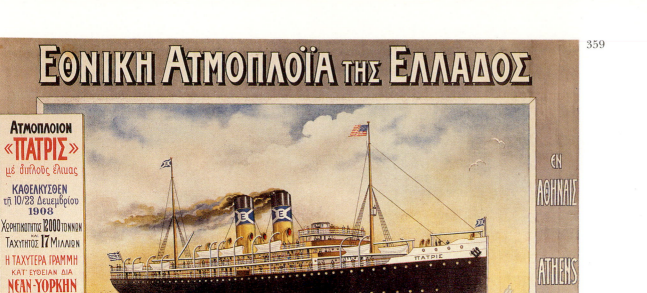

**359-360.** *Steamships owned by the "Greek National Steamship Company" for the American line. Bilingual advertising posters from the early 20th century. Athens, Society of the Greek Literary and Historical Archive.*

**361.** *Hundred-drachma note issued by the National Bank of Greece, with the personification of Hope and a scene of a ship. Ionian Bank Collection.*

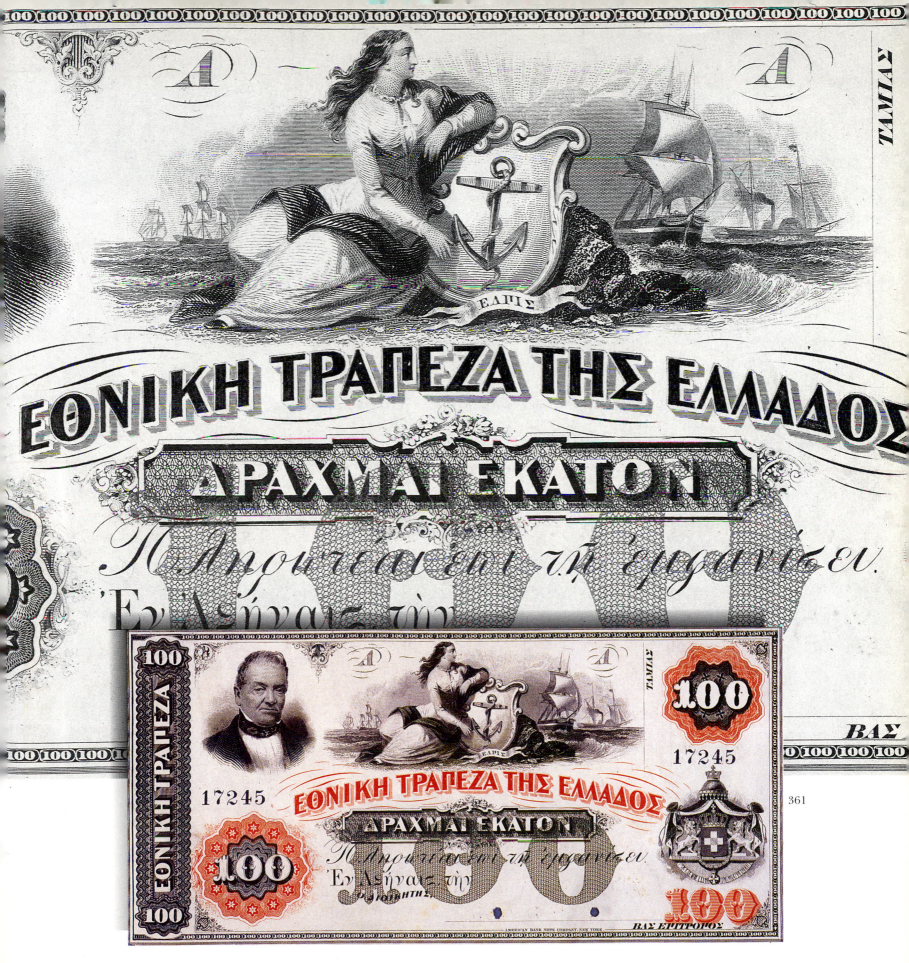

361

# BIBLIOGRAPHY

AHLBERG G., *Fighting on Land and Sea in Greek Geometric Art*, Stockholm 1971.

AHRWEILER H., *Byzance et la mer. La marine de guerre, la politique et les institutions de Byzance aux VIIe-XVe siècles*, Paris 1966.

AMANDRY A., *Η Ελληνική Επανάσταση σε γαλλικά κεραμεικά του 19ου αιώνα*, 1982.

AMIT M., *Athens and the Sea. A Study in Athenian Sea-power*, Bruxelles 1965.

ΑΧΕΙΜΑΣΤΟΥ - ΠΟΤΑΜΙΑΝΟΥ Μ., *Η Μονή των Φιλανθρωπηνών*, Αθήνα 1983.

BASCH L., *Le musée imaginaire de la marine antique*, Athènes 1987.

BASS G.F., *A History of Seafaring Based on Underwater Archaeology*, London 1972.

BASSETT F.S., *Legends and Superstitions of the Sea and of Sailors in All Lands and at All Times*, 1885.

BECKWITH J., *Early Christian and Byzantine Art. The Pelican History of Art*, 1970.

BIEBER M., *The Sculpture of Hellenistic Age*, 1961.

BOARDMAN J., *The Greeks Overseas. Their Early Colonies and Trade*, London 1980.

ΒΡΑΝΟΥΣΗ Ε. Λ., *Βυζαντινά έγγραφα της Μονής Πάτμου, Α΄, Αυτοκρατορικά*, Εθνικό Ίδρυμα Ερευνών, Αθήνα 1980.

BRAUDEL F., *La Mediterranée et le monde méditerranéen à l'époque de Philippe II*, 1966.

BRAUDEL F., AYMARD A., COARELLI F., *Η Μεσόγειος* (translated from the French), Αθήνα 1990.

CASSON L., *Ships and Seamanship in the Ancient World*, Princeton N.J. 1971.
   *Travel in the Ancient World*, London 1974.
   *The Ancient Mariners; Seafarers and Sea Fighters of the Mediterranean in Ancient Times*, Princeton N. J. 1991².

COLDSTREAM J.N., *Geometric Greece*, London 1977.

ΔΑΒΑΡΑΣ Κ., «*Μινωϊκό κηριοφόρο πλοιάριο της Συλλογής Μητσοτάκη*», AE 1984, 55-95.

DEMARGUE P., *Aegean Art*, London 1964.

DOUMAS CH., *The Wall-paintings of Thera*, Athens 1992.

FORSYTHE JOHNSTON P., *Ship and Boat Models in Ancient Greece*, Naval Institute Press, Annapolis Maryland 1985.

GÖTTLICHER A., *Materialien für ein Corpus der Schiffsmodelle im Altertum*, Mainz am Rhein 1978.

GRABAR A., MANOUSSAKAS M., *L' illustration du manuscrit de Skylitzès de la Bibliothèque Nationale de Madrid*, 1979.

GRAY D., *Seewesen* (Archaeologia Homerica), 1974.

HARDEN D., *The Phoenicians*, London 1963.

HYDE W.W., *Ancient Greek Mariners*, New York 1947.

JACOBSEN T.W. (ed.), Excavations at Franchthi Cave, Greece, 1-9, Indiana University Press, 1987 ss.

LANDSTRÖM B., *The Ship*, London 1961.

LANDSTRÖM B., *Ships of the Pharahos*, London 1970.

LANGLOTZ E., *The Art of Magna Graecia*, London 1965.

LING R., *Roman Painting*, Cambridge 1991.

MORGAN L., *The Miniature Wall-Paintings of Thera*, 1985.

MORRISON J.S., COATES J.F., *The Athenian Trireme*, Cambridge 1986.

MORRISON J.S.,WILLIAMS R.T., *Greek Oared Ships, 900-322 B.C.*, Cambridge 1968.

ΞΥΙΤΟΠΟΥΛΟΣ Α., *Οι τοιχογραφίες του Αγίου Νικολάου Ορφανού στη Θεσσαλονίκη*, 1974.

ΠΑΠΑΔΟΠΟΥΛΟΣ Σ., *Ελληνική Εμπορική Ναυτιλία*, ed. by the National Bank of Greece, Αθήνα 1972.

ΠΑΠΑΘΑΝΑΣΟΠΟΥΛΟΣ Γ., *Νεολιθικά - Κυκλαδικά*, 1981.

ΠΑΠΑΧΑΤΖΗΣ Ν., *Αρχαία ελληνική θρησκεία*, Αθήνα 1985.

POLLITT J.J., *Art in the Hellenistic Age*, Cambridge 1987.

REDDÉ, M., *Mare Nostrum*, Roma 1986.

RENFREW C., *The Emergence of Civilization. The Cyclades and the Aegean in the Third Millennium B.C.*, London 1972.

RODGERS W.L., *Greek and Roman Naval Warfare*, 1937.

ROSTOVTZEFF M., *The Social and Economic History of the Hellenistic World*, Oxford 1941.

ROUGÉ J., *Recherches sur l'organisation du commerce maritime en Méditerranée sous l'empire romain*, Paris 1966.

ΣΑΚΕΛΛΑΡΑΚΗΣ Ι., «*Ελεφάντινον πλοίον εκ Μυκηνών*», AE 1971, 188-233.

ΣΑΠΟΥΝΑ - ΣΑΚΕΛΛΑΡΑΚΗ Ε., *Cycladic Civilization and the Cycladic Collection of the National Archaeological Museum of Athens*, 1973.

SNODGRASS A.M., *The Dark Ages of Greece*, Edinburgh 1971.

ΣΠΗΤΕΡΗΣ Τ., *Τρεις αιώνες Νεοελληνικής τέχνης, 1660-1967*, Αθήνα 1979.

ΣΤΑΥΡΙΔΗ Α., «*Ρωμαϊκά γλυπτά από το Εθνικό Μουσείο*», AE 1984, 161-190.

ΤΣΙΓΚΑΚΟΥ Φ. Μ., *Ανακαλύπτοντας την Ελλάδα*, Αθήνα 1981.

VERMEULE E., *Aspects of Death in Early Greek Art and Poetry*, California 1981.

VERNANT J.P., *Mythe et pensée chez les Grecs*, Paris 1974.

VIERECK, H.D.L., *Die römische Flotte*, 1975.

WELSH, F., *Building the Trireme*, London 1988.

WESTERBERG K., *Cypriote Ships from the Bronze Age to c. 500 B.C.*, Gothenburg 1983.

ΧΑΤΖΗΔΑΚΗΣ Μ., *Εικόνες της Πάτμου*, ed. by the National Bank of Greece, Αθήνα 1987.

ZERVOS C., *L' art des Cyclades*, Paris 1965.

## CATALOGUES

*Ναυτικό Μουσείο της Ελλάδος*, Πειραιάς 1984.

*Βυζαντινή και Μεταβυζαντινή Τέχνη*, ΥΠΠΟ - Βυζαντινό Μουσείο, Αθήνα 1986.

*Γαλαξιδιώτικα καράβια*, Μουσείο Γαλαξιδιού, Αθήνα 1987.

*Ναυτικό Μουσείο Αιγαίου* (Γ.Μ. Δρακόπουλος), 1987.

*Greece and the Sea*, ΥΠΠΟ - Μουσείο Μπενάκη, 1987.

*Ταξιδεύοντας με το πλοίο της Κυρήνειας στο χρόνο και στο μύθο*, ΥΠΠΟ - Ελληνικό Ινστιτούτο Προστασίας Ναυτικής Παράδοσης, Αθήνα 1987.

*Η Ελλάδα ακουμπάει στη θάλασσα*, Αθήνα 1988.

*Ο Μυκηναϊκός κόσμος*, ΥΠΠΟ - Ελληνικό Τμήμα ICOM, Αθήνα 1988.

*I Fenici*, ed. Bompiani, Milano 1988.

*Ναυτικό Μουσείο Οινουσσών*, Χίος-Αθήνα, 1991.

# PHOTOGRAPHERS
# AND SOURCES OF ILLUSTRATIONS

**ATHENS**: *Commercial Bank*: fig. 350, 351.

*Credit Bank*: G. Kitsios fig. 110-112, 137, 148-151, 155, 187, 188.

*Ionian Bank*: fig. 361.

*A. Amandry Collection*: fig. 310, 312.

*A. G. Levendis Collection*: fig. 337.

*I. Vorres Collection*: fig. 355.

*National Gallery*: fig. 335, 336, 338.

*Acropolis Museum*: G. Fafalis fig. 130.

*Benaki Museum*: Phot. Archive fig. 175, 344-348, G. Fafalis fig. 104, M. Skiadaresis fig. 23, 101, 208, 227, 248, 285, 291-294, 296, 301, 316, 317.

*Byzantine Museum*: G. Kitsios fig. 250, 251, 253, 254, 256, 264, 265, 276, 277, 282.

*Kanellopoulos Museum*: G. Kitsios fig. 228, 229, 255.

*Kerameikos Museum*: G. Kitsios fig. 167.

*Museum of Cycladic Art*: fig. 30.

*Museum of Greek Folk Art*: G. Kitsios fig. 283, 284, 297, 300.

*National Archaeological Museum*: G. Fafalis, fig. 45-46, G. Kitsios fig. 2, 19, 20, 21, 26, 105, 128, 145-147, 178, 179, 180, M. Skiadaresis fig. 177, 349

*National Historical Museum*: G. Kitsios fig. 236-238, 298, 299, 302-307, 311, 313, 318, 320, 321, 326-328, 334, 339.

*Numismatic Mueum*: G. Kitsios fig. 127, 152-154, 160-162, 164, 189-194, 210, 211, M. Skiadaresis fig. 134-135.

*Phot. Archives: Archaeological Receipts Fund*: fig. 42-46, 61, 72, 73, 75, 87, 120 (G. Fafalis), 49, 77, 157, 165, 204, 280, 281, 316, 317 (M. Skiadaresis). *ICOM*: fig. 47, 50, 62, 88 (G. Fafalis). *M. and R. Kapon*: fig. 12, 14, 15, 93, 139, 143, 144, 174, 233, 287, 329-331. *A. Kokkou*: fig. 203, 332, 333.

*Publishing House "Melissa"*: fig. 352-354.

*Society of the Greek Literary and Historical Archive*: fig. 234, 359, 360.

**HERAKLEION**: *Archaeological Museum*: G. Kitsios fig. 22, 28, 29, 31-41, 53, 60, 76.

*Historical Museum of Crete*: G. Kitsios fig. 239, 240, 243, 278, 279.

**ISTHMIA**: *Archaeological Museum*: G. Kitsios fig. 89, 90, 198.

**IOANNINA**: *Monastery of Philanthropinon*: fig. 266-268.

**KERKYRA**: I. Iliadis fig. 244, 245, 252, 263.

**LAMIA**: *Archaeological Museum*: fig. 48.

**MOUNT ATHOS**: *Monastery of Panteleimon*: fig. 221, 222.

**MYKONOS**: *Aegean Nautical Museum*: G. Fafalis fig. 125, 126, 337.

**NAFPLION**: *Archaeological Museum*: G. Kitsios fig. 51, 52.

*Peloponnesian Folklore Foundation*: G. Kitsios fig. 322, 323, 340-342.

**NICOSIA**: *Archaeological Museum*: X. Michail fig. 56-58, 115, 116, 119, 226, 269-273, 288-290.

*Makarios III Foundation*: fig. 230, 231.

**OINOUSSAI**: *Naval Museum*: D. Kalapodas fig. 356, 357.

**PIRAEUS**: *Greek Naval Museum*: fig. 241, 242, 314, 315, 343, 358.

**SITEIA**: *Toplou Monastery*: G. Kitsios fig. 258-262, 274, 275, 324, 325.

**VOLOS**: *K. Makris Collection*: M. Skiadaresis fig. 349.

**ALEXANDRIA**: *Phot. Archive Sarapis*: fig. 136.

**BASEL**: *Antikenmuseum und Sammlung Ludwig*: fig. 86.

**BERLIN**: *Staatliche Museen - Antikensammlungen*: fig. 156.

**LONDON**: *British Museum*: fig. 4, 6, 8, 27, 71, 74, 78, 83, 100, 102, 106, 108, 118, 121, 159, 168, 169.

*Victoria and Albert Museum*: fig. 286, 295.

*Private Collection*: fig. 103, 214.

**MADRID**: *National Library*: fig. 215-218, 220.

**MUNICH**: *Antikensammlungen*: *Phot. Archive Koppermann*: fig. 70, 109.

**NEW YORK**: *Metropolitan Museum*: fig. 67, 68, 113, 117.

**PARIS**: *Musée du Louvre*: A. Reppas fig. 10, 11, 16, 17, 18, 59, 63-65, 80-82, 91, 95-99, 107, 138, 142, 170, 171, 195, 207, 212. *Phot. Archive*: fig. 3, 9, 84, 196, 197.

*National Library*: fig. 235.

**ROME**: *Phot. Archive Luciano Pedicini*: fig. 79, 122, 163, 199-201.

*Phot. Archive Scala*: fig. 92, 172, 173, 176, 202, 205, 206, 209, 213, 223, 224.

*Phot. Archive Alessantro Vasari*: fig. 85, 94, 123, 124, 182-186.

**STOCKHOLM**: *Museum of Mediterranean and Middle Eastern Antiquities*: fig. 54, 55.

**TORONTO**: *Royal Ontario Museum*: fig. 66.

**VATICAN**: *Pio Clementino Museum*: fig. 181.

**VENICE**: *Greek Institute of Byzantine and Post-Byzantine Studies*: fig. 219, 246, 247, 249.

SELECTION OF ILLUSTRATIONS: ELSI SPATHARI

DESIGN: RACHEL MISDRACHI-KAPON

ARTISTIC ADVISOR: MOSES KAPON

ELECTRONIC LAYOUT OF TEXT: K. ILIOPOULOU

COLOUR SEPARATION: MICHAILIDES BROS

STRIPPING: G. PANOPOULOS, PH. VRETTAS

PRINTING: E. DANIEL & Co S.A.

BINDING: G. MOUTSIS - G. ILIOPOULOS

COVER DESIGN (fig. 99, 356): MOSES KAPON